FORD
MADOX
BROWN

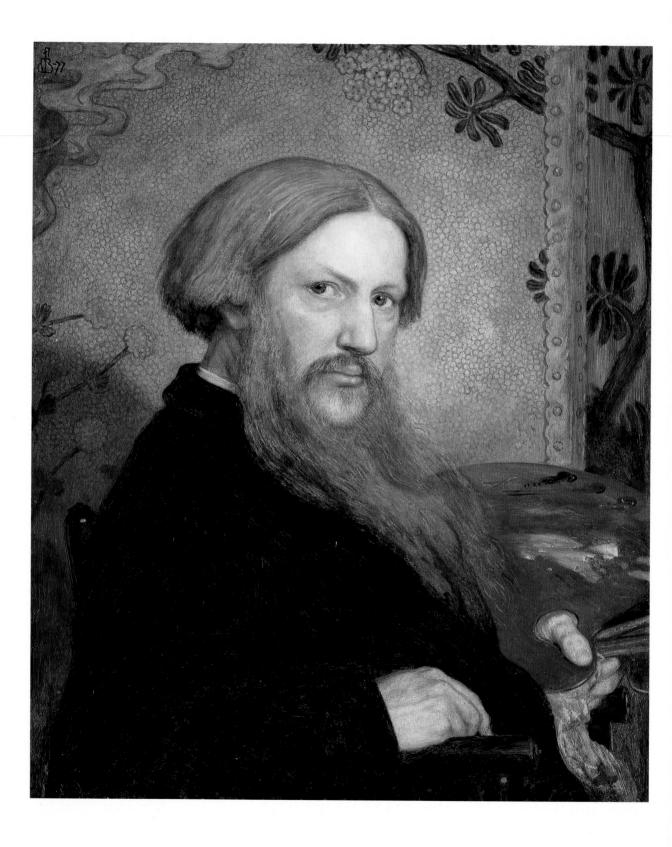

FORD MADOX BROWN

AND THE
PRE-RAPHAELITE CIRCLE

Teresa Newman and Ray Watkinson

CHATTO & WINDUS

LONDON

HALF TITLE Ford Madox Brown's monogram.

FRONTISPIECE *Self portrait, 1875–6.*

First published in 1991 by
Chatto & Windus Ltd
20 Vauxhall Bridge Road
London SW1V 2SA

A CIP catalogue record for this book
is available from the British Library

ISBN 0 7011 3186 1

Teresa Newman and Ray Watkinson have asserted
their right to be identified as the authors of this book.

Photoset and printed in Great Britain by
Butler & Tanner Ltd, Frome and London

In memory of Barney Blackley
whose quiet encouragement
and keen editorial eye helped
turn a cherished project
into a book

CONTENTS

Acknowledgements

The author and publishers would like to thank the following institutions for permission to quote from manuscripts in their possession: Princeton University Library; The Huntington Library, San Marino, California; The Clerk of the Records at the House of Lords; The National Galleries of Merseyside; The Department of Rare Books, Cornell University Library; The Harry Ransom Humanities Research Center, the University of Texas at Austin; The Brotherton Library, Leeds University; The Bodleian Library, Oxford; The John Rylands University Library of Manchester; The Library of the University of British Columbia, Vancouver; and Oxford University Press for permission to quote from *The Letters of Dante Gabriel Rossetti*.

We also wish to thank many individuals for ideas, help and hospitality over the five years this book has been in gestation, including Mary Bennett, Imogen Dennis, Lucy and Roderic O'Conor, Lady Soskice and the Hon. Oliver Soskice, Elisabeth Servan-Schreiber, Julian Treuherz, Jeremy Maas, Virginia Surtees, Professor William Fredeman, Carole Silver, Jan Marsh, Penelope Fitzgerald, Lady Longford, Betty and Rowland Elzea, Lucy Rabin, Ann Yandle, Dan Murray, Norman Kelvin, Joe Dunlap, George Landow, Dudley Johnson, Hélène Roberts, Max Saunders, Norah Gillow, Peter Cormack, David Dallas, Elizabeth Aslin, Barbara Morris, Margaret and Mrs Nini Borgerhoff, Hélène Parreaux, Michèle Norel, Margaret Sonn, Ruth and Edmund Frow. We owe a special debt to our patient and capable editor at Chatto and Windus, Jenny Uglow, and to Sara Robin and Mark Bell.

INTRODUCTION

'HIS WORK STARTLES ONE into the belief that we have in him an artist of singular truth, soundness and originality; while so strong is the evidence of intellectual insight, at once into the spirit of the past and of our own day, and of vividness in the dramatic exhibition of character, that we must henceforth assign him one of the leading places among our very small but honoured company of genuine historical painters.'

Thus the contemporary critic Palgrave, writing of Ford Madox Brown's 1865 retrospective, where *Work* formed the centrepiece. A hundred and twenty-five years on, the artist remains relatively unknown, although Mary Bennett's 1964 exhibition at the Walker Art Gallery, Liverpool, brought together many important works, and the Tate Gallery's The Pre-Raphaelites (1984), where Brown appeared alongside his famous contemporaries Millais, Hunt and Rossetti, confirmed Palgrave's judgement. We believe that the time is ripe for a new assessment of this great original, the most underrated figure in British art of the nineteenth century.

His range was wide. *Work* and *The Last of England* were the contemporary face of a large body of imaginative painting, beginning in the 1840s with *Chaucer at the Court of Edward III* and ending with the Manchester Town Hall murals of 1878–93. A realist, Brown gave almost as much value to the landscape setting of his dramas as to the figures: as a landscape painter in his own right, he rejected the picturesque, finding poetry in the very 'ordinariness' of the workaday countryside. For Madox Brown, truthfulness and genuineness were more important than the 'Beauty' so eagerly sought by nineteenth-century collectors, and his portraits show an unsentimental interest in the sitter's character and expression. The furniture he designed was likewise sturdy and functional, making no concessions to the fashionable, while his stained-glass designs for Morris, Marshall, Faulkner & Co. (over a hundred and fifty) are distinguished from the aestheticism of his contemporaries by a bold directness. These qualities, a strong vein of eccentricity and his wilfulness in constantly making new beginnings have baffled and sometimes repelled the public.

His career was a triumph of spirit over domestic and professional adversity. The bright promise of youth was overshadowed by bereavement, poverty and ill-health, and a warm and generous personality became warped (over time) by neurotic suspicion bordering at times on paranoia. Born abroad, he was always an outsider.

———

1

In England, faced with an art establishment he never understood, his ambition turned to rebellion. Fired with admiration for William Hogarth and Benjamin Robert Haydon, those eloquent foes of the Royal Academy, he increasingly took on their role.

Along with a real genius for friendship (witness his love of Rossetti), Brown had an equal talent for making enemies – among them fellow artists, critics, dealers and patrons. Mutual hostility, for example, governed his relations with the most influential critic of the day, John Ruskin, who did his best to prevent the sale of his pictures.

Nor has posterity helped Brown, caught as he was between William Rossetti's promotion of his brother Gabriel and Holman Hunt's jealousy of the Rossettis. Those seminal historians of the Pre-Raphaelite renaissance undervalued Brown's contribution, while Ford Madox Hueffer, only twenty-three when he published his *Ford Madox Brown* in 1896, was too inexperienced to measure his grandfather's artistic status in what is very much a family biography.

In this book we show for the first time the range and wealth of Ford Madox Brown's production, in the context of a life wholly dedicated to art.

1
KENT, CALAIS, BELGIUM
1821 – 1841

'This blessed plot, this earth, this realm, this England, . . .'

SHAKESPEARE, *King Richard II*

A GALE WHIPS UP THE ENGLISH CHANNEL as the *Eldorado*, crowded with emigrants, steams out of Dover harbour bound for the Antipodes. The rocking motion throws her passengers into a jumble of shapes, faces, bonnets and limbs; and a chorus of hands – blue with cold and variously spread, curled or clenched – signifies departure. By contrast, the young couple huddled in the stern are as still as icons. Wide-eyed they watch the familiar landmarks recede, realising the implications of their loss. But while the woman's expression is gentle and accepting (the tiny hand and boot of a baby are just visible under her shawl), his is darkly brooding, eloquent of disappointment and the bitterness of enforced exile. This is the face of Ford Madox Brown at thirty-one.

Brown did not emigrate, and *The Last of England* is among the great painted fictions of the nineteenth century. But the picture is the most nakedly autobiographical of his works – at once a tribute to England and a measure of the artist's disenchantment when, unrecognised and penniless, he contemplated a new life in India. At the same time, in 1852, the twin portrait of himself and his second wife, Emma, had a wider purpose: to dramatise the phenomenon of mass emigration.

For Brown, the White Cliffs symbolised the kindlier England of childhood memory – old John of Gaunt's idealised 'other Eden' and his own early dreams of success. The young couple gaze back – as we cannot – at the living emblems of English history on the skyline, Dover's ancient lighthouse and ruined Roman tower, her castle with its square Norman keep, the Saxon church of St Mary. And, travelling back in memory inland, along the childhood familiar route to Uncle James Madox's house at Foots Cray, he pictures the fertile, rolling Kentish countryside, dotted with

small farms and orchards, and the wide Thames estuary full of ships. Across it, on a fine day, you could see the village of Southend on the Essex shore. Nearer London are Thornhill's great painted hall at Greenwich, which had inspired his vision of English history, and the humbler wharf on Ravensbourne Creek, whose rents brought his small share of the Madox family income.[1]

How often, since infancy, had Brown crossed the English Channel! His Englishness was the product of his continental birth and upbringing: it was only in 1846, a widower of twenty-five with a young child, that he had adopted England as his home. When he did so it was with an exile's fervour, his brain teeming with images of her history, language and culture, to be realised in a series of masterpieces: *The Body of Harold Brought Before William the Conqueror; Chaucer at the Court of Edward III; Wycliffe Reading his Translation of the Bible to John of Gaunt; Cordelia at the Bedside of Lear; An English Autumn Afternoon; The Last of England; Cromwell on his Farm; An English Fireside.*

In all but the last, the English landscape plays a key role and is meticulously recorded as to season, play of light and prevailing weather, establishing a precise historical context and setting the dramatic mood. By contrast, Brown's handful of pure landscapes of Kent, Essex and Middlesex document his pleasure in the 'workaday beauties of the country'[2] and are among the most haunting and intense of the nineteenth century.

Ford Madox Brown was born in 1821 in Calais, the second child of Ford Brown and his wife Caroline Madox. Their daughter Eliza Coffin (Lyly) was then two years old. The Browns had settled in northern France soon after their marriage in 1818, in circumstances of genteel poverty. Ford senior's career had culminated in service on the seventy-four-gun *Arethusa* under Admiral Sir Isaac Coffin during the Napoleonic Wars, as ship's purser or, euphemistically, 'commissariat officer of the British navy'. But, like thousands of fellow officers, with the peace of 1815 he was placed on half-pay and effectively retired. He was then thirty-five. The propertied Madoxes — long established in Kent — did not oppose his marriage, but Caroline's brother James, head of the family and a solid City lawyer, prudently drew up a settlement securing her share in the Madox properties to her and her children.[3]

Ford Brown never got another ship and despite financial difficulties never found alternative work. Instead he embarked on a programme of self-education. 'My father was a cultivated Scotchman, possessing besides fair classical attainments a knowledge

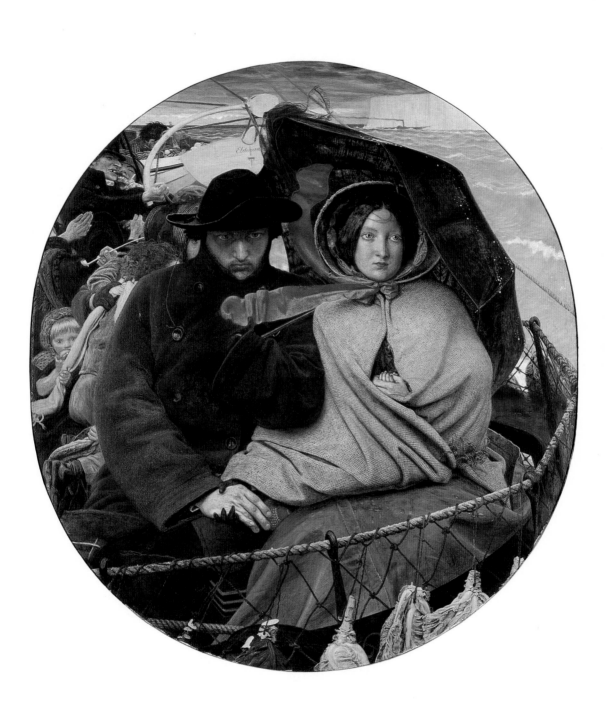

1 *The Last of England*, 1852–5. Brown with his second wife, Emma.

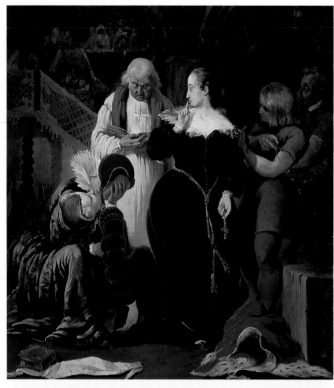

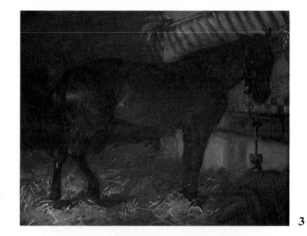

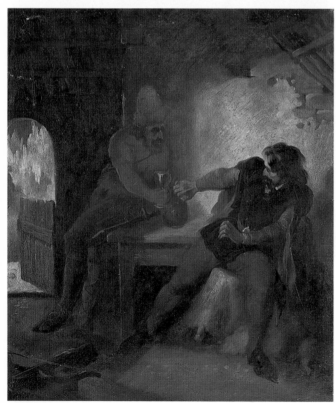

2 *The Execution of Mary, Queen of Scots*, 1839–40. Painted in Antwerp, exhibited Paris, 1842.

3 *Study of a Pony (Major Freulich's Horse)*, Ghent, 1857.

4 *Manfred in the Chamois Hunter's Hat*, Antwerp, Paris, 1840–1. Companion to *Manfred on the Jungfrau*.

5 *The Young Mother (The Infant's Repast)* Clipstone Street, 1848.

of the literature of France, Spain and Italy besides a great love of science and the fine arts,' his son remembered. He could be good company too, having a rich fund of stories about naval life, 'but having earlier acquired a restless habit cruising at sea for years, he could not stay long in one place but kept … shifting his family from France to England and from town to town'.[4]

At sixteen, young Ford painted a life-size portrait of his father whose ruddy face and shock of grey hair suggest an alert and forceful personality. But his children knew him mainly as a frustrated invalid, a martyr to disabling gout, increasingly querulous and demanding. Despite, or perhaps because of this, however, Papa inspired great affection.

He had grown up in the shadow of his famous father, Dr John Brown (1735–1788) of Edinburgh. The son of a farm labourer, this brilliant classical scholar and leading physician of his day had developed an unorthodox system of medicine. Instead of the then-universal bloodletting, Dr Brown treated his patients by dietary means, building up their strength and administering, according to need, stimulants or tranquillisers – alcohol or opium. For twenty years he enjoyed great professional success. Convivial and entertaining, this maverick doctor was popular with his students but (like his grandson) antagonised the professional establishment and was excluded from any academic post in Edinburgh. Still, he earned enough to educate his large family and indulge a taste for good living, and he was admired throughout Europe – not least by Napoleon. But a stormy life ended prematurely and in disappointment. In 1786 enemies and debts drove him from Edinburgh to London, where he died of a stroke in 1788 – an end his enemies attributed to the whisky and laudanum he took for gout. Of his eight children, two sons were successful doctors, and his daughter (Madox Brown's Aunt Bessy) became a novelist. But the education of Ford, the youngest son, was cut short and he was placed in the navy as a boy clerk.[5]

The Calais family was close-knit. Gentle and self-effacing, Caroline Brown found fulfilment in nurturing her irascible, restless husband and her children. An excellent housekeeper, she managed the family's straitened budget with calm good humour, personifying Ford's lifelong ideal of secure, loving womanliness. Her son captured the sweet, serious face, worn by anxiety, in one of his earliest extant drawings.

They were always on the move. They had at least two spells in Dunkirk, when Ford was four and again at thirteen, but 'home' in his memory was medieval Calais – the so-called English town – where they first lodged in the narrow rue de l'Horloge, above a shoemaker called Faskel. From the windows they could see over the red-tiled roofs to the old fortress and hear the carillon of the Hôtel de Ville as it slowly chimed the quarters. The children shopped with Mama in the colourful market-place,

crowded each Saturday with farmers and their wives in starched white caps and aprons, their sabots clattering on the cobbles. Food was cheap in France, and the cost of living in general was about half that in affluent England.

Three times a year a great fair was held in the market-place, with carousels and side-shows, rope-dancers heralded by drummers, and raucous music echoing down the streets far into the night. The children were looked after by a *bonne* who would let them run barefoot on the wet and windy sands, or take them up to the fortress ramparts to look out on the dunes. On one such expedition she pointed out a shabby old man exercising his bulldog, and Ford recalled her awestruck whisper: *'C'est le grand Monsieur Brummell, l'ami du roi d'Angleterre.'*[6]

There were picnics with other English residents in the nearby forest of Guisnes – elaborate affairs with servants. On one of these, dressed in his 'blouse' – a one-piece suit buttoned up the back like the small boy's in *John Dalton* (one of his murals painted for Manchester Town Hall in 1887) – young Ford wandered off in search of the food hampers, got lost and was rescued by a sandboy and sandgirl with a donkey. 'I could only howl and keep repeating *"je veux maman"* but at length they seated me on the sand panniers and carried me to my friends.'[7] Ford's unbroken hold on the imaginative life of his own childhood accounts for the peculiar intensity of his paintings of children, which show such empathy with their subjects. Much of his childhood, he told William Rossetti, had had the quality of a dream. He was about eleven when he 'passed a whole year in great mental dismay having somehow come to the conclusion that all he saw about him, including his parents, were nothing but a vision and a simulacrum'.[8]

Calais life revolved around their contacts with other expatriates. Sometimes they met at Dessein's Hotel, but Mama also gave 'at homes', when Ford would play his violin accompanied by Lyly on the guitar and such musical entertaining would become a significant feature of Ford's later life. Mama was proud of her fair-haired son, with his old-fashioned and courteous manners, his slow, deliberate speech (he was bilingual) and his precocious talent for drawing. This had manifested itself at the age of four, when he astonished his parents by correcting Papa's drawing of a horse; at six he was making skilful copies of the tapestries of *Pizarro's Conquest of Peru* which hung in their salon; by twelve he was turning out portraits and lively sketches of dogs and huntsmen done from imagination.

Ford senior and Caroline did not send their children to school. Mama taught them the three Rs, but Ford's formal education did not progress much beyond these. His excellent spoken English was, for this reason, not matched by a corresponding fluency in the written language, either in spelling or in syntax, and throughout his life he felt this as a handicap. But music and drawing-masters were engaged – the

latter an Italian who set both children to routine copying of old master engravings by the fashionable eighteenth-century artist Bartolozzi.[9] More important than his formal education, perhaps, were the attitudes Ford inherited from his parents, not least the absolute value placed on the concepts of Genius and independence, which his grandfather's career exemplified and which his father constantly inculcated, and, poor as they were, pride in his mother's Kentish ancestry – her 'good blood'. Ford clung tenaciously throughout his life to the status of gentleman.

In 1834 Papa's gout was compounded by a paralysing stroke. On 5 July he wrote to the Admiralty claiming a recent increase in half-pay. Alternatively he asked to be transferred to land duties on full pay. Both were refused. In the same year he made another application, this time to his former commander, Admiral Coffin, asking him to sponsor thirteen-year-old Ford for a midshipman's place. But an 'estrangement of his father from his patron', all-too-typical of the male Browns, produced a further rejection. His own future being precarious, the father now urgently sought a suitable career for the boy who would become the family breadwinner.

Ford's disappointment was keen: he would have enjoyed the life of 'a sucking Nelson'. But his parents decided on the more congenial and lucrative possibilities of Art. Ford must receive the finest professional training, and to this end mother, father and sister now dedicated themselves. 'In Belgium,' says Ford Hueffer, Ford's father '... saw how honours and emoluments awaited a successful artist.'[10]

Belgium had recently undergone a revolution (1830–3), winning its independence from the Dutch. The new king, Leopold – cousin of Prince Albert of Saxe-Coburg (later Queen Victoria's consort) – had recently raised the artist Gustave Wappers to the rank of Baron and had appointed him to his court in recognition of his nationalist history paintings. He was now Professor of Painting at the Academy of Antwerp and hopes of an equally brilliant career led to the enrolling of fourteen-year-old Ford at the Bruges Academy of Painting, Sculpture and Architecture in the autumn of 1835. The old Academy, a late-Gothic brick building with a symmetrical façade, an octagonal tower and tall dormers piercing the steep roof, still stands on the corner of Academiestraat and Jan van Eyck Plaats by the cobbled quayside in the heart of medieval Bruges, and it was here that Albert Gregorius, its newly-appointed Director and a former pupil of the great Jacques-Louis David, was engaged to transform a sleepy provincial school into an instrument worthy of the new Belgium. By the standards of the day, the conservative Gregorius was something of an innovator: the state archives reveal, for example, his desire to bring a new professionalism to the students and greater realism to their academic compositions by the use of a variety of models. He arrived from Paris in November 1835 while 'Brown, Ford' and nine other students were wrestling with the mysteries of life

drawing in the Figure Class. He may also have taken private lessons in portraiture from Gregorius. Ford had joined the school just in time, as its new prestige was to attract more students than it could accommodate. At the end of the winter session in April 1836, he was placed third.[11]

Bruges made an indelible impression on the young artist. Ford was enchanted by its unexpected turnings and quaint vistas, its canals, small bridges and lacemakers' shops. In his day the canals carried painted boats and barges loaded with country produce or fish from the port of Ostend, while horses and dogcarts shared the narrow streets with smart carriages. Along the canals, beneath the wide Belgian sky, was reflected an ever-changing kaleidoscope of turrets and patterned brickwork, of chequered casements and high-stepped gables, while the ornate façades of the Grande Place and great belfry awed him.

More important, however, was the experience of Flemish art which infuses the best of Ford's work: the earthy realism of Dieric Bouts and Pieter Bruegel, verging on the grotesque, and the splendid Memlings, van Eycks, Campins and van der Weydens at the Hôpital Saint-Jean. At once mystical and real, decorative and symbolic, these psychological dramas set in luminous interiors or landscapes were deeply absorbed. The jewel of this collection is Memling's *Reliquary of St Ursula*, echoed in Ford's Gothic masterpieces, *Wycliffe* and *Chaucer*. Fifteen years later young Dante Gabriel Rossetti visited Bruges at Ford's instigation and reported to his fellow Pre-Raphaelites:

> This is the most stunning place, immeasurably the best we have come to ... by far the best of all are the miraculous works of Memling and Van Eyck. The former is here in a strength that quite stunned us — the perfection of character and even drawing, the astounding finish, the glory of colour and above all the pure religious sentiment and ecstatic poetry of these works is not to be conceived or described ...[12]

At the Bruges Academy, the pictures were by living, and mostly local, artists whose domestic genre paintings and romantic landscapes augmented the austere classical works of the turn of the century. Gregorius was represented by pictures of two types: studies from the antique and realistic portraits. In September 1836, a painting of *Belisarius at his Wife's Deathbed* by the Bruges classicist Kinsoen entered the Academy's collection, perhaps inspiring Ford's first life-size composition: *A Blind Beggar and his Child* (now lost).

As no works are known to survive from the year in Bruges, no precise influences

can be attributed to Ford's time there. By the autumn of 1836 he had moved on to the nearby Academy in Ghent (a stepping-stone to his ultimate goal, Antwerp). Here another David pupil, Pieter van Hanselaer, taught him, leaving as little mark as Gregorius, though Ford diligently attended the regulation Antique, Life and Still Life classes.

Meanwhile he was developing fast as a painter. At Ghent, Ford began regularly to produce works for sale. His first productions were realistic genre scenes and conventional portraits, sold locally or in England – lucrative pot-boilers fetching around £8 apiece. Some paintings were shown at the annual exhibitions which rotated three-yearly between Bruges, Ghent and Antwerp, while others were sold or given away at various times during his life. Few survive. Those that do show him already a master of the oil medium; they are characteristically dark-toned, with strongly contrasted light and shade and vigorous brushwork.

Ford was a natural portraitist. The early portrait of his father dating from 1836–7 is convincingly lifelike and well drawn, while a small portrait of his musician friend *Frederic Pendleton* has the directness of a work swiftly executed. Pendleton was a student at Ghent University who taught him the violin, probably on the instrument shown in the portrait. Although inscribed '*A mon ami . . .*', Ford's account book notes, 'Given, Portrait of Surtees or Pembroke – his name was quite uncertain – a fiddler', to which a note was added in 1877, 'I find he is Pendleton, now a clergyman' – typical of the artist's chronic inability to remember names. Other commissions, now lost, included likenesses of 'a coloured gentleman named Halliday, a friend of mine' and a nameless 'gentleman of Ghent', sold for £8.[13]

He was good at animals too. A small oil *Study of a Pony*, sometimes called *Major Freulich's Horse*, also dates from 1836, but its original browns, blacks and ochres were enlivened in 1862 by the addition of a red horsecloth. Young Ford borrowed the animal from a neighbouring officer, and it was 'the most unmilitary looking bruit I think I ever beheld or at any rate saw Major mounted on. It fell under me one day as I was trotting it over one of the Flemish wooden drawbridges and peeled the skin off my chin.'[14]

Among the lost works of 1837 are the first history paintings recorded by the artist: *Fleming Watching the Duke of Alba Pass*, a Protestant–nationalist theme calculated to appeal to English as well as Flemish taste, and *Queen Elizabeth at the Deathbed of the Countess of Nottingham*, also for the English market. Hueffer commented that 'both are works of really remarkable vigour, the *Elizabeth* especially being an almost violent study of a hard-featured face under the influence of sudden passion.'[15]

Ford, who later retouched almost everything he painted, was proud of the vigorous realism of these early works, largely neglected by art historians. As he

noted at the height of his Pre-Raphaelite phase, 'At this time when I first began art seriatiom and before I fell into any kind of mannerism many of my studies are better than I was able to do for years afterwards.'[16]

The cultural capital of the new Belgium was Antwerp, which had been the home of Rubens, van Dyck and Jordaens. Their vigorous painterly art had inspired the romantic Belgian school of history painting now being promoted at the Academy: instant revolutionary history as established by Horace Vernet and Baron Gros in Paris and exemplified by Wappers' great pictorial *machines*. His vast *An Incident of the Belgian Revolution*, full of drama, arrested action and violent encounters, was widely imitated in Belgium, and under his inspiring leadership, the Antwerp Academy was becoming not only the *'première institution nationale'* but in European terms the equal of Paris and Rome.

Founded in 1663, the Antwerp Academy was modelled on the French Académie des Beaux-Arts. The routines of the school had hardly changed when, in 1838, seventeen-year-old Ford Brown enrolled in the Winter Session of the Antique class.[17] He was an assiduous pupil, arriving early each morning from his lodgings at the Pot d'Etain (Copper Kettle) and returning after a frugal lunch to work until dusk fell.

Here Ford familiarised himself with the exacting procedures of history painting. The initial sketch – all his life he was swift to visualise a subject – would be followed by detailed research to ensure accuracy in the story, settings and costumes. Then came nude drawings of each individual figure and detailed costume studies. A colour sketch would be followed by a full-size cartoon traced on to the canvas. After this came the first laying in of tone, over which the finished colour was applied in successive glazes and scumbles. Numerous studies from his early career prove how thoroughly the young painter assimilated these routines.

Wappers powerfully influenced Ford's ideal of history painting. In 1846 the master described himself as 'a romantic rebel dedicated to the ideals of life and truth', asking, 'What is the use of cartoons and irrevocably predetermined draperies which the moment of inspiration should launch forth into existence?' He 'sought bold conceptions and freedom of expression in contemporary art'.[18] Soon Ford's appetite for 'big' subjects was whetted in the master's studio, where with other chosen students he helped prepare the great canvases commissioned by the government. 'My respected master', he recalled, '... had, for speed's sake, two of his pupils whose duty it was to smear in with their hands, early in the morning, as much asphaltum [bitumen] as he could afterwards cover in with revolutionary heroes during the remainder of the long summer day.'[19] The dark asphaltum was to meet the convention – long established in the academies of Europe – that a picture should have twice as much dark as light in it. Convention further dictated that the principal figure

in a composition, forming the apex of a pyramid, should be most fully lit. Such illumination, falling typically at an angle of forty-five degrees, created a theatrical and essentially artificial tableau.

The family had accompanied sixteen-year-old Ford to Ghent, where Caroline kept house. While jealously guarding his freedom to study and shielding him from his invalid father's demands, she acted as his banker and selling agent in England. Now, after installing him at Antwerp in the winter of 1838, Ford's parents left for London. Their departure gave him his first taste of independence and the chance to live a normal art student's life, glimpsed through his sketch of a friend at his easel. His lodgings at the Pot d'Etain were shared with the Irishman Daniel Casey. Four years older than Ford, Casey had been brought up in Bordeaux, where he was a prize student of the Academy. A particular talent for horses made him useful to Wappers, whose assistant he now was.[20] Also lodging at the Pot d'Etain was a contingent of cadet officers or *'quinze-sous pensionnaires'*, who could only afford to eat potatoes. Ford's weekly allowance of twenty francs seemed handsome — enough to cover board and lodgings and allow frequent visits to the local opera and theatre — but, when short of cash, Ford and Casey would join their fellow artists for long evenings smoking enormous pipes and telling racy stories. They would sing, Ford readily volunteering his fine bass for solos such as 'Tis Jolly to Hunt' or accompanying his friends on the fiddle. In this bohemian company, the young artist blossomed.[21]

Letters from London soon threatened this carefree interlude. His father began pressing him to join the family and contribute to their income. Caroline, ever mindful of Ford's long-term interests, persuaded him to wait until the Winter Session at the Academy closed and prizes were awarded, meanwhile urging him to exhibit in Belgium, while submitting his most important pictures to the Royal Academy or the British Institution. They hoped thus to establish him in the profitable London market.

On 24 January 1839, Ford senior wrote to his son from 26 Stockbridge Terrace, Pimlico:

> I am delighted to hear you get on so well and I shall not think of your quitting Antwerp should I continue as well as I do, until after the hurricane months at least, for you employ your time so well. You had better send your *Job* over rolled up, the frame tied up with a bit of string. It had better be addressed to your mother or me here ... I feel convinced your improvement keeps pace with my most sanguine hopes professionally ...[22]

Caroline had been active: she had brought over three Ghent pictures and had already sold the *Blind Beggar and his Child*. She hoped to find buyers for the two

others: *Pigeon Girls* and a *Complaisant*. Adept at juggling small sums of money and concealing the fact from her husband, she enclosed a money order for nine pounds:

> You will see by your papa's letter that he intends you to stop the six months at least ... I shall keep your dress money as you have only had £1 of it as £4 was for your board and the money for your Beggar is for your own use to enable you to do another picture. It is not so much the money makes your papa want you back as to send you of [*sic*] little messages and waste your time for him for he is just as fidgety after Eliza [Lyly] ... he is certainly much better and sleeps better. He has been taking very painful medicines and is not so confined in his bowels.

She well understood Ford's reluctance to leave Antwerp and the ambition which now outran the humdrum possibilities of portraiture, adding: 'Your Uncle James always says that he can introduce you to people who will be the making of you — but generally ends with how he should like Trissy or his wife or cottage taken.'[23]

Although she did not mention it, Caroline was in the later stages of consumption. Exacerbated by a foggy London winter and the smoke of a million coal fires, her symptoms grew worse and by the spring of 1839 she was back in Calais, at lodgings in the rue de la Citadelle. Ford felt reprieved. On 27 August, preoccupied as ever with Papa's comfort, she wrote to her son about a washhand stand and a new armchair for him. A week later, aged only forty-seven, she was dead.[24]

Ford made the long journey from Antwerp to Calais for her funeral at the Protestant cemetery of Saint-Pierre. For the eighteen-year-old artist it was also the journey from carefree boyhood to manhood, and the most powerful emotional experience of his life. 'I remember how bewildered I felt,' he wrote much later to a bereaved friend, 'and what a relief it was to me on the way home from the funeral to find tangible proof of my not being quite deficient in feeling — those tears were perhaps the greatest relief I have ever experienced.'[25]

His mother's death not only deprived him of support and encouragement he had always taken for granted, but burdened him with bewildering responsibilities. Under the terms of her marriage settlement, Eliza and he inherited Caroline's share of the Madox income, but as minors neither could exercise legal control and they had to rely on their father. Soon afterwards, Ford senior and Lyly, both ailing, joined Ford in Antwerp, where they set up house in the rue Marché au Lait (now Melkstraat) with a Flemish-speaking servant. Lyly assumed her mother's mantle, keeping the household accounts and a concerned eye on her brother's professional interests, while he encouraged her to paint.

Distracted by the need to earn, Ford's attendance at the Academy, where he had been working on history paintings for exhibition, fell off. Again he turned to the old standby of portrait commissions, typical of which were three likenesses of the Dembinsky family at five pounds apiece which took him away to Luxembourg: 'M. Wappers called over your name at the Academy,' wrote Lyly on 16 December 1839, 'and said ... he did not like a good *scholar* to absent himself for any other reason when he had *so much likelihood* of gaining the prize.'[26]

At home, the father made himself useful researching for his son's history paintings; he had earlier done this for a life-size *Colonel Kirke*, depicting 'the monster ... that committed all those butcheries in the reign of James II'. It was a melodramatic subject involving a Colonel of dragoons in the Monmouth Rebellion, a murdered husband and a deceived wife. 'K[irke] with fiendish sarcasm in his face. A repulsive sort of picture, painted with some force and ... strong expression' was typical of Ford's sensational production before leaving Antwerp.[27]

His first Byron subject, too, dealt with a seduced wife and the murder of a rival: *The Giaour's Confession* was exhibited in 1840 at the Royal Academy, where it made a memorable impact on twelve-year-old Dante Gabriel Rossetti. Wappers himself drew on Byron for at least half a dozen pictures, including two versions of *The Giaour*.[28] Ford's has disappeared but its successors, two scenes from *Manfred*, were largely done at Antwerp. The first, *Manfred in the Chamois Hunter's Hut* (1840), is unmistakably Belgian and melodramatic, showing the tortured hero, white-knuckled fingers outstretched, rejecting the help of his would-be rescuer. It is a sombre and unconvincing picture — a pictorial equivalent for the extremes of Romantic poetry. Much more successful is *Manfred on the Jungfrau* (1841) showing the same protagonists on an Alpine peak, silhouetted against swirling mists and snow. This second subject designed in Antwerp was finished (but transformed) in Paris.

Wappers must have encouraged *The Execution of Mary Queen of Scots*, a huge picture shown at the Paris Salon in 1841/2 but begun in Antwerp. Such subjects from English history were very much in vogue on both sides of the Channel. The large picture has disappeared, but a bold oil study, not apparently retouched, shows the sombre, earthy palette of the Antwerp period, the broad brushstrokes and impastoed surface in the virtuoso tradition of the seventeenth century. The composition is built up on strong contrasts of light and shade typical of Belgian studio paintings of the time. *Mary* is an ambitious work which does not quite come off: there are oddities of proportion and it is stagy and melodramatic. But it is a remarkable piece of work by a nineteen-year-old, with some excellent passages of painting — especially in the fine expressive heads of the Dean and the swooning attendant.[29]

The attendant was modelled by Ford's cousin Elisabeth Bromley, who, returning

from finishing school in Germany in the summer of 1840, joined the small Antwerp household. Her arrival coincided with a second domestic tragedy – twenty-two-year-old Lyly Brown died suddenly that June, carried away like her mother by consumption. Coming so soon after their mother's death, this was a shattering blow which left a permanent scar. Ford and Lyly had been deeply attached, and their childhood intimacy had deepened during the year at Antwerp.[30]

There was an inevitability about the sequel. Earlier that year Ford had, on one of his frequent trips to England, painted several family portraits in Kent, including likenesses of two Bromley cousins, children of his mother's sister Mary, Richard (a rising star in the Admiralty) and dark, attractive Elisabeth. The nineteen-year-old artist had always been fond of this slightly older cousin, well-educated and more sophisticated than himself. Soon she had assumed a mothering role, and their intimacy developed rapidly into love.

How long Elisabeth remained in Antwerp with Ford and his ailing father over the winter of 1840–1 is uncertain, but in autumn 1840 he enrolled in the life-drawing class at the Antwerp Academy – he needed to complete *Mary Queen of Scots* for exhibition at the Royal Academy or the Paris Salon in 1841. The spring of 1841 found him back in Kent, staying with Elisabeth's brother Augustus and his wife Helen at Milliker Farm, Meopham. On 3 April Elisabeth and he were married at the parish church, the bride being given away by her brother. Standing at the altar, fair-haired, slight and boyish, Ford looked so extremely youthful that the officiating clergyman asked where the bridegroom was.[31]

2
PARIS, ROME, LONDON
1841 – 1846

IN THE SUMMER OF 1841 the young couple arrived in Paris, taking lodgings in Montmartre, up whose green and windmill-crowned slopes the (then) *deuxième arrondissement* was rapidly spreading. With them came Ford's father, now almost bedridden. It was a *quartier* inhabited by artisans and craftsmen but also, increasingly, by artists – like Daniel Casey, who had preceded them here from Antwerp.

They had been lured to Paris chiefly by France's vigorous patronage of the arts. Under Louis-Philippe, the French government bought regularly from the annual Salons, while commissioning many new works for public buildings – a strong inducement for an aspiring history painter. Casey's own *Saint Louis at the Siege of Damietta*, purchased from the 1842 Salon, was presented to Bordeaux for the Hôtel de Ville. Another factor was the low cost of living. Elisabeth had a dowry of £900 from which they received the income, and Ford had inherited Lyly's share of their mother's money. With old Ford's modest pension, they could live comfortably.

These first years of marriage were an idyll, setting a standard of contented domesticity Ford would never forget. He and Elisabeth were deeply in love. Capable and sensitive, she entered enthusiastically into his imaginative world, proving a crucial source of encouragement. He was very proud of her. Elisabeth, Hueffer writes, 'was sufficiently handsome and accomplished to move with some distinction in the society of the better class of English in that city'. Ford's three known portraits of her show a slim young woman, attractive rather than strictly pretty, with dark hair parted in the middle and swept up in fashionable bangs. Her eyes, her best feature, soften a rather long face, while her mobile expressive mouth suggests a warm, sympathetic personality. She was also romantically ambitious for her nineteen-year-old husband, encouraging his dawning sense of his own genius.

Ford's decision to pursue an independent path was probably dictated by the reception of *The Execution of Mary Queen of Scots* at the Salon during their first summer, when critics took exception to its 'foreign' eccentricity. Determined to rid

himself of his dark, stagy mannerisms, he turned to the old masters in the Louvre, avoiding the great Parisian *ateliers* 'for which I always entertained the greatest aversion. Cold pedantic drawing and heavy opaque colour were impartially dispensed to all in those huge manufactories of artists.'[1] Such, perhaps, were the studios of the artist Paul Delaroche, the popular historical painter whose scenes of royalty on the scaffold — painted equivalents of the novels of Scott and Harrison Ainsworth — had influenced his own *Mary Queen of Scots*. Soon Ford was copying works by Rembrandt and Velázquez, masters of psychological realism, whose scrupulous observations of form under natural light differed radically from the artificial conventions in which he had been trained. 'Here in Paris,' wrote his daughter Lucy Rossetti, 'the artist, while walking in the gardens of the Tuileries with his friend Casey ... discussed a dream of truth in art, the possibility of showing not only the emotions and costumes of the *personae* but also of evincing by the lighting the very time of day indicated by the subject; in fact, to do away with the conventional studio light.'[2] The liberating effect of these studies is seen in his beautifully rendered *Head of a Girl* by a window, with a Spanish comb in her hair.

But the prevailing taste for melodrama put a brake on Brown's pioneering pursuit of 'truth to Nature'. In 1865 he pointed to his first dramatic experiment in naturalistic lighting, *Manfred on the Jungfrau*, as 'a first though not very recognisable attempt at outdoor effect of light'. Like so many of his early works this was later retouched and brightened, but the dark figures poised against a background of luminous snow reveal his original idea. *Manfred* was an invention, of course, 'glaciers not having formed part of my scheme of study in those days'. *Parisina's Sleep* (1842, now lost), which followed, would be the first example of a style originating 'in Spanish pictures and in Rembrandt'.[3] The dramatic bedroom scene was lit by candlelight.

If Elisabeth's money bought time for such vital experiments, it also fostered an illusory independence from the market-place, with serious consequences for Ford's career. True, he sent works to the Salon, but whether from shyness or from the bloody-mindedness which was to blight his career, he did not cultivate influential friends in Paris, mixing exclusively with other English artists. He might, for instance, have visited Delacroix, that quintessentially Romantic painter, then at the height of his career. His English contemporaries, aspiring history painters like John Cross, Edward Armitage and the genial Charles Lucy, knew better. While Ford pursued his studies in isolation, these ambitious artists were hard at work assisting Delaroche on his famous *Hemicycle* murals at the Académie des Beaux-Arts, gaining vital experience and contacts. Despite his determined individualism, however, Ford followed all aspects of the Hemicycle project closely, later admitting its influence on him.

The cult of Byronism was still potent in Louis-Philippe's Paris. Delacroix's *Death*

of Sardanapalus and *The Barque of Don Juan,* seen at the Salon in 1841, gave authoritative visual expression to the great poet and Ford was equally bewitched: *Manfred on the Jungfrau* (1841) showed the tortured hero about to jump off a precipice, while *Parisina's Sleep* (1842) is about incest and murder. To judge from surviving sketches, this must have been his most successful melodrama to date, with the Grand Guignol villain Prince Azo and the delicate, sensitively drawn head of his sleeping wife finely contrasted. The design points to a new mastery of dramatic relationships:

> *He clasp'd her sleeping to his heart,*
> *And listened to each broken word.*
> *He hears — why doth Prince Azo start?*
> *... His earthly peace*
> *Upon that sound is doomed to cease*
> *That sleeping whisper of a name*
> *Bespeaks her guilt and Azo's shame.*

In *The Prisoners of Chillon* of the same year, three brothers chained in a dungeon await a lingering death; a strong Rembrandtesque sunbeam penetrates the gloom, forming a dramatic link with the world above. But overtaking Byronism in the Paris of the early 1840s was the cult of Shakespeare. *Hamlet* had recently inspired a series of lithographs by Delacroix, and it was now, in 1843, that the figure of Lear acquired its special place in Ford's mythology. In that year he produced sixteen dramatic small pen-and-ink drawings, as remarkable for their nervous, expressive line and inventiveness as any of the century and the first to announce Ford's distinctive, quirky genius. The tragic figure of Lear dominates each scene, whether angrily banishing Cordelia, slumped on a throne carved with menacing beasts, railing at the storm or conducting a mad dance with Tom O'Bedlam on Dover Beach. The subsidiary characters, in their mannered, menacing attitudes, are equally expressive and the ingenious architectural and landscape settings, costumes and animals have an almost Japanese savagery. These are no ordinary illustrations, but redolent of *performance,* showing the artist's empathy with his characters. Later, Ford's firm belief that good pictures resulted from the capacity to *feel* every emotion and action portrayed, would be spelled out in the Pre-Raphaelite magazine, *The Germ.* It is not surprising, therefore, that the series inspired Henry Irving's 1892 production of *Lear,* with Irving himself as the mad old king: at that time the actor-manager acquired several of Brown's drawings for his collection, while a print of *Cordelia's Portion —* one of three major oils based on this material — hung in his dressing room.

More lighthearted was Ford's projected series of subjects from the eighteenth-century novelist Laurence Sterne. Although there are several drawings, only one painting survives: *Dr Primrose and his Daughters,* a pastiche of a French conversation piece, with overtones of early Hogarth – the artist Ford would come to venerate as the father of English art.

In Paris, Ford's intellectual horizons broadened, despite his lack of contact with the Parisian avant-garde and some curious gaps in his awareness. He discovered Alexandre Dumas and Victor Hugo, writers for whom he had a lifelong love, and Weber and Meyerbeer, but not Berlioz, whom he later admired as the first of modern composers. Nor did his path cross those of Baudelaire or the young Gustave Courbet, newly arrived in Paris and painting a series of self-portraits in the role of Romantic Artist. He never mentioned the pioneering landscapes of Diaz or Rousseau at Barbizon. He was, however, affected by the pre-revolutionary political climate, later developing the then-prevalent ideas of Proudhon and Fourier in *Work.*

At their Montmartre *pension,* meanwhile, Ford senior grew daily weaker. In June 1842 he made a will, bequeathing his modest possessions to his son and regularising the inheritance from Caroline.[4] He did this soon after the birth of the Browns' first baby, who did not survive the year.[5] Dying in November (they buried him in the Cimetière de Montmartre),[6] old Ford never saw his second grandchild, Emma Lucy, born in July 1843. His death freed Ford and Elisabeth from a heavy responsibility. The grumbling and stories would be missed, but the latter became absorbed into the mature artist's repertoire.

Early in 1843, Ford's circle of English artists in Paris was alerted to a unique professional opportunity: the annual competition for the mural decorations of the new Houses of Parliament was the first act of British state patronage for over a century. Barry and Pugin's Gothic palace, rising by the Thames at Westminster, was to be adorned with patriotic episodes from British history; themes from Spenser, Shakespeare and Milton; or subjects personifying abstract virtues. Cartoons for the design measuring 'not less than 10ft or more than 15ft in their longest dimension', with life-size figures, were to be submitted to the judges at Westminster Hall from early June. Commissions and cash prizes would be awarded.[7] From 1844, a sample part of the design carried out in fresco was called for.

Everyone seized this great chance. Ford abandoned his easel paintings and set swiftly to work on a cartoon of *Adam and Eve,* over eight feet high and seven feet

wide, taking his text from the Book of Genesis: 'And they heard the voice of the Lord God walking in the garden in the cool of the day: and the man and his wife hid themselves among the trees of the garden.' 'It is evening,' wrote Hueffer, who knew the work; 'a mighty wind is blowing the leaves of the garden all in one direction; a vivid streak of sunset sky divides the gloom of the foliage, and in the foreground Adam and Eve sit, in attitudes of intense fear, at the foot of the Tree of Knowledge. The feeling of terror suggested is almost strong enough to present some of the mysticism of Blake.'[8] This cartoon, since lost, was shown at the 1844 competition, but failed to win a prize.

At a stroke, the Westminster competitions freed Ford from Byronic introspection and committed him to an ideal of public art. Hueffer's allusion to Blake recalls the oil sketch Ford sent to another competition that year — *The Ascension*, for an altarpiece for St James's Church in Bermondsey, south London.[9] *The Ascension* is interesting both in its own right and as documenting Ford's development towards the end of his stay in Paris. The event is recorded in the Gospels of Mark and Luke, but not described; there was thus no text to illustrate, and Ford conceived his drama in terms of light and darkness. The setting is outside Jerusalem in hilly country, the mountains of Judaea in the background. As Christ soars from the darkening earth to join the welcoming angelic host, a setting sun falls beneath the horizon. Below, a pool of golden light illuminates the upturned faces of Mary and the disciples, hands outstretched in wonder and adoration. It is a highly expressionistic work, with sources in William Blake and Henry Fuseli; the strong local colour in the earthly group and the strip of sunset sky are especially Blakean. Some Flaxmanesque pen-and-ink studies of angels survive, linking this picture with the Lear drawings of the same year and showing Ford's familiarity with English art.

Amongst living artists Ford particularly admired William Etty, a senior Royal Academician and one of the Westminster competition judges, for his classical subjects featuring voluptuous nudes. A letter of 8 September 1843 from Etty, in London, thanks Ford for hospitality on Etty's recent visit to Paris, asks him to look after another artist friend who will soon arrive, and sends particulars of the 1844 competition.[10] But apart from Etty, who retired to York in 1846, Ford made no greater effort to woo the English art Establishment than he had to woo the French.

Throughout 1843 he was working on a huge cartoon, thirteen feet tall by fifteen feet wide, of *The Body of Harold Brought Before William the Conqueror* for the 1844 competition. *Harold* was not only the first of his *English* subjects, but by far the most ambitious composition he had yet attempted. Carefully researched and tautly drawn in the best academic tradition, it has echoes of Delacroix's *Taking of Constantinople*, which had appeared in the 1841 Salon. But the unorthodox construction of the

central group, the strained poses of the subsidiary figures, the dramatic contrast between the illuminated body of dead Harold and the shadowed figure of the Conqueror, and the use of a specific landscape background and time of day (in this case Beachy Head at sunset) are typically Brunonian. 'The cartoon has more sense for historical painting, or rather a peculiar talent for dramatic representation [than any other],' wrote the leading German art critic Foerster reviewing the entries in *Kunstblatt* in 1844. Although troubled by its many unorthodoxies, he devoted more space to a detailed criticism of *Harold* than to any other submission of that year.[11]

As a result of Westminster, the English history painters deserted Paris. Charles Lucy had found studios at Tudor Lodge in Mornington Crescent, north London, and Edward Armitage, winner of one of the three top prizes in 1843, had already left to join him. Ford and Elisabeth followed suit. Meanwhile Augustus Bromley, from whose Meopham house they had been so happily married, had died of a heart attack in December 1843. Only twenty-eight, he had left his wife with four young children, and the Browns were now anxious to see her.

They arrived in the summer of 1844, from which time dates a curious memorial portrait of the assembled Bromleys, in the style of contemporary German group portraiture. If the artist is correct in his dating, this puzzling picture must have been compiled from both new and existing family likenesses. Six figures — two men and four women — pose in a garden, perhaps the Bromleys' garden at South Street, Meopham, overlooking the fields of Milliker Farm.[12] The men, in dark suits with bow-ties, seem to be discussing farming as they gesture towards the fields, while their women wear white and carry bouquets like brides. The subjects are Richard Bromley (leaning on his mother's chair) and his wife Clara, married the previous summer; Augustus and Helen Bromley, Mrs Mary Bromley (Lizzie's mother) in the foreground, with widow's cap, spectacles and work-basket; and a figure on the right who must be Elisabeth herself. Dressed in black, she leans, with a dreamy expression, on a chair which bears the artist's signature. This, with the volume of prints and the jar of roses signifying love in front of her, fits what we know of her personality and their relationship.

The Browns spent the summer and autumn months at Meopham, but, with the onset of winter and an enormous *Abstract Spirit of Justice* to complete for the 1845 Westminster competition, Ford left reluctantly for London. By November he was installed in Charles Lucy's studios at Tudor Lodge.

Charles Lucy was a short, easy-going character, in appearance more like a country land-agent than the bohemian he was. Working in the same studios were Edward Armitage and John Cross and new acquaintances, among them the painter Frank Howard; Douglas Jerrold, *Punch* contributor and friend of Dickens who joked

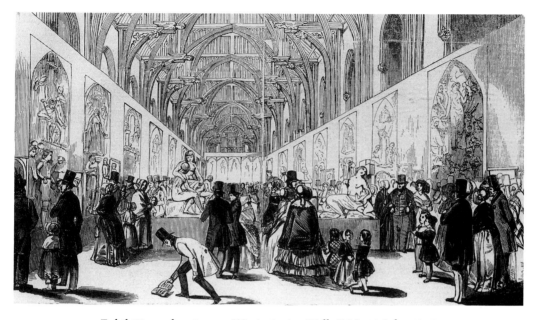

Exhibition of cartoons, Westminster Hall. ILN, 19 July 1845.

incessantly; John Marshall, later medico-extraordinary to the Pre-Raphaelites; and John Tenniel, illustrator of *Alice in Wonderland*. There too Ford met William Cave Thomas, newly returned from the Munich studio of the German history painter Kaulbach. All but Jerrold were designing cartoons for Westminster. At first Ford, always a disciplined worker, was irritated by the convivial bachelor atmosphere and lack of privacy at Tudor Lodge, but he soon fell victim to its distractions, as a sequence of letters to Elisabeth shows.[13]

In December 1844 he wrote, 'I am bothered and anxious. This is a horrid place: that study [studio] is a regular castle of indolence and it is catching — indeed nothing is more so. The study is continually full of all of them gabbling and it distracts me. That infernal Howard is a pest and yet he is so good natured ...' He was feeling the pressure of time in a way which was to become all too familiar: 'I have got more work than I can get through. I ought to have done it all before the New Year. I have showed my coloured sketch to Etty and Martin they were both pleased with it, which is a rare feeling for Etty to express.' But he missed her: 'God bless you, I have no time or humour to write more but believe me your husband loves you as the first day. God bless you.'

By February 1845 he was in high spirits: 'My dearest Liz. I write to you from the studio again ... I went to the British Institution yesterday, as it is varnishing day

... They have not hung my sketch [the *Ascension* oil study mentioned above] but the *Parisina* looks very well as it has got a good light.' He had been complimented on it by the painter and actor McIan at Etty's house: 'He was in perfect raptures with *Parisina*, said the price I asked was perfectly preposterous – 50 guineas – it was worth six times as much.' Ford wondered if he could find time for a 'Burns subject' and a portrait commission for the Summer Exhibition at the Royal Academy.

By May, 'My sand and lime is all mixed and I'm only waiting for tracing paper to begin my fresco. In the meantime I have finished off the top part of the cartoon. I have also finished the knight, and the lawyer and the widow and have begun the father of the knight. I am getting on and *so is the time* ...'

Life at Tudor Lodge had light-hearted moments:

Mrs Wharton the model came to sit to Mr Lucy the other morning; ... rather a pretty girl. [She] asked me if Mrs Lucy was jealous of her husband. I said I did not think so, but why? 'Why' says the woman 'while I was waiting for Mr Lucy ... Mrs Lucy came into the room and pretended to look for a book and says she "are you come here to sit for Mr Lucy?" Says I "I don't know I'm sure which of the gentlemen I'm wanted for." "So", says she, "are you going to sit undressed to him? ... I'm sure I can't think how ever a woman can be so nasty undelicant as to take off all her things before a man; ... I wouldn't", says she, "No, that I wouldn't" ... With that she flounced out the room with her face as red as a turkeycock.' Mrs Wharton would have it that she was on the tiles, peeping down through the skylight; because it rattled with the wind ...[14]

'My blessed Liz,' he wrote later that May – when the new cartoon and sketch for *The Abstract Spirit of Justice* were almost finished and he was working flat out – 'I lay the plaster myself overnight and work all next day from five a.m. until dark ... I have hired an alarum that wakes me at half past four ... God bless you over and over again. How cruel of you never to say a word about your health!'[15] He was anxious: she had recently been ill, was often flushed and had fits of coughing. Tiring easily, she had gone to Hastings for the sea air and bathing. Her visits to Tudor Lodge had been combined with medical consultations, which had so far reassured them.

... first and foremost make yourself happy and quiet. As for myself but for you I never was in better spirits ... Our prospects seem brighter to me than ever. It may be a kind of excitement, but I feel sure that in a few years I shall be known and begin to be valued, and in the meantime I shall be increasing in

6 *Dr John Brown,* etching by John Kay, 1837.

7 *Caroline Madox Brown,* drawing by FMB, 1836.

8 *Ford Brown,* by FMB, oils, 1837.

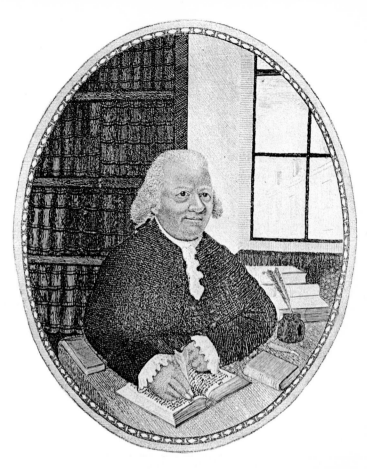

6

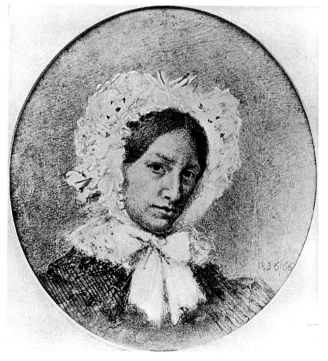

7

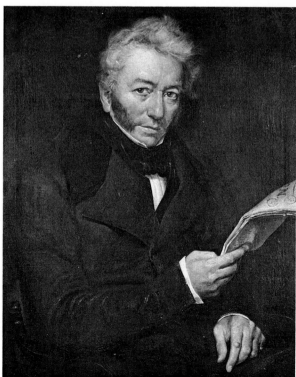

8

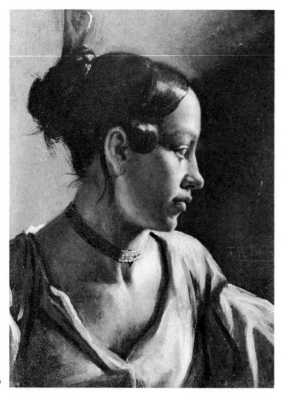

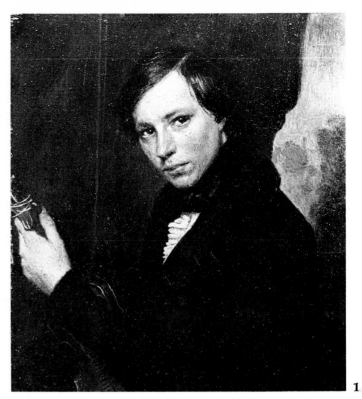

9

1

9 *Girl's Head*, oil study, 1840.

10 *The Reverend FHS Pendleton*, oils on panel, Ghent, 1837.

11 *A Man Painting*, chalk study, Antwerp, 1839.

11

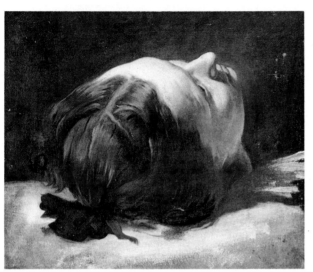

12

13

12 Study for head of swooning attendant, *Mary, Queen of Scots,* 1839.

13 Study for the head of the Dean, *Mary, Queen of Scots,* 1839.

14 *Manfred on the Jungfrau,* oils, Antwerp/Paris, 1839–40. Later re-touched.

14

15 *View of Calais*, engraving from painting by Clarkson Stanfield, contemporary with Dover Harbour.

16 *Bruges, Quai des Marbriers*, drawing by A Danse.

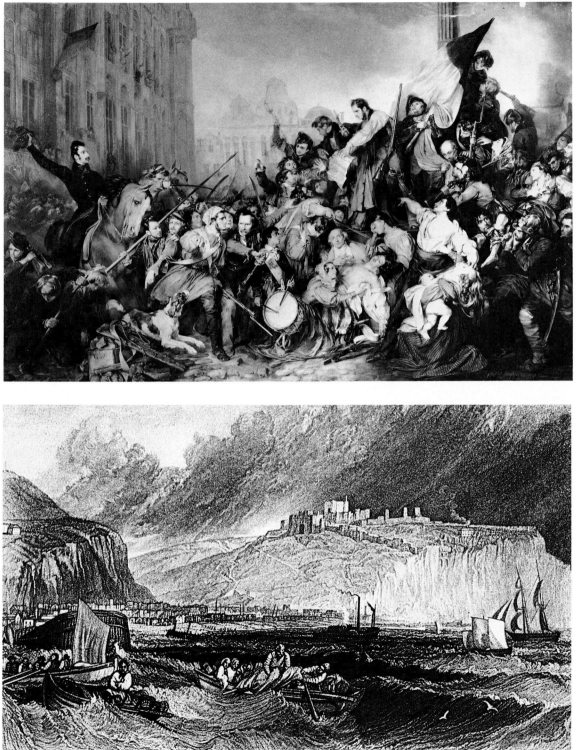

17 *An Incident in the Belgian Revolution of 1830* by Gustave Wappers, Brussels, 1835.

18 *Dover*, from Harbours of England by J M W Turner. Issued, edited by Ruskin, 1856.

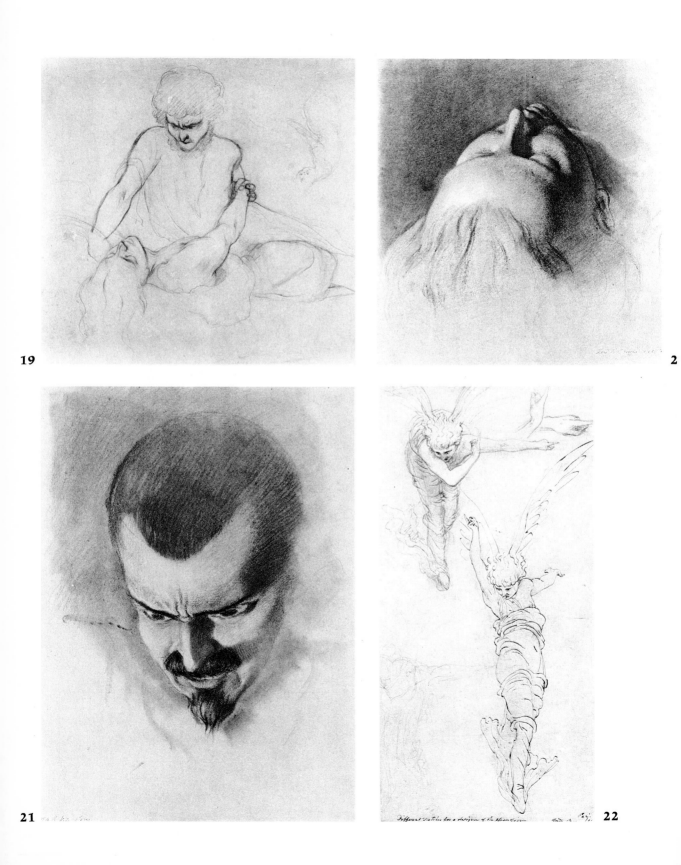

19

2

21

22

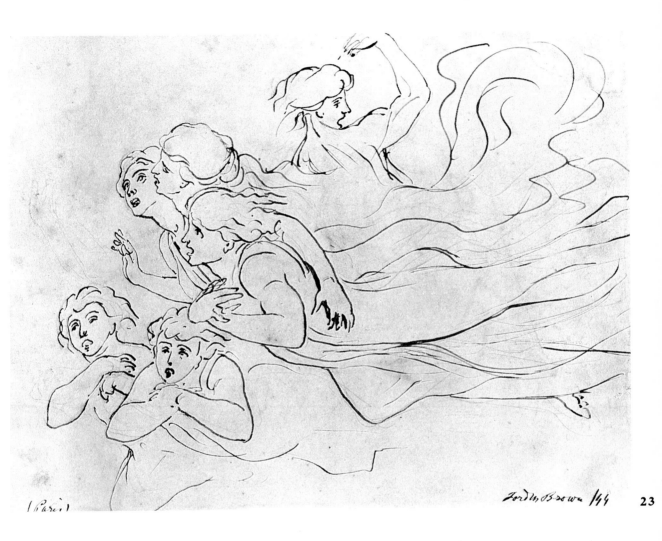

(Paris)

Ford M Brown /44

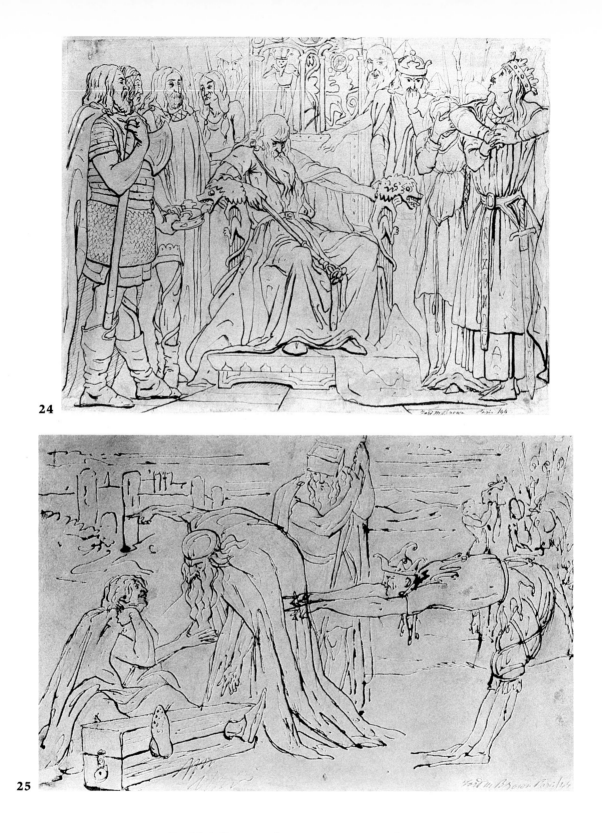

24 *Cordelia's Portion*, ink, Paris, 1844. One of Lear series.

25 *Lear with Kent in the Stocks*, Paris, 1844.

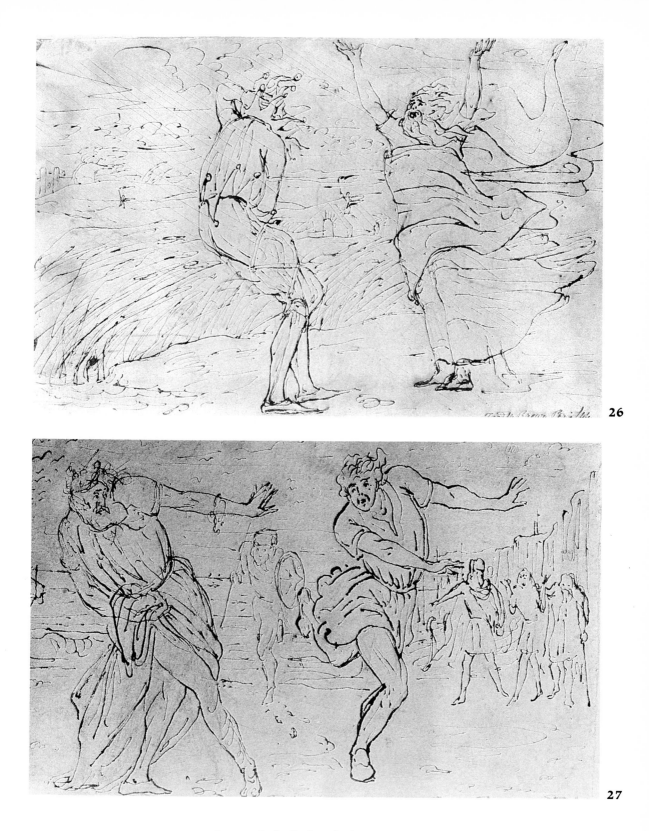

26 *Lear with the Fool in the Storm*, Paris, 1844.

27 *Lear Mad on the Beach at Dover*, Paris, 1844.

28

29

30

31

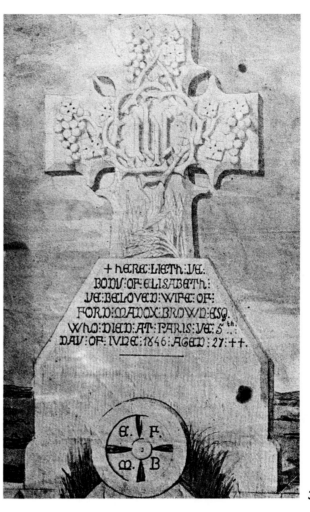

The tombstone inscription reads:

+ hERE:LIETh:UE:
BODU:OF:ELISABETh:
UE:BELOVED:WIFE:OF:
FORD:MADOX:BROWD:ESQ.
WhO:DIED:AT:PARIS:UE:5th
DAU:OF:IVDE:1846:AGED:27:++

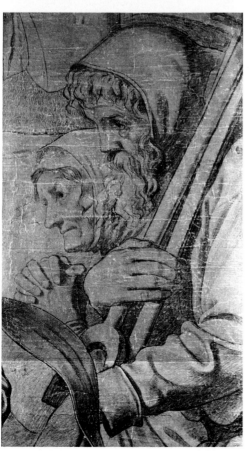

28 *The Spirit of Chivalry,* cartoon by Daniel Maclise for mural in the House of Lords.

29 *The Baptism of Ethelbert,* cartoon by William Dyce for mural in the House of Lords.

30 Interior, House of Lords. Dyce's mural in place above the throne.

31 *The Spirit of Justice,* half-sized colour cartoon by FMB.

32 *Spirit of Justice* (central figure) by W Cave Thomas.

33 *The Spirit of Justice,* fragment of cartoon by FMB.

34 FMB's design for Elisabeth's tombstone.

35

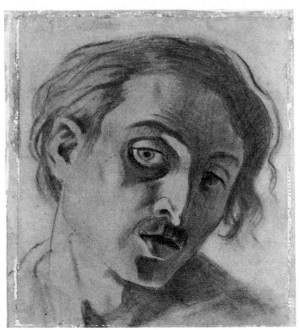

35 *The Body of Harold brought before William the Conqueror*, FMB's cartoon, Paris, 1843–4. Now in fragments.

36 Study of a man's head, possibly for Harold cartoon. FMB, c, 1843.

36

reputation daily. The artists seem to be pleased with the picture now exhibited, as I hear from divers models; and this, as it was never painted to suit public taste is as much as I can wish ... Mr Lucy is very kind and mightily taken with me and you ... what lies you wrote about their child![16]

Ford's cartoon of *The Abstract Spirit of Justice* survives only in a colour design and several highly finished studies. It represents a widow appealing to personified Justice. Pointing vehemently at her oppressive overlord, she calls on Justice, Mercy and the Natural Law over the heads of armoured knights and croziered bishops, a king and a lawyer. The villain has thrown down his gauntlet. The widow's only champions are fellow victims.

This composition is marked by a circulating upward movement and, as in *The Ascension*, separated and contrasted earthly and ideal planes. Several finished drawings for individual heads, and surviving fragments of the cartoon are monumentally conceived; a few are masterly. Especially fine are the bearded and laurelled figure of the philosopher with his scroll of Natural Law (perhaps inspired by the life-size Raphael cartoons at Hampton Court, or his *School of Athens*), the powerfully accusing figure of the widow, and an elderly labouring couple. The Art Union singled out this work, which 'differs from every other in the series: it presents a version of Justice in reference to the sources of the executive power of our constitution and is brought forward with much success.'[17] Ford had conceived his *Justice* within an English social context and in characteristically active mode − by comparison, Daniel Maclise's admired *Spirit of Chivalry* looks static and idealised. His specimen of fresco also caught the eye of Benjamin Robert Haydon, painter of heroic subjects and long-time scourge of the Royal Academy for not promoting public monumental art in Britain. Haydon noted: 'Passed the morning in Westminster Hall. The only bit of fresco fit to look at is by Ford Brown. It is a figure of Justice and is exquisite so far as that figure goes.'[18] Haydon wrote to the young artist begging 'to know what he asks for his fragment of fresco No 99',[19] an enquiry which, coming from one of Ford's heroes, meant more than any critic's praise.

The Abstract Spirit of Justice is the first hint, in Ford's art, of the social conscience which would inform *Work* and of the influence of the ideas of Saint-Simon and Fourier: Saint-Simon's vision of a responsible social hierarchy, ensuring justice for all, in turn influenced Christian Socialism, for which *Work* was something of a manifesto.

When the prizes were announced, William Dyce gained a commission to paint a *Baptism of St Ethelbert* on the walls of the Queen's Robing Room in the House of Lords, while two other Tudor Lodge painters won prizes: Tenniel for an *Allegory of*

Justice and Armitage with a *Spirit of Religion*. Ford won nothing, but, not at all discouraged, began research for next year's subject:

> In the summer of 1845 I went to the British Museum to read Sir James Mackintosh's History of England … with a view to select some subject … I was already wavering in my mind between … 'The First Naval Victory' and … 'The Origin of our Native Tongue'. The former … at first engaged my attention but the sight of Maclise's cartoon of *Chivalry* [exhibited 1845] and the wish to handle more luxuriant and attractive materials afterwards changed the current of my thoughts. In this mood, glancing over the pages of the above-mentioned history, I fell upon a passage … 'and it is scarcely to be wondered at that English about this period should have become the judicial language of the country, ennobled as it had recently been by the genius of Geoffrey Chaucer.' This at once fixed me. I immediately saw visions of Chaucer reading his poems to knights and ladyes fair, to the king and court amid air and sunshine.[20]

The Browns' happiness was shattered in July. By now Elisabeth was in an advanced state of consumption, and their doctor advised Ford to remove her without delay to a warmer climate, recommending Rome. The couple began preparations for the long journey south, and on 26 August 1845 a passport made out for Ford Brown, accompanied by his wife, child and a maid, was issued by the Belgian Legation in London. The much-stamped document records these particulars: 'Age 24, profession painter, height 5' 7", hair, chestnut; beard, fair; face, oval with round chin.'[21]

Arriving at Ostend, they travelled leisurely by Antwerp and Aachen to Cologne, then up the Rhine by steamboat in the wake of Queen Victoria's recent progress to Bonn. At Basle they rested before the arduous crossing of the Alps, a pause which led to a momentous artistic encounter – with Hans Holbein's works in the Basle Kunstmuseum: 'I do not think,' Hueffer comments, basing his judgement on Ford's own account, 'that all the magnificence of Italian art … he then saw spread out before him touched him nearly as closely as did the sincere and direct – one may call it archaic – work of Hans Holbein.' Chief among the works he saw was the master's *Dead Christ*: this image of a bruised and bloody corpse in rigor mortis, as starkly realistic as anything in European art, set a new standard of truthfulness for the painter. At the same time, family likenesses made for Holbein's *Meyer Madonna* affected his approach to portraiture, and on his return to England, a year later, his first thought was to paint 'a modern Holbein'.[22]

By 15 September they were in Milan, admiring *The Last Supper* and other works by Leonardo and his assistant Luini. Towards the end of the month they reached

Florence, where Ford was overwhelmed by the great early masters: Giotto in the Cathedral, Masaccio in the Brancacci Chapel and Fra Angelico in the Convent of San Marco.[23] A final week's travelling brought them to Rome on 3 October 1845.

During the next sad months, Elisabeth grew steadily weaker. Ford could never bear to talk about this time, but later showed his gratitude to Dr Richard Deakin who attended her.[24] With a young child, social life was severely restricted, but Ford managed to visit the German Nazarene painters Friedrich Overbeck and Peter Cornelius. Cornelius – highly regarded by the English art Establishment – had in 1841 been consulted by Eastlake and Dyce on the organisation of the Westminster competitions, and on the use of fresco.[25]

> Overbeck I visited first. No introductions were necessary in Rome at that time. [He] was in a small studio with some four or five visitors. He was habited in a black velvet dressing-gown down to the ground and corded around the waist; on his head a velvet cap, furred, which allowed his grey curling locks to stray on his shoulders. He bore exactly the appearance of some figure of the fifteenth century. When he spoke to me it was with the humility of a saint ... I noted that where any naked flesh was shown, it looked exactly like wooden dolls' or lay figures'. I heard him explain that he never drew these parts from nature, on the principle of avoiding the sensuous in religious art. In spite of this, never-theless, the sentiment ... was so vivid, so unlike most other art, that one felt a disinclination to go away ...[26]

Cornelius, 'short, with red hair and keen eyes under', was showing his large cartoon of *Death on the Pale Horse* to some ladies: 'He was explaining his picture exactly as a showman would, and I have remembered the lesson since ... Full of action and strange character, it was everything reverse of that dreadful commonplace into which Art on the continent seems to be hurrying back.' Ford felt drawn to Cornelius by the very characteristics which mark his own work: 'no commonplace being ... he was the man of genius, the man of the unexpected emphaticality.'[26]

William Dyce was also in Rome, fresh from his triumph at the 1845 competition. Ford would have met him at the unofficial English Academy, where his fellow artists could work or relax. It had a library, and it was here that Brown continued his research for *The Seeds and Fruits of English Poetry*. He had begun to focus on Chaucer: 'When I arrived at Rome, from the library of the English academy I procured the works and life of our first poet and fortunately found that the facts known respecting him perfectly admitted of the idea I had already conceived ...'[27]

He had brought from England a pencil design for the scheme of the central

panel; now he developed it into a small triptych. *The Seeds and Fruits*, like *The Spirit of Justice*, represented an abstract idea, but this time an overtly patriotic one. He had decided to make Chaucer his hero, and show him reading aloud from his *Canterbury Tales* to King Edward III and the assembled English court 'amid air and sunshine'. Below him, grouped around a fountain, are 'knights and ladyes fair', two minstrels, a jester, a bishop, and assorted courtiers and page-boys. To either side, in the wings, niches present Chaucer's successors: the laurelled figures of Milton, Spenser and Shakespeare to the right; Byron, Pope and Burns to the left.

Ford could envisage the work already – a monumental twelve feet tall, with nearly forty figures, some life-sized – and he worked out his scheme in countless discussions with Elisabeth, whose knowledge of English literature was much greater than his own. Such a work would be commensurate with her ambition for him, a fitting testament to their love.

Elisabeth was dying. Sickened by the impending catastrophe, he divided his time in Rome between studies for the triptych, the large cartoon he had begun for exhibition and caring for her. He clung to his work as to a talisman:

> Never can I forget the pleasure with which I could muse over my work in Rome at a time when visited by the most bitter afflictions and apprehensions for the future, at a time when all other satisfaction was impossible; never can I forget that *she* gave it her unqualified approbation, prophecied that it would ensure me ultimate success, regretted that she would never live to see it and *ordered me* to complete it after her death.[28]

With a heavy heart he made portraits of his wife and three-year-old Lucy, placing them side by side in a gold mount. He arranged every detail as he wanted to remember them, setting off Elisabeth's fragile features with a cameo of the Madonna and Child at her throat. Both portraits are charged with the intensity of love and are superbly painted. That of Lucy, whose blue eyes confront the spectator with disconcerting directness, is the first of Brown's many fine child portraits.

By 9 May 1846 they had set out for England, passing, this time by sea, from Civitavecchia to Marseilles then up the Rhône to Lyons and thence by carriage to Paris, which they reached on 5 June. They made a desperate bid to reach the Caseys in Montmartre but, crossing the Boulevard des Italiens, Elisabeth died in Ford's arms. Deeply shocked, Ford went through the legal formalities, arranging to bring her body back to England and leaving the family silver with Casey to pawn for the expenses.[29]

Ford buried her in the new cemetery at Highgate, beneath a Celtic cross of his own design. The inscription reads:

Here lieth ye body of Elisabeth
Ye beloved wife of Ford Madox Brown Esq
Who died at Paris ye 5th day of June 1846
Aged 27.

3
CLIPSTONE STREET
1846 – 1848

ORD WAS INCONSOLABLE: for the next twelve months, distraught and unable
to settle, he led a nomad's life. On arriving in England he took three-year-old
Lucy to her widowed aunt, Helen Bromley, at Gravesend. Helen was about to
open a school at Milton Lodge and was thus able to offer her niece an education as
well as a home. Henceforth, as Lucy's surrogate mother, Helen played a crucial role
in both her life and Ford's.

During the first August in Kent, the artist took Lucy for a short holiday to the
small resort of Southend, across the Thames estuary from Gravesend. In these peaceful
surroundings, 'before the invasion of gas and railroad', he discovered the healing
power of landscape painting, of which he wrote much later to his friend William
Davis: 'I was extremely glad to hear from you that you had got from the harassing
monotony of the studio to the invigorating and glorious change of open air painting.
I have always found cares and annoyances (I have had my share) unable to keep their
ground beside a camp stool and a colour box in the open fields ...'[1]

Walking out of Southend with his painting gear, Ford came upon the fishing
hamlet of Thorpe and set up his easel in a shady lane overlooking it. From here,
across the sweep of flat fields, the jetty and river craft, he could see distant Sheppey
and the Nore lightship, a coastal landscape with powerful childhood associations:
'The scenery of this part of the coast,' he would recall, 'is full of freshness and interest,
cliffs and ridges of clay intercepting salt marshes give it a certain Dutch–English
character.'[2]

Southend, retouched some years later, was a first shot at the sunny landscape
setting in which he had conceived Chaucer at King Edward's court. He had brought
with him an outline of the composition and now tried 'to fill it up in colour',[3] but
the effort proved too great. As a distraction, he painted on a table napkin in their
lodgings two views of his landlord's daughter, Milly Smith, who had become Lucy's
playmate.

That autumn he was back in London, moving from place to place. One stop was at Milk Street, Cheapside, where he painted the silk merchant James Bamford, a Bromley family connection. Now lost, the portrait was 'the first evidence of an entirely new direction of thought and feeling on my part', a decision to begin again and try out the lessons of simplicity and truth to Nature learned on his Italian journey. The results surprised him, looking 'as if painted by another hand and that of a beginner', clumsy and naive. 'Even to myself, this instinctive turning back to get round by another road seems remarkable ... wishing to substitute simple imitation for *scenic effectiveness* and purity of natural colour for scholastic depth of tone. I found no better way of doing so than to paint what I called a Holbein of the 19th century.'[4] A similar turning back to Nature was soon to preoccupy nineteen-year-old William Holman Hunt, a student at the Royal Academy Schools and already dissatisfied with the conventions of academic painting.

At Blackheath, staying with one of Elisabeth's brothers, Ford began a Madonna and Child, to commemorate his lost happiness and exorcise his grief: his design for *Our Lady of Saturday Night* was worked out in a series of sketches on the back of a letter. Although enthroned under a Gothic canopy, this young madonna is not idealised but is an ordinary young mother bathing a very human baby, a picture of gentle domesticity. A young angel stands beside her, holding a bowl of water; behind the throne are faint suggestions of landscape. The image of the Madonna and Child would often recur in Ford's art, acknowledging the sacred place of home and family in his life and, especially, the support of woman. By early 1847 he had moved to Kensington, where he elaborated the sketches into a large chalk drawing, giving a distinctly Italian feel to the architectural and landscape settings. This drawing was rejected by the Royal Academy, but shown at the British Institution later that year.

That spring Ford rejoined his artist friends at Tudor Lodge, Mornington Crescent. He was glad to be back with Charles Lucy, and in the latter's life classes, among his peers, he gathered up the threads of normal existence. At last he was able to resume 'Elisabeth's Picture': soon he was looking for a studio big enough to house the huge triptych.

By August Ford was installed in a mews behind Clipstone Street, Bloomsbury, in an area abounding in artists' studios and craft workshops. He rented a former carpenter's workshop – a 'rascally barn of a studio' with one wall completely of glass, a skylight overhead, and swarming with rats. But at least it was his own. He hung blinds, installed a stove for the winter and, since all his furniture and properties were with Casey in Paris, re-equipped the studio from scratch: urgently needed were a lay figure and, for the triptych, three huge stretchers with enough canvas to cover them. He bought a rat-trap.

The task was impossible. The monumental *Seeds and Fruits of English Poetry* — with thirty half-life-size figures in the central panel, six life-size poets in the wings and an elaborate architectural setting — would have occupied two or three years of any artist's time working with assistants. But, desperate to redeem his pledge to Elisabeth, Ford persuaded himself that it would be ready for next year's Academy. He had no time to lose. To spur his conscience and brush, he bought an exercise book in which to record his daily progress and his hours of work.

Ford's delightful diary, kept on and off for the next decade and written each evening before he went to bed, has become a prime source for art historians. Written guilelessly and spontaneously in idiosyncratic style, its rhythms and structures carry the immediacy of the spoken word, with many oddities of syntax and spelling, providing unique insights into the artist and man. With the innocence of a Pooter and flashes of humour and irony, Ford chronicles his ambitions, frustrations and fluctuating moods, and his relationships with family, friends and models. What started out as a simple record became a rare piece of autobiography.[5]

'I have long intended beginning this journal. Praise be God it is begun at last!' Ford wrote on 5 September 1847, vowing to visit Elisabeth's grave that same day each month. Meanwhile, he began work on the six poets in the wings; he bought flannel and tartan plaid to make the costumes for Burns, Milton, Byron, Pope, Spenser and Shakespeare, making careful pencil and oil studies from his lay figure. Each character's head had, however, to be studied from the best existing likenesses in print-shops or elsewhere — he took Pope's from the monument by Roubiliac in Westminster Abbey.

Ford's day usually began at 7 a.m., but progress was slowed by psychosomatic depressions, headaches, colds, toothaches and oversleeping. On 25 September, conscious of the enormity of the task ahead, he switched to the costumes of the central panel, buying lengths of damask, blue satin and green velvet: 'Got up Early — got to work late, fumbled till 12 o'clock over the Hood of the left hand figure of the "knight", made a lirlipipe for it ... set to work at a small drawing ... had not finished it by dusk — am a very swine — shall never get the painting done in time — am a beast and a sleepy brute.' The following days saw the hood finished and the desultory beginnings of other costumes: a chamberlain's cloak, a cardinal's cape, a hood for Alice Perrers (mistress of the old Edward III), a lady's white capuchon.

On 4 October: 'Got up late, felt Low and dejected, never feel Happy ...'

By 12 October, blinds and stove now in place, Ford had hired live models for nude studies of 'the muses of impassioned and satyrical Poetry' in the roundels and the female figures in the central panel, posed in various expressive attitudes. He had begun to realise the essential conception. On 14 October he bought '6 yards of

Germon velvet' for Chaucer himself, and a workwoman arrived to make up the gown. By now he had begun to transfer the figures to the canvas.

Visitors came, relieving his isolation. Tudor Lodge friends like John Marshall, the Lucys and Cave Thomas would drop regularly into the studio, enticing him out for walks in Regent's Park or up to Hampstead Heath: he was all too easily distracted.

14th [Sept.] ... began a drawing for the robe of Robert Burns. Mr & Mrs Lucy came in afterwards. [Cave] Thomas interrupted & did not do much ...

20th Sept. ... worked very hard all day finished the drapery for Lord Byron, dined and walked round the Regents park with Thomas ...

2nd Oct. Went to Hampton court to see the cartoons with Thomas and Lucy.

3rd [Oct.] ... to Richmond with Thomas to see Lucy. Had a row on the Thames up as far as Pope's villa and the Eal Pie House.

Sometimes he indulged his old love of the theatre:

9th Oct. ... up at nine — Painted in the blue satin cloak [the study for] and part of the veil went out to see Mr Bamford — found him out walked back and went to the Princess's Theatre, came in late with wet feet and a cold. Have been suffering 8 or 10 days from indigestion, live upon mutton chops and tea and coffee, quite a teatotaler.

16th Oct. to see young Elliott's painting at Westminster Road and to the abby to see some of the old effegies ... went to Reeves to get some millboards and canvas for Studies and then with Thomas to the Princess's theatre to see Miss Cushman and Cooper in the Stranger, both nature to the life, and 'She Stoops to Conquer' a fine *fine* play. Went and supped with Thomas and stopped till $\frac{1}{2}$ past 1!!!![6]

He kept in close touch with his family. Aunt Bessy Brown, living nearby in Great Coram Street, would make him 'drink too much Wiskey', while Uncle Madox 'made himself quite Jolly, went away by Six'. At least once a month Ford would visit Helen and 'Lucy dear' at Gravesend, combining these expeditions with collecting rents from Ravensbourne Wharf. Richard Bromley, seconded from the Admiralty to help organise famine relief in Ireland, would call on Ford during his visits home. Richard's stories of the people's distress moved Ford to indignation. He had already composed a sonnet on the poverty and oppression he had seen in Italy, and he now

penned another angry one – *To Ireland* – urging an end to British 'tyranny' over Erin.[7]

With all these diversions, by November it was clear that *The Seeds and Fruits of English Poetry* would not be ready for the 1848 Royal Academy. The perception paralysed him, and the grave in Highgate cemetery reproached him. Could he, by abandoning the wings, complete the central panel, or must he shelve the whole project and paint a related subject of more manageable size? Either course seemed a betrayal, but not to exhibit would be even worse.

> *26th* [*Nov.*] I have been reflecting seriously about my large composition, that I had better paint the middle compartment small for next year's exhibition ... I have almost made up my mind to do so. I have sat up thinking of the new composition ... so as not to risk sacrificing the present one to no purpose and I believe I have succeeded ...

> *27th* ... Have been thinking about my change and have decided to go and order the small canvass ... am going to Blackheath to sleep and to Foots Cray tomorrow to return Monday to work. Have called on Thomas. He has dissuaded me from changing the large work.

The crisis was resolved on 29 November as Ford travelled home from his visit to Uncle Madox at Foots Cray:

> Thought of a subject as I went along. Wycliff reading his translation of the bible to John of Gaunt, Chaucer and Gower Present – arranged it in my mind. Called on Lucy ... Dined, came home, made a slight scetch of it (3 hours).

Thus freed, he set about designing *Wycliffe Reading his Translation of the Bible to John of Gaunt*.

On Christmas Eve, laden with presents for Lucy and Helen, he went to Gravesend. New Year was celebrated, as usual, at Uncle Madox's at Foots Cray, where there was a party with music and young ladies. After seeing the old year out, Ford sat up talking till three in the morning with Tristram, Madox's sailor son. Back in London he did not forget his ritual visit to Highgate on 5 January when he 'had some standard roses planted on my poor wife's grave ...'

4
FRIENDS AND MODELS
1848 – 1849

A T OR AWAY FROM THE EASEL, Ford Brown's social life was sustained by the male friends, mostly artists, whom he knew from Paris and Tudor Lodge. Of these, the names of Charles Lucy, Tom Seddon, William Cave Thomas and Mark Anthony appear most frequently in his diary, along with Dr John Marshall. To this professional circle he was simply 'Brown'.

The most important influence on his art was the Welshman William Cave Thomas, the gifted son of a framemaker. Thomas had done well in the Westminster competitions, winning a £100 prize for his cartoon of *St Augustine Preaching to the Saxons* in 1843, and in 1844 a mural commission for *The Throne of Intellect* (also known as *Philosophy*) at the House of Lords. His *Abstract Spirit of Justice* of the following year paralleled Brown's own.

An early visitor to Clipstone Street, Thomas took an active interest in the progress of *The Seeds and Fruits of English Poetry*: the two friends would dine together, walk in Regent's Park or on Primrose Hill or, when the weather grew warmer, go rowing on the Thames. With Thomas, Brown rediscovered his old love of the theatre for the first time since Lizzie's death.

Thomas was a well-known 'Germanist'. In 1840 he had gone to Munich hoping to study under the famous Nazarene, Peter Cornelius, but instead he had found himself working under Heinrich Hess on the fresco decoration of the Bonifazius Basilika and later with Cornelius's pupil Wilhelm von Kaulbach. Thomas steeped himself in the austere ethos of German public art: soon he was sufficiently familiar with aesthetic theory to advise Charles Eastlake on subject matter and technique when, as Secretary of the Fine Art Commission, Eastlake was planning the Westminster competitions. It was probably at Thomas's instigation that Brown had visited Cornelius and Overbeck in Rome.

In endless discussions, the loquacious Welshman imbued his admiring friend with philosophical ideas about art, architecture and life. Impressed by Thomas's

erudition and his plan to take a degree at Cambridge, Brown talked with him about literature and accompanied him to lectures on archaeology and aesthetics. In one another's studios the two applied theory to art.

> *5 October.* Went to Thomas to make a sketch of some vine leaves [for the frame of *Seeds*] – found him at work on his designe of the *Penseroso* for the Art Union.

> *13th Oct.* Called on Thomas to see some sketches of his, some fine ideas, one in particular a scramble for lawrels – grandly satyrical.

The laurelled and togaed poets in the wings of *The Seeds and Fruits* were especially open to Thomas's Germanic bias – Brown himself was working on a figure of Milton, and the 'grandly satyrical scramble for lawrels' was translated next day into two 'muses of impassioned and satyrical poetry' in the spandrels of his vine-ornamented frame. Thomas liked the wings and it was he who, on 27 November, dissuaded his friend from changing the original scheme of his *magnum opus.*

Thomas's influence was however strongest on *Wycliffe,* under way by January 1848, whose progress he watched almost daily; it can be seen in the severe linearity of style, symmetrical composition, cool fresco-like colours with little tonal contrast and an architectural framework much more austere than that of the florid *Seeds and Fruits.*

'Thomas called in to know if I would accompany him tomorrow ... to hear a lecture on beauty by a baronet MP,' Brown noted on 7 February. 'He for the first time explained to me his views on beauty and the explanation thereof. Wonderful fellow I hardly know what to make of him his talents are so wonderful and varied ...' Despite this, all his life Brown had a robust contempt for the art talk of theoreticians and critics; he dismissed the lecture 'by a Bart' as 'most absurd'.

Brown's assimilation into the social fringes of the London art world was particularly helped by Charles Lucy and his common-law wife, whose wedding on 11 January 1848 was celebrated at a dinner at Tudor Lodge. Brown enjoyed their domesticity and, in these Clipstone Street days, saw them almost as often as Thomas. Lucy, unlike Thomas, painted popular histories and was no theorist. His prize in the 1844 Westminster competition not having resulted in a fresco commission, he was now researching an easel painting of *The Pilgrim Fathers Landing on Plymouth Rock.*[1]

One of the best places to meet fellow artists in the 1840s was at a life-drawing class. In 1848 Lucy's Tudor Lodge life class made way for a new academy set up by the art dealers, the Dickinson brothers in Maddox Street, off Bond Street.[2] Here students aspiring to enter the Royal Academy Schools took drawing lessons, but

also, of more importance to Brown, professional artists attended evening and early morning life classes at either end of the working day. Through the Maddox Street Academy, Brown came into contact with a wide circle of London artists.

Lucy also introduced Brown to the lively politics of the 'Free Exhibition of Modern Art', now in its second year.³ Lucy was a leading figure among the artists organising the 'Free', one of several 'democratic' alternatives to the exclusive Royal Academy. Members' subscriptions entitled them to show their works without submission to a jury, and for this purpose the former Chinese Gallery at Hyde Park Corner had been taken. Like most artists' associations, the Free was riven with factions; lately there had been an attempt to impose selective membership and centralised control on the collective — a move which Brown and his friends strongly opposed:

> *6 Nov 1847.* At 7 went with Lucy to a meeting of the shareholders of the Free Exn. We both refused to be on the committee, Martin in consequence is afraid they will turn him off — poor Martin Hon Sec! We have written to him to say that if they do we will have nothing more to do with them.
>
> Marshall Claxton and his party want to make Dibdin secretary. What a set of Muffs!

By February 1848, when Brown attended one of the conversaziones at which artists showed work, the influential Art Union had joined the Free, and 'members must be proposed and seconded'. Brown showed at the Free, in preference to the Academy, in 1848 and 1849.

Of all Brown's artist friends the most entertaining was Tom Seddon, who had known Lucy while studying decorative art in Paris (1840–1), meeting Brown later at the Tudor Lodge life classes. The eldest of three brothers (the others were Charles and John Pritchard, the architect), Tom was chief designer at the family furnishing works in Gray's Inn Road. He had some talent as a designer, and in June 1848 he won the Society of Arts Silver Medal and a prize of twenty pounds for an ornamental sideboard.⁴

Tom's high spirits and enjoyment of life were infectious. Something of a womaniser, an accomplished and often bawdy storyteller and an inveterate practical joker, he shared Brown's love of the theatre. But he also had a serious and deeply religious side. His ambition was to escape from the family firm and become a professional painter — something that Brown, who had a particularly soft spot for him, encouraged wholeheartedly; he was to be the first of Brown's many artist

protégés. Beginning, like so many amateurs, with holiday landscape studies at Bettws-y-Coed and Barbizon, Tom now joined Brown and Lucy at Maddox Street for life drawing, meanwhile conscientiously pursuing his job as a designer, studying archaeology and decorative arts in the British Museum, and attending lectures on architectural history. He was thus the ideal person to consult over the Gothic furniture in *Wycliffe*: '1st Feb. Went to Grays in Lane to Seddon to get his "Shaw's furniture", thence to Mark Anthony's to get the dictionary of architecture.'[5] Brown looked over the furniture works with Thomas and 'afterwards set about composing the furniture for my painting'. The insights thus acquired came in useful when, soon afterwards, he began designing furniture for his own household use.

The landscape painter Mark Anthony was working at Barbizon long before Seddon. William Rossetti praised Anthony's 'powerful paintings rich in colour and impasto'[6] which appeared at the Academy between 1837 and 1854, many done in Wales during summer trips. Brown shared Anthony's passions for landscape and music — both were violinists — but in November 1847 it was Anthony's pioneering interest in photography which particularly interested him. On 12 November 1847, increasingly anxious about *The Seeds and Fruits of English Poetry*, he consulted Anthony 'about a daguerotipe think of having some struck off for the figures in the picture to save time'. In the event, he solved the problem by switching to *Wycliffe*. Anthony belonged to the older, more established exhibiting group — The Society of British Artists, at Suffolk Street — and, hoping to recruit Brown to this rather than the Free, he invited him along to a lecture. 'Went to Suffolk St to hear Professor Anstead tell us that the colour of the air is blue and that of Mist grey etc etc — this they call geology' was Brown's dismissive reaction. He took no further interest in Suffolk Street and decided to throw in his lot with the Free.

Important as these male friends were to him, Brown's slow recovery owed as much to the world of female models. As *Wycliffe* took shape on the canvas early in 1848, there arrived at the studio a succession of models, including Julia Wild — 'celebrated as model and prostitute, also for black eyes' — impersonating The Protestant Faith. On 10 January 'that devil Miss Chamberlain called. Walked round Regents Park and dined'. The previous October her behaviour when posing for several figures in *The Seeds and Fruits* had upset him: '... Miss Chamberlain all day. A very devil, a very devil. Made outlines of the nudes of several female figures.'

On 26 January there was a freeze; skaters were out on the lake in Regent's Park, and the vast studio was too cold for models to pose in the nude. But Brown could get on with the clothed figure of the duchess who appears to the right of the painting, between Wycliffe and John of Gaunt: 'Went out for a walk, found it too cold. Went and bespoke Miss Ashley and came back. Miss Ashley came at 11, stopped till 4, let

the fire out three times and talked all day, will never do.' On 17 February, 'Breakfasted in bed, Miss Ashley called in', and, on 22 February, 'Came back to my studio, found Miss Ashley waiting for me. Made me some beautiful Castor oil pomatum, paid her /3 for it.' Later, this unmarried mother would pose with her baby for Brown's charming *The Young Mother (Infant's Repast)*.

Brown enjoyed the company of these women, some of whom undoubtedly hoped to 'catch' the attractive and susceptible widower. But in February a *memento mori* through the letter box — a letter from a school friend of Elisabeth's asking 'my poor wife's address' — brought him sharply back to reality: 'Oh dear! Her's has been for upwards of 19 months the cemetery of Highgate, mine this rascally barn of a studio, to think that We once had a home together! in Paris how different and even in Rome how different, bless you my poor child.' Nevertheless, the following night found him dancing 'till three in the morning' at Mr Bamford's, getting to bed at 5.30 a.m. Among his partners was Bamford's daughter Elizabeth, whose placid features appear as the duchess in *Wycliffe*, with Lucy Brown asleep on her lap.

Pictures for the Free were due at Hyde Park Corner on 19 April. Throughout the spring of 1848 Brown worked for up to ten hours a day at *Wycliffe* — relatively plain sailing after the huge and complex *Seeds and Fruits*. He had substantially completed the figures and was working on the traceried Gothic arch, balustrade and pavement when, on 25 February, news reached London of the 1848 Paris revolution and Louis-Philippe's abdication. It came as a shock to the Tudor Lodge circle, most of whom had worked in Paris. Two of them — Cross and J. L. Brodie — arrived with first-hand news of the fighting and Brown, who had been scouring the papers, anxious about Dan Casey, plied them with questions. Now, too, he met Roger Fenton, former student of Delaroche and later photographer-extraordinary of the Crimean War. '... Went again to get a sight of the paper and went at 11 at night to see Lucy. Found him in great excitement ... Fenton his pupil in a sad state about it. We all three have associations with paris ...' On 28 February he wrote begging Casey for news.

Trouble was to flare up again at the end of June, with bloodier battles between the provisional government and working-class revolutionaries. Meanwhile, at home, popular unrest was fanned and Chartist demonstrations were planned in London for 10 April.

From March, work on *Wycliffe* accelerated to a frantic twelve hours a day, as the artist perfected each detail of his picture:

17th April. Got up at six to work by half past eight — finished the pages and Chaucer & Gower & Wickliff. Painted the Green rushes, finished the ground,

the reading desk and the females chair. In the evening painted at the letters [the inscription on the Puginesque trompe-l'œil frame] from 9–11 then again at the female & the mosaic work till 4 am (17 hrs).

Two days later Brown delivered his canvas.

Wycliffe Reading his Translation of the New Testament to his Protector John of Gaunt in the presence of Chaucer and Gower, his Retainers was admired by Brown's friends and sympathetically reviewed in the press. The *Athenaeum*, assuming that it was 'designed with a view to its execution in fresco', praised the artist's effective use of colour contrasts, and the *People's Journal* published a wood-engraving. The artist, wrote their reviewer, 'had secured himself imperishable fame in this selection of a subject'.

On 24 March, as the pressure of work mounted, a letter had been delivered to $20\frac{1}{2}$ Clipstone Street:

> 50 Charlotte Street,
> Portland Place

Sir,

I am a student in the Antique School of the Royal Academy. Since the first time I ever went to an exhibition (which was several years ago, and when I saw a picture of yours from Byron's *Giaour*) I have always listened with avidity if your name happened to be mentioned, and rushed first of all to your number in the Catalogues. The *Parisina, the Study in the manner of the Early Masters, Our Lady of Saturday Night*, and the glorious works you have exhibited, have successively raised my admiration and kept me standing in the same spot for fabulous lengths of time. The outline from your *Abstract Representation of Justice*, which appeared in one of the illustrated papers, constitutes together with an engraving after that great painter Von Holst, the sole pictorial adornment of my room. And as for the *Mary Queen of Scots*, if ever I do anything in the art, it will certainly be attributable in a great degree to the constant study of that work. It is not, therefore, to be wondered at if, wishing to obtain some knowledge of colour (which I have as yet scarcely attempted) the hope suggests itself that you *may* probably admit pupils to profit by your invaluable assistance. If, such being the case, you would do me the honour to inform me what your terms would be for six months' instruction, I feel convinced that I should have some chance in the art.

I remain, Sir,
Very truly yours,
GABRIEL C ROSSETTI.[7]

Despite his youthful exaggeration, Rossetti was sincere. He would have seen *The Giaour's Confession* at the 1840 Academy, when only twelve years old, the others at irregular intervals since, and Brown's art must have influenced his early decision to become a painter. Rossetti had already applied similar heartwarming flattery, based on unusual familiarity with the recipient's work, to the poets Browning, Leigh Hunt and, most recently, William Bell Scott.[8]

What, precisely, were the qualities in Brown's work which had fired Rossetti's poetic imagination? At thirteen, Gabriel's favourite poets were Byron and Poe, his favourite novelist Scott. With his brother William, he amassed theatrical and illustrative prints, as well as romantic novels by popular authors like Bulwer-Lytton and Charles Lever, usually in serial form. The boys copied these pictures and wrote romantic ballads and stories. The Byron connection was peculiarly important to them – their uncle, Dr John Polidori, had travelled with Byron to Italy before poisoning himself, and Brown's intensely dramatic treatment of Byronic wickedness and (in *Parisina*) illicit passion would specially appeal to a boy encountering them in London exhibitions. But these early works of Brown's had been balanced by moral and improving ones of more recent date: one can imagine the appeal of *Our Lady of Saturday Night* to Rossetti's devout mother Frances, and of the monumental *Abstract Spirit of Justice*, innocence appealing to justice against tyranny, to his father, the old Neapolitan revolutionary Gabriele. As for von Holst, presently adorning Gabriel's bedroom wall, he too was a follower of Fuseli and even more melodramatic than Brown.

Harassed and anxious, still unrecognised in his profession, Brown's violent reaction to a friendly letter is the first recorded instance of his notorious touchiness. Such improbable familiarity with his work suggested a hoaxer and, grabbing a stout stick, the artist hurried round to 50 Charlotte Street to chastise the offender.[9] But the youth who ran downstairs disarmed his visitor on sight. Nineteen-year-old Rossetti, dark auburn curls falling to his collar, and grey eyes set deep in a pale olive face, was all charm and conciliation and his manner so deferential that Brown's suspicions evaporated. From that moment he came under Gabriel's spell. As they parted, he invited the younger man round to his studio: the painting lessons would be given without charge.

On 25 March Brown briefly recorded the return visit: '... Rossetti called, ... my first pupil. Curious enough he wrote to ask me to give him lessons, from his opinion of my *high Talents* knew every work I had exhibited & all about – will see what we can make of him.' *Wycliffe*, nearing completion on the easel, was not at all what Rossetti was expecting to see and must have come as something of a shock – its Nazarene archaism and light tonality being the latest development in Brown's art.

At Rossetti's first lesson, on 4 May, Brown demonstrated the painting of a head. This day's teaching is the only one Brown recorded, although Gabriel was constantly at Clipstone Street in the next two months. The teacher would emphasise such basics as the setting of a palette, the tonal laying in of the form, and the building up of light, shade and local colour. Above all, the older man would insist on the accurate rendering of appearances as the foundation for any *imaginative* work. At first Brown asked Rossetti to copy a recent picture of his own, *The Seraphs Watch*, for practice in handling the brush. Brown's original is lost, but Rossetti's two heads of angels, painted with considerable delicacy and charm, are typical Brunonian essays in domestic scene-setting showing his delight in children. These heads recall the angels in *Our Lady*, in which the Christ child is shown surrounded by the everyday paraphernalia of bathtime; that painting was echoed in turn by Rossetti in *The Girlhood of Mary Virgin*. Then Brown made him paint a still-life, a group of studio bottles. These Rossetti would later transform by adding a decorative female figure.

The disciplines of naturalism bored Rossetti, who tired of his lessons as quickly as he had tired of those at the Academy Schools. He had probably abandoned Clipstone Street by the time Brown decided to visit Paris in July. But their friendship had by then taken deep root, embracing all Rossetti's family. William Rossetti later recorded their impressions of Brown at the age of twenty-seven (Rossetti was just twenty): 'We all saw something of Brown from the spring of 1848 and liked him extremely. His pleasant open manner, equally manly and quiet and his generous kindness in looking after Dante's art studies impressed us all.' Again, 'he was a vigorous-looking young man with a face full of insight and purpose; thick straight brown hair, fair skin, well coloured visage, bluish eyes, broad brow, square and rather high shoulders, slow and distinct articulation. His face was good looking as well as fine; but less decidedly handsome than it became towards the age of forty.' Brown's unusual way of speaking impressed him particularly: 'What struck us at first, more than his personal aspect, was his slow, deliberate, uniform voice . . .'[10]

A full-face self-portrait by Brown, made around this time, bears out William's description. The artist here looks calm, thoughtful and confident, unlike the troubled drawing Rossetti was to make of him in 1852. The thick chestnut hair, later invariably parted in the centre, is shown parted on the left.

Over and above the kindness to Gabriel, Brown's habitual courtesy, continental formality of manner and ready Italian made him particularly welcome in the Rossetti household. With his wide interests and conviviality, Gabriel's new friend could tell a good story in French or Italian, while 'his English talk was thoroughly native, not interlarded by foreign words or idioms' despite occasional oddities of pronunciation.[11]

In Paris that summer, renewed violence erupted in the north of the city, where Casey lived. Free now of *Wycliffe*, Brown decided to visit his old friend. He was anxious, too, about the items, including studio property, left behind at the time of Elisabeth's death, some of which had been pawned. But by the time he arrived, on 17 July, the violence had largely subsided and the visit turned into a holiday, during which he painted Casey's portrait and brought back two fine pencil studies of his head. This renewal of an old and dear friendship tempted Brown to return permanently to Paris, and Casey even sought out lodgings in the Faubourg Broussel. But the old Paris circle was dispersed for good: new friendships and commitments pointed firmly towards London.

The trip unsettled him with its memories. Back in August he tidied the studio and tinkered with *The Seeds and Fruits of English Poetry*, but without enthusiasm, and when Charles Lucy suggested a painting holiday in the Lake District he readily agreed. On 21 September the two set off for Cumberland, visiting the Royal Manchester Institution's annual exhibition *en route*. On 25 September, alongside Lucy, he 'began painting a view of [Lake] Windermere; Worked six days at about 4 hours a day last day in the rain under an umbrella.' There followed four days' hard walking on the fells. On 6 October they went by train to Liverpool, where *Wycliffe* hung at the Academy, but Brown was upset by the hanging: 'Saw my *Wycliffe* there, up high, looked damned bad.' On the way back they took in the Birmingham Academy exhibition, completing Brown's introduction to the provincial art circuit which would become so important to him.

Back home, he was swept up in artistic controversy. In September, Cave Thomas contributed a series of articles to the *Builder*, a periodical widely read by artists and architects and a well-established debating forum. Thomas's didactic pieces were written in Brown's studio and marked the recent gift of Robert Vernon's collection of modern British paintings to the nation,[12] a gift which had focused renewed attention on an endemic issue: the patronage of living artists. Thomas's three articles 'On the Influences which tend to Retard the Progress of the Fine Arts' appeared on 9, 16 and 23 September 1848.

The Westminster competitions had run their course; Thomas called on the British Government to take new action to encourage living artists, as in France and Germany. While patronage was important, he argued, so was the provision of a broad aesthetic education for all levels of society from the poorest, in their squalid urban rookeries, to the industrial working class, with its new access to cheap literature and Mechanics Institutes, and the bourgeoisie who bought art. Such education was, he continued, the key not only to improving art but to elevating society; it was also a necessary condition of 'Progress', with economic implications:

The condition of art is intimately bound up with and dependent on our social condition ... We consider that the circumstances which regulate the production of the fine arts are precisely similar to those of any branch of the manufactures ... It is our firm conviction that any demand made upon the arts by the public will be responded to and that the quality demanded will be the quality supplied.

Such thinking led directly to the Great Exhibition of 1851, and Ruskin, who certainly read these articles, would develop the theme in his lectures and writings from 1852. Here Thomas addressed himself to the dynamic middle-class readership of the *Builder*, the producers and consumers of culture, as best able to promote the desired policy. Yet it was this group, so preoccupied with display and status, which insisted on buying so-called old masters, thus ensuring a decadent taste in modern art. He blamed the aristocracy:

We have never been able to discover that our great scholastic institutions have been famed for the instructions which they communicate in the arts; why then should the nobility assume superiority of judgement in this respect? The course of study which obtains the degree of connoisseur is something like the following:– To have attended annually sales of ... Old Masters, Etruscan vases, Egyptian mummies and Elizabethan furniture; to have inserted in one or 2 windows of the mansion a few pieces of old painted glass ... such are the conditions which render him eligible to committees which, self-elected, legislate on matters of taste.

In his third article, Thomas looked at the education of artists and called for them to study 'Nature' before the Antique. But in considering Nature, Thomas took a scientific and rationalist line – Baconian rather than romantic. Artists, he thought, should study 'the thews and sinews, the anatomy if it may be so expressed, of the universe ...': the rules of art, in other words, were to be derived from the analysis of Nature, and he went on to deplore the specialisation which has divided science and art since the Renaissance.

A correspondent signing himself 'Amateur' responded, defending the National Gallery's 'old master' policy and recent acquisition of a (dubious) Tintoretto. He attacked the 'trifling nature' of the contemporary art at the Royal Academy next door. On 4 November, 'An Artist' – Brown – counter-attacked with a letter taking up the theme of patronage. The idea that Tintoretto would inspire living artists was, he said, 'nonsense'. The picture's existence as an altarpiece in sixteenth-century Italy

was the outcome of a church commission, precisely the kind of patronage 'Amateur' would deny modern painters. Compared to Germany, France and even tiny Bavaria, England spent a minute fraction of its great wealth on art. Yet without patronage no great art could be generated – he cited Lorenzo de' Medici. So far Ford Brown supported Cave Thomas.

'An Artist' attacked (not without arrogance) 'Amateur's' ignorance and lack of discrimination, showing familiarity with recent historical research and art criticism, which was rediscovering the power of quattrocento art:

> I must inform him that it is not customary ... to praise at one breath masters such as Fra Angelico, Perugino and the Bellini; and ... Tintoret, Guido and the Caracci; it is not at present customary to express equal pleasure at the guileless inexperience of the one school and the pedantic incapacity of the other; neither is it common at this moment to hear historical painters mention Domenichino and the eclectic school as if their efforts were ... to be admired or imitated.[13]

Whether or not the National Gallery trustees had been swayed by Ruskin's enthusiasm for Tintoretto, 'Amateur' and English connoisseurs were increasingly influenced by him. Ford Brown had no time for such connoisseurship: '... it is not prudent to make such a display about Tintoret merely because a Graduate of Oxford has lately made a great fuss about him ...'[14] Herein, perhaps, lies the key to Ruskin's lifelong hostility to Brown – indeed to their mutual antipathy.

'An Artist' knew the modern art of Europe, too. The best of it, he argued, arose from a renewed study of nature – source of all art – the worst from poor imitations of Raphael and his successors. Among the former he instanced Lessing and Cornelius in Germany, Ary Scheffer and Ingres in France, and in England Maclise, while the father of English painting, Hogarth, 'in an age of the greatest mediocrity studied nature unassisted'.

But he disliked any system of rules for art, revealing his strong romantic allegiance:

> Let me candidly state that I myself belong to the hair-brained and poetic race that is but little disposed to submit to the shackles of self-constituted legislators ... it is my belief that there are certain comprehensive rules which we all feel and work by although as yet undefined. I know by experience that from originality to eccentricity there is but one step out of the ruled circle of perfection.

This letter encapsulates Brown's views at the moment of the Pre-Raphaelite revolution, before he had discussed his ideas with Hunt and Millais. While obviously influenced by his conversations with Cave Thomas, it shows a vigorous independence of mind, and a confidence born of practical experience and long study of art and its history.

Whatever Rossetti's shortcomings in the studio, Brown had quickly conceived a deep respect for him as a poet. The huge *Seeds and Fruits of English Poetry* triptych, propped half-finished against the wall, had generated heated discussions between two artists equally interested in poetry and painting. For months Gabriel had been working on a series of translations of medieval Italian poets, unearthing unknown examples in the British Museum. The parallel between Dante and Chaucer as founders of a vernacular poetry in their own countries was a constant focus which led to far-ranging talk about medieval art in general; it was reflected in Brown's article 'On the Influences of Antiquity on Italian Art', published in the *Builder* on 2 December 1848.

The thesis of this article was the destructive effect of the Renaissance on the unified culture of Gothic Italy, illustrated by direct reference to Gabriel's unpublished translations. Through Gabriel, Brown had discovered in Italian poetry the qualities he had admired in Giotto and Masaccio – 'the tenderness, richness and truth of these effusions of an age 150 years anterior to that of our Chaucer'. Such art sprang from the love and study of nature; the new study of the antique in the followers of Mantegna, Raphael and Michelangelo had signalled the long decline of art. Only the early Venetians 'resisted the degeneracy of the times.'

Lastly came a recall to the study of Nature, her principles and appearances, which all good artists understand. 'Nature is the stay of the artist,' he wrote: 'she is our kind mother and she will never desert us if we trust in her . . .'

Throughout the autumn of 1848 Brown continued to visit Elisabeth's Highgate grave, though less regularly than before. The Celtic cross reproached him, but the more he contemplated resuming *The Seeds and Fruits of English Poetry* for next year's Academy, the less he wanted to do so. His doubts about the scheme had been reinforced by Rossetti, who laughed at his old-fashioned choice of poets. The elaborate architectural

setting looked fussy to him now, and the cost of framing this enormous work was beyond his means.

In November, perhaps inspired by the actor-manager Macready's performance of Lear, which he had seen in May, he embarked instead on a new picture, *Cordelia at the Bedside of Lear*, with its origins in the Paris sketches of 1843.

On 7 and 8 December, a new model came to Clipstone Street to pose for the nude figure of Cordelia. Days after her first visit, Brown's sleep pattern was disturbed, while his working hours suddenly dropped to two or three a day. Christmas at Gravesend was drawn out to four days and found him unusually reluctant to return: on 28 December 'Against my will came home, went to Highgate and to see Lucy. In the evening worked at the outline of Lear.' As *Cordelia* grew on the canvas, he alternated work on it with short sessions on *The Young Mother*, modelled by Miss Ashley and her baby.

On 8 January, 'In the evening, drew at the outline of Cordelia from Model – two hours'. This model was almost certainly 'Miss Stone', who returned on 13 and 14 January to pose for Cordelia's head, and on 15 January for her hands. During these five days Brown must have made the careful pencil study of her face in profile, later dated 'FMB Xmas/48'. He worked at getting the head right throughout February and March, requiring Miss Stone's presence every few days – and not only to be painted:

10 Feb. Up late through foolery the night before. Began the veil of Cordelia, only laid in a part of it when a girl as loves me came in and disturbed me. (only 3 hours work).

11th Feb. To work late, quite upset.

23rd Feb. Arranged the Drapery of Lear, could not get it right, tried at it till 3 o'clock then Miss Stone came in and I did nothing more.

10th March. Finished the musicians and the tent ... even[ing] foolery and to see Thomas.

18th March ... finished the sleeves of Cordelia. Repainted her head from Model and her hands, found I had spoiled the head, rubbed out part of it in the evening and made a mess of it.

He repainted it again the next day and on 21 March 'finished the head of Cordelia at Last'.

We do not know how Matilda Hill – always known as Emma – came to be a model in Brown's studio, but she had probably earned her living in this way for some years. She was the younger daughter of Thomas Hill, bricklayer, of Newent,

Gloucestershire, and his wife Catherine, née Stone, a mason's daughter from nearby Oxenhall on the Herefordshire border. They had married in 1817, and their daughters Eliza and Matilda were born at Newent in 1824 and 1829 respectively, spending their early childhood in this rural backwater. Family myth, emanating from Emma herself, later held that she was 'the daughter of a Herefordshire farmer who ... had so involved his estate, that when suddenly carried off by apoplexy, he left his widow with little more means of subsistence than a Chancery suit ...'[15] and gave Emma's age at the time of meeting Brown as fifteen. This was Emma's fantasy. She was actually twenty when they met, but Ford believed her, calling her 'Child when you first were mine' in a much later sonnet. The myth persisted to the grave: the Order of Service at Emma's funeral in October 1890 stated that she was born in 1835, a date confirmed on her tombstone, where she is described as fifty-five.

The Hills seem to have left Newent during the hungry 1830s — certainly before Emma was twelve — to seek work in London. By the time of the 1841 census, Thomas Hill was living with his wife and younger daughter in Essex Street, St Pancras, still working as a 'Bricklayer' — Newent had long been a centre of the brick industry, and in the rapid northward expansion of London generated by the railways from St Pancras and King's Cross plenty of building work was available to displaced countryfolk.

The elder daughter, Eliza, was not living at home in 1841. In 1846, from an address in Silver Street, Soho, she married John Gandy of the same parish, a self-styled 'architect', and it is therefore possible that when Emma posed for Brown she was living with her sister's family and her widowed mother a mile or so from Clipstone Street.

Emma was 'without educational advantage' — in other words illiterate — and her charm for Ford lay in her lack of sophistication. She was and remained what she looked: a country lass, soft and pretty, with, as William Rossetti tells us, 'a pink complexion, regular features and a fine abundance of beautiful yellow hair, the tint of harvest corn'.[16] She had a sweet singing voice and had about her the scent, as her granddaughter Juliet recalled, 'of country herbs and flowers'.[17]

Brown's friends, with the exception of William Bell Scott who could not stand her, were later silent on the subject of Emma — probably because she was so placid and ineffectual. She had faults, as we shall see, but what perceptive offspring and friends remembered most was her extreme gentleness of voice and manner and her kindly amenable nature. These qualities, added to her excellence as a model and a complete absence of middle-class inhibitions, made her eminently attractive to Brown. Emma freed him, at last, from his obsession with Elisabeth. By the spring of 1849, Ford Brown was in love for the second time.

5
PRE-RAPHAELITISM
1847 – 1852

HOLMAN HUNT, 'THE ONLIE BEGETTER' of Pre-Raphaelitism, radiated a single-mindedness which impressed all his contemporaries. An accomplished oarsman, swimmer and boxer, Hunt surveyed the world through keen blue eyes, and his art from first to last followed an ethical imperative. Rossetti had approached this fellow Academy student in May 1848, full of admiration for his painting *The Eve of St Agnes* – the only Keats subject in that year's Summer Exhibition, and one showing great feeling for the then little-known poet. Colourful and sensuous in the tradition of Chaucer, Keats formed an instant bond between these enthusiasts of totally opposite temperament, and Rossetti recognised in this veteran of three London exhibitions a man to cultivate.

In 1847, Hunt had already been experimenting with naturalism when he borrowed the second volume of Ruskin's *Modern Painters*, with its famous injunction to artists to 'go to nature in all singleness of heart, selecting nothing, rejecting nothing'.[1] These words had acquired a scriptural force as Hunt sought ways to unlearn the Academy's methods and cultivate the innocent eye. At the time he met Hunt, Rossetti had just begun his pupillage with Brown at Clipstone Street, but, when Brown left for Paris in mid-July, Gabriel was in a mood for change. Moving into the sculptor John Hancock's studio nearby, frustrated by copying and bored by the technicalities of form and perspective, he was impatient to paint a picture of his own – *The Girlhood of Mary Virgin*, which he had designed with Brown's help.

His teacher returned to Clipstone Street on 16 August, just as Rossetti, seizing the chance to work alongside an experienced painter of his own age, and an equal, was moving into Hunt's new Cleveland Street studio. He had not told 'Bruno', but did not think he would mind. Two weeks later they came to Clipstone Street: 'Rossetti called with Hunt. A clever young man', Brown noted simply, but years later Hunt described what happened at this, for him, embarrassing meeting:

His deliberate manner of speech and the reserve of his demeanour at this first interview suggested to me that he was offended at the manner of my intrusion between him and his former pupil ... [and] I was too awkward and bashful to attempt to explain how unsought for ... was my position as teacher ... [but] Brown's cordiality soon made it clear that no unfriendliness was intended.[2]

Hunt's bashfulness did not prevent his forming a highly critical opinion of *The Seeds and Fruits of English Poetry* – especially the central panel on its vast easel in one corner of the studio; it stood twelve feet from floor to ceiling, while the wings, each six feet wide, were propped against the wall. As Brown, now working on the painted 'architecture', expounded the picture's theme, Hunt found himself disliking it. The formal, symmetrical framework threatened to swamp the figures, while its German 'academic ingenuity', pale colour and conscious archaism offended his new ideal of 'truth to Nature'. An awkward silence was filled by Rossetti, who 'began a sweeping tirade with what struck me as scant reverence, against the choice of poets in the side designs; growing quite warm, he declared that Shelley and Keats should have been whole-length full figures instead of Pope and Burns and the introduction of Kirk White's name, he said, was ridiculous'. Despite protests at such 'new-fangled' ideas, Gabriel pressed the argument until they left, claiming as they walked down Clipstone Street that 'Bruno would respect his opinion', so greatly affected had he been by a recent reading of Rossetti's 'My Sister's Sleep'. He knew his man.[3]

The three artists pursued their discussions in Hunt's studio on 18 October. Again Brown's brief diary entry is amplified by Hunt. Brown had not seen *The Girlhood of Mary Virgin* in painted form, and much remained to do, but even in its present state the picture recalled the thin painting and pale silvery colours of his own *Wycliffe*. The low wall pierced with Gothic tracery and the small angel on the left – a transposition of Brown's page-boy with his pile of books – were obvious 'quotations', while the atmosphere of domestic purity – a George-Herbert-like quietism – echoed *Our Lady*. He was surprised and delighted by Rossetti's rapid progress, despite the *Girlhood*'s oddities of scale and lack of depth.

Hunt's picture *Rienzi* was on his easel. Illustrating a dramatic moment from Bulwer-Lytton's novel of that name, the subject stirred Brown's republican sympathies, especially as it had a topical ring; Hunt had witnessed the abortive Chartist demonstration on Kennington Common earlier that year, being moved 'by the spirit of freedom of the passing revolutionary time'.[4] *Rienzi* provoked memories of his own *Abstract Spirit of Justice*, and was indeed conceived in the spirit of the Westminster decorations.

It was now Brown's turn to criticise Hunt. While commenting 'frankly and

kindly' on the design, he objected to the 'microscopic detail' of the foreground pebbles and plants, painted so diligently in a Lambeth garden. This important feature of early Pre-Raphaelite work, the botanico-geological approach influenced by Ruskin, never appealed to Brown with his much broader feeling for nature. And at the height of his own involvement with the Pre-Raphaelites he often expressed dislike of the pedantry of 'PRB-ism', a far cry from the naïveté of Giotto and Fra Angelico. Brown would speak of these masters 'earnestly and humorously' by turns; the younger men knew them only through engravings.

Hunt was suspicious. To his staunchly Protestant and nationalistic mind, 'early Christian' art smacked of Roman Catholicism. It was also unscientific, archaic and not to be imitated. He preferred eighteenth-century artists like Flaxman, Reynolds and Boucher. All three men were united, however, in their admiration for those robust champions of English art, William Hogarth and Benjamin Robert Haydon.

In September 1848, between these two meetings, the Pre-Raphaelite Brotherhood had been formed. There was never any question of Brown's joining these youngsters in 1848, and it never mattered to him. As he told his grandson, 'I don't know ... whether they ever asked me to become a P.R.B. ... but I never would have to do with societies ... besides, I was a good deal older than they were. Of course it was Rossetti who kept things going by his talking ... and really he talked them into founding it.'[5] This was true; from the beginning, the PRB was a Rossettian coterie: the first three recruits were his brother William (not an artist), the sculptor Thomas Woolner and James Collinson, who was engaged to Christina Rossetti. Hunt brought in his friend and former pupil Frederic George Stephens, while Millais wondered why he and Hunt needed to get involved with these people at all.

Millais intended to take the Royal Academy by storm. A natural conformist, he had joined forces with Hunt early in 1848 only after his Academy picture for that year had been rejected. Now, determined to outpaint all rivals, he had adopted Hunt's revolutionary experiments and (for a time) his mission to redeem English art. Rossetti, by contrast, more a poet and man of ideas than a painter, despised the institutional career path and, far from adopting Hunt's ideals, sought an extended Pre-Raphaelite Brotherhood of artists and writers. The link was Hunt. Brown did not meet the elegant Millais until the spring of 1849 and, despite generally cordial relations, was never as intimate with him as with the other two. He could hardly ignore Millais' formidable talent and precocious skills, but his attitude to the boy wonder was critical — admiration mixed with suspicion of his opportunism (which he tried but failed to emulate). Personally and professionally he rated Holman Hunt much more highly.

The collaboration of Hunt and Millais between 1848 and 1850 defined Pre-

Raphaelitism as a distinctive mode. Hunt's *The Eve of St Agnes*, exhibited in May 1848, though not a Pre-Raphaelite picture, generated a joint project to illustrate Keats' *Isabella*, or *The Pot of Basil* – out of which came Millais' *Lorenzo and Isabella* of 1849, bearing the secret monogram PRB. The first of many Millais pictures to feature tender sentiment and thwarted love, this picture makes nonsense of Hunt's later attack on Brown's 'medievalism'. The characters wear fourteenth-century costume and the stiff poses, taut linear drawing, flat composition with the figures in false perspective, and bright local colours without systematic light and shade were even more archaic than Brown's – indeed the reviewers, noting its 'early Italian qualities', saw the picture as a direct imitation of Italian fresco.

In 1850 a more confident, less imitative Pre-Raphaelitism appeared at the Academy, drawing the united wrath of the Establishment. Hunt's *A Converted British Family Sheltering a Christian Missionary from the Persecution of the Druids* is a better picture than *Rienzi* – less stagy, more unified in structure and lighting, and far better painted. Hunt had conceived his scene of a Christian missionary fleeing pagan Druids in naturalistic terms, imagining how this might actually have looked. Costume and weapons had been carefully researched, while the open-air setting had been painted on the Lea Marshes in sunlight. Despite this there remain echoes of the neo-classical frieze, while the flimsy thatched shelter overgrown by vines is borrowed (like Brown's earlier portrait of the Bromleys) from nineteenth-century German sources. The foreground reeds and water are meticulously observed. Much more upsetting to viewers was Millais' *Christ in the House of His Parents* which offended religious sensibilities by its eye-witness approach to the sacred figures. In its rarefied domestic atmosphere, naïveté and prefiguring symbolism of Christ's wounded hand the picture echoed Rossetti's *Girlhood* of the previous year; but this was a real carpenter's shop, with a real carpenter. Again the composition is frieze-like, set within a shallow stage partly open to a landscape background, but the sheep, unlike those in Hunt's *Hireling Shepherd* of 1851, were faked, being painted from two heads from the butcher.

Brown played no part in this pioneering work. It was not until 1851 that he first adopted, then radically extended, his colleagues' experiments. Meanwhile, under their influence, *The Seeds and Fruits of English Poetry* became *Chaucer at the Court of Edward III*.

After delivering *Cordelia at the Bedside of Lear* and *The Young Mother* to the 'Free' Exhibition in March 1849, he paid visits to Hunt's and Millais' studios, hoping for a last-minute sight of their Academy pictures. He was now actively interested in their progress: 'Went to see young Hunt and then to see Millais' picture Isabella, wonderfully painted, full of expression, sentiment and colour and extreme good painting but somewhat exaggerated in character and careless in drawing' was his

largely enthusiastic verdict.[6] He missed Hunt, but afterwards, wishing to show solidarity, sent *Windermere* to the Academy. It was rejected.

This was the panoramic view of Lake Windermere under a stormy sky he had painted beside Charles Lucy back in September 1848. The extant version was reworked in 1855 and, like all Brown's landscapes, is peaceful, spacious and liberating in effect. Only a lithograph made in 1854 remains to show the scene as Brown originally experienced it.

The emotional upsets blocking progress on *The Seeds and Fruits of English Poetry* for over a year had ended with Emma's arrival. She was a distraction of course, but now he would work on his big picture, with interruptions, over the next two years. Going back to beginnings he redrew some figures 'from Nature' and reworked the Rome sketch in April. May was a joyous romp. In June he advanced the central compartment and on 2 July he 'Set off to Thorp ridgway, found some fine scenery overlooking the Thames and Essex. Began a study of it for my background to Chaucer.' Brown meant not Thorpe, but Shorne Ridgeway near Gravesend on the Kentish side of the Thames. From here he looked across to Thorpe where, in 1846, he had painted his first study for this background, *Southend*. The Kentish countryside and distant Thames appear in *The Medway from Shorne Ridgeway*, but in *Chaucer* this summer scene is transformed into the poet's 'Aprille', the trees in leaf, ploughmen in the fields, the Bruegelian medieval landscape his pilgrims would have seen *en route* to Canterbury. This evokes the springtime of English poetry and culture, just as Brown had always conceived the picture.

Back in London, he 'waited in vain for E to come back from the country'. On 10 July 'did nothing in consequence of forgetting the time walking too long in the park ... after dinner Emma came back, went to the play'. The love-making resumed. Emma was probably living in Hendon or Highgate, for on 12 July Brown 'went to meet Emma in the fields by Highgate'. From now on she was constantly in the studio, modelling such female roles as the Fair Maid of Kent, and friends grew aware of the relationship. Soon Tom Seddon was painting her alongside Brown, while Hunt, too poor to afford a studio any longer, brought his new study of a cornfield and *Rienzi* to Clipstone Street for safe-keeping and here he retouched the *Rienzi* foreground after looking at the Shorne Ridgeway studies and the *Windermere*. From such beginnings, Hunt and Brown developed the Pre-Raphaelite landscape.

A lost drawing, *Beauty before She became Acquainted with the Beast*, was inspired by this rapturous reunion with Emma, a time Brown recalled long afterwards in a sonnet:

> *Sweet love of twenty years, still young and fair*
> *Impassioned mistress, friend and wife in one*

Child when you first were mine, nor yet scarce done . . .
Nor yet can I forget our April sun,
Of raptures beggaring comparison
The raptures we did wanton in and dare![7]

The raptures culminated in a week's holiday at Ramsgate in September and the decision to find a new studio with living quarters – Clipstone Street was too large, draughty and rat-infested. During the three months it took to find and negotiate terms for 17 Newman Street, *Chaucer* made way for a portrait of Tom Seddon's father, painted in exchange for a sofa made to Brown's design. Old Seddon took a strong fancy to Brown's gentle Muse.

Gabriel, meanwhile, was busy writing poetry and translating Dante's *Vita Nuova*. He was constantly with Hunt, and by August was organising the literary organ of the PRB. The magazine's prospectus was in preparation during September, when he and Hunt set off for a continental tour, to Paris, Bruges, Ghent and Brussels, where, armed with introductions and advice, they would see at first hand the places and pictures dear to Brown. Their reaction to French painting was generally hostile and chauvinistic, but Gabriel's enthusiasm for the 'miraculous works' of van Eyck and Memling in Bruges was unbounded.[8]

Rossetti moved into a studio at 72 Newman Street in November, just before Brown and Emma took possession of number 17. He had always wanted Brown in the Brotherhood; now he brought him into the enlarged circle gathering to compile the first number of *The Germ*.[9]

As Secretary of the PRB and designated editor, William Rossetti recorded the choice of this title at a meeting on 19 December, noting that 'at the end of a meeting in Gabriel's studio where, besides the whole PRB there were the Tupper brothers, Deverell, Hancock and Cave Thomas ... Brown came in with a sonnet he had composed.'[10] This appeared in January, among fine poems by Christina and Gabriel Rossetti, Coventry Patmore and Woolner. Incoherent, if deeply felt, it speaks of eternal art transcending mortal loves:

THE LOVE OF BEAUTY

John Boccaccio, love's own squire, deepsworn,
In service to all beauty, joy and rest,
When first the love-earned royal Mary press'd,
To her smooth cheek, his pale brows, passion-worn,
'Tis said he, by her grace nigh frenzied, torn

By longings unattainable, address'd
To his chief friend most strange misgivings, lest
Some madness in his brain had thence been born.
The artist-mind alone can feel his meaning:
Such as have watched the battle-rank'd array
Of sunset or the face of girlhood seen in
Line-blending twilight, with sick hope.
Oh! they may feed desire on some fond bosom leaning
But where shall such their thirst of Nature stay?

More important perhaps was Brown's article 'On the Mechanism of a Historical Picture', the first of three projected on the subject, in February. It is addressed 'to all who are about to paint their first picture', and he must have had Gabriel in mind, for the piece advises on technical procedures rather than choice of subjects. Taking the reader through the research and technical preparations for a picture, he goes on to discuss the choice and direction of models in terms of his own practice and, significantly for his future work, Hogarth's:

studying his own acting (in a looking glass) or else that of any friend ... of an artistic or poetic temperament but not employing for the purpose the ordinary paid models ... Here, let the artist spare neither time nor labour, but exert himself ... seeking to enter into the character of each actor, studying them one after the other limb for limb, hand for hand, finger for finger, noting each inflexion of joint or tension of sinew, searching for dramatic truth internally in himself and in all external nature, shunning affectation and exaggeration and striving after pathos and purity of feeling with patient endeavour and utter simplicity of heart.

Despite the different context, Brown unconsciously echoes Ruskin's 'go to nature in all singleness of heart'. One counsel of perfection was ironic, given his own propensities: 'never to leave a design while they imagine they could alter for the better the place of a single figure or group or the direction of a line'. Here, in a nutshell, was a philosophy of art which particularly appealed to Hunt.

In the April *Germ*, now renamed 'Art and Poetry', appeared Brown's idiosyncratic etching of *Cordelia Parting from her Sisters*, adapted from one of the 1843 *Lear* designs. Brown's first attempt at etching, the result is mechanical and laborious in comparison with the original drawing. Rossetti and Brown had worked together at their etchings, and both were dissatisfied with the proofs; Rossetti tore his up and scored the plate,

while 'Brown ... stipulated at first that his name should not be published but was finally persuaded to allow it ...' William wrote a poem, 'Cordelia', to accompany the etching.[11] He may have helped Brown with his 'Beauty' sonnet — certainly this cool, disciplined civil servant was by now almost as intimate a friend as his exuberant brother.

On 12 January 1850 'all the PRB was at Ford Brown's with several others to induct him properly into his new rooms in Newman Street.'[12] Brown's older friends, including Cave Thomas, Lucy and Anthony, were there too. From Rome, Lowes Dickinson, another friend from Tudor Lodge days, would write:

> Think of me when all your dear old faces are met together to canvas the exhibition, when the PRBs are all talking at once, when you and old Thomas are quietly laughing and smoking, and Lucy at the door, where he has been trying to get home for an hour ... we will imagine the *Chaucer* yet unfinished ... three mutton chops and 9 penn'orth of gin on the stove beside the delicious jar of birdseye ... and you, my dear boy — just as you used to be, that is all — I ask for nothing more.[13]

After supper, discussing contributions to *The Germ*, they divided along generation lines when the PRBs 'waged tremendous battle' with the Tudor Lodgers over Rubens' painting of horses till 4 a.m.[14] It was a subject of which the latter had had considerable experience. Perhaps mural painting was under discussion, for less than a month later Brown was in correspondence with Admiral Runcombe at the House of Commons over possible Government work — probably the restoration of John Rigaud's murals at Trinity House, the responsibility of the Admiralty.[15] (The Rigaud work later went to Holman Hunt and Stephens.)

Apart from three weeks in 1850 (2–25 March), Brown's diary lapsed on 4 November 1849 and was not resumed until 16 August 1854, when he provided a detailed resumé of his work over the past three and a half years. The perplexities associated with his relationship with Emma — pregnant by March 1850 — were no doubt responsible; and the search for Government work, at a time when professional sense dictated the early exhibition of *Chaucer*, suggests serious financial worries. The undertaking of two commissions for the Dickinson brothers, print-sellers of New Bond Street and now copublishers with Aylott and Jones of *The Germ*, bears this out. For them Brown painted a celebratory portrait of Shakespeare, designing an ornate invitation card for its private view — for sixty guineas. He also made a drawing, with ornamental border, of *The Lord Jesus* for Sunday school use, for two pounds. This was later lithographed 'in shameful stile so as to cause me much annoyance'.

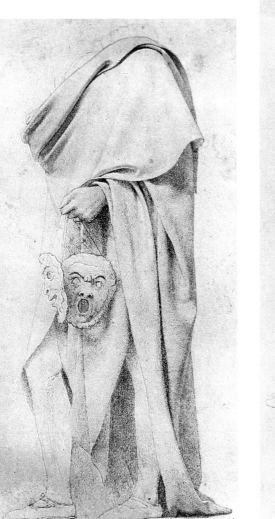

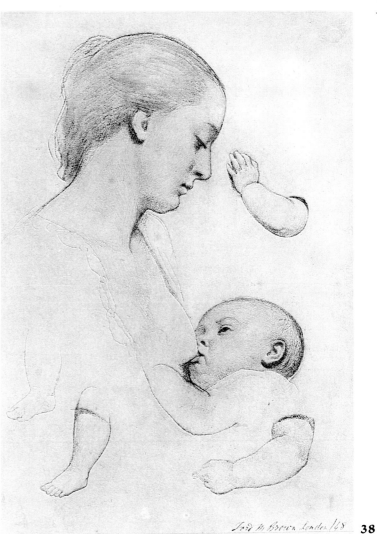

38

37 Study of Shakespeare for *Seeds and Fruits of English Poetry*, pencil, 1847.

38 Study of Mrs Ashley and child for *The Infant's Repast*, now *The Young Mother*, 1848.

39 *Protestantism*, design for roundel in frame of *Wycliffe*, 1848.

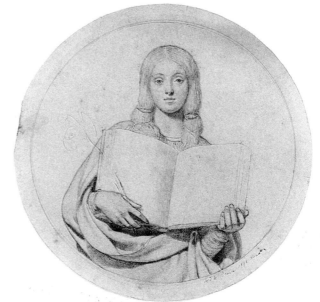

39

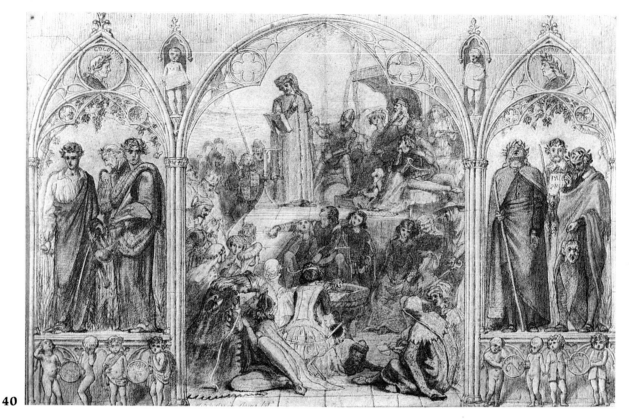

40

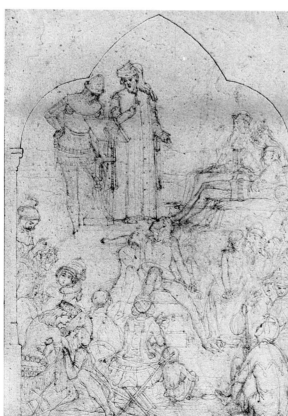

41

40 First surviving pencil design for
Seeds and Fruits of English Poetry, Rome,
1845.

41 Early design for central panel of
Seeds and Fruits of English Poetry, later
finished as *Chaucer*, Rome, 1845.

42 *Our Ladye of Saturday Night,* chalk and watercolour, 1847.

42

43 Sketch design for unpainted *Rest on the Flight to Egypt,* 1847.

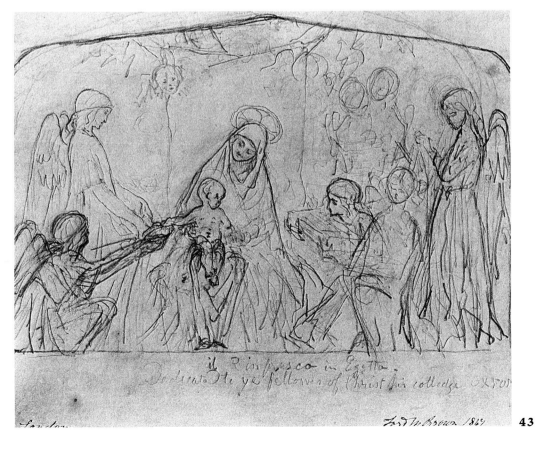

43

44

46

48

49

44 *Daniel Casey*, pencil, summer 1848. One of two studies by Brown.

45 *Self-Portrait* by Rossetti, pencil, dated March 1847, a year before the famous letter to Brown.

46 Brown, *Self-Portrait, aged 29*, pencil and chalk, September 1850. Retouched 1853.

47 Brown's first drawing of Emma (Hill), black chalk, dated Christmas 1848.

48, 49 & 50 Pen sketches of FMB (with peaked cap), Hunt and Millais ('Slosh!') by Rossetti, c. 1848–9.

50

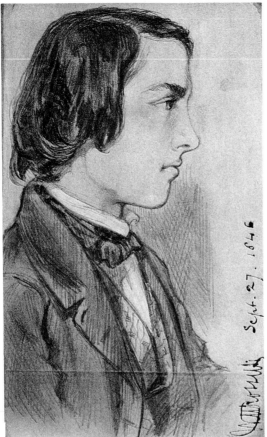

51

51 *William Michael Rossetti* by Dante Gabriel Rossetti, dated 27 September 1846.

52 *Thomas Seddon*, lithograph from photograph, 1858.

53 *Holman Hunt*, pencil portrait by Millais, 1853–4.

54 *Rienzi*, Holman Hunt's first Pre-Raphaelite painting. Exhibited RA, 1849.

55 Study of still life, with later additions, by Rossetti. Started in Brown's studio, Clipstone Street, 1848.

56 *The Girlhood of Mary, Virgin*. Rossetti's first finished painting, exhibited 'Free' exhibition, April 1849.

52

53

54

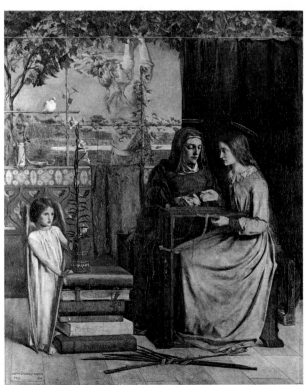

56

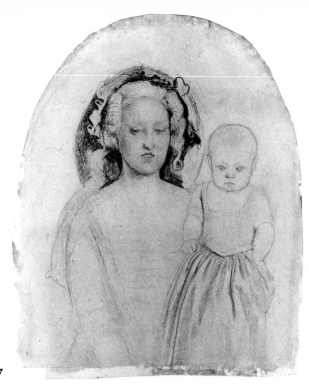

57

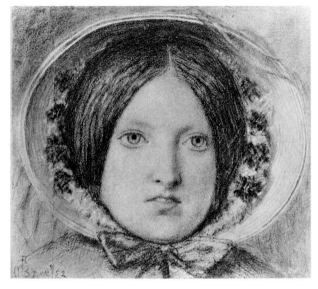

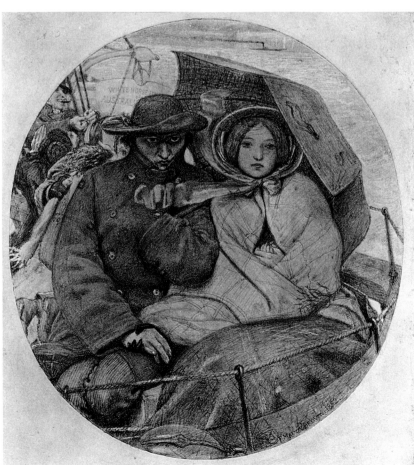

59

60

61

62

57 Study of Emma with Catherine, for *Pretty Baa Lambs*, Stockwell, 1851.

58 *Portrait of Emma*, chalk. Study for the wife in *The Emigrants*, finished as *The Last of England*.

59 First complete design for *The Emigrants*, later *The Last of England*, pencil, 1852.

60 Study of Carlyle and FD Maurice for *Work*, pencil.

61 Photograph of Carlyle posed for *Work*.

62 Study for the beer-drinking navvy in *Work*, pencil. No date.

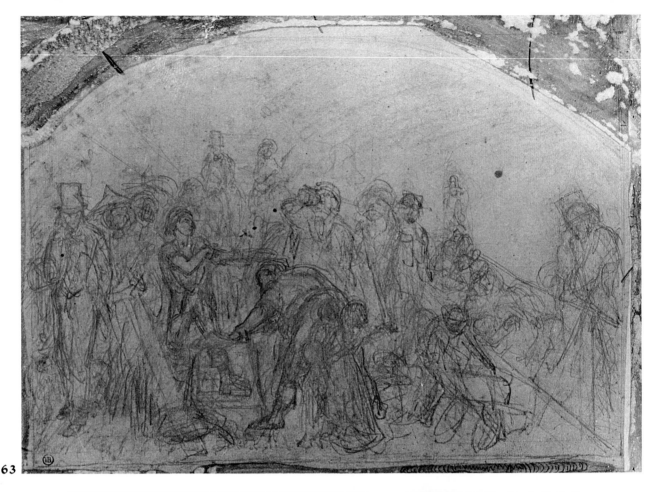

63

65

66

64

63 First pencil sketch for *Work*, Hampstead, no date.

64 Elaborated design for *Work*, with Fop at left and Artist at right, watercolour over pencil. No date.

65 *Beer Street.* One of a pair of engravings by Hogarth.

66 *William Hogarth*, wood-engraving from his self portrait. Illustration to 'The Father of English Art', *Penny Magazine*, 1834–5.

67 Page from Brown's diary, August 1854, recording his visit with Emma to St Albans.

67

68 *Elizabeth Siddal at Chatham Place*, pencil drawing by Rossetti, 1854.

69 *Found*, first design by Rossetti, pen and ink, 1853.

70 Study for *Stages of Cruelty*, pencil, from *Cathy Madox Brown*, 1857.

71 *Stages of Cruelty*, oils, 1890. The little girl is Cathy's daughter.

Apart from six-year-old Lucy, he had to support Emma. On 4 March, Brown attended the first committee meeting of Seddon's North London School of Drawing and Modelling, probably with a view to paid teaching, while on 23 March he went 'to the City about money'.

Rossetti demanded constant attention as he planned the background, bed and accessories for his second picture, *The Annunciation*; these, William noted on 22 February, included 'a curious lamp of Brown's'. The picture was to be the second of his 'triptych' on the life of the Virgin, an idea probably influenced by the tripartite *Seeds and Fruits of English Poetry*.

The year 1850 proved a watershed for the Pre-Raphaelites. Rossetti showed *The Annunciation*, like *The Girlhood of Mary Virgin*, at the Free Exhibition in April, unwilling to risk rejection by the Royal Academy. Hunt and Millais saw this unbrotherly action as a defection, and never really forgave him. All three artists came under heavy attack that year, with different results: while the criticism strengthened the resolve of Hunt and Millais, it distressed Rossetti so much that he gave up oil painting for the rest of the decade, never again showing a finished canvas in public. This episode illustrates his lack of confidence and, more specifically, a psychological dependence on Brown disguised over the years by their mutual affection and admiration. Neither, in fact, could be limited by a narrow professionalism, and herein lies the significance of Brown's placing Gabriel the poet at the apex of his *Chaucer*.

During the second half of 1850 and the early months of 1851, Brown worked feverishly at the great picture, now covered with scaffolding, for the Academy's Summer Exhibition, modifying it little by little to bring it more into line with the recent work of Hunt and Millais. Its progress can be charted through his diary, William's 'PRB Journal' and letters to friends:

... In 1851 I finished the centre compartment of the 'Fruits of English poetry' having determined to abandon the wings. To get this part finished for the academy I had to labour very hard & at the last worked three whole nights in one week only lying down with my cloathes on for a couple of hours. Emma sat for the Princess, which was done in two sittings of 2 hours each, Gabriel Rossetti sat for Chaucer beginning at 11 at night, he sitting up beside me on the scaffolding scetching while I worked. We finished about 4 in the morning & the head was never subsequently touched. His brother William was the troubadour, Elliot, a pupil of Charles Lucy's, the Cardinal, John Marshall of University Hospital was the Jester while Maitland then under Marshall's hands for an operation, sat for the Black prince. The boys were mostly portraits, the other heads Ideal chiefly.[16]

In *The Germ*, Brown had recommended the use of friends as models, rather than professionals. This was already PRB practice — Rossetti had used his mother and sister in *The Girlhood* in 1848, and Millais in the same year painted friends and family into *Lorenzo and Isabella*, for convenience. Brown's approach was different: that of the actor-manager. It began with *Cordelia at the Bedside of Lear* early in 1849 and the advent of Emma and Gabriel as intimates. *Cordelia*, his first dramatic picture since coming to England, recreates the critical scene where Cordelia and the court await the mad king's recovery. Entering into this situation, Brown's friends played roles under his direction, rather than posing as models. And if King Lear contained an element of self-identification, the Fool, at once mocking and supportive, was Gabriel's natural part. *Chaucer* was a different kind of picture. Given the number of figures, professional models were unavoidable — for example, Maitland played the Black Prince and Julia Wild played Catherine Roet, but Emma was the Fair Maid of Kent with Lucy at her knee, John Marshall was the jester and young Walter Deverell was Thomas of Woodstock.[17]

The gulf in taste and age between Brown's old friends and his new was vividly illustrated by the problem of the wings. On 25 October 1850, Brown gave a farewell party for Lowes Dickinson, about to leave for Rome.[18] The party was in full swing when Brown was again taken to task, this time by Woolner and William Rossetti, for not including great living poets. Under Pre-Raphaelite pressure, he abandoned the wings. At the end of the year, with time at a premium, he suddenly perceived the dramatic possibilities of the central panel alone, shorn of the great dead. At the last minute he introduced Emma as his real-life Princess and Gabriel as the supreme poet. Thus concentrated, the picture gained in dramatic force.

Holman Hunt and Rossetti had spent the autumn of 1850 in Sevenoaks, where Hunt painted the background to his largest and most dramatic scene to date. Brown saw the autumn landscape of Knole Park on Hunt's return in November, and his admiration for the meticulous technique and brilliant palette of *Valentine Rescuing Sylvia from Proteus* affected the colours of *Chaucer*, shown at the Academy in May 1851. Meanwhile a visit to Hunt's new studio in Prospect Place, Chelsea, just before the Academy opened, elicited this warm tribute:

> I can scarcely describe the emotions I felt on finding myself alone with your beautiful work (quite finished and you out — that was something of a triumph) but certainly your picture makes me feel ashamed that I have not done more in all the years I have worked. Your picture seems to me without fault and beautiful to its minutest detail and I do not think that there is a man in England that could do a finer work; it is fine all over.

Millais' pictures, *Mariana, The Woodman's Daughter* and *The Return of the Dove to the Ark*, were 'wonders in colour and truth, but I like yours better for my own use.'[19]

Brown was now ready to make common cause with the Pre-Raphaelites:

I have had serious thoughts of joining PRB on my pictures this year but in the first place I am rather old to play the fool, or at least to be thought to be doing so; in the next place I do not feel confident enough how the picture [*Chaucer*] will look and unless very much liked I would not do it; but the best reason against it is that we may be of more service to each other as we are than openly bound together.[20]

Meanwhile he urged the new practices on Lowes Dickinson:

paint a good deal from *external* nature making studies very careful[ly] of walls with the blue sky and the vines etc in sunlight, and with a determination to apply the whole force of your palette to it ... as to the pure white grounds you had better adopt them at once as I can assure you ... Hunt and Millais whose works already kill everything in the exhibition for brilliancy, will in a few years force everyone ... to use their methods.[21]

He was replying to Lowes' letter of congratulations after the success of Brown's *Chaucer* at the Academy:

Before this reaches you, I trust you will have begun to reap the harvest of your fame on the walls of the Academy. Robert [Dickinson, his brother] writes me that your work is really 'gorgeous and splendid; ... I can quite believe that the picture must sell, as he says, 'as a grand and successful flight of British art.' I cannot grasp your hand with the warmth of delighted friendship, but, believe me, I am happy and very proud of you, perhaps a little vain at having such a friend.[22]

But Brown was far from satisfied: 'The Accademitians hung *Chaucer* in such a way as to shine all over and without the frame.'[23] As the *Spectator* confirmed, *Chaucer*'s placing in the Middle Room left much to be desired, 'causing a kind of glare all over the surface'. Nevertheless, it was a critical success.[24] The *Illustrated London News* wrote:

For comprehensive grasp of mind, the leading picture of the middle room is on this occasion what it seldom is when it is the best also – the largest ... the spirit-stirring picture by Mr F. Madox Brown ... Mr Brown has revived the old poet and the court of King Edward with a spirit worthy of Sir Walter Scott. He has caught a chivalric and poetic feeling (they are always allied in the highest poetry) and has really represented a scene of great interest, much as it probably occurred ...

The *Athenaeum* and *Art Journal* were also complimentary, though the latter complained of 'a deficiency of shade depriving the composition of depth and the figures of substance'. All three sought, however, to detach Brown from the PRB, while noting his association with them: 'Mr Brown is understood to be one of the Pre-Raphaelite flock, who has strayed from his proper pasture,' wrote the *Illustrated London News*, 'but in this Chaucer picture there is no Pre-Raphaelite nonsense, while the advantages of having studied in a severer school, [as well as] having worked and felt and thought with the Pre-Raphaelites, are obvious at every turn. But Mr Brown has known when to quit a peculiar school; he sees its beauties and its defects and knows what to copy and what to reject.' This was as well, since there was an orchestrated press attack on 'the class of juvenile artists who style themselves PRB', whose 'faith seems to consist in an absolute contempt for perspective and the known laws of light and shade, an aversion to beauty in every shape, and a singular devotion to the minute accidents of their subjects, including ... every excess of sharpness and deformity.' Here *The Times* associated Brown 'in some degree' with Pre-Raphaelite attempts 'to reform the art on these principles'; only the partisan *Spectator* critic, William Rossetti, concentrated on the picture itself, praising the effects of broad sunlight and the 'brilliant and delicate colour'. He made it the pretext for a congratulatory review of Brown's career and prospects: 'This work cannot fail of establishing at once for Mr Brown a reputation of the first class; which indeed he might have secured before now had he contributed more regularly to our annual exhibitions.'

At this moment of success, with every prospect of a successful Establishment career, Brown turned his back on the academic and wholeheartedly embraced Pre-Raphaelitism. His next picture, *The Pretty Baa-Lambs*, was a textbook exercise in the genre. Meanwhile he sold *Chaucer* to Robert Dickinson 'for 85 per cent of whatever he might afterwards sell it for, to be paid after he should have received the money' – a characteristically unbusinesslike arrangement no doubt made to get the huge picture off his hands, and perhaps in the hope that the Dickinsons would have it engraved.[25]

In November 1850 Emma had given birth to a daughter, Catherine Emily, a lively pretty child with her mother's fairness and blue eyes. The birth does not seem

to have been registered, but, with *Chaucer* now off his hands, Brown urgently sought a home for his new family. In June, he took a year's lease on a cottage in rural Stockwell, on the edge of Clapham Common, where he planned a major landscape. Meanwhile, still keeping his liaison secret from all but Rossetti and a few close friends, he kept on the Newman Street studio. These arrangements finalised, he set off with his two favourite landscape painters, Mark Anthony and Holman Hunt, for a brief walking tour of the Isle of Wight: 'The first day we marched for five hours in the rain,' he recorded; 'the second and third revelled in enjoyment, liberty, novelty of scene, fine weather and huge appetite, the fourth we returned home.'[26]

Walking across the island from Ryde to Carisbrooke, taking in the rolling green countryside, flowery meadows with grazing cattle and frisking lambs, the friends talked enthusiastically about the use of landscape in figure compositions and especially of the unifying importance of sunlight. From this came the picture originally known as *Summer Heat*. It shows Emma in eighteenth-century costume feeding sheep, with a solemn baby Catty on her left arm. Behind her a servant girl picks flowers for her basket. Originally this was a suburban scene, with the Browns' back garden and lawn in the foreground and 'a few cottages, small and distinct, on the fringe of the grazing land of Clapham Common' behind,[27] as seen in the replica at the Ashmolean. The original was altered in 1852 to give a greater sense of space. The landscape, recognisably that of north Kent looking across the Thames from a point near Shorne Ridgeway, recedes into hazy distance which emphasises the brilliant definition of the foreground.

As Brown later explained, 'This picture was painted out in the sunlight; the only intention being to render that effect as well as my powers in a first attempt of this kind would allow.'[28] Hunt's *Valentine Rescuing Sylvia from Proteus* had rekindled an old enthusiasm, but Brown went further:

> The Baa Lamb picture was painted almost entirely in sunlight, which twice gave me a fever while painting. I used to take the lay figure out every morning and bring it in at night or if it rained. My painting room being on a level with the garden Emma sat for the lady and Kate for the child. The Lambs and sheep used to be brought every morning from Clappam Common in a truck. One of them eat up all the flowers one morning in the garden where they used to behave very ill. The background was painted on the Common.[29]

Brown's *The Pretty Baa-Lambs* was the first fully Pre-Raphaelite picture. Unlike Millais and Hunt, whose expeditions to the countryside produced landscape backgrounds for figures added later in the studio, his models were part of the scene,

painted under identical conditions of light and atmosphere from the same spot outside, or perhaps through the studio door which opened on to the lawn. This consistency over 'five months of hard labour' was made possible by the fact that garden, wife and baby were on the spot. In this domestic picture, despite the fancy dress, Emma is totally unglamorised; her fair complexion, flushed with the heat, contrasts with white shoulders, as does the forearm with her reddened hands – an uncompromising truthfulness characteristic of Brown's portraits of her. This *is* Pre-Raphaelitism, 'as if the brotherhood looked at the world without eyelids; for them a livelier emerald twinkled in the grass, a purer sapphire melted into the sea ... every floating prismatic ray, each drifting filament of vegetation was rendered in all its complexity with heraldic brilliance and distinctness.'[30] *The Pretty Baa-Lambs* is revolutionary in this way – the local colour of grass, the sandy path, the quilted gown, the fleeces of the sheep – while at the same time it captures the translucency of shadows whose violets complement the golden sunlight. The drawing of the figures and sheep is precise, but the vegetation is free from the 'botanical' gloss so conspicuous in, say, Hunt's *The Hireling Shepherd*. There is no narrative here, no moral, and, despite the eighteenth-century costume, no concession to tradition in the stark vertical pose of Emma against the sky.

In the course of its painting, later that summer of 1851, Millais and Hunt settled at Ewell in Surrey to paint luxuriant backgrounds for *Ophelia* and *The Hireling Shepherd*, making use of their secret wet-white technique. Brown was still unaware of the brilliancy this could produce; *Baa-Lambs* was painted on a ground 'of flake white' mixed with 'Roberson's undrying copal medium' – a traditional base.[31] He discovered their secret when, early in November, he and William Rossetti visited Worcester Park Farm at Ewell. According to Hunt:

> After showing our pictures to the visitors, Millais increased his intimacy with Brown by a warm conversation on music, illustrated by the humming and whistling of airs by both ... When Brown cordially complemented us upon the purity and brilliancy of our pictures in the Exhibition, Millais with impulsive forgetfulness ... burst out 'How do you think Hunt and I paint flesh and brilliant passages in our pictures?' ... Brown expressed unbounded astonishment and pressed to master exact particulars. When this was done in detail, he became enthusiastic and with bated breath enlarged on the mystery as nothing less than the secret of the old masters who thus secured the transparency and solidity ... which they had valued so much in fresco, the wet white half dry forming an equivalent to the moist intonaco grounds upon which the master had to do his painting of that day while the surface was still humid.[32]

Brown must have looked closely at the large canvas of *The Hireling Shepherd*, with its spaces for the still-unpainted figures. But Hunt's sheep and green grass, his distant landscape painted in an envelope of bright sunlight with translucent shadows, matched those of *Baa-Lambs*. For both artists the desire to capture a summer landscape as observed in Nature took precedence over any 'moralising' aim.

At Stockwell, Brown began a small portrait of Emma and Catty: *Waiting* — an intimate but unsentimental picture of a domestic evening at home. Family life had sharpened his vision, giving this picture an immediacy lacking in *The Young Mother*, shown that year at the British Institution. Gone was the fancy dress. Now Emma, wearing a simple gown with a lace collar, is seen sewing a bonnet for the sleeping Catty sprawled on her lap. Beside her stands a table-lamp, the table-cloth just skirting a wicker cradle. It is a modest middle-class Victorian interior, newly furnished with gilt mirror, polished steel fender and fire irons, Turkey rug and upholstered chair; the red glow of the fire and the yellow lamplight fell on the homely faces as he watched them from his armchair.

He was educating Emma now. Away for part of each week at Newman Street, he thought of her as she struggled to write letters about the baby's progress, and he encouraged her in his replies — 'Your last letter was a great improvement on the one before', runs one postscript. She was new to housekeeping, and the tradesmen's bills were all-too-often excessive for an artist now 'very hard up generally'. Sometimes she brought Catty up to Newman Street. One night Brown began a portrait of her 'with the head back laughing' — the picture which later became *Take Your Son, Sir*. She also posed for Rossetti as Delia in his *Return of Tibullus*.[33]

Hunt, meanwhile, had embarked on a night scene of his own at Ewell — *The Light of the World*. The subject illustrates the Book of Revelation: 'Behold, I stand at the door, and knock . . .' Sitting in an icy moonlit orchard, his feet wrapped in a sack of straw while Millais held a lantern, Hunt studied the effects of moon and candlelight for the figure of Christ knocking at the sinner's door. A diptych or triptych such as Rossetti had conceived for the Virgin's life seems to have been originally in his mind, together with a haloed Jesus clad in a simple white robe. But, back in London, Hunt elaborated a complex typological symbolism. In the crowned and nimbused, bejewelled and cloaked Christ exhibited in 1854, we see a modern icon, at odds to modern eyes with the hyper-realism of the ivy, brambles and hogweed in the orchard.

At Newman Street — now shared with Rossetti — Brown embarked on a very different religious subject: *Jesus Washing Peter's Feet*. It would occupy a special place in Brown's œuvre, anticipating as it does the moral message of *Work* — that of the dignity of service. He worked feverishly at this all winter. Twelve days before the Academy's sending-in day in April 1852 he had 'given it up in despair, none of the

heads being yet done', only to take it up again at Millais' urging: 'took up the Christ again at the instigation of Millais & painted the heads of Peter Christ and John (this one the only one laid in) also all the other figures of apostles in ten days and sent it in.'[34] In 1865 he wrote:

> St John tells us that Jesus, rising from supper, 'Laid aside his garments', perhaps to give more impressiveness to the lesson of humility 'and took a towel and girded himself ... and began to wash the disciples feet and to wipe them ...' Then Peter said 'Lord dost thou wash my feet' and again Peter said unto him 'thou shalt never wash my feet.' The purposely assumed humility of Jesus at this moment and the intense veneration implied in the words of Peter I have endeavoured to render ...[35]

Millais had recognised affinities with his own *Christ in the House of His Parents* in Brown's domestic presentation. But, the more one compares the two, the wider seems the conceptual gap between the self-conscious symbolism of the one and the human reality of the other. Brown entered fully into the roles of his protagonists — the naked Jesus kneeling, the reluctant, deeply embarrassed Peter submitting, effect-ively fill the canvas. The disciples (their feet already washed) are subordinate as they watch a divine drama in which their Lord becomes their servant. Apart from the halo, Brown uses no symbols, and the only accessories are a homely copper bowl, a pottery jug, a few bits of blue-and-white china, and Judas's moneybag on the table.

Brown drew partly on tradition: there are echoes of Leonardo's *Last Supper* and of Dürer in the youthfulness of John, the curly grey hair of Peter and red hair of Judas; perhaps also of Caravaggio. His symbolism grew out of the ordinariness of the scene, as it does in George Herbert's devotional poems. The realism was 'to be subordinate to the supernatural and Christianic — wherefore I have retained the nimbus. This, however, everyone ... must understand, appeals out from the picture to the beholder, not to the other characters in the picture.'[36] Among early studies for this picture is a pen-and-ink study ascribed to Brown but apparently in Holman Hunt's hand — evidence of how close the two artists were at this time.

The painting was a truly Pre-Raphaelite collaboration, for which many of the circle posed, though accurate identification is impossible. Besides F. G. Stephens, who posed for a drawing of Christ, the Rossetti brothers, 'Mad' Hunt and his father, Seddon, Bell Scott and Elizabeth Siddal are names which have at different times been attached to the apostles' faces.[37]

What had held Brown up was his struggle to master the wet-white technique — 'the flesh painted on *wet white* at Millais lying instigation'[38] — and he had not in fact

assimilated it fully when the picture was brought, late and still wet, to the Royal Academy.

After his success with *Chaucer*, the artist might reasonably have expected to find himself well hung on the line alongside Hunt and Millais. To his dismay, he found *Pretty Baa-Lambs* placed against the light in the dark octagon room, while *Jesus Washing Peter's Feet* was hung 'so as to shine all over', 'high above the line in a most unworthy place'.

Brown was bitterly upset. He had put all his commitment and skill into these first Pre-Raphaelite works and, into *Jesus Washing Peter's Feet*, his most serious moral convictions. Both sprang from his new life with Emma. At the private view he was standing near Hunt, 'pouting and frowning more than he knew', when Francis Grant, a future President of the Royal Academy, came up anxious to placate this potential recruit. He assured Brown that the picture had been 'greatly admired' and hung in its present position only because it had arrived wet, with the colours trickling down the canvas. This left the artist speechless. 'He glowered at the speaker till the last word,' Hunt recalled, 'then pivoted on his heel without uttering a remark' and left the building.[39]

6

HAMPSTEAD
1852 – 1853

IN JUNE 1852 BROWN TOOK LODGINGS in Hampstead, at 33 High Street, above a china-shop. His room overlooked the street, but from the rear of the house a panoramic view extended north-eastward over Hampstead Heath towards Kenwood and Highgate village, the view he would immortalise in *An English Autumn Afternoon.*

He needed money: he had sold no new works, and a promising job – that of assisting William Dyce on a fresco cycle of The Holy Trinity and Saints at William Butterfield's new church of All Saints, Margaret Street – had come to nothing through his own intransigence. Dyce's invitation of 25 May had come through Hunt, but Dyce could not meet Brown's demand to be sole assistant and employed over a long period.[1]

Still smarting from the *débâcle* at the Academy, Brown was determined to succeed on his own terms. Now, if ever, he must concentrate on painting. When the Stockwell lease expired, Emma took the baby to Dover for the summer and, exasperated by Rossetti's behaviour at Newman Street – 'keeping me up talking till 4 am, painting sometimes all night making the whole place miserable and filthy' – Brown abandoned the studio.[2]

Unable to resolve the situation or to support Emma financially, he fell prey to depression and, as after Elisabeth's death, sought relief in solitary work. That spring, the couple had stayed at Weedington Street, in Kentish Town. On 18 April, seventeen-month-old Cathy had been secretly christened at Old St Pancras Church, along with her cousin Emily Gandy and twenty-four other babies. Ford and Emma falsely gave her date of birth as 11 November 1851 (rather than 1850), while her name appears in the parish register as Catherine Emily Brown Hill, daughter of 'Ford and Matilda Hill'.[3] These subterfuges suggest that, although he loved Emma and had accepted moral responsibility for their child, Brown was neither willing nor able to marry her. Although it has proved impossible to establish her mother's whereabouts

in 1852, Mrs Hill died years later (1877) at St Paul's Terrace, King's Road, in the mean streets around St Pancras Station. Widowed, she blamed Brown for her daughter's situation and was already pressing him for money. But, with little more income than the hundred pounds a year from Ravensbourne Wharf, he could not respond. Emma must work to support herself and Cathy.[4]

In nearby Camden Town lived Emma's sister Eliza, also very poor. Described at the time of their marriage in 1846 as an 'architect', her husband John Gandy had become a 'french polisher' by 1852. The Gandy family lived in a succession of rented rooms in the area, ending up in Bayham Street, where Gandy paid rates for a short time. But he soon fell ill, dying in 1857 in the noxious Camden Town workhouse adjoining the burial ground.[5]

'At Hampstead,' Brown later recalled, 'I remained one year and nine months — most of the time intensely miserable very hard up and a little mad.'[6] He lived there in fact for under a year, but the unparalleled creative intensity of these solitary months generated his finest Pre-Raphaelite paintings: *Work, An English Autumn Afternoon, The Last of England* and *Cromwell on his Farm* — all autobiographical.

Brown probably meditated on Hampstead while at Kentish Town. Hampstead Heath, where Keats had written his 'Ode to a Nightingale' and whose splendid scenery had inspired Constable, was only a short walk away. He was looking for landscape subjects, and by early summer he had settled on a view looking up The Mount, a steep offshoot of picturesque Heath Street, where old red houses clustered among shady elms. By June he had chosen his lodgings. On his daily walks from the High Street, carrying his easel and painting gear, he passed the navvies digging up the street and, stopping to watch them, conceived the idea of *Work*.

The men were laying the first sewers, part of a programme of sanitary improvements following a series of cholera epidemics, and the extensive excavations, in evidence all summer, obstructed Hampstead's well-heeled residents as they walked the narrow streets.[7] The weather was hot, and the sight of the navvies' 'manly and picturesque costume and the rich glow of colour which exercise under a hot sun will impart' struck Brown as 'at least as worthy of the powers of an English painter as the fisherman of the Adriatic, the peasant of the Campagna or the Neapolitan lazzarone' — subjects popularised by artists like Eastlake at the Academy. Perhaps it evoked his own memories of Italy. But *Pretty Baa-Lambs* (originally known as *Summer Heat*) had been just such a study of figures under strong sunlight. He sketched the group, and got to know the men: the navvies' invasion of Hampstead strongly attracted a painter whose liaison with a bricklayer's daughter had given him a new sympathy with the working class.[8]

His apotheosis of the urban labourer was unprecedented. Courbet's *The Stone-*

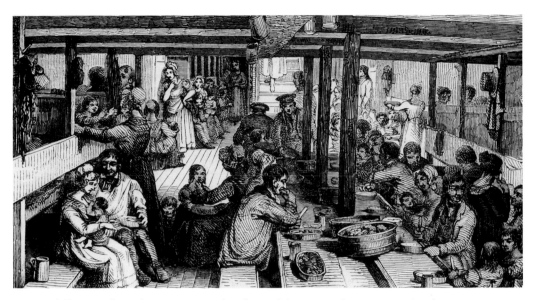

Dinner aboard an emigrant ship bound for Australia. ILN, 14 April 1844.

breakers of 1851 depicted rural workers, and was in any case unknown to Brown. Stubbs, Lambert and Millet had celebrated peasant farmworkers, but the navvies – construction workers whose canals, roads and railways had transformed the face of England for a century – had never been the subject of High Art.

The initial sketches made between June and August 1852 throw light both on Brown's personal situation and on the new chapter of Pre-Raphaelite history on which he was now embarked. Along with Hunt's procedures, Brown had assimilated an urge to tackle real-life issues in paint – documentary equivalents of Hogarth's 'modern moral subjects' which both artists were now eagerly studying. Hampstead marked the turning-point.

During the thirteen years he took to paint his *magnum opus, Work* became the very different picture discussed in chapter 10. Only three sketches survive to show Brown's original scheme: a small oil landscape of The Mount rising steeply up to the Georgian Mount Square, a first rough sketch of the figures only, without background, and a more detailed watercolour study combining both landscape and figures. Taken together with Brown's 1865 account of *Work*'s genesis, these present something of a puzzle. In what order were they made? Was the *action* of *Work* first observed on The Mount, where the artist located it, or further down Heath Street – or even in the High Street where he lived?

The small landscape scene, painted in the early morning, as we see from the

long shadows and absence of people, is a straightforward view with no indication of any works in the length of the street; the diggings had evidently not yet reached the spot. The butcher's boy was not added until 1856.[9]

Brown's rough sketch of the figures is without background, and the figures were clearly worked out in his studio. With the Heath Street study on his easel, what easier than to design the figures to exploit the spaces and stage the drama in his chosen setting, Pre-Raphaelite fashion? The navvies had inspired a wider contemporary theme of special significance to him: the fundamental importance of labour in society. The pencil sketch bears this out, contrasting as it does active workers with idle onlookers. The elements of the finished painting were in place from the start – the central group of navvies, to the left a top-hatted fop and two women with parasols, to the right some casual labourers, a couple on horseback at the apex and in the centre foreground a group of children. A bareheaded man leans against the railings watching, his top hat balanced on his walking-stick.

This group was integrated with the landscape background and the figures were individualised in the watercolour drawing, our only surviving record of *Work* as first envisaged. Simpler than the final version, it is broadly Hogarthian in the theme of industry and idleness, and in the choice of street types.[10] It differs from the final version in a crucial detail, however: where Carlyle and F. D. Maurice now stand, the artist originally included himself brooding on the scene. This gave *Work* the stamp of direct engagement: as if the workers' colourful life had the power to break through his gloom and isolation; as if he envied them their *comradeship*.

A hot June gave way to a cool July. His preparations complete, Brown began to paint his background direct from nature on to a canvas six and a half feet wide, planning to paint the figures later, in the studio. Soon he was installed at the bottom of The Mount in a mobile booth. Climbing into it he would set to work 'to the astonishment of all well-regulated people ... The Hampstead police I can affirm to be not altogether wanting in veneration: meanwhile ... "wonder" appeared developed in the little boys to the extent of wondering "if he stopped there all night," and "how he got his victuals".'[11] They took him for a travelling showman. According to Holman Hunt, who visited Brown in July, he had mounted his canvas on 'a rack on ... a costermongers barrow; above the canvas were rods with curtains suspended which could be turned on a hinge so that they shrouded the artist while painting'.[12] This ingenious device controlled the fall of light on the canvas and ensured a degree of privacy and protection.

Hunt was impressed by Brown's essay in contemporary life – the first by a Pre-Raphaelite. He admired Brown's background and Hogarthian idea so much that he planned a modern picture of his own, *The Awakening Conscience*, begun later that

year. His claim to have suggested the subject of *Work* to Brown can be dismissed.[13]

Brilliant October days succeeded the summer. *Work*'s background finished, Brown saw another subject crying out to be painted. Exhilarated by the golden light flooding the north-London countryside, he now embarked on the wide elliptical landscape known as *An English Autumn Afternoon*. He had borrowed his landlady's first-floor bedroom for its commanding view north-eastwards over the Heath. In the foreground he captured red-tiled roofs, a dovecot and a steep wooden stairway descending to a maze of kitchen gardens. In the distance, Kenwood House among the trees, the spire of St Anne's Church, Highgate, the roofs of Hornsey village, and the new brick tower of Caledonian Market.[14] His painting was, as Brown later explained, 'a literal transcript of the scenery round London as it looked from Hampstead' that October.[15]

Though quite a large picture, *An English Autumn Afternoon* is intimate and restful. Such a scene was a powerful antidote to nervous depression, renewing the earlier vision of *Southend*, where a sunny vista stretches to the far horizon, untrammelled by the Claudean picturesque. The landscape has the undifferentiated clarity of early Flemish art, with every feature precisely observed and recorded. Such landscapes can be traced back to Jan van Eyck, whose long vistas, high horizons and mediating figures on rising foregrounds *reconstructed* an observed scene for devotional ends. But Brown's approach here was empirical, and his description echoes the scientific interests of his friends Mark Anthony and Cave Thomas:

> The smoke is seen rising half way above the fantastic-shaped small distant cumuli which accompany particularly fine weather. The upper portion of the sky would be blue as seen reflected in the youth's hat; the grey mist of autumn only rising a certain height. The time is 3 pm when late in October the shadows already lie long, and the sun's rays (coming from behind us) are preternaturally glowing, as in rivalry of the foliage.[16]

Not all these atmospheric effects are visible now in the darkened oil. But Brown accurately described changes in colour brought about on even the brightest days by a humid atmosphere which, over a great city like London, was thickened by a veil of smoke. Only high up was the sky truly blue. At the same time, on such an autumn afternoon the sun intensifies the colour of the still-leafy trees, green gardens and red roofs.

He was working 'in a state of seclusion quite imperial, only to be equalled by that of a captain of a man of war', when he wrote on 17 October to Lowes Dickinson in Rome: 'I have not been doing much good for myself or anyone else that I can

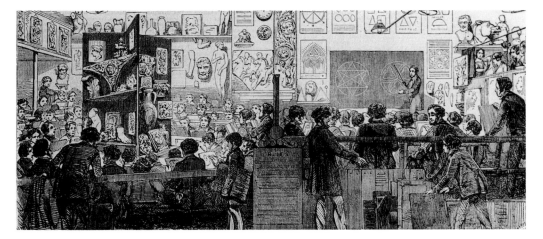

North London School of Drawing and Modelling. ILN, 19 July 1845.

make out since my last report ... I do not feel in the best of dispositions towards things human or inanimate, but, if anything, dull, and crabbed, and stupid.'[17]

Brown went on to summarise in ironic detail the professional progress of his circle. Of them all, only Millais, with commissions 'without end', and Hunt, with three, were prospering. His own situation was the worst, with no commissions and his three latest works unsold. 'I sent two pictures to the Academy with perfect unsuccess, unless of abuse,' he confided.

When Mrs Coates, the landlady, fell ill at the end of October, Brown had to give up the bedroom – an interruption he could ill afford, as he needed to exhibit the landscape next spring. Nor, painting as slowly as he did, could he finish the twenty-figure *Work* by April. Excluded from the market-place, he faced another year of isolated struggle.

Cave Thomas, the conscientious and popular headmaster of Seddon's North London School of Drawing and Modelling, had just resigned for health reasons 'in despair of ever getting his salary'. Brown agreed to take over, and the nominal salary of sixty pounds a year might have transformed his situation. But, 'I once received £5 from the secretary as a loan which I returned to him a short time after; this was all I ever saw of my salary.'[18] Thus evenings which should have been devoted to *Work* were taken up with teaching craftsmen to draw and with administration.

Seddon had started the North London School in 1850, to provide a technical education for artisans. It had been very successful in the first two years under Thomas, attracting good numbers of pupils and support from Prince Albert and the art community. He ran separate evening classes for men and women. But during Brown's

incumbency attendances fell off, fees were not paid, and, after a year's struggle, the harassed headmaster was unable to continue.[19]

The breakup of the PRB was already under way. Millais, whose *Ophelia* and *The Huguenot* had been acclaimed at the Summer Exhibition, was now on the road to professional success, with commissions, prizes and election as Associate of the Royal Academy assured. He would miss this by a whisker in November. Hunt, meanwhile, having sold *The Hireling Shepherd* from the Academy, and having won the patronage of Thomas Combe, Printer to Oxford University, and his High Church friends, was hard at work that autumn on another 'sheep' picture, *Our English Coasts*, at Fairlight, near Hastings. Despite his success, Hunt did not rate his chances of election as ARA highly and was, in any case, as Brown told Dickinson sadly, 'soon going to the East'. His departure was bleak news for the circle, for, as William Rossetti later recalled, he was the artist most admired by them all 'for his powers in art, his strenuous efforts, his vigorous personality, his gifts of mind and character, his warm and helpful friendship'. It came hard on Woolner's departure for Australia in June and Mark Anthony's move to Ireland.

Brown must have heard Hunt's news from Gabriel, who dropped into the Camden Town school from time to time with his sister Christina, who was a pupil there. Since Brown's departure from Newman Street, Rossetti had spent a good deal of time in north London, staying early that summer with friends in nearby Highgate. Now he was house-hunting in the area.

Gabriel was in love with Elizabeth ('Lizzie') Siddal, the Pre-Raphaelites' favourite model and by now his exclusive property. So far as Gabriel's family and friends were concerned, Lizzie was his pupil — only Brown, also concealing a liaison from the world, was fully aware of their relationship. From the previous winter, when both she and Emma had frequented the Newman Street studio, these secret attachments, with all their financial and emotional problems, had forged a new bond between the painters. Equally, they had forged a close bond between Emma and Lizzie.

Gabriel and Lizzie had spent idyllic days in Highgate that spring. Now, urgently, Gabriel sought escape from the family home in Arlington Street. In October he wrote enthusiastically to his mother about an 'affordable house' in Crouch End, just east of Highgate. But practical considerations brought a change of plan. He could not afford to marry Lizzie but he might live nearer to her, and in mid-November he found rooms overlooking the Thames at Chatham Place, Blackfriars, across the river from her Southwark home.

Both men suffered from depression that autumn. Moody, listless and unsettled, unable to finish his *Annunciation* for McCracken, Gabriel took refuge in poetry. He had also been painting watercolours inspired by Dante's *Divina Commedia*, featuring

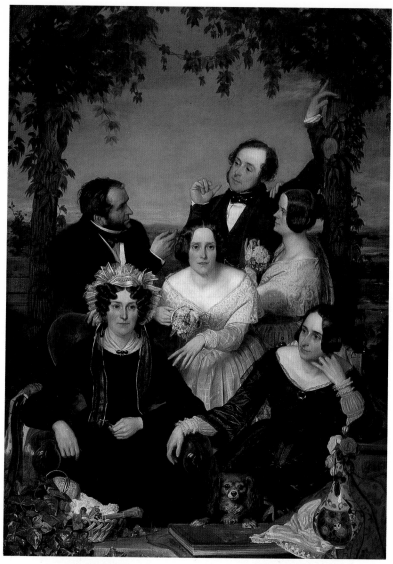

73

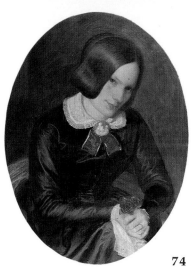

74

75

72 *The Bromley Family*, 1844. Mary Madox Bromley, her sons Richard and Augustus, Elisabeth, Clara and Helen.

73 *The Ascension*, 1844. Submitted for Bermondsey Competition.

74 & 75 *Elisabeth and Lucy Madox Brown*, Rome, 1845.

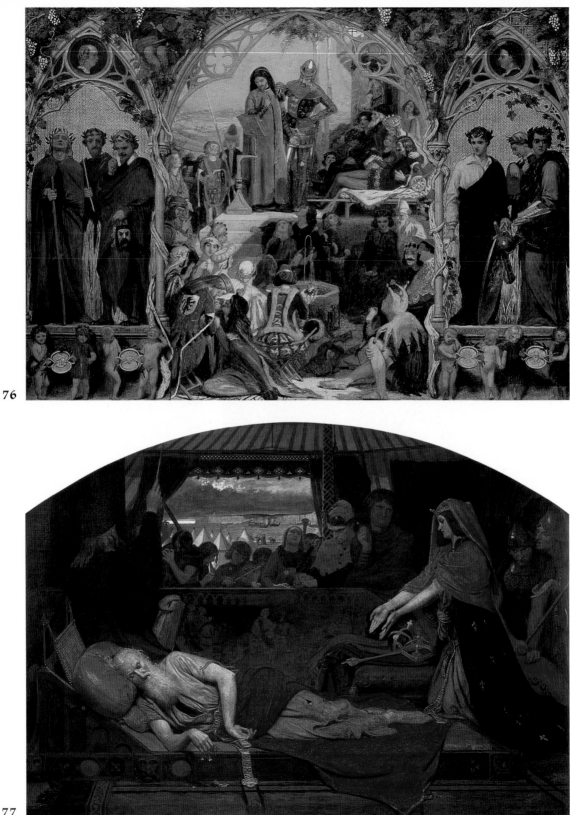

76

77

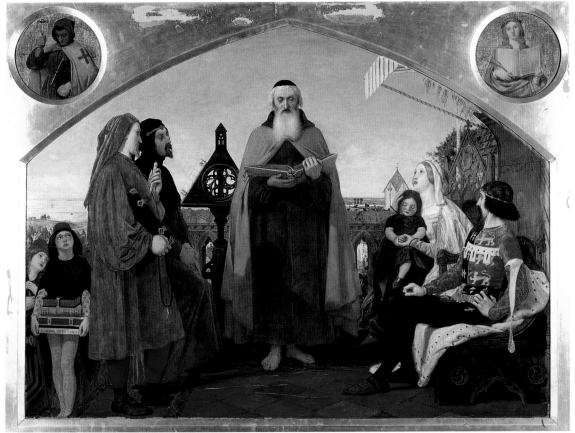

78

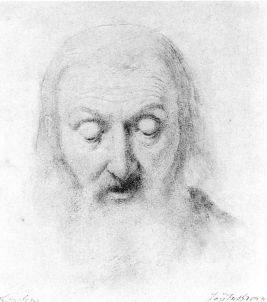

76 *Seeds and Fruits of English Poetry*, Rome, 1845–51. Coloured in 1853 after the wings had been abandoned in favour of the central panel, Chaucer.

77 *Cordelia at the Bedside of Lear*, 1848–59. Emma Hill as Cordelia.

78 *Wycliffe reading his Translation of the Bible to John of Gaunt*, Chaucer and Gower present, 1847–8.

79 Study for Head of Wycliffe.

79

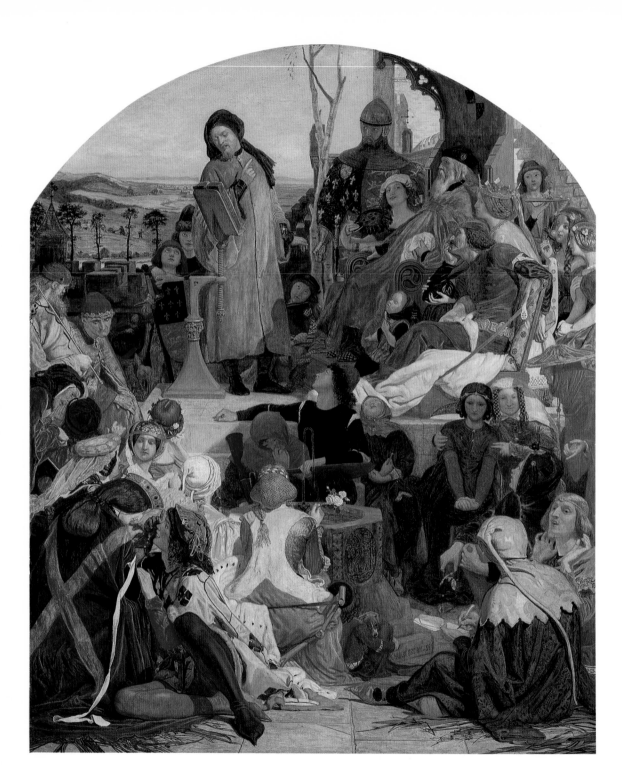

80 *Chaucer reading the Legend of Custance to Edward III and his Court* (replica, painted early 1860s).

Lizzie as Beatrice. Made increasingly uneasy by Millais' success, he too dreaded Hunt's departure, fearing professional isolation. He needed Brown more than ever, for despite his dominating personality, Rossetti was insecure, accepting as intimates only those on whose admiration he could rely. But Chatham Place was a long way from Hampstead and, during the winter of 1852–3, by turns pleading, cajoling and mocking, he urged his misanthropic friend to join the enlarged Pre-Raphaelite circle at Blackfriars:

[23 October] I am uncertain whether or not you engaged to come down here this evening, after refusing (in a brutal manner) my invitation to dinner ... Scott and my brother are going this evening to Millais who also requested particularly that we would bring you ...

[21 November, when about to move to Chatham Place] ... I shall positively go down tomorrow; if therefore you are inclined to do a charitable action let me earnestly solicit you to find your way thither ... this is of course supposing that you are not at work.

[29 November] Hunt, Millais, Stephens and Deverell will be here on Thursday ... I now write to get you, intending also to invite the Seddons, Collins and perhaps [James] Hannay ... I should be immensely glad to see you this evening if you can call in after the school. I am sure to be at home and can give you half my bed if you like ...

[8 January] I would advise you, if you wish to pursue your present solitary habits, to get off Edgar's part in King Lear, and when anyone addresses you answer 'Fee fi fo fum' or 'Pillicock sat on Pillicock's hill', which would perhaps be a quicker method still of cutting off human intercourse.[20]

What Rossetti's qualities of friendship – inspirational at this time – meant to Brown can only be imagined. Though exasperated by his faults and clear-sighted about his character, Brown's admiration for the younger man was unshakeable. In his relations with Brown, Gabriel was encouraging, sympathetic and intensely loyal. Add to this his charm, intelligence and sheer high spirits and one understands the fascination he exerted in these ascendant years. Later, when so much the more successful of the two, his help and constant pursuit of patrons on Brown's behalf was impressive.

Equally striking was Rossetti's dependence on Brown's human qualities, professional judgement and expertise. Could Brown come and see such and such a

picture, advise on colour or perspective, discuss exhibition strategy or how to handle patrons? This secretive man had no secrets from Brown, who from the first gave freely in return. In a profession notorious for rivalries, theirs was a remarkable friendship.

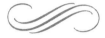

A courting couple appear in the foreground of *An English Autumn Afternoon*, looking out over the golden landscape. Despite Brown's explanation – 'they are hardly lovers, more boy and girl neighbours and friends' – the autobiographical nature of his art in 1852 suggests that Emma and himself are represented. She had returned from Dover and since September had been living at Hendon, an hour's country walk away, in the household of a young farmer, John Hardiman. Here she probably worked as a servant.[21] Visiting her in the summer evenings, Brown walked through this scene and came to know it intimately. Their new harmony is projected into it, underlined by their holding hands and the man's gesture towards the dovecot on the right. Doubts resolved, Ford proposed marriage at last. From now on their plight would be shared: here, for a moment, they found themselves in Eden.

But as the November days shortened and winter fogs descended, Brown's gloom intensified. What prospects were there in England for a penniless artist without patrons and out of favour at the Academy? Woolner, recently arrived at the Australian gold diggings and confident of making a fortune, had shown the way; Hunt, too, would soon be leaving. Now Brown thought of emigrating – perhaps to India – and he was soon designing a new picture to indulge this fantasy.

Despite its autobiographical significance, *The Last of England* was a potential winner, so topical and universal was the emigrant phenomenon at the time. On 19 June 1852 the *Illustrated London News* carried a popular song, 'The Emigrants', by Charles Bennett, the Betjeman of his day. To music by Thomas Arne with an illustration by John Gilbert, it reflects the impact of the great emigration wave before the Crimean War of 1853–5:

> *Farewell to thee England, oh land of our birth,*
> *The pride and the glory and queen of the earth.*
> *We sail with sad hearts to a land far away*
> *In search of the bread that may fail if we stay.*
>
> *New faces glow bright in the blaze of our fires.*
> *The stranger sits down in the halls of our sires.*

Farewell, oh farewell to thy beautiful shore
England, dear England, farewell evermore!

Brown was working on his designs in November when Rossetti visited him. Alarmed by talk of departure, Gabriel made a careful pencil portrait of his friend, a memento of their friendship in which the sitter appears dishevelled, tense and wary. There is no hint of humour, but rather a feeling of contained despair.

Emma moved closer, to Highgate North Hill. Here she seems to have attended a school for young ladies, to acquire basic domestic and social skills in preparation for marriage, along with the smattering of culture so necessary for a middle-class wife. But Brown could not spare her for long, so urgent was his need to realise her features alongside his own in *The Emigrants*.[22] He was now most certainly 'intensely miserable, very hard up and a little mad'. He saw himself, more than ever, as an unrecognised genius, with a mission to lead, and the hand thrust into the breast of the coat, the upturned hat brim above a pale face, consciously evoke the exile of St Helena. The face so scrupulously recorded in the mirror is brooding and apprehensive. By contrast, Emma's placid symmetrical features convey resignation and trust. He made a separate study of her in December, a faithful likeness of the girl whose affectionate presence could alone dispel his gloom.

In January Brown embarked on the painting of this picture with renewed determination, and, as he later recorded, Emma was the most unselfish of models. In 1851 she had posed for weeks in hot sunlight at Stockwell. Now she would sit for as many in the freezing cold: 'At the beginning of 53, I worked for about six weeks on *Last of England*, Emma coming to sit to me in the most inhuman weather from Highgate. This work representing an outdoor scene without sunlight, I painted at it chiefly out of doors when the snow was lieing on the ground. The madder ribbons of the bonnet took me four weeks to paint ...' In his anxiety to project his interior desolation into the canvas, he again ignored the Summer Exhibition deadline: 'at length, finding that at this rate I could not get it done ... I gave it up in much disgust ...' and turned back to retouching old works for quick sale.[23]

'About this time,' he wrote, 'I lost many days through interruptions of a domestic nature.' Brown referred to their marriage at St Dunstan in the West, Fleet Street, on 5 April 1853. This took place in the atmosphere of secrecy which had shrouded their whole relationship; only two close friends, Tom Seddon and Gabriel Rossetti, were present, as witnesses.[24] Brown had probably used Gabriel's Chatham Place address to establish residence, and there, perhaps, Gabriel and Lizzie did the honours. Ford made a chalk portrait of his bride in her wedding-veil that day; shortly afterwards,

in May, Gabriel presented the couple with his own etched likeness of Emma by candlelight – neither portrait making any concession to glamour.

The couple started married life in a Highgate cottage – possibly Woodside Cottage on Highgate North Hill – but soon moved back into the country, Brown retaining his painting room at Hampstead.

A letter to Holman Hunt from Hampstead must date from August 1853. Unaware, like most people, of Brown's marriage, Hunt had proposed a joint sketching expedition, but by now Brown was hard at work retouching *Cordelia at the Bedside of Lear* and *Waiting* for the Royal Manchester Institution and *Pretty Baa-Lambs* for the Glasgow Royal Institute of Fine Arts in September. *Waiting* had been returned unsold from the Royal Academy. 'I shall expect you,' Brown wrote:

> if you can be here rather early we can have tea and then walk over to Hendon where you will have a bed. But as to the proposed excursion alas! Man proposes but Heaven disposes ... in a summary way. For several weighty reasons I find it impossible at present. I am toiling in the greatest hurry to prepare some pictures for the Country exhibition and I have got to look out for a house at the same time and am at my wits end for that commodity time.

A postscript enjoined Hunt to secrecy:

> I am at Hendon chiefly now *entre-nous* but will be here on Monday evening by six expecting you. There is a bus from here to Hendon at 1/4 past eight, so if you can do not be later than that as we had better ride by it ... as it is an hour's walk.[25]

Hunt had had a successful year: at the Academy *Claudio and Isabella*, *Our English Coasts* and *New College Cloisters* (a portrait of an Oxford cleric commissioned through his patron Thomas Combe) had been well received. Despite his resolve to go to the Holy Land, Hunt was still in England. Now he wanted to discuss his new picture with Brown. *The Awakening Conscience* was a topical 'morality', projecting an emotional dilemma of his own. Hunt too was deeply involved with a woman: the wayward beauty Annie Miller.[26]

Brown and Hunt would never be closer than now. Millais was away in Scotland with his new patron, John Ruskin, painting Ruskin's portrait at Glenfinlas and falling in love with Ruskin's wife, Effie. But Hunt was drawn to Brown for reasons other than loneliness: a common vision of art, a parallel experience of love and its problems

and, most important, Hunt's resolve to lead a new school of English painting outside the Royal Academy.

Hunt was detaching himself from Millais. In November 1852, back in London from Hastings, he had organised a meeting in Chelsea to discuss alternative Pre-Raphaelite exhibitions. He knew that Brown would be sympathetic, and Hunt saw his support as crucial. Treading carefully to avoid offending his touchy friend, Hunt had sought to recruit him into a new exhibiting group which would include, besides the original PRB, Deverell and Brown's pupil Tom Seddon:[27]

> ... as I may not be able to get to Hampstead for a day or two ... I write to endeavour to influence you while you are still undecided... It is true that I wish the talk to be on a particular subject, but not if you and the others think it unnecessary. My notion is that, long before you, Gabriel, and I are elected associates of the highly honoured and esteemed Royal Academy, it will be necessary for us to consider whether we prefer having our pictures hung out of sight in that institution or taking measures for their better exhibition elsewhere. If you think with me, then it seems to be desirable that the expediency of exhibiting together or apart be decided before I leave England, as my directions to Mr. Combe ... must be regulated by the intentions of yourself, Gabriel, and Millais.[28]

Neither Brown nor Rossetti had attended the meeting, and nothing came of Hunt's initiative. Now, however, there was much to discuss. So far as English art-politics were concerned, Hogarth — who had led the democratic opposition to the founding of a Royal Academy in the 1760s — was an inspiration to both men. So were his pictures. Just as *Work* owed much to Hogarth's pictures of street scenes, so Hunt's new picture, an interior in which we see a kept woman struck with remorse, was based on two Hogarths — *The Lady's Last Stake* (which it elaborately inverts) and the first scene of *Marriage à la Mode*. But while Hogarth was the detached commentator, both Brown and Hunt had dramatised their own interior states while presenting them as social 'issues'. Like Hogarth, they saw themselves as dramatists in paint, not illustrators of texts.

Brown would have shown Hunt a sonnet he had written in praise of Hogarth, the first of three.[29] That July he had made a pilgrimage to Hogarth's house at Chiswick and his tomb, whose dilapidation had recently provoked a correspondence in the *Illustrated London News* and *Art Journal*.[30] Brown identified the neglected tomb with his own continuing lack of recognition; Hogarth's life and death seemed eloquent of England's indifference to art. Walking about the little house and garden, an empty

shell devoid of paintings, he pictured Hogarth at work in his 'small quaint painting room' and, humbled by its simplicity, renewed his own resolve – the sestet of 'Hogarth's House' reads:

> But I, while there, felt broken-like at heart
> With finding how for me t'was all too mean
> Yet having left, I thought I should have been
> More moved, also (from seeing such an end
> Reached through such means) how high our aim should tend
> Who own such pomp and circumstance of art.

Brown thought of Hogarth's father-in-law, James Thornhill, painter to the king, whose career had been crowned with a knighthood and a seat in Parliament. Thornhill's commissions had included the dome of St Paul's and the painted hall at Greenwich, the sort of spaces Brown still aspired to paint – a far cry from Hogarth's lively, satirical, cabinet pictures. 'Hogarth's Grave' expressed outrage at the state of the tomb:

> Here is his Grave – lo all ye amateurs
> Come see the mound which England o'er the dust
> Of her first borne to Art hath nigh upthrust.
> (Sir James Thornhill in half) an insecure
> Small urn atop, with Garrick's rhymes, quite pure
> Of any sence, it stands in mouldering crust . . .

As Rossetti tactfully pointed out, this presents 'a few obscurities' – as does the third sonnet, 'Hogarth's Spirit':

> The Lordly bag-wigg's stage Mycoenas, rhymed
> The epitaph, and begs us 'drop one Tear
> As we prize genius or hold nature dear;'
> If I prize genius! Me whose zeal ill-timed
> Her laurel twigs, alas! were chiefly limed
> To snare (where Torn I flutter) no drops blear
> My sight. May we not yet hear
> (Though broke the bell) its magic peal still chimed
> Grasping the rails, bare-headed, I knelt low,

And whilst his conjur'd spirit mine oppressed
Like that poor witless soul's dumb prayer, which well
The good French prelate liked, I said Oh! Oh!
And mentally afar off, smote my breast,
Crying Oh! Oh! I also would excell!

The idea of genius and a brooding sense of destiny stamp Brown's last Hampstead design, *Cromwell on his Farm*, begun that autumn. The hero, on horseback, is withdrawn from the world, sunk in profound meditation. Like the emigrant's face in *The Last of England*, Cromwell's face is recognisably Brown's own, but, whereas Napoleon goes into exile, Cromwell will soon emerge as England's great revolutionary leader.

In his depression, Brown had been reading Carlyle's *Letters and Speeches of Oliver Cromwell* (1846). When Charles I dismissed Parliament in 1629, Cromwell had returned to his estates to live the life of 'a solid, substantial, inoffensive farmer'. Brown was fascinated by Cromwell's inner world of 'hypochondria, fits of the blackness of darkness with glances of the brightness of very Heaven, prayer, religious reading and meditation ... wider destinies than he anticipated were appointed him.' Reading Cromwell's letter number 2 of 1648, in which, two years before he led the Parliamentarians to victory, he described the long wait for God's call, Brown identified with his hero.

Cromwell had featured as a major figure in paintings by Delaroche and Charles Lucy, and Brown would paint him again as 'Protector of the Vaudois'. But that this first drawing, reflecting his own mental state, had special significance for him was borne out when, three years later, his first son was christened Oliver.

In his hopeless state, his hero's isolated introspection was his own. Again the artist would later put a universal gloss on an intensely personal document: 'At this date [1636] the electrical unease of nerves which is felt by nations prior to the bursting of the psychological storm seems to have produced in him [Cromwell] a state of exalted religious fervour mingled with hypochondria ... the farmer is intended to foreshadow the King, and everything is significant or emblematic.' Cromwell rides abstractedly round the farm: his horse stops before a bonfire and crops the grass; his master gazes into the emblematic flames. An oak sapling which serves as a riding switch symbolises kingship. A stray lamb crosses his path. The servant calling him to dinner is unheard. He has been reading the Bible and meditates on Psalm 89: 'Lord, how long wilt thou hide thyself – for ever? And shall thy wrath burn like fire?'

7
FINCHLEY
1853–1855

FIVE MONTHS AFTER THEIR MARRIAGE, Ford and Emma went to live in Hendon, the Middlesex village where she had worked for the Hardimans, whose land stretched north-eastwards to Church End, Finchley. It was here, in August 1853, that the couple found 1 Grove Villas, in a brand-new terrace fronting Ballards Lane. The house was ideally placed for a landscape painter, with open views and a wealth of paintable subjects within easy walking distance; also, with a rent of only twenty pounds a year, life would be cheaper than in London. On 1 September they moved in, Brown retaining his Hampstead studio for a further year.

Like most of its neighbours, 1 Grove Villas has disappeared, but two surviving 'villas' – unpretentious 'two up, two downs' of light-coloured brick, with contrasting red-brick dressings and slate roofs – suggest its appearance. Number 1 also boasted some sculptured ornament over the parlour window – 'three hideous grinning heads',[1] which Brown later demolished. Downstairs were the parlour, with the family piano, and a kitchen; upstairs were two bedrooms, in one of which they installed a modern convenience – a shower-bath, mentioned proudly in the diary. Emma and Ford created a pretty cottage garden in front of the house; behind was the yard where he painted *The Last of England* and a long strip of garden leading to fields and the village pond. Beyond, across Hendon Lane, stood St Mary's parish church, which the family attended most Sundays.

As the foliage turned, Brown took up his half-finished *An English Autumn Afternoon*, painting from Mrs Coates' back window in Hampstead until the colours vanished. Now, with a painting room full of unsold works, he had to face the reality of his situation: he was supporting five people including Emma's mother, and his expenses had increased with the new house. Once again, rural peace would prove damaging professionally, making him inaccessible to friends, potential buyers and dealers at a time when studio visits accounted for many direct sales. Close friends like Hunt and Rossetti repeatedly urged a return to town, but Brown let thirteen

years elapse before taking their advice. Fiercely proud, suspecting professional enemies on all sides he was still anxious to keep his marriage secret; even well-wishers feared to intrude on his privacy.

Ironically, just as Millais and Hunt, powerfully served by the advocacy of John Ruskin, were poised for a breakthrough at the Royal Academy, Brown stopped exhibiting with them; the small *Waiting*, shown that spring, was his last work to appear there. Instead he looked to the provinces and to Scotland, exhibiting unsuccessfully in Glasgow and Edinburgh that autumn. He also sent work to Antwerp and Ghent.

For an artist as thin-skinned as Brown, lack of recognition was worse than poverty. Increasingly anxious, he yielded to self-doubt and self-disgust. For almost a year he produced nothing new and his creative energy deserted him. As winter approached, fearing some kind of breakdown, he consulted his old friend Dr John Marshall.[2]

Later he noted time wasted in 'nervous dissorders of the brain'. Marshall prescribed a break from domestic responsibilities, a spell in Hampstead, visits to the theatre and other relaxations. Brown took this advice, writing from his Hampstead studio to Emma: 'I received your dear affectionate letter last night on coming home it is very sweet to have such loving words from such a sweet young wife as you; it is the only enjoyment I have left to me so pray do not be sparing of it.' After sympathising with Emma's own problems – Cathy's attack of measles and her mother's request for cash – he urged her to 'be of good cheer and make yourself happy ... I feel certainly in better tone and spirits and hope shortly to be again a help to you in all your troubles sweet love, but at present I think I had better carry out Marshall's advice to the letter ...'[3]

He amused Emma with accounts of plays and farces he had seen. As ever, he drew strength from her: 'Pray, dearest, write and let me know how Kate is, and be as loving as your last letter,' and he ends with a renewed declaration of love – 'I am yours entirely dearest Emma.' By Christmas he was back with her and Cathy at Church End.

By May 1854 Emma was pregnant again, and Brown devised an emergency plan to retrieve their fortunes. Throughout the first half of 1854 he scraped, repainted and finally framed to his own designs all his most saleable works for auction that July. In the prevailing market this was folly: Pre-Raphaelite prices remained depressed, collectors few. In June, McCracken had put most of his own collection (including important works by Millais, Hunt and Rossetti) up for sale at Christie's: few works reached their reserves. Brown's *Wycliffe* was acquired privately by the dealer D. T. White.[4]

Brown's sale was a disaster. *Cordelia at the Bedside of Lear*, warmly praised in 1849 and the product of eight months' work, was knocked down to the architect John Seddon for fifteen pounds. Seddon also got *An English Autumn Afternoon*, for nine guineas. Brown glossed over this humiliating experience in his diary, but five years later the memory surfaced in a letter to his friend and protégé William Davis, warning him strongly against this method of sale.[5]

The dealer White now came to occupy a position of growing importance in Brown's life: known as 'Old White', he had premises at 28 Maddox Street in the West End, and was one of the first London dealers to invest in Pre-Raphaelite pictures – selling on to a small but growing body of collectors. One of his first clients was Benjamin 'Godfrey's Cordial' Windus – a retired coachmaker whose fortune derived from a popular patent medicine. At Tottenham Green, Windus had a fine collection of Turners to which he was now adding Pre-Raphaelite paintings.

Brown's isolation made him far too dependent on Old White, whom he regarded with wary cynicism – with good reason, for the smiling dealer took advantage of his situation. Sentiment played no part in White's dealings with artists, his policy being to buy and sell cheap, and his visit to Grove Villas in August 1854 was well-timed; desperate for money, Brown let him have four works for a fraction of their value.

White's appearances and non-appearances, alternately raising and dashing the painter's hopes, run through Brown's diary, which, after a break of four and a half years, resumed on 16 August 1854: 'I have become lazy through discouragement, yet not so much as some people think – but broken in spirit and but a melancholy copy of what I once was. Ah what to me shall be the End!'

In that month, Ford and Emma took a jaunt to St Albans, riding 'on the top of the bus in the most lovely weather. Emma in a state of buoyant enjoyment. We should have thought more of the fields no doubt were we not so much used to them of late, but one field of turnips against the afternoon sky did surprise us into exclamation with its wonderful emerald tints.' At their lodgings in St Albans High Street, Ford sat up writing his diary after Emma had gone to bed (as was his practice). The mood of elation had subsided and he complained angrily about the expense of it all: 'we have spent 6 shillings getting here which is sheer madness ... besides one bob wasted on a description of the Abbey, certainly the sillyest little book that fool ever penned ...' Next morning he bullied the chambermaid for failing to wake them and kicked up a row because the Abbey doors were late in opening; for this Brown promised the poor verger 'a most venomus letter to *The Times*'. Serenity returned as the ancient stones – 'these workings up and scrapings down of so many centuries' – worked their magic on him, especially the mortal remains of Good Duke Humphrey

'... too good for this country 400 years ago ...' Back home again he was 'Lazy, sad, nervous ... hopes gone, unspeakably flown, onions for supper.'

He brooded on the gulf between human ambition and failure. Hogarth's light had been eclipsed by a rising tide of 'foreign' academicism, and Benjamin Robert Haydon, aspiring to make English history paintings in the grand style, had ignominiously failed. Brown had been reading 'poor Haydon's recently published *Autobiography*'.[6] The artist who had admired his fresco had been driven to suicide by the neglect of the art Establishment. Meditating on this, Brown's fellow-feeling with Haydon grew. Surely suicide was preferable to a degraded life?

As August drew to a close with no improvement in their finances, a 'serious and too long-deferred visit to Old White' brought a promise to buy *Our Lady of Saturday Night* for twenty pounds. 'This will save our bacon for a little time longer, I do begin to think that the run of ill luck is out.'

The prospect stimulated new activity. Brown was on the look-out for suitable landscape subjects, and one in particular caught his eye. On 1 September he set out over the fields to Dollis Brook, a wooded stretch of the river Brent flowing through Holders Hill towards Hendon: 'Out by 1/4 to 8 to examine the River Brent at Hendon, a mere brooklet running in most dainty sinuosity under overshadowing oaks and all manner of leafgrass. Many beauties and hard to chuse amongst for I had determined to make a little picture of it.'

Work began at once on *The Brent at Hendon*. Setting up his easel on a small bridge, he painted Emma seated by the stream, but it is hard to make her out in this half-lit glade. *The Brent* is unique among Brown's landscapes, which are otherwise open sunny vistas, and perhaps expresses the dark state of mind from which he was struggling to escape. Minute imitation in the Ruskinian sense, he had discovered, was not enough. To remain true to the experience rather than the detail of Nature called for imaginative selection – that 'something to make the bosom tingle' he would miss in Seddon's 'cruelly PRB'd' pictures. But there were real difficulties in the way 'of work I have not been bred to ... nature that at first sight appears so lovely ... is almost always incomplete; moreover there is no painting intertangled foliage without losing half its beauties. If imitated exactly it can only be done as seen from one eye and quite flat and confused therefore.' Over the following weeks, he struggled with problems which would obsess an artist like Cézanne for a lifetime.

Life at Church End assumed a pattern around his work. He rose early, took a shower-bath and after breakfast went off to the Brent, returning home for dinner at one. Sometimes, when he started late, Emma and Cathy would bring dinner to him over the fields, as on 12 September: 'Emma and the child brought me my dinner there at 2 – in a little basket. Hot Hashed mutton & potatoes in a basin, cold rice

pudding & a little bottle of rum & water, beer being bad for cholera. Very delightful & very great appetite.' At other times Emma sat with him, modelling for the demure 'little ladye' who sits reading by the brook.

Meanwhile, in the afternoons, a second small masterpiece was taking shape. 'About 3 out to laying in the outline of a small landscape, found it of surpassing lovelyness, Corn shocks in long perspective, farm, hayricks and steeple seen between them, foreground of turnips, blue sky and afternoon sun.' Brown's *Carrying Corn* may have been painted at nearby Grass Farm, from a position looking south-east towards St Mary's Church, although no steeple is in fact visible. It is harvest time, and farm-workers — perhaps two of the many Irish casual labourers employed in the Hendon district — are shown at work loading sheaves on to a cart in the mid-afternoon sun, while a female worker stoops in shadow among the foreground turnips. Here the painter had to contend with another problem, for the harvesting proceeded apace: 'By the time I had drawn in the outline they had carted half my wheat,' and a day later it had all gone.

Both *The Brent at Hendon* and *Carrying Corn* show a broadening of the meticulous Pre-Raphaelite landscape technique, a freedom to which Brown was naturally inclined. These are pure landscapes, the figures incidental, the brushstrokes larger, the whole giving the appearance of swift execution. Such subjects posed the perennial problem facing painters before impressionism — how to capture the fleeting, ever-changing effects of nature, or of human activity in the landscape, on canvases which by their nature suggest permanence. *Carrying Corn* is a revolutionary small landscape; its ordinariness, brilliant colour, bold technique and firm structure have more in common with Pissarro and Seurat's divisionism than with Victorian art of the 1850s.

Brown worked slowly against the clock, as summer turned to autumn and sunshine gave way to cold winds and rain. Soon he had to admit that speed of execution was a prerequisite of success. 'Altogether,' he noted ruefully, 'these little landscapes take up too much time to be profitable.' At last, on 13 October, 'The Swedes' was finished.

There had been no sign of Old White. Emma's mother was asking for money again, and to stave her off they sent groceries and 'five bob as a breather'. By 24 September, with only two pounds in the kitty, they were wondering how they would manage till the next quarter's twenty-six pounds came from the wharf. By careful management Brown had kept afloat, but the pawnshop beckoned. Driven indoors by the weather, he took up his 'Emigrants', scraping out the zinc-white ground which had cracked and preparing a new tin compound. Forlornly, he placed a number of 'old rubbishy things' in specially designed frames; they would sell, he supposed, 'to dealers or others' one day.

He was happy with Emma; she was placid and biddable, cooking and keeping house with a young servant and attempting to keep accounts. After work, they would roam the countryside looking for new subjects, sometimes venturing as far as Mill Hill for tea. In the September heat she grew stouter, and his tenderness increased. With cholera raging in the neighbourhood, he was worried by her frequent headaches, 'sick fits' or cramps, and fussed over her with medicines. A month earlier he had intemperately dismissed their servant-girl Sarah 'for insolence', immediately regretting his action. Now he was anxious about the household chores, for Emma tired easily.

30 September. Worked today $5\frac{1}{2}$ hours at *Windermere* and $2\frac{1}{2}$ at *Beauty* ... Sunday I did not work nor go to church but laid the staircarpet down (8 hours, heat intense). About 5 pm had a shower bath and dressed and so spent the afternoon and eve loving Emma, the poor dear tired with no servant and char woman ...

Soon a new girl, Ruth, 'with splendid black eyes and brows and colour to paint', was found, only to fall ill with suspected cholera. Emma's 'extravagance' was the only source of friction. The household accounts did not always add up, and money had a way of disappearing. Then he would spend hours checking their expenditure and blaming her, only to relent and, by way of amends, buy 'the duck' a present — a new bonnet, jewellery or a dress.

October still brought no word from White. Coming home one evening and finding no candles in the house, Ford came close to despair: 'Emma strongly advising lazyness ... I cuddled the children and her on the sofa till tea time it being very cold ...' Disillusion overwhelmed him:

White does not come he cannot value my works much ... or he would show more anxiety to purchase, buying at such prices as I offer at. What chance is there for me out of all the Bodies, Institutions, Art unions & accademies and Commissions of this country, Classes sects or coteries, nobles, patrons, rich men or friends. Which one takes an interest in me or my works?

Obsessed with Lizzie, Rossetti had paid only two flying visits to Finchley since the spring. Now Brown decided to call on them at Blackfriars. The sight of Lizzie touched him — 'thinner and more deathlike and more beautiful & more ragged than ever, a real artist, a woman without parallel for many a year'. For most of that summer, with Lizzie mysteriously ailing, the couple had been together in Hastings.

Following the success of his watercolours at Pall Mall in the winter of 1852–3[7] and the sale of *The Annunciation* to McCracken, Rossetti had been translating Italian

poetry and toying with a watercolour but had made no progress in oils; instead he had made many drawings of Lizzie in characteristic everyday attitudes – working at her designs, standing by windows or languishing in a chair. Brown admired these almost as much as their original: 'wonderful & lovely Guggums one after another each one a fresh charm each one stamped with immortality and his picture never advancing'.[8] He made some drawings of Emma, similarly posed.

Rossetti's picture that was 'never advancing' was *Found*, commissioned some eighteen months earlier by McCracken and Rossetti's only attempt at a realistic modern subject. *Found* was to be a morality like Hunt's *The Awakening Conscience* – a conflict of love and remorse. A prostitute faints by the roadside; seeing her, her former lover, a young farmer taking his calf to Smithfield Market, tries to raise her up.

Gabriel had spent the advance; now, short of tin, he had finally got to work, beginning with that essential Pre-Raphaelite backdrop – a red-brick wall, which Brown had seen at Chiswick. A calf and a cart would be needed, and Brown promised to help: 'I am to get him a White Calf & a cart to paint here, would he but study the *golden one* a little more. Poor Gabrielo ...'

Brown's own situation was more desperate. He had just walked into London and pawned their teaspoons, Elisabeth Brown's jewellery, and his bronzes, watch and opera glasses for eleven pounds. With a pair of shoes for himself and flannel to make babyclothes, it would keep them for four weeks. White's visit assumed fantastic dimensions:

> Could I but see him here once more
> That shining Bald pate deep old file
> Oh how I'd meet him at my door
> And greet him with a pleasant smile,
>
> His blarney soft I'd suck it in
> Nor let his comments stir my bile,
> And when my hand once grasped his tin
> How kindly on him would I smile.
>
> And as he strained my hand, full fain
> My daubs were in his cab the while
> And promised soon to come again –
> Oh! how I'd smile him back his smile.

Calf and cart were found at Manor Farm, a mile across the fields from Grove Villas. Persuading the kindly farmer to lend them, an elated Brown communicated the news to Gabriel '... like an ass ... in bad rhimes'.

Rossetti arrived at Church End on 31 October, taking over the back bedroom. As always, Brown found him stimulating, and altered a picture at his suggestion. The two sat up by the parlour fire talking and arguing poetry late into the night. Rossetti pooh-poohed Bruno's old-fashioned tastes, urging him to read younger poets like his friends William Allingham and William Bell Scott, and Brown was soon writing to Scott to express warm appreciation of his work, much as Rossetti had done in 1847. Both admired Tennyson, but Brown could not tolerate Browning, disliking the 'screeching' quality of his verse. Rossetti was not to be crossed in such matters but, noting how dictatorial his friend had become, Brown determined to resist the bullying: 'After he has talked as much as his strength will bear he becomes spiteful and crusty denying everything and when chaffed he at length grows bitterly sarcastic in his way, but never quite unpleasant nor ever unbearable.'

Woolner called, back from Australia and busy chasing commissions. Brown liked the sculptor but thought him more opinionated than ever, echoing Carlyle's more reactionary ideas and being 'in fumes sulphurious about the ministry and aristocracy' or anxious 'to tell us how badly we are governed'. But Woolner was taken with *The Last of England*, the picture he had partly inspired, and with the studies for *Work* in the studio. A quieter visitor was William Rossetti, summoned to bring Gabriel (though not, alas, his host) fresh supplies of 'tin'. In William's honour, Brown bought a set of pewter spoons – 'there being but one left in the house'.

In the short daylight hours the men worked outdoors on their pictures – Brown at his Emigrants in the backyard, Rossetti (who rarely rose before noon) at his calf and cart across the fields. He had set up his easel in the farmyard, determined to paint 'from Nature', but was out of practice, struggling in the bright cold days of early November to render his reluctant model 'like Albert Dürer hair by hair'. As Brown well knew, 'Nature' put Rossetti out; that imaginative and impulsive temperament shrank from its disciplines, and, with worsening weather, Gabriel's enthusiasm evaporated.

Soon he wrote to William Allingham on the last of Brown's notepaper: 'these two days the rain has set in (for good I fear), as even if I was inclined to paint notwithstanding the calf would be like a hearth rug after half an hours rain ... As for the calf, he fights and kicks all the time he remains tied up which is five or six hours daily ...'9 By 2 December he was still at it. The calf was, Brown noted testily, 'very beautiful, but takes a long time. Endless emendations no perceptebel progress from day to day & all the time he wearing my great coat which I want and a pair of my breeches, besides food and an unlimited supply of turpentine.' Rossetti had outstayed his welcome in the overcrowded little house; bills mounted and Brown had to arrange credit with Mr Smart the grocer. There were quarrels:

... to the farm with Emma to see Rossetti's calf. Coming home he walks on & leaves us – arrived home we find as usual that he has been frightening Kattie telling her he would put her *in the fire*. Begins to us, on our entering, with 'That ass of a child' – I stop him with 'I've told you before I don't choose you to call my child an ass; it is not gentlemanly to come and abuse a person's children to them. If you can't stay here without calling her names you had better go.'

Rossetti stayed.

On 9 December, Lucy and Lizzie Bromley came home for the Christmas holidays and Rossetti moved down to the parlour. On 17 December there was a show-down:

This morning Gabriel not yet having done his cart and talking quite freely about *several days yet*, having been here since 1st November & not seeming to notice any hint, moreover the two children being here and one stupid girl insufficient for so much work Emma being within a week or two of her confinement and he having had his bed made on the floor in the parlour for one week now & not getting up till eleven & moreover making himself infernally disagreeable besides my finances being reduced to £2. 12s which must last till 20th January, I told him delicately he must go – or go home at night by the bus – this he said was too expensive. I told him he might ride to his work in the morning & walk home at night ... he thinks nothing of putting us to trouble or expense ...

At last the elements intervened. A strong wind blew Gabriel's picture off its easel in the farmyard, injuring his leg and forcing his return to Blackfriars for Christmas. The respite was brief; on 10 January the painter recorded the presence at Grove Villas of himself, Emma, two children, the servant, Emma's nurse, both Rossetti brothers and Woolner.

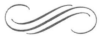

The strains of Rossetti's visit were increased by a factor on which Brown's diary is largely silent. Rossetti's persistence with the calf owed less to artistic conviction than to his new friendship with John Ruskin. It was in June that Ruskin had written to *The Times* in support of Hunt's *The Awakening Conscience*.

Ruskin's acquaintance with Pre-Raphaelite art went back to 1851, but his involvement with the artists began only after the death of Turner that December.

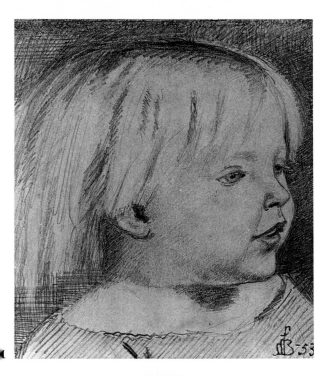

82

3

84

81 *Cathy Madox Brown, aged three,* by FMB.

82 *Oliver Madox Brown at three days old,* pencil/chalk, 1856, by FMB.

83 *Lucy Madox Brown as a child,* chalk, by FMB.

84 *Ford Madox Brown,* pencil drawing by Rossetti, November 1852.

85

86

87

85 *Take Your Son, Sir*, oils. Begun Newman Street, winter 1851; continued at intervals but never finished.

86 *Penelope*, oils. Painting by Thomas Seddon, shown 1852. Extensively reworked by FMB for the memorial exhibition.

87 *Jerusalem from the Valley of Jehosaphat* by Thomas Seddon, 1854. Presented to the National Gallery.

88 13 Fortess Terrace, showing blue plaque commemorating Brown's residence there.

89 View of Dollis Brook near Brown's Finchley home.

88

89

90 Interior showing ladderback chairs designed by FMB.

91 Brown's variant on the 'Sussex' chair. Manufactured by Morris, Marshall Faulkner & Co from early 1860s.

92 Egyptian chair designed by FMB. Manufactured by MMF & Co, 1860s.

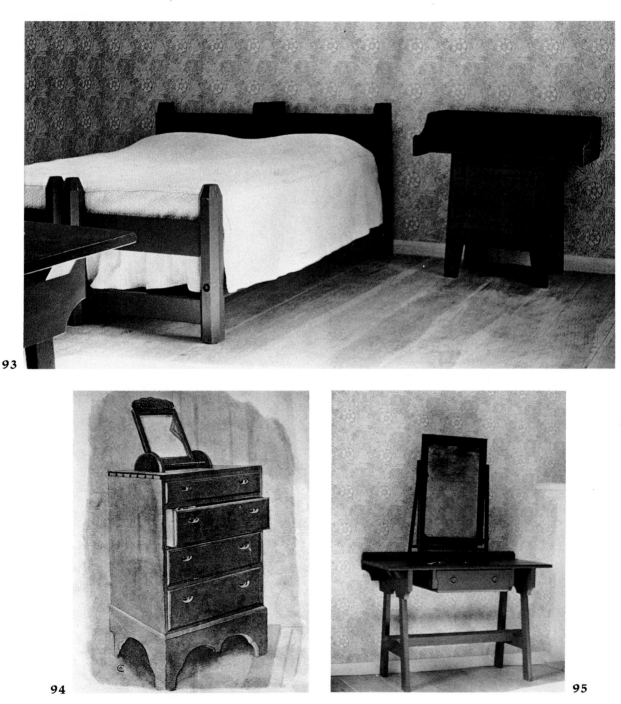

93 Bed and wash stand.

94 Chest of drawers, designed by FMB. Manufactured by MMF & Co. Drawing reproduced in *The Artist*, 1898.

95 Dressing-table, designed by FMB. Manufactured by MMF & Co. Surviving at Kelmscott Manor.

96 *Architecture* panel, oils, painted by FMB for the Seddon cabinet. Exhibited by MMF & Co, 1862.

97 & 98 Stained glass cartoons, possibly finished by Philip Webb, for St Martin's Church, Scarborough, 1862.

99 *The Entombment* for *Lyra Germanica*, wood engraving, 1868.

100 *Christ Walking on the Water*, cartoon for glass.

101 *Woodcutter*, design for tile. Used by MMF & Co, Queen's College, Cambridge.

102 *Hawking*, design for tile. See **101**.

103 Seven designs for a painted book case, designed by FMB. Manufactured by MMF & Co, 1862.

104

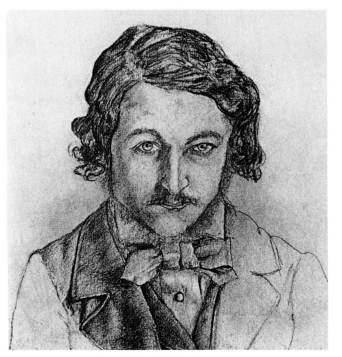

105

104 *Edward Burne Jones as Sir Lancelot*, pencil, 1857. Study by DG Rossetti for Oxford mural.

105 *Self-Portrait* by William Morris, pencil, c. 1857–8.

Millais had then become his particular protégé, accompanying the Ruskins to Scotland in the summer of 1853 and falling in love with Mrs Ruskin. By the spring of 1854, Effie Ruskin's petition for an annulment of her marriage was before the courts.

Although Ruskin had seen and admired Rossetti's Dante watercolours and praised his *Annunciation* to McCracken, the two did not meet until April 1854. Then, as news of his private affairs began to circulate in London society, he had twice visited Rossetti at Chatham Place, warmly praising his works and inviting the painter to lunch at Denmark Hill. Commissions for new watercolours followed and, like Millais and Hunt before him, Rossetti felt the benefits of the Ruskin imprimatur.[10]

Back from Switzerland, Ruskin wooed Gabriel, eager to involve him in a new venture, the Working Men's College at 31 Red Lion Square. Ruskin did nothing by halves; for a protégé, no trouble was too great and, as Rossetti told Brown, 'he seems in a mood to make my fortune'.[11] Over the next few years, Ruskin's support would transform Gabriel's professional prospects.

Full of his new friend, Rossetti brought Ruskin up too often in those conversations by the parlour fire − both knew that the critic disliked Brown's work as intensely as he now desired Rossetti's. The reasons for this are unclear. The prejudice may be traced back to Brown's dismissive references to Ruskin in the *Builder*, in 1848, but Ruskin had also objected to the homely realism of *Jesus Washing Peter's Feet* in 1852. Now, despite all Rossetti's efforts, he set his face against Brown's 'ugly' subjects. Avoiding any mention of him in his writings and lectures, Ruskin privately advised buyers against his work.[12]

Brown's response was to ridicule the critic who 'jawed so nauseously about art' − inventing a whole vocabulary of sexual *doubles entendres* to mock Ruskin's supposed impotence. His prejudice against critics became acute.

Since December, Brown had been working outdoors on his Emigrants. Snow fell as, wrapped in two coats, feet in a blanket, he painted at the ship's tarpaulin and at Emma's plaid shawl draped over a lay figure. The winter of 1854−5 was hard and long. Too poor to take buses, he walked, covering many miles in a day. His shoes leaked, a painful boil on his foot crippled him and he caught feverish chills.

Just before Christmas, Emma's pains began. Sending the girls back to Gravesend, Ford hurried to Islington for the nurse, returning by bus to Highgate 'in distress of mind at not being able to afford a cab in such an emergency and so walked home four miles racked with anxiety about Emma the most beautiful duck in existence'. It

was all a false alarm: 'As I walked down the Grove very tired and with a weak foot I felt that mysterious assurance that all was right, which I have before felt when nearing some dreaded event . . .'

Oliver Madox Brown was eventually born just after midnight on 20 January 1855: 'This morning at $\frac{1}{2}$ past 12 am Dearest Emma was delivered of a son, my first. He is very red, a large nose, eyes & shape of face like a calmuck Tartar, shape of head like a Bosjeman [bushman], sucks liberally . . .' Three days later Ford completed a fine drawing of his son's head, proudly inscribing it 'Oliver Madox Brown Pater su Des Jan 23 1855 Aetas Die 3.'. Nothing in his life gave him deeper satisfaction than this son's birth, until the publication of Nolly's first novel in 1872.

Now Brown advertised in *The Times*: 'To small capitalists. WANTED TO BORROW £300, on mortgage of good freehold property. Address to BYZ, Shaw's Library, Hampstead.' The property was Ravensbourne Wharf.[13]

He had become 'a regular Haydon at pawning'. After popping his evening clothes and Emma's silk cape and brooch, he applied for a teaching job at the Government School of Design, not wanting or expecting to succeed: 'Evening at length wrote the long deferred much dreaded application to the humbug Henry Cole C.B.' The reply, requesting a teaching certificate, ensured that 'the scoundrel Cole' got a piece of his mind.

Two paintings were destined for the Paris Universal Exhibition that summer. In February *Chaucer* was delivered from store to the Dickinsons' Maddox Street gallery. The pale insubstantial figures looked so old-fashioned that he retouched and brightened them. White called to see it, raising his hopes, but made no offer. Brown updated *Waiting* in a different way: as *An English Fireside, 1853–4*, depicting an officer's wife awaiting news from Sebastopol, it acquired topical appeal, like Millais' *Peace Concluded* of the following year.

The mortgage notice having brought no satisfactory reply and 'about 30/- being my all', Brown swallowed his pride. He visited Uncle Madox in the City, persuading him to make family enquiries, and meanwhile appealed to Old Seddon, who had a soft spot for Emma. He called fruitlessly on White, who only 'abused my prices'. 'The cunning old rogue', the Seddons told him, had already sold four of his pictures (including *Wycliffe*) to Windus — welcome news as it was bound to enhance his reputation and prices in the longer term. Better still, Uncle Madox 'has got the old lady to send me the £500 . . . I can now go to India or continue my picturs as may prove prudent.'[14] As March opened, the sale of his early *Two Views of a Little Girl's Head* at the Pall Mall for a paltry ten pounds seemed to confirm his luck.

With new resolve Brown set about *The Last of England*, determined at last to make his fortune:

This picture is in the strictest sense historical. It treats of the great emigration movement which attained its culminating point in 1852. The educated are bound to their country by closer ties than the illiterate man, whose chief consideration is food and physical comfort. I have therefore in order to present the parting scene in its fullest tragic development, singled out a couple from the middle classes, high enough through education and refinement, to appreciate all they are now giving up, and yet depressed enough in means to have to put up with the discomforts and humiliations incident to a vessel 'all one class'. The husband broods bitterly over blighted hopes and severance from all he has been striving for. The young wife's grief is of a less cankerous sort, probably confined to the sorrow of parting with a few friends of early years. The circle of her love moves with her.[15]

The circular design, emphasising the couple's unity, also carries associations with the Renaissance tondo. True icons of their time, they implicate the viewer in condemning poverty and injustice. Wealthy England, they seem to say, wastes her most precious resource, her people, driving artists and poor alike into exile.

Brown's picture was ingeniously contrived. The *Eldorado* is suggested by a piece of pig net, an old block and a coil of rope picked up at a marine store in Limehouse. For the bulwark, Brown spent an evening adapting a piece of framework, while the cabbages slung round the stern to 'indicate . . . a lengthy voyage' were begged from neighbouring gardens in Finchley. But, as the artist made clear, he relied for his chief effect upon the weather:

To insure the peculiar look of *light all round* which objects have on a dull day at sea, it was painted for the most part in the open air on dull days, and the flesh . . . on cold days . . . the minuteness of detail which would be visible under such conditions of broad daylight, I have thought it necessary to imitate, as bringing the pathos of the subject more home to the beholder.[16]

The tarpaulin, cloak and other inanimate items had occupied most of the winter. Now, in the cold spring of 1855, he concentrated on the figures, painting and repainting the faces and expressive hands which run through, identifying and linking the various characters. Brown pressed his whole family into service:

[*9 March*] began the babies hand . . . from Emma and Oliver, painted them badly.

[*10 March*] . . . drew at the man's hand again, then painted in the woman's glove from Lucy holding the Nurse's hand . . . at 4 pm out into back yard & painted

the man's hand from my own with Lucy holding it (in a Glass). Snow on the ground and very cold.

[*11 March*] Obliged to work. Rain so could not paint in the yard. After sweeping away the snow, altered the drawing of the hand again, painted the skirts of the coat indoors.

Dull days with an even light were best, permitting the desired 'minuteness of detail' in every part of the picture.

In his original scheme, the *Eldorado*'s subsidiary cast was confined to two or three characters; now more token emigrants come aboard, but, compressed into the left-hand side of the picture, are scarcely distinguishable. It is not easy to make out 'the honest family of the green-grocer class'[17] huddled behind the couple, although Cathy is recognisably the small girl eating an apple. She was a competent sitter, unlike 'all the red headed boys in Finchley' and an old washerwoman who only wasted his time. As March wore on he dispensed with these unprofessional models.

'Whatever I am about,' he had written, 'I must see it through to extremities.' The Academy deadline found his painting still unfinished; yet exhibit he must. Framing his small *Carrying Corn* he sent that instead, along with *Cordelia Parting from her Sisters*. Both were rejected: there was 'no prospect but going to India'.

Brown's difficulties with *The Last of England* owed much to new problems in his marriage. Since Nolly's birth, Emma had become surprisingly assertive and showed a disinclination to pose. His frustration increased with the failure to realise her essential image. Working perforce 'from feeling', he struggled obsessively to keep it faithfully like Emma. On 20 April he 'woke up very unhappy ... the head of Emma struck me as very bad and made me miserable all night. This morning I scraped at it with a penknife and so widened the cheeks some ... the colour is good but the chin and jowls look heavy.'

Emma took to spending days and nights away, alone or with one of the children, visiting her mother and returning late by cab, 'breaking all promises and spending more money'. After she fell off a stile, he discovered her secret drinking – her extravagance, late homecomings, frequent accidents and alarming fainting fits fell into a pattern. Drunk, his normally placid wife turned quarrelsome and violent, and even showed suicidal tendencies, but to keep her away from the bottle required constant vigilance. This struggle would continue throughout their marriage.

Yet his life depended on her. On 2 July, 'Emma began the day with quarelling ... did not speak to Emma nor she to me.' She locked him out of her room and the next morning 'started off to London ... borrowing two shillings off Lucy and more

of the servant'. This was repeated, and Ford in anguish wrote her a letter 'the answer to which our fate now seems to hinge on'. That night (5 July) he confided to his diary: 'When I was young a disappointment in painting used to give me a dreadful pain in my throat, now other miseries take the place of these and the nervous system feels most acutely about the heart & chest – no pain is like this.' Sleeping on the parlour sofa, dreams of thwarted sex assailed him. Awake, he meditated suicide. By 6 July Emma 'gives in so we are all happy again'. To celebrate, he took her shopping – choosing 'a bracelet in mosaic gold, so beautiful that I could not resist it'.

Meanwhile Gabriel and Lizzie blossomed under Ruskin's patronage. On a recent visit to Denmark Hill she had so charmed Ruskin's parents that the critic had offered to pay her £150 a year, taking all her work to that value and making her financially independent. As for Gabriel, Ruskin had commissioned several watercolours and was busy persuading his friends to do the same. It was 'to toady Ruskin', Brown believed, that John Seddon had commissioned from Gabriel an altarpiece for Llandaff Cathedral which should have gone to himself.[18]

Against this background, Brown's famous encounter with Ruskin took place on 13 July 1855. Staying overnight at Chatham Place after a late party, he was smoking a pipe in his shirt-sleeves on the sofa next morning when:

> Enter to us *Ruskin*. I smoke. He talks diverse nonsense about art, hurriedly in shrill flippant tones – I answer him civilly – then resume my coat and prepare to leave. Suddenly upon this he sais 'Mr Brown will you tell me why you chose such a very ugly subject for your last picture?' I dumbfounded at such a beginning from a stranger look in his face expectant of some *qualifiycation* and ask 'what picture.'

Ruskin identified *An English Autumn Afternoon*, shown the previous winter at the British Institution.

> What made you take such a very ugly subject, it was a pitty for their was some *nice* painting in it.' I, from his manner ... being satisfied that he intended impertinence replied contemptuously 'Because it lay out of a back window' & turning on my heel took my hat and wished Gabriel goodbuy.

Brown paid dearly for this good exit line.

Marriage was at issue between Gabriel and Lizzie when they arrived at Grove Villas in August, a visit overshadowed by Ruskin's paternalism. Independence had raised Lizzie's expectations; there was now no reason why they should not marry,

and indeed her introduction to the Rossetti family that spring had seemed a prelude to their engagement. Meek Lizzie, Gabriel's 'dove', the queenly Guggum who had inspired so many drawings of matchless beauty, could also be a girl of spirit with a sharp tongue. She was angry, and relations between the lovers were stormy. Their quarrels wasted a good deal of Brown's precious time that summer. Tactlessly, Gabriel demanded help with *Rachel and Leah*, the watercolour he was painting for Ruskin, while pretending to ignore Lizzie's loud complaints. Emma took her side against Gabriel, provoking accusations of mischief-making, but Brown too had every sympathy with her. With Gabriel behaving 'especially badly', the girls began a campaign of subversion.

> *16th Aug.* Emma went into town with Miss Siddal before Rossetti was come in from his rooms at the Queens Head so that when he did come his rage knew no bounds at being done out of the society of Guggum & vented itself in abuse of Emma who 'was always trying to persuade Miss Sid that he was plaguing her etc etc' whereas of course Miss Sid liked it as much as he did etc. ... I did not know whether to laugh ... or be angry so did both, laughed at him and damned him & at length thought it best to tell him where he could find them ... this appeased him & presently off he started.

Brown had just got back to his cabbages when there came a summons from Rossetti to join them at Chatham Place, 'as they were all going to the play'. In such ways, time and emotional energy were dissipated.

At last Old White was 'in a mood to buy', sensing a rising market in Pre-Raphaelites. Popping in on 27 June he had taken off two landscapes,[19] *The Seeds and Fruits of English Poetry* triptych, and the newly finished sketch for *The Last of England* for a total of forty pounds. 'Gloria in Excelsis,' Brown wrote. Soon afterwards, out looking again 'for little landscape subjects that will paint off at once', he found at twilight 'what appeared a very lovely piece of scenery with the full moon behind it just risen'. This became *The Hayfield*. Confidence was restored.

A cool September followed a blazing August. The Browns had decided to leave Grove Villas on the quarter day, yet their future still hung in the balance. On 2 September, 'fortune seemed to favour me. It has been intensely cold, no sun, no rain – high wind, but this seemed the sweetest weather possible for it was the weather for my picture & made my hand look blue with the cold ...' He signed *The Last of England* and two days later nailed it into its enlarged oval frame. He had decided to show his *magnum opus*, with some other recent work, in central London, and had hired a room for a week in Percy Street.

Next morning, loading his five pictures on to a cart, Brown drove down the new Finchley Road to the West End. 'It was Barnet Fair and we were taken for return showmen.' White had anticipated him: 'As I got to the door in Percy Street Old White was knocking there. He looked at the picture for about one hour & was most warm in his euologium.' Brown wanted £200 for it, with copyright, but after some haggling agreed to sell it outright for £150 – by far the highest sum he had ever earned – while the dealer promised 'speedy fortune & that in two years I shall no longer sell my pictures to him but command the highest prices in the art market … Amen! say I.'

William Rossetti and his sister Christina were the last visitors at Grove Villas. Brown was fond of quiet Christina, who 'works at worsted ever and talks sparingly', but she did not like Lizzie and there was 'a coldness between her and Gabriel' over the affair. Brown, however, was preoccupied. Quarter day had come and gone and the need to find less cramped accommodation was pressing. After some searching, the couple found another house, larger and closer to London. Their move to 13 Fortess Terrace, Kentish Town, took place at the end of September 1855.

8

FORTESS TERRACE
1855 – 1856

'INDIA' RECEDED. 'I HAVE BEEN thriving rather more of late,' he informed Hunt in Jerusalem on 30 September, 'and am now living in a large house instead of (as you used to say) an outhouse.' This he had taken for 'three years determined to try it on again...', meaning his renewed determination to exhibit. But he missed Hunt, whose letter of 23 August had reaffirmed his interest in exhibiting independently. 'I hope you will be back soon, you are the only rallying point now possible if anything is to be done.'[1]

At the Paris Universal Exhibition, Hunt's, Millais' and Brown's paintings had had a *succès d'estime*; unlike Landseer, they had won no prizes but their colourful and direct work had impressed the French artists. Paris had revived the artists' shared interest in a regenerated English school. Brown's letter touched on the reception of their pictures, on his contempt for the Francophilia now sweeping London and on the continuing domination of the Academy: 'Every booby comes back proclaiming the supremacy of French art, the whole London public having gone wild for a fortnight on a canvas 18 foot long by Rosa Bonheur representing carthorses trotting ... I have been aware of the strength of French art for many years, but think now not one jot the better of it nor the worse of ours...' For himself, he felt cautiously optimistic.[2]

Number 13 Fortess Terrace, where the Browns lived until 1865, stands a little to the north of Kentish Town station. In 1855 the terrace was being further 'developed' and was a desirable suburban address where most of the neighbours were well-to-do professionals. Brown recorded the north-westerly view over Parliament Hill Fields, one of its chief attractions, in the delightful *Hampstead from my Window* in 1857. Situated on the extreme edge of London, but with easy access to the centre, the house had five floors and a large garden.

The optimism with which Brown took on an annual rent of £52.10s. (more than double that at Finchley) and a second living-in servant was scarcely justified by his

earnings: 'thriving' he was not. Rather, the sale of *The Last of England* had proved a psychological turning-point, a vindication of Pre-Raphaelitism, though it was true that Old White, having snapped up *Chaucer* for fifty pounds, began to frequent Fortess Terrace – still grumbling, despite a generous discount, about Brown's strong colours and extortionate prices while steadily building up his stock.

By 1856 prices for modern British art were rising fast and the Pre-Raphaelite avant-garde, now widely imitated, shared in the buoyant market. There were some staggering prices – Millais, immensely successful, could command a thousand guineas for a major canvas;[3] while Hunt, in 1860, obtained 5,500 guineas for his *Finding of our Saviour in the Temple* – but these were exceptional; a successful Academy oil at this date might fetch 400 guineas – the figure Rossetti obtained for his Llandaff altarpiece, for example. Only Brown, unseen at the Royal Academy, unsung by the critics and scarcely known outside his small circle, lagged behind. But his success in gaining the Liverpool Academy prize later that year would bring two major patrons and a growing reputation outside London.

During the winter of 1855–6 the Browns luxuriated in the new house. Naturally sociable and hospitable, full of new projects and looking forward to entertaining his friends, he set about decorating it. The parlour became, fashionably, 'the drawing room' and, with its new carpet of 'claret coloured Kidderminster powdered with chockolate fleur de lis', occupied both ground-floor rooms. The carpet only just survived a visit from Rossetti, who panicked when the chimney caught fire and raked red-hot cinders over it. Brown reupholstered their shabby old chairs and sofa (the local upholsterer refused to touch them), and was soon designing new tables and chairs. 'In a sort of luxury of idleness' he hung his first-floor studio with almost forgotten early works – the *Mary Queen of Scots* brought from Antwerp to Paris, *Study of a Pony* and the pencil design for *Cordelia Parting from her Sisters* etched for *The Germ*. Their vigour surprised and pleased him.[4]

On Christmas Eve, as the family hung the drawing room with holly and evergreens, he conceived a celebratory picture. Brown's 'Christmas subject' never materialised, but the mutilated remains of pages torn from the diary between 17 January and 14 February 1856 give a good idea of it. Emma would have been seated 'somehow ill, reading or singing to the children', who would be depicted as in life: 'Katty will be lugging Nolly along to see the tree … she holds him under the arms and drags him about . . .' etc. This was the kind of domestic subject which was popular at the Royal Academy and which might be followed by an engraving in the *Illustrated London News*.

But this archetypal Victorian Christmas scene was never painted: other realities interposed themselves – money anxieties and Emma's condition. To increase their

modest income they had originally planned to let the two first-floor rooms, but, 'as poor dear Emma had a sad fit again' soon after moving, the plan had to be dropped. Her seizures – always exacerbated by drink – could hardly be inflicted on strangers: '22 December 1855: To Gravesend to fetch Lucy, left Emma in bed with a bad cold, came home by 7, found her in a fit raving & did not know me. Very sad – these fits...' A year later he described a more serious attack to William Rossetti: 'Mrs Brown has been very ill all this afternoon again with hysteria. It is very sad.'[5]

This domestic situation particularly threatened twelve-year-old Lucy, who was now living with them. Reared since early childhood by Aunt Helen at Gravesend, she had lived apart from her adored father until his marriage to Emma in 1853 offered a chance of home. Even then her visits to Church End were confined to school holidays. How Lucy reacted to Emma can be inferred from the record of her grief at the loss of her own mother, over whom she shed 'many bitter tears' all her life. She could never accept Emma as 'Mama'.

Lucy's special place in her father's affections can be glimpsed through his diary, where she appears as his close companion from an early age. Intelligent, carefully educated and ladylike, she presented a complete contrast to Emma; we glimpse her playing the piano to him, walking to church with him, posing for him and, out in the icy yard, holding the mirror while he painted both their freezing hands. At around this age he made a chalk study of her – perhaps for Aunt Helen – alert, smiling and bright-eyed, with the same dark looks as her mother.

Lucy had outgrown Helen's school, but Brown's hopes of educating her at home were now abandoned. Rejecting Mrs Seddon's kind offer to educate Lucy with her youngest daughter, he wrote instead to Maria Rossetti – sister of Gabriel, William and Christina – who took pupils at home. His daughter was to have the finest schooling he could afford:

> ... the subject which I allude to is the education of ... Lucy and the proposal which I am about to make bold with is that you should yourself take charge of its continuation and obtain Mrs Rossetti's consent for her to form one of your domestic circle during such time ... Should it prove agreeable to yourself and Mama, it will certainly be a source of the greatest comfort to me...[6]

Over dinner it was settled that Lucy would board with the Rossettis for forty pounds a year and receive free tuition: 'A blessed thing for Lucy,' he thankfully recorded.

Brown had just resumed *Cromwell on his Farm*, the last of his Hampstead history pictures, when, in a fit of anxiety, he suddenly succumbed to an offer of hack work in the Dickinsons' portrait manufactory. For a guinea a day, three days a week, he

added costumes and backgrounds to the faces of famous people which Lowes Dickinson had painted from enlarged calotypes. These were mostly 'presentation or memorial pictures, the individuals represented being either dead or too busy to sit to the artist'.[7] Brown worked on at least four, including one of General de Bathe, a hero of the Crimea, and another of the prime minister, Lord John Russell.

He was ashamed of such work: 'At Lowes Dickinsons again ... the worst of it is people cannot be kept out of the studio & so everyone soon will know I have been daubing for them which is horrid. Oh! Money!' runs a diary entry of late January. Robert Dickinson, another 'scoundrel' in the mould of 'Cole C. B.', was his boss; he not only withheld wages but also criticised Brown's imaginative work, insisting that he repaint his backgrounds according to a formula. Though angered – 'I told him I could not paint such. I never could, he is an ass but this does not make it more pleasant' – the artist swallowed his pride. He was still working for the Dickinsons in June.

The old problem, acute since 1852, of how and where to exhibit still tormented him. In Hunt's absence he had been turning over the old idea of an independent exhibition under Pre-Raphaelite control, but what he really wanted was to exhibit with Hunt, the artist whose values most closely matched his own. Eagerly awaiting his return in January 1856, he wondered if Hunt would be still of the same mind.

His hopes rose when, with William Rossetti, Hunt called at Fortess Terrace early in February. To his relief, Hunt disapproved as much as ever of the Academicians and their doings: 'Hunt thinks a curse hangs over all,' he noted after they had talked into the small hours. If an exhibition could be got up, Hunt seemed willing to take part.

Hunt's *The Scapegoat*, painted on the shores of the Dead Sea, was his major achievement in Palestine. Unlike Millais, who disliked the picture intensely, Brown was overwhelmed by *The Scapegoat* – 'one of the most tragic and impressive works in the annals of art'. Unfortunately for Brown, Hunt's patron Thomas Combe was no less impressed and soon persuaded the artist not only to show it at the Academy but to stand for election as an Associate.[8]

Brown was horrified at the volte-face: 'that is all knocked on the head and I don't know what to do,' he noted, wondering where to send *The Last of England*. There seemed no alternative but to follow Hunt's example, so great was his admiration for his art and character.

But the collector Windus, owner of the picture, was uncooperative. He had not forgotten the Academy's rejection of Brown's *Cordelia*, lent from his collection in 1855, and was unwilling (perhaps on White's advice) to risk lowering the market value of his investment. Thus it came about that Brown's *magnum opus* – the painting

which should have launched him definitively in London – stayed unseen on Windus's walls at Tottenham.

This was unfortunate for that summer Brown would have exhibited in the best possible company. His friends appeared in force at the Academy: Millais with five works, Henry Wallis with his *The Death of Chatterton*, Arthur Hughes with *April Love* and Hunt with several views of the Holy Land besides *The Scapegoat*. All were well hung, indicating apparent acceptance of the new school.

Windus's decision marked a decisive shift. From now on, without Hunt's support, Brown abandoned the Academy. In Liverpool the Pre-Raphaelites were highly regarded; Millais and Hunt had successively won the Liverpool Academy's annual fifty pound prize, and Windus raised no objection to showing his picture there. Brown wrote immediately to James Pelham, Secretary of the Liverpool Academy, proposing to send his three best pictures to the Autumn Exhibition, including *Jesus Washing Peter's Feet*. They were dispatched on 1 September.

Brown had attended Millais' preview at his Langham Place studio, not having seen him for three years. His admiration for Millais' skill was unchanged, but now he reacted more critically, knowing the strength of his own recent work: 'I have seen Millais' picture of this year the Autumn leave, the finest in painting & colour he has done yet – but the subject somewhat without purpose and looking like portraits.' He disliked *Peace Concluded* for its 'made up look', 'stupidish' subject and 'bad' colour – 'despite some beautiful expression and lovely parts'. Only *The Blind Girl* aroused his old enthusiasm – 'altogether the finest subject, a glorious one, a religious picture', though (alluding to Millais' broadened style) 'it is a pity he has so scamped the execution'.

The growing divergence within the Brotherhood was deepened by personal and professional tensions. Millais was 'in a very excited state ... abusing every one, Hunt because he has wasted his time ... Rossetti for getting an immense reputation *and having done nothing to deserve it*, I for not sending to the RA. What could anyone find to say against the justice of the RA (this was to Seddon).' Millais spoke disparagingly of Hunt's 'continuing stale virginities', though he reserved for Effie his private opinion of Hunt's pictures from the Holy Land: 'Here is poor old Hunt returned with not so much work as I have done in a few months and, which is truly unfortunate, not of the excellence his friends expected ... I confess it has been nearly his ruin as his work disappoints all ...' He contrasted this with his own triumph and the throng of eager buyers in his studio: 'I now see I may get two thousand for my pictures instead of one.' Now he could discount Hunt as a rival: 'the comparison which has so often been made between our relative merits ceases for ever with this year...'[9]

The new Associate was embattled, resenting the old caucus and more than ever determined to triumph over them. Needing strong Pre-Raphaelite support inside the Academy, he offered to sponsor Brown for election – with predictable results: 'Millais offered to patronise me but shan't.' Still, Brown enjoyed the renewed intimacy with Millais, based on a common loathing of Ruskin and appreciation of married sex, and, to his delight, he was able to effect a *rapprochement* between Millais and Rossetti, Ruskin's new favourite.

Lizzie Siddal had spent the winter of 1855–6 in Nice. In May she returned to London, and once again the Browns were caught up in her affairs. Relations between Rossetti and the Browns, unclouded for months, suddenly deteriorated and Lizzie's arrival at Fortess Terrace renewed Gabriel's hostility to Emma: once more she bore the blame for 'setting Miss Sid against him'. Gabriel's rudeness drove the normally indulgent Brown to demand an explanation; he noted in his diary, 'Emma was his very good friend till this sort of brutish behaviour', adding:

> I put down these things not from any wish to be always giving the unpleasant side of him but because I think him ... so great an artist that anything tending to give a correct insight into his character is as it were public property ... I could narrate a hundred instances of the most disinterested and noble minded conduct towards his art rivals which place him far above Hunt or Millais for greatness of soul and yet he will hate and backbite anyone who gives him offence & spunge on anyone & rather hate them than otherwise for it.

Lizzie haunted Fortess Terrace, often abusing the Browns' hospitality. They came home one afternoon to find her with Gabriel 'upstairs. I was very cool to them as I am sick of them coming here and his rudeness to Emma.' Some weeks' silence ensued, during which Brown was to hear from Hunt of Rossetti's flirtation with Annie Miller and neglect of Guggum, while Emma, visiting Lizzie in August at her Weymouth Street lodging, found her 'very ill and complaining much of Gabriel. He seems to have transferred his affections to Annie Miller and does nothing but talk of her to Miss Sid. He is mad past care.'

Brown still relied on Old White. On 3 July the dealer called to see the almost finished watercolour of *Cromwell* and encouraged him to hope for an oil commission.

Brown immediately set off by train for Huntingdonshire, to explore the Fen country-side described in Carlyle's *Letters and Speeches of Oliver Cromwell*.

Walking through fields to the river Ouse, the artist sought information from the locals. He discovered that Slepe Manor, assumed by Carlyle to have been the Cromwell home, had been demolished in 1848, but sketched the new house and ancient barn nearby for local colour. Neither these, however, nor the view of St Ives from Huntingdon described in his diary, were incorporated into the later oil version, almost certainly because Brown could not for historical reasons fix the scene too definitely.

Back home, he eagerly framed his watercolour and delivered it to White for Windus's approval:

> The result was that instead of buying it he strongly recommended me not to paint it, nothing I do pleases him now. I came home and debated what I should do and by Friday night I settled on two fresh subjects, one in the garden a young lady seated on the wall working under a lilac tree and a youths head just visible on the far side to be called 'Stolen Pleasures are Sweet'. The other in my conservatory with the beautiful vine in it. Three figures, to be called 'How it was', a youth quite a boy home from the Crimea *with one arm*, narrating to a poor young widow 'how it was', a young girl his sister hugging him.[10]

Painting *'sans culottes'* in his back garden in the sweltering summer heat, Brown embarked on *Stolen Pleasures*, later elaborated and given the Hogarthian title *Stages of Cruelty*. It began as a simple-minded picture of a stolen kiss, featuring a typically Pre-Raphaelite pair of guilty modern lovers by a brick wall, in the shade of a carefully rendered lilac-tree. Finding that strong sunlight distorted and flattened his colours, dazzling him, the artist erected a tent and painted in its shade. Tom Seddon and his young wife, Emmeline, came from nearby Grove Terrace to pose, but progress was frustrated by Mrs Seddon's unreliability as a sitter and halted when without explanation she stopped coming. 'Really Tom and Mrs Seddon, this is not right to a friend!' Brown expostulated, and, despite attempts to improvise by standing Lucy on the parlour piano and painting both of their portraits in a mirror, he had to abandon the canvas.

The approach of the Liverpool Academy exhibition at the start of September found Brown working feverishly to improve *Jesus Washing Peter's Feet*, heightening the colours and clothing the previously naked figure of Christ. He was hard at it when Rossetti called with his new friend William Morris — a rich young admirer

who, having commissioned several watercolours from him, had just bought Hughes's *April Love* from the Academy. Thus began a significant new friendship, cemented on the spot by Morris's purchase of 'my little Hayfield' for forty guineas.

Gabriel also brought two other collectors to Fortess Terrace – the poet Robert Browning and Ellen Heaton of Leeds. He urged the latter to buy, writing: 'I can assure you ... that anything by Madox Brown will be sure to increase yearly in value & that no-one's works, except those of Hunt and Millais will ultimately be so highly esteemed or stand so high in the market as his. The tide of justice is at last beginning to set in towards him.'[11] On 9 September, in the *Daily News*, appeared Gabriel's glowing review of Brown's five Liverpool pictures; 'Gabrielo seems bent on making my fortune at one blow,' wrote Brown delightedly.

The tide turned quite suddenly. On 11 September news came from Liverpool that *Jesus Washing Peter's Feet* had won the coveted fifty pound prize, with *The Last of England* a close runner-up.

The modest success proved a landmark for Brown, giving him new confidence in the future. His happiness was complete when, a week later, Emma gave birth to their second son, Arthur Gabriel Madox Brown. Their friends rejoiced, and soon afterwards came Brown's meeting with the jovial Liverpool collector John Miller, when he joined Hunt at the exhibition. Brown and Miller hit it off immediately, as Brown's diary entry for 25 September makes clear, painting an attractive picture of the new friend with whom he had sat up talking and smoking till midnight: 'This Millas is a jolly kind old man with streaming white hair, fine features and a beautiful keen eye like Mulready's ... A rich brogue, a pipe of cavendish & smart rejoinder with a pleasant word for every man, woman or child he meets is characteristic of him. His house is full of Pictures even to the kitchen.'

Miller's deplorable cuisine, consisting largely of salt beef and bottled beer, ensured that 'few people who have ever dined with him come back again', but his fine collection of English landscapes – including work by Turner, Constable and Mark Anthony as well as 'a hoste of good pictures by Liverpool artists' – delighted Brown. Among these Liverpool artists he noticed the work of William Davis, already singled out at the Royal Academy, and, on being introduced to Davis by Miller, he was moved to buy 'a little sketch from nature, very beautiful'. Perhaps in recompense, 'Miller bought my little picture of Emma and boy for £84' (*An English Fireside*, 1854–5). Thus began a cordial relationship between artist and patron and, much encouraged, Brown bought Emma a dress 'for having sold her and the child'.

Success breeds success. Later, in November, Rossetti sent another patron to Fortess Terrace. This was Thomas Plint of Leeds, who commissioned Brown's *Work* for 400 guineas. To Allingham, Woolner reported that 'Brown the brick has a

commission to paint that picture. The thorough brick is in good spirits of course, considers himself over the bar at last and on broad water.' And to the same correspondent Rossetti waxed equally enthusiastic: 'It will be a noble affair and will at last I should hope settle the question of his fame...'[12]

9
COLLECTIVE ENTERPRISES
1857–1859

Brown's efforts in organising a series of independent group exhibitions now played a vital part in establishing Pre-Raphaelitism as the English avant-garde. Through these model exhibitions, his own work was seen for the first time in a sympathetic context in London. He became better known in art circles. At the same time, Pre-Raphaelitism was redefined, the intense realism of the early years giving way to the Rossettian aesthetic of the next decade.

On 3 August 1857, Hunt was to write to Brown from Pimlico:

> I am really very glad that you have given up the task of hanging the pictures in America; it would have lost you much time, and an artist in the unavoidable troubles of life has quite enough interruptions to his work. I often think the game of success as dependent on *production*, regular, speedy production, *as much* as on any other card, and in your case as requiring it particularly at this time. I say this because I think that another may occasionally see the position of a man in whom he is interested better than himself.[1]

Hunt was right. Distracted on all sides, Brown had let Plint's big commission languish in the studio for months: '... the very little I have done this summer is in part owing to the interruptions of the Russell Place affair besides family troubles & in part to the fear I have of doing things insufficiently which makes me always pausing and hesitating – But I mean now God willing to shake off sloth & have a good spell of work this autumn – but pray always tell me the truth, the entire truth & all you think about me ...'[2] The 'entire truth' was, of course, more complex:

production was one thing, exhibition quite another, and Hunt's defection to the Academy had left Brown no choice but to organise the independents himself. His break with the Royal Academy was final.

The interruptions had started early in December 1856, with the news of Tom Seddon's death at thirty-five in Cairo. Tom had returned to the Holy Land with commissions for several pictures, only to fall victim to dysentery, leaving his wife Emmeline and a baby daughter. The loss of this genial and high-spirited friend, 'a general favourite with all sorts of people' as William Rossetti recalled, affected the whole circle and none more deeply than Brown, who had been Seddon's confidant, colleague and teacher: 'A startler,' he called it, 'making one think of spirit land with a vengeance.' Hunt, who had been with Seddon in the Holy Land, was the first to suggest a memorial exhibition, but it was Brown, ever practical and resourceful on others' behalf, who called the first meeting of Tom's friends at 13 Fortess Terrace in January. At this small gathering, plans for a subscription fund were discussed, and in February a well-attended meeting at Holman Hunt's elected a committee with Ruskin as Treasurer and William as Secretary. An appeal was launched for 400 guineas to buy Seddon's panoramic *Jerusalem from the Valley of Jehoshaphat* from his widow for presentation to the National Gallery, and a small retrospective exhibition was arranged that May.

Ruskin's prominence in the Seddon affair explains Brown's absence from subsequent meetings. Reluctantly, he agreed to attend one at Ruskin's house in Denmark Hill on 2 March, writing to William: 'As I suppose it would look too pointed were I to hold off ... I will go on Monday ... and shall consider myself in the light of a martyr to duty ... and if he insults me, as I know he cannot well avoid from his nature I shall visit it upon you ...'[3] Later he recorded this vivid impression of the critic at home:

> Ruskin was playful and childish & the tea table overcharged with cakes and sweets as for a juvenile party. After this, about an hour later, cake & wine was again produced of which R. again partook largely, reaching out with his thin paw and swiftly absorbing 3 or 4 large lumps of cake in succession. At home he looks young & rompish ..., at Hunt's he looked old & ungainly, but his power & elegance as a speaker were homeric ... but for his speaking he looked like a cross between a fiend and tallow chandler.[4]

Gabriel proposed that Tom's artist friends should each take a work from his studio to 'finish' for the exhibition. Brown, who had already given Seddon con-

siderable help with *Jerusalem*, chose *Penelope* – an imaginative figure painting exhibited in 1852 before Seddon's conversion to Pre-Raphaelitism.

When the pictures were finally shown at the Royal Society of Arts, with *Jerusalem* in the place of honour, it was Ruskin who spoke for the committee to the assembled guests. His speech must have struck Tom's artist friends as wonderfully beside the point, although 'it was listened to throughout with the most marked attention by the large assembly'. Of Seddon himself Ruskin said little; rather the dead painter occasioned a sermon on the moral role of Pre-Raphaelitism as documentary science. The value of Seddon's art lay in its objective recording of the architecture and scenery of the Holy Land. They were not celebrating Tom's pictures because they were exceptional but because their very 'ordinariness' was exemplary, such as 'might be understood and imitated by other men' who could not aspire to the heights of poetic invention.[5]

If this view of Everyman's art seems patronising, Ruskin was here rehearsing a key element of his philosophy. It was barely a month since Brown had attended the Working Men's College in Red Lion Square to hear 'Ruskin jawing ... as eloquent as ever and as wildly popular with the men and as absurd and spiteful ...'.[6] Now Ruskin paid fulsome tribute to Tom Seddon's pioneering work at the North London School, without mentioning the contributions of Cave Thomas and Ford Madox Brown (in the audience) to that enterprise.

Brown must have been surprised and not a little amused when Ruskin singled out Seddon's newly repainted *Penelope* for special praise, declaring that, 'Whereas beforehand he had only regarded Seddon as a landscape painter of great promise, he now saw that he was a great figure painter'. *Penelope* was 'noble in every possible way, showing inventive genius of the highest order', especially in its 'fine breadth and harmony of rich colouring'. When, however, this judgement was repeated in J. P. Seddon's pious memoir of Tom a year later, Rossetti protested: 'I do think the way that picture Penelope is talked about when ... in its present state it is almost more Brown's than Seddon's, is the coolest thing I ever saw ...'.[7]

Jerusalem was duly purchased for the nation. Meanwhile, Brown was organising the first Pre-Raphaelite exhibition, at 4 Russell Place, Fitzroy Square. 'Got up the collection of PreRafael works in Russell Place during the month of June,' he recorded in January 1858. 'On this I must have wasted at least 4 weeks. All that came of it was that Ruskin's father bought the charcoal of *Beauty* for ten guineas.' Preoccupied with making ends meet, he underrated his considerable achievement in bringing the exhibition about.

Russell Place was triggered by renewed prejudice at the Academy, where the Pre-Raphaelites found their pictures either rejected or hung out of sight. Anger at

sales and reputations thus jeopardised finally tipped the balance in favour of Brown's long-cherished project.

His recent success at the Liverpool Academy had encouraged Brown to seek allies among the northern Pre-Raphaelites; now he was quick to enlist their support and that of their influential patron, John Miller. His letters to William Davis, the unassuming landscape painter he so admired, cast unique light on Brown at this period. Acting as Davis's London agent, ensuring that his pictures were seen, he advised him 'to paint from nature', and to choose his subjects carefully for the market they were creating: while children and animals were popular, for instance, 'dogs are scarcely the works to take with our set', while 'still life generally is . . . too unintellectual to be taking with the patrons of the new school'.[8] Grateful for Davis's support in Liverpool, he encouraged the struggling artist in turn: 'Every unlucky man is my brother,' he wrote, and again: 'We shall all be powerful, in our small artistic way, one day, when looking back on early struggles I trust we shall receive our success as a sacred charge entrusted to us to the advancement of true art.'[9]

'Everyone is disgusted and abusing [the hanging committee],' he told Davis in May, 'but as to what is done about it, I firmly believe that their conduct this year will be in great measure the cause of the success of a little private exhibition which we are getting up & to which Mr Miller kindly lends Windus's *Surgeon's Daughter* and your *Ducks*.'[10]

Miller wholeheartedly supported the plan, lending or obtaining loans of many pictures; he was as anxious as Brown that the Pre-Raphaelites should make a major impact on the London art world. To Brown he wrote, 'One thing I advise you, and that is to hang nothing whatever but what is first rate, and passed as such by your select committee. You may thus make your little exhibition extremely attractive — it will be the reverse of the Royal Academy both in quantity and quality.'[11]

Georgie Burne-Jones remembered a 'beautiful little exhibition'. The specially framed paintings were displayed in two first-floor rooms of a private house off Fitzroy Square, to maximum advantage, although G. P. Boyce complained on seeing his 'sunset sketch in North Wales mounted in a wide gilt flat' where it looked 'ridiculously pretentious'.[12]

The exhibition, opening in June 1857, was a semi-private affair, with admission by invitation only and free, to avoid contravening the Academy's ban on works previously shown in public. This assembly of seventy-two works by twenty-two invited artists remained for over a century the most complete survey of Pre-Raphaelite art, despite the poor representation of Millais and Hunt — it being dominated by Brown, with ten pictures, and Rossetti, with seven recent watercolours. Lizzie Siddal, exhibiting for the first time, contributed five works; others included Charles Collins,

Arthur Hughes, John Brett, G. P. Boyce, Robert Martineau, Seddon, Bell Scott, Windus and Davis, to cite the best-known.[13]

Writing to Miller at the end of June, Brown claimed a modest success. Hoping to extend the exhibition into July, he reported: 'the attendance has been such as we have no cause to complain of and I believe that ultimately all those about whom we care ... will have visited the collection, visitors having gone away entirely satisfied.'[14] Even Ruskin, who had walked out on seeing a portrait of Effie by Millais, returned later to praise Windus and Davis, while his father bought Brown's charcoal *Beauty before She became Acquainted with the Beast* for ten guineas.

Critical coverage was limited by the private nature of the exhibition and the universal focus, in 1857, on the great Manchester Art Treasures Exhibition. But favourable notices appeared in the *Daily News*, the *Critic* and the *Spectator*. On 12 July, soon after the doors closed, the *Saturday Review* carried a long enthusiastic article by Coventry Patmore, poet of *The Angel in the House* and early champion of the PRB. He had found the show 'instructive ... especially interesting as showing what are the real views and aims of the people calling themselves Pre-Raphaelites'. He saw throughout the 'simple and sincere endeavour to render genuine and independent impressions of nature', whether it be in the topographical landscapes of Seddon and John Brett, 'whose eyes are simple photographic lenses', or in imaginative works by artists 'who see things in the light that never was on sea or land, but for all that a true and genuine light'. He praised the universal palette of high-keyed colour and avoidance of 'theatricality'. But for him the main interest lay in Rossetti's quaint elaborate watercolours, 'the peculiar tenderness of his conceits'. In terms familiar to Ruskin's readers, but galling to Hunt, Patmore stressed the influence of the little-known Rossetti. He praised *Dante Drawing an Angel*, with its accompanying lines from the *Vita Nuova, Mary Magdalene* and the magical *Blue Closet* (lent by its owner, William Morris) 'for the delight which these must afford all imaginative minds'.

The Last of England appeared in London for the first time. Patmore devoted the latter part of his review to it, noting the dramatic power and fine passages of painting — especially of Emma's face, 'the chief charm of the picture'. Indeed, all Brown's pictures 'were more or less notable for originality of feeling and conscientious workmanship'.

Public perception of Pre-Raphaelitism was now radically changed. The *Athenaeum* anticipated the confusions of a century, writing of

Mr Collins, Mr Millais, chief of the sect; Mr H. Hunt, the apostle of the order; and Mr D. Rossetti, the original founder of the three lettered race who is generally spoken of by them in a low voice and is supposed from the fertility

of his allegorical sketches to be capable of doing anything though he does not and will not exhibit in public ... next to Mr D. Rossetti's thoughtful sketches, the most interesting thing was Mr H. Hunt's last look at England, a fine picture of departing emigrants [with its] Hogarthian fertility of thought.[15]

A year before Russell Place, in 1856, a more ambitious scheme had been mooted by Captain Augustus Ruxton, late of the British army and the Crimea. This enthusiastic young sympathiser had approached William Rossetti proposing a travelling Pre-Raphaelite exhibition in the United States, to acquaint the American public with the new English painting. By June 1857, plans for the American Exhibition of British Art were well advanced. The time seemed opportune; with a buoyant market on both sides of the Atlantic, the British artists were optimistic. A bridgehead had already been established by the Ruskinian art journal *The Crayon*, edited by W. J. Stillman of New York, where articles about the circle had been appearing since 1855. As *The Crayon*'s London correspondent, William Rossetti had played a key promotional role.[16]

He had enlisted Brown's help. Throughout the autumn of 1856, after work at Somerset House, William had been posing in the parlour at Fortess Terrace for a small portrait – a thank-offering for Mrs Rossetti's kindness to Lucy. It was a token, too, of their shared commitment to Pre-Raphaelite art and close friendship: over the next two years, artist and critic worked hand in hand for the cause. The portrait was finished in December, when Seddon's death diverted them to the task of raising money for his widow. Undeterred, by May 1857 Captain Ruxton had visited galleries in the main East Coast cities; in June, William, as Secretary, circulated the artists with requests for pictures. Brown, as chief selector, would accompany the works to America and supervise each installation.

Old dreams revived: the New World held out possibilities that Brown hoped to explore. But, says Hueffer, he 'entertained ideas that intrigues were working against him, and he abandoned the scheme, which at one time had included that of a permanent residence in the New World'.[17] This was not mere paranoia: art politics intervened to put an end to his plans, forcing a drastic revision of the whole American project. Its organisers had not reckoned with commercial interests and on 5 July 1857, the dealer Gambart, alerted by a notice in the *Athenaeum*, informed William that he too had designs on the American market that autumn. The spectre of two rival exhibitions was raised.[18]

Gambart set about disarming William. He had, he insisted, no direct personal stake in such an exhibition; his firm stood to gain from 'anything that spreads and promotes the interest in the fine Arts ... therefore if this exhibition can be well managed by you and your friends I shall at once give up my own project ...' But by 21 July Gambart's tone had changed. Writing again to William, he informed him that the artists he represented (including luminaries like Leighton, Danby and Maclise) were 'indignant' about the proposed exhibition, seeing it as quite unrepresentative of modern British art and unworthy to represent Britain abroad:

> They denounce your ability of gathering a genuine English collection and representing the British school ... if, as I am told on every side, you represent only a very small body of men & have no support of the academical body & the generality of artists I would be guilty of gross neglect towards my friends if, by my withdrawal, I lent myself to the furtherance of the interests of a cottery [*sic*] ...[19]

An unsatisfactory compromise was reached: the two exhibitions were combined and oils by Gambart's artists were brought in to balance the Pre-Raphaelites, augmented by watercolours from his stock. With the exhibition scheduled to open in New York that October, artists were asked to submit works by the end of August 1857.

Brown made the selection, but Gambart appointed his own representative to tour America with Ruxton. 'I was to have gone over to hang the pictures,' the artist noted, 'however the scoundrel Gambart put a stop to that and all I had was the trouble of selecting the daubs.'[20] As he told Davis, 'it gave, or Gambart pretended it gave too much pain to the academic breast.' Yet some small satisfactions remained: 'I have been today at Gambart's examining the works as yet sent in for the American Trip (and between ourselves doing a little in the rejecting line) amongst others one "Persian Maiden" of old Pickersgill — and another Grecian Maiden by the same ...'[21]

In July, Brown resumed life studies for *Work*. An early model was ten-month-old Arthur, the baby in the central group of ragged children. Brown, intensely proud of his son, had made a careful drawing of Arthur the previous December and painted him into *Take Your Son, Sir*, where Emma proffers the child to its father (himself glimpsed minute in a convex mirror). Now, on 15 July, tragedy struck: he had just begun the new drawing 'when our poor little Arthur sickened and died in one painful week'.

At home, troubles multiplied. Emma, who had been seriously ill, was pregnant again but soon miscarried. Finances, too, had hit a bad patch: 'After poor baby's

death I was very hard up, the Russell St exhibition which I paid at first all out of my own pocket (£42) came back to me but slowly and at this date Millais, Rossetti and Miss Sid have never paid their shares and obliged to ask Plint for money to bury him.'[22] With characteristic kindness the stockbroker promptly advanced the money to buy a plot in the new St Pancras cemetery, where Arthur was buried on 25 July. Soon afterwards, Plint bought *Jesus Washing Peter's Feet* from the Manchester Art Treasures Exhibition for 200 guineas, while his unsolicited gift of thirty-eight pounds enabled Ford to take Emma and Lucy to Old Trafford early in October.

The Manchester Art Treasures Exhibition – the first great international art survey in Britain – was the cultural triumph of 1857. Besides its old masters, selected from royal and private collections all over England, the British section included many masterpieces. Woolner returned full of excitement about the English works, 'almost too rich, with watercolours of Turner, William Hunt, David Cox transcendentally beautiful and Mulreadys marvellous'.[23] But Holman Hunt was more concerned with living artists, urging Brown to come and take stock of their contemporaries: 'The English pictures,' he reported, 'are unworthy *as work* to the superiority of the thoughts they ... embody, but works so feeble in line and colour as most of them are can scarcely be said to embody anything. I think we show to great disadvantage and that ... we ought to hold a council upon the matter. So come and talk.'[24]

In his diary, Brown dismissed the Art Treasures in a few cryptic lines: 'At Manchester (to give one recording line to it) all I remember is that an old English picture of Richard 2 [the Wilton Diptych] was the only really beautiful work of the Old Masters and Hunt and Millais the only fine among the new. Hunt in fact made the exhibition. The music was jolly and the waiters tried very hard to cheat.'[25] He did not mention his distress, recalled by Hunt, at finding *Jesus Washing Peter's Feet* hung far too high. According to Hunt, 'It was well seen, although above the line', but another witness, the Manchester artist Frederic Shields, saw the picture 'almost out of sight in the roof space'.[26]

Brown's projects embraced his domestic as well as professional needs. The ideal of working communities, widespread in the nineteenth century, was attractive to these

friends whose individualism, common opposition to the Establishment and bohemian life-style set them apart from their conventional peers. Brown's career exemplifies the dilemma of the isolated artist: for him the community ideal was never far away.

His self-exile with Emma in north London made it more desirable. For Hunt and Gabriel, Brown the family man was something of a father-figure and, at the height of the Seddon fund-raising of 1857, both men were keen to share quarters with the Browns. But, according to Hunt, the womenfolk were to blame for the failure of the scheme. For some years Hunt had been obsessed with beautiful Annie Miller, his model for the kept woman in *The Awakening Conscience*, whom he had determined to mould, educate and marry — 'a most syren-like' creature, according to Brown, whom Hunt had consulted about her education and flirtations, especially with Rossetti. 'They all seem mad about Annie Miller and poor Hunt has a fever about it ...' Brown had noted in July 1856.[27]

In March 1857, 'Hunt came in and talked about a college plan & staid till 12.' A scheme involving two or three married couples living together was projected, but foundered on the problem of Gabriel and Lizzie. 'Miss Siddall has been here for 3 days,' Brown notes on 16 March, 'and is, I fear, dying. She seems now to hate Gabriel in toto.' No wonder, for despite all his promises of a honeymoon in sunny Algeria, and several loans from Brown, Gabriel had successfully evaded marriage.

Brown's indulgence of Rossetti rested on a conviction that Gabriel's real interest depended on this marriage and this unique insight into Rossetti's psyche was vindicated by events. Justice apart, he understood Lizzie's importance for him at the creative level, and the idea of sharing 'married quarters' with Hunt was a last-minute attempt to persuade him into matrimony. It failed, for Lizzie had long detested Hunt, resented Annie's ascendancy over Gabriel and angrily vetoed the idea.[28] There was no more talk of marriage, and the college scheme was dropped.

For months now Gabriel had been basking in the stimulating company of William Morris and Edward (Ned) Jones, who were learning to paint under his direction as Lizzie had once done. In Rossetti's old rooms at Red Lion Square, Morris was 'doing the magnificent' and together the three were busy decorating their 'intensely medieval furniture'.[29] As *primus inter pares* in this male company, Rossetti blossomed as never before. Lizzie was not introduced to these new friends, whose long working days ended with visits to the theatre or convivial evenings with other female company. Thus excluded, she took herself off in July to her family in Sheffield, intending to make a final break.

She had good reason to be angry; although she had posed for Rossetti as *Guenevere*, she was not invited to take part in the all-male enterprise starting at the Oxford Union. This prismatic assault on the walls of the new debating chamber, a

project redolent of Gabriel's enthusiasms and fine carelessness, was the happiest episode of his life, surrounded as he was by a hand-picked band, his personal and artistic supremacy unquestioned, all irksome responsibilities shed: his acolytes 'sank our own individuality in the strong personality of our adored Gabriel'.[30]

Though enthusiastic about the Oxford murals, Brown refused Rossetti's invitation to work on them. What with the aftermath of Russell Place, selecting pictures for America, his long-neglected *Work* and family commitments, he could not afford it. Even Rossetti, writing from Oxford to apologise for not paying his debts, admitted 'one is mad to do such things'. Mad, Brown must have thought, on several counts – starting with their blithe ignorance of mural painting. Whether he, with his hard-won knowledge of fresco, might have saved those bright Arthurian dreams by proper preparation of the porous brick surface and a medium more permanent than distemper is an intriguing question. As it was, they flaked and faded into invisibility within months.

He paid a flying visit to Oxford on the last day of October. Rossetti and his friends were playing whist one evening at their George Street lodgings: 'Rossetti and I versus Top [Morris] and Faulkner. Madox Brown turned up. Rossetti said that Topsy had the greatest capacity for annexing dirt of any man he had ever met.'[31] Like all visitors, Brown was swept up in the atmosphere of rampant high spirits, writing to Emma in the small hours of 1 November: 'We are very jolly here and they much want me to do one of the works but as it would not pay I think there is small chance of my consent being obtained. The Oxford Museum is very fine … I have been up ladders this morning eighty feet high, making me feel quite giddy … Neither William nor Hunt have come, but there are lots of good fellows of all sorts …' It would be twenty years before his own opportunity came.

Soon the party was over. On 14 November, Rossetti left to join Lizzie at Matlock, in circumstances still far from clear, remaining there, off and on, until the spring. His *Vision of Sir Launcelot* was never finished.

Meanwhile, in New York, the Exhibition of British Art had opened to a hailstorm and a Wall Street crash. 'Literally,' Ruxton reported, 'money is not to be had.' The six galleries were filled to capacity with over a hundred works, and Ruxton reported on the opening on 19 October. 'All the leading people of the city were present – indeed the rooms were crammed and the most cordial and kindly feeling was manifested … Madox Brown's *King Lear* [*Cordelia at the Bedside of Lear*] seems to be

the most popular picture of the exhibition.'[32] But the display confused the New Yorkers: the Pre-Raphaelite works were scattered among, and heavily outnumbered by, Gambart's stable of 'safe' academic painters — some of whom ironically caused offence, notably Leighton, whose classical nudes had to be huddled out of sight.

On 15 November Stillman of *The Crayon* informed William Rossetti that

> The Pre-Raphaelite pictures have saved the exhibition so far ... there must be something vital and earnest in a picture to make it interesting to our public — and any picture which has not that had better stay in England. The PRB pictures have, I venture to say, attracted more admirers than all the others for this reason and at the same time been more fully appreciated than they are *at this day* in England.[33]

In January they opened at the Pennsylvania Academy of Fine Arts, Philadelphia. Here Brown, who had sent *Cordelia at the Bedside of Lear* and three watercolours, sold his small *Hampstead from my Window* to a local businessman. For Boston that April he substituted *Jesus Washing Peter's Feet* and *An English Autumn Afternoon*, which attracted much enthusiasm. *Cordelia*, again, appealed to the critics. The *Boston Daily Courier* (15 May 1858) thought that

> by subject and treatment [it] claims the first place ... for true grandeur of conception, the character of magnificence ... expressed in the royal design of all the costumes and properties ... there is an all pervading air of romantic regality in it and notwithstanding the brightness and warmth of light that falls on the prostrate monarch and the tents and cliffs in the distance ... a tragic gloom both penetrating and profound.

But it did not sell, and at the end of the tour Brown was not only out of pocket, as usual, but without pictures for autumn exhibition. He wrote angrily to William, complaining of their late return and the damage done by storms and careless handling.[34]

Brown's most ambitious bid for autonomy was the Hogarth Club, so called in honour of that painter's role in the Free Society of Artists a century before. In its short and turbulent life (April 1858 to December 1861), the Hogarth provided a central

exhibiting forum where artists could meet and relax with friends and patrons. The experiment had far-reaching consequences. At its height, the membership embraced many leading talents of the day – men of letters and architects as well as painters, anticipating the Grosvenor Gallery, the Art Workers Guild, the Arts & Crafts Exhibition Society and the New English Art Club. Its catholicity broke new ground, embracing decorative as well as fine arts. But jealousies, factions and financial problems dogged the club, leading to its early demise.

Holman Hunt later claimed that he had joined the Hogarth to placate Brown once the 'college' scheme was abandoned. 'Having had to discourage Brown in his Utopian plan, I felt obliged to become a member of the Hogarth Club. We fixed upon this name to do homage to the stalwart founder of modern British art.'[35] In fact, the project stemmed from their Manchester meeting in the autumn of 1857, and Hunt's involvement was taken for granted, as evidenced by the landscape painter Alfred Hunt, who, in March 1858, reported Rossetti's invitation to join a new 'PreRaphaelite association of which Holman Hunt's and Windus's pictures are to form the chief attraction'.[36] But Hunt rapidly cooled to the project, excusing himself from the preliminary meetings and making much of the expense and trouble. He did not join for months, sent (to Brown's chagrin) 'scrappy and poor' works to the first exhibition and always thereafter ran the Hogarth down to his friends.

Hunt was not alone in not wishing to offend the powerful art Establishment. Alfred Hunt found 'these divisions most unfortunate', and Leighton also felt uneasy within the club. But more distasteful for Holman Hunt, in the spring of 1858, was the prospect of professional association with Rossetti, towards whom he now felt real bitterness. If in 1857 Hunt had seen the Hogarth as a potential sphere of influence, a chance to reassert his leadership of the Pre-Raphaelites, Rossetti's ascending star made him change his mind. There was first the running sore of the affair with Annie Miller. Next he was enraged by Ruskin's constant 'laudations', in conversation and in print, of the man Hunt still regarded as a pupil who had never mastered 'our principles'. Thirdly, his and Millais' invention of Pre-Raphaelitism was being ignored as, fresh from his Oxford Union *réclame*, Rossetti was credited with inspiring the original movement. Now a clique of younger artists looked to him, not to Hunt, for inspiration. Caught between loyalties, Hunt knew that Brown would always support Rossetti, for whom the club would be a showcase. If, as Hunt later claimed, 'an envious spirit' was at work in the club, his own was at least partly to blame.[37]

The inaugural meeting was held in Morris and Jones's rooms at 17 Red Lion Square on 10 April 1858. Brown was now especially close to Ned Jones, whose development he had supported with practical advice and encouragement. 'Madox Brown is a lark!' Ned had written soon after he met the older man. 'I asked him the

other day if I wasn't very old to begin painting and he said "Oh no, a man I know began older. By the bye he cut his throat the other day."' After the murals, with Morris and Rossetti out of London, Ned turned increasingly to the Browns for support. With Arthur Hughes, he found a large house in Kensington where they might all live and work.[38]

Shy, effusive and delicate, Gabriel's young protégé readily inspired affection, and Jones in turn adopted Brown as a father-figure. Taking his cue from Rossetti, he was soon addressing him as 'dear old Bruno' and consulting him on art, business and love. Brown it was — that 'wisest and kindest of friends' — who fostered his courtship of Georgie Macdonald, inviting this talented sixteen-year-old to join his little 'Academy' of female pupils at Fortess Terrace. Her later recollections of the Brown household are filled with affection:

> Who that was present at it could ever forget one of their dinners, with Madox Brown and his wife seated at either end of a long table and every guest a welcome friend who had come to talk and to laugh and to listen? For listening was the attitude into which people naturally fell when in his company. He had so much to say and was so happy in saying it that sometimes he would pause, carving knife in hand, to go on with his story until Mrs Brown's soft voice could be heard breathing his name from her distant place and reminding him of his duties.[39]

The close relations thus formed, though later soured, were of the greatest importance to both artists.

Ned gave active support in setting up the Hogarth, hoping it would fulfil their long-cherished dream of a community. He and Spencer Stanhope, also fresh from the Oxford murals, 'thought it would be nice to have a club where we could chatter', and both were present on 10 April when Brown was elected Chairman and F. G. Stephens Honorary Secretary. Gabriel was away but William Rossetti, Boyce, Burton, Morris, Hughes, Woolner and Wallis all signed the invitation to fellow artists. There were to be two kinds of membership — 'artistic', and 'non-artistic', the latter being patrons and sympathisers — while Browning, Carlyle, Delacroix and other eminent men were accorded honorary membership. Despite professional jealousies expressed in constant blackballing of artist candidates, membership grew steadily from thirty-eight in the first year to eighty-eight by 1860. By this time, with a sprinkling of Academicians, the original strong opposition to the Academy had softened.[40]

Once again, Brown threw himself into organising exhibitions — this proving even more frustrating than his earlier attempts. In July 1858 premises were found at

178 Piccadilly, and Stephens invited the members to send '... such Works of Art as you may desire to place in the club rooms for private view'. But the rule governing access and publicity discouraged many. Visitors had to have tickets whose use was 'conditional that no publication, notice or criticism of any kind whatever be made on the works placed in the club rooms'. Returning in September from Southend, where he had taken Emma for a working holiday, Brown found the club room deserted. To Davis he wrote: 'The Hogarth has been languishing frightfully, but of course everyone has been out of town & little else was to be expected but certainly a very strange disinclination to go there has manifested itself among its members.'[41]

In the first full year, 1859, two formal exhibitions were held. In January some works submitted failed to come up to scratch, raising the eternal problem of selection. Rossetti objected to Alfred Hunt's landscapes and three paintings by Burton — '3 staring shop Puseyisms'. Anxious to show his Llandaff altarpiece, he urged post-ponement until 'better things were ready'.[42] In the event, eighty works were shown — too many for the small room: some had to be placed in a passage and others in portfolios.

Brown was again the largest single exhibitor, with ten works — including the early *Southend*, newly brightened and improved, and his first stained-glass cartoon, *The Transfiguration*, for glassmakers Powell & Son. Rossetti sent four rich watercolours, anticipating his sensuous oils, while Hunt 'has not treated the club well, sending only a scrubby pen and ink drawing one of his worst productions'.[43] The outstanding new talent was that of Ned Jones, whose nine pen-and-ink designs and cartoons for stained glass — 'wonderful things all', as Rossetti enthused — were widely admired.[44] With five architectural drawings by the Gothic revivalists Bodley and Street and Brown's glass cartoon, these set out a new agenda, projecting that greater unity of decorative and fine arts which would later characterise the Morris Firm. As the number of architect members increased, to include Philip Webb and Benjamin Woodward in 1859, so this trend became more pronounced.

Dissension marred the second exhibition, that summer, which included Wallis's *The Stonebreaker* and two landscapes by John Inchbold. Infuriated by the reception of Gabriel's watercolours, Hunt sent his own early *Valentine Rescuing Sylvia from Proteus* as a direct challenge to his former friend. But a more fundamental issue affected Brown. Along with pictures, he had sent several designs for furniture, but had reckoned without the hanging committee — an aspect of the Hogarth's increasingly hierarchical structure. Astonishment turned to rage when the club's founder saw these designs rejected as not 'art'. Furious, he arrived in a cab, removed all his works from the already-hung show and resigned from the committee on the spot.

10
WORK

Work! which beads the brow and tans the flesh
Of lusty manhood, casting out its devils!
By whose weird art, transmuting poor men's evils
Their bed seems down, their one dish ever fresh,
Ah me! For lack of it what ills in leash
Hold us. Its want the pale mechanic levels
To workhouse depths, while Master Spendthrift revels
For want to work, the fiends soon him immesh.

Ah! beauteous tripping dame with bell like skirts
Intent on thy small scarlet-coated hound
Are ragged wayside babes not lovesome too?
Untrained their state reflects on thy deserts
Or they grow noisome beggars to abound,
Or dreaded midnight robbers, breaking through.[1]

MID-DAY ON THE MOUNT, Hampstead. Out of a brilliant sky, the July sun beats down on some workmen digging a deep trench. Their teamwork is impressive. Some excavate underground, heads and shovels just visible, while another descends a ladder with a hodful of bricks to line the manhole. Above ground they prepare the mortar, riddle gravel, mix sand with lime and carry buckets of water. It is hot work, and the elms overhead provide little shade from the sun. Sleeves are rolled up over strong brown forearms, and brightly patterned caps and kerchiefs protect the men's heads. A big brickie pauses for refreshment, downing a pint from a pewter mug as the potman winds his way through the group bearing pipes, tobacco and newspapers. 'Beer ho!' he shouts, jangling the coins in his apron pocket. Business is brisk.

The gang presents a self-contained group, their muscular bodies eloquent of a healthy outdoor life: by contrast, the Hampstead passers-by look pale and overdressed on such a day. They resent the inconvenience. Above the men, a top-hatted monocled colonel and his daughter return from a canter on the Heath to find their route blocked: they rein in their horses, silhouetted for a moment against red-brick Mount Square. But pedestrians are squeezing past in single file, like the pastrycook and the two fashionable ladies: a fair young one and a respectable matron holding her daughter's hand. Spotting the brickie with the pewter mug, the matron launches a temperance tract at him; it flutters unnoticed into the trench, catching the bright sunlight. In front, a barefoot herbseller holds everyone up. A strange, wild figure, he clutches his precious basket of plants, surveying the world fearfully through a torn hat brim. Meanwhile, the young lady's Italian greyhound in a smart red jacket bounds ahead, to find his way barred by growling class enemies: a mongrel dog and the navvies' bullpup.

The mongrel belongs to the ragged and motherless children in the foreground. Look more closely and you may recognise this family as the greengrocer's children — late of Finchley and the *Eldorado*. Beyond the young girl's outstretched arm lies a grassy slope where unemployed farm-workers lie, heads cradled in brawny arms, scythes and rakes propped beside them. In the shade of the trees, Irish vagrants rest. It is dinner time, and a young couple feed their baby from a tin mug. An older man leans against a tree, watching the policeman as he moves an orangeseller along, knocking her bonnet askew and sending the bright fruit tumbling into the road in a shower of violet shadows. Above, small children watch as a procession of sandwich-boards snakes its way up Heath Street urging 'Votes for Bobus Higgins', to encounter a coach and horses rounding the bend. A mounted policeman and rifle-carrying soldiers are discreetly present, while children swing on the railings and a small girl displays her bottom to the world.

Fashionable Hampstead encourages Enterprise. An estate agent's board advertises 'A Genteel house for sale', while a poster offers fifty pounds for information about a highway robbery; 'Money! Money! Money!' shouts another. Charity is fashionable, too, with notices about the Working Men's College and a fund-raising evening for the Boys' Home in Euston Road. Meanwhile, the Flampstead Institute of Arts caters for culture, advertising Professor Snoöx's popular lecture on the domestic cat. Above, on the parapet, moggies stretch in the sun.

Two professional men take in the scene. The taller, with wideawake hat and walking-stick, is Thomas Carlyle. The other, hatless, holding a book, watches the workers thoughtfully. He is the Revd Frederick Denison Maurice, much-loved Principal of the Working Men's College.

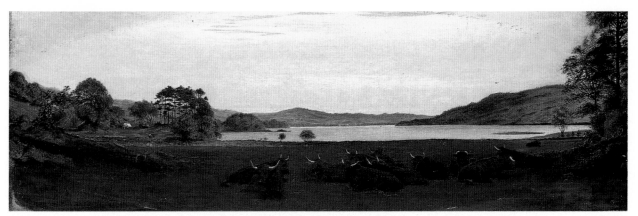

106

107

106 *Windermere*, 1848, retouched 1855.

107 *Southend*, 1846, retouched later.

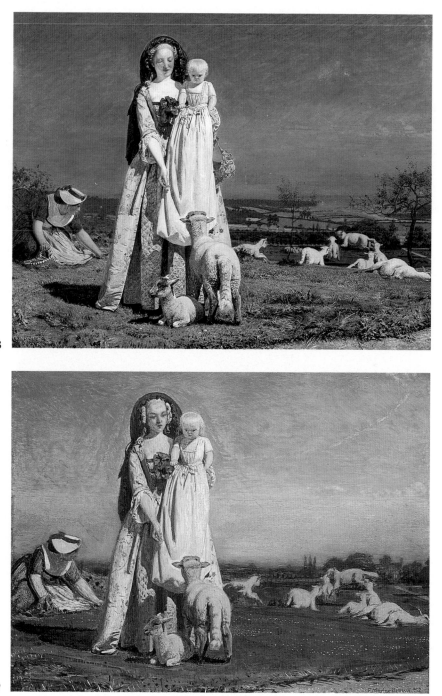

108 *Pretty Baa Lambs*, 1851–2. Exhibited RA, 1852,
Newcastle, 1853, Glasgow, 1854. Contemporary of
Hunt's *The Hireling Shepherd and Strayed Sheep*.

109 *Pretty Baa Lambs*. Replica, 1852, with original
Clapham background.

110

110 *Waiting*, 1851–4. Adapted for the Crimean War
(originally *An English Fireside*).

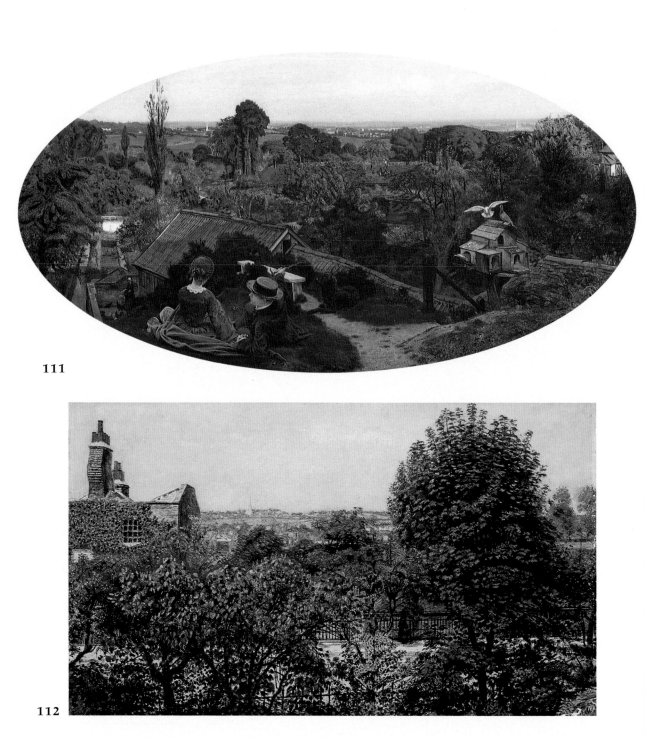

111

112

111 *An English Autumn Afternoon*, 1852–3. Exhibited British Institution, 1855.

112 *Hampstead from my Window* (*A Sketch from Nature*), 1857.

113 *The Hayfield*, Hendon, 1855–6. Bought in August 1856 by William Morris.

114 *The Brent at Hendon*, 1854–5. Painted at the same time as *Carrying Corn*.

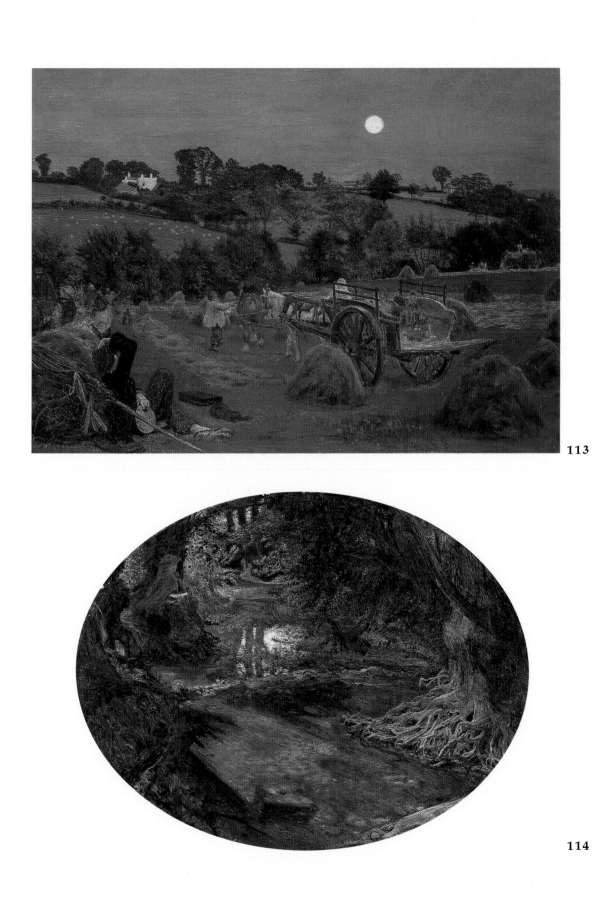

113

114

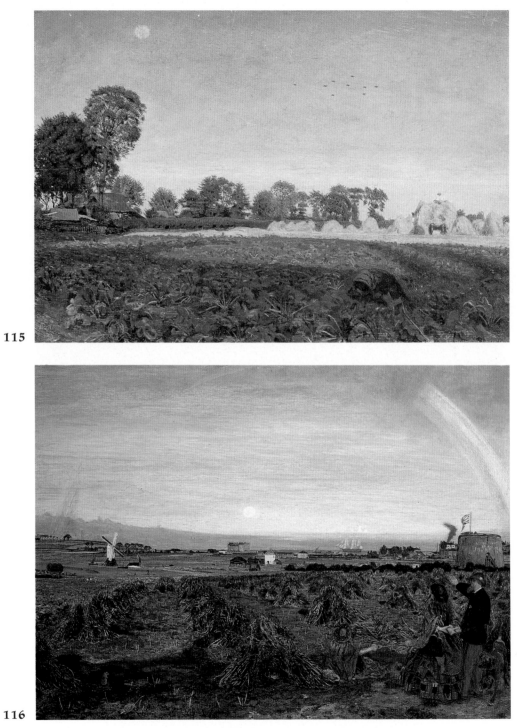

115 *Carrying Corn*, 1854–5.

116 *Walton on the Naze*, Hampstead, 1859–60. Brown,
Emma and Cathy appear in the right foreground.

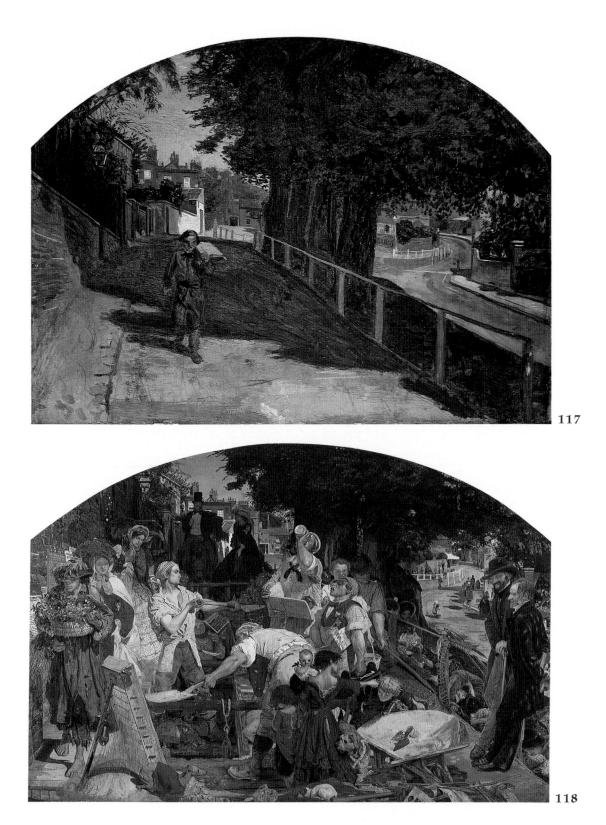

117 *Heath Street, Hampstead*, 1852. Figure of butcher's boy added 1856. The scene of *Work*, it preceded that painting.

118 *Work*, 1852, 1856–63. Exhibited 1865.

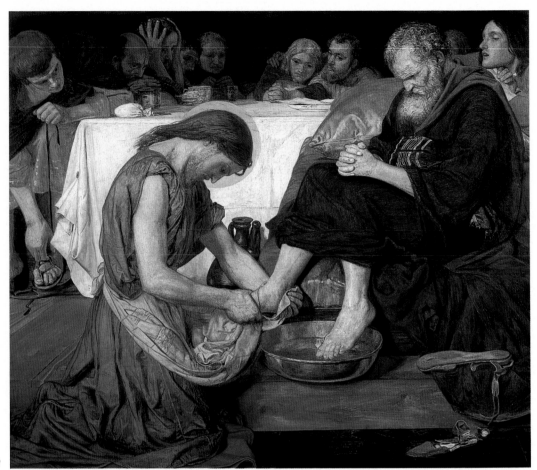

119

121

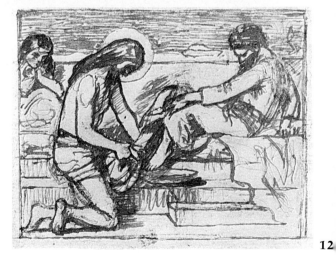

12

119 *Jesus washing Peter's Feet.* 1851–2, later retouched. Exhibited RA 1852.

120 Study of *Jesus washing Peter's Feet.*

121 *Cromwell on his Farm at St Ives,* 1853–6. Study.

A low-arched frame bearing three inscriptions encloses this painted world. In the left spandrel, above the fashionable ladies, appears this text, an ironic commentary on their life-style:

> Neither did we eat any man's bread but wrought with labour and travail night and day [2 Thess. 3:8]

Above Carlyle the writer and Maurice the philanthropist is written:

> Seest thou a man diligent in his business? he shall stand before kings [Proverbs 22:29]

while above the central group of workmen we find the key to the whole, lines from St John's gospel:

> I must work while it is day, for the night cometh, when no man can work [John 9:4]

reinforced below by a more general exhortation:

> In the sweat of thy face shalt thou eat bread [Genesis, 3:19][2]

No reproduction of this picture reveals the rich detail of the original or does justice to its superb colour. *Work* is quite large (137 × 197.3 cm) and perfectly legible seen at eye level and in good daylight. But the real matter for regret is that Brown did not paint this most public and public-spirited of nineteenth-century pictures on the monumental scale implicit in the conception, being denied the longed-for mural commission when at the height of his powers.

The masterpiece which hung at the centre of Brown's 1865 retrospective had been thirteen years in gestation. A piece of observed actuality one summer day in 1852 became in turn a Hogarthian morality, a Carlylean critique of class relations in Victorian Britain and a full-blown Tract for the Times. As these developments ever more intimately reflected the artist's world, so they demanded more of the viewer until *Work* became a veritable novel in paint.

It never was a 'realist' painting. Like the early Flemish pictures Brown knew so well, it presents a central idea in concrete, everyday images realised with great intensity. In the collective activity of the navvies, the idea of work-in-society assumes a religious significance, transcending humdrum reality, while innumerable symbolic details of activity, dress and behaviour build up the whole. The element of grotesque is Flemish too – in Carlyle and the potman, in the hostile dogs, in the half-glimpsed navvies in the trench: beauty is secondary, arising from the intensity of the painting rather than any preconceived ideal.

From its opening pages, Brown's diary shows the absolute value he attached to work:

> ... of one thing fortune cannot rob me – the pleasure I have already extracted, distilled I may say from the very work itself; warned by bitter experience I have learned not to trust only to hope, nor to consider toil a sacrifice, but to value the present, the pleasure that I have received and daily yet receive from the marking out of a subject after mine own heart ...[3]

This belief in work as both natural duty and source of fulfilment accounts for the self-exhortations as well as for the carefully recorded working hours each day. Brown readily identified with those who toiled to earn a living and he disapproved of 'the idle rich', as several entries in his diary show. His 'socialism' and his class-consciousness had their roots in the work ethic.

Though middle-class by birth, Ford Madox Brown had seen his father's career cut short by ill-health and his old age blighted by official neglect. In this he identified with Hogarth, whose talented father had died in poverty. Young Brown – expected early in life to change all this by a successful career in art – came to resent the 'nobs' who failed in turn to become his patrons. Conversely, he felt drawn to unrecognised but deserving workers, whom he invariably sought to help.

Brown's democratic and republican sympathies, inherited from his Whig father and grandfather, were nurtured in the revolutionary Paris of the 1840s. Although contemptuous of political parties and institutions, he had a marked dislike of privilege or luxury, and was quick to explode pretensions of any kind. The pastrycook with his tray, for example – a common sight in the wealthier parts of London in the 1850s – struck him as a 'symbol of superfluity' provoking 'a certain socialistic twinge'.[4] Appearing among 'the rich who have no need to work ... at least not for bread' he evokes the politics of 1789.

Ford Hueffer characterised his grandfather's early political outlook as being compassionate in nature. 'It was only in later life,' he wrote, 'that he came to regard

the relief of distress as a matter too far-reaching to be solved by ... individual or even organised charity.'[5] In the 1880s, indeed, shocked by the plight of the Manchester unemployed and influenced by William Morris's revolutionary ideas, Brown spoke at demonstrations and started a labour bureau. But *Work* is itself a seminal document of British socialism. In progress throughout Brown's early association with Morris (1856–63), the painting must have had a formative influence on the latter – not least for its identification of the artist with the manual labourer. This identification, as we have seen, was at its height in 1852 when Brown made common cause with the workmen – his feelings reinforced by his liaison with a bricklayer's daughter and direct experience, through her, of working-class poverty and solidarity.

Four years of poverty and discouragement had elapsed between that summer and the commissioning of *Work* in 1856. While wrestling with *The Last of England*, he took up his old design and developed it in earnest in the parlour at night. His enthusiasm was rekindled by Woolner, who visited Church End in December 1854, saw the landscape background and 'liked it much'. In gratitude to 'Tommy', whose emigration had helped to inspire *The Last of England*, Brown worked up the original Heath Street sketch, added a butcher's boy and gave it to him in 1856.

His diary records his growing excitement as the composition came to life: 'This evening worked at the design of the Hampstead picture. Whenever I set too at designing I feel in the most etherial and extatic state possible. I do not hurry with it because it is such enjoyment. Tonight I arranged the chief navvy tossing off the beer, also the one decending the ladder ...' Then followed the figure of the artist himself, the couple on horseback, the navvies again: 'the pot boy a triumph, the mortarman perfection and the ragged child getting cuffed, all creations and the whole becoming more and more exciting'.[6] All this consoled him at a time of intense financial and personal anxiety.

He set *Work* aside in February in the race to finish *The Last of England*, but resumed it again on 29 April: 'All day at the designe of Worke. This is now to me a species of intoxication. When I drew in the poor little vixen girl pulling her brother's hair I quite growled with delight.'

In November 1856, 'inveigled here by Rossetti', Thomas Plint of Leeds called at 13 Fortess Terrace. A youngish businessman and stockbroker, Plint bought pictures for investment, but he was also a cultured philanthropist, devoutly evangelical, who liked a picture with a moral. Seeing the studies for *Work* among the canvases stacked in Brown's studio, he perceived its possibilities and, a few days later, commissioned the painting, hoping to see it at the Academy in 1858.

From the outset, Plint took an active interest in 'his' picture, proposing alterations and additions that would express his own social concerns. Could Mr Brown, he

asked, add two figures, 'a young lady as a tract or bible distributor and ... another, to give more fully the head and heart of the work of the mind'? Brown agreed, but, still not quite satisfied, Plint wrote again on 24 November:

'Could you introduce *both* Carlyle and *Kingsley*, and change one of the four *fashionable* young ladies into a *quiet, earnest, holy*-looking one with a book or two and *tracts*? I want *this* put in for I am much interested in *this* work *myself* and know those who are,' adding with characteristically naïve kindliness, 'Think this matter over, and excuse me asking you.'[7]

To accommodate these figures Brown sacrificed his own place as artist-observer, changing the original meaning of the work. Instead of Kingsley, who was a country parson, he chose F.D. Maurice, co-founder of Christian Socialism and Principal of the Working Men's College. Thus through the intervention of his patron were introduced the religious and philanthropic elements which made Brown's class-based critique of English society acceptable.

Work is among the great tributes paid by one artist to another. Brown's admiration for Carlyle – his favourite prose writer – has been mentioned. He marked passages of particular interest in his copies of Carlyle's books,[8] and in August 1855 a visit to the Duke of Sutherland's picture gallery at Stafford House prompted this fine Carlylean entry in his diary:

The magnificence of the place, such as I had never witnessed but in Pallaces, gave food for much reflection ... how strange a place is this world, only those seem to possess power who don't know how to use it. What an accumulation of wealth and impotence is this which is gained by stability and old institutions. Is it for this that a people toils and wearies out its miriad lives, for such heaping up of bad taste, for such gilding of hidiousness ... Oh how much more beautiful would 6 model labourers cottages be, built by a man of skill for £100 each. As Carlyle said 'enough to make not only the angels but the very jackasses weep'.[9]

That December, Brown was deep in Carlyle's *Miscellanies*. Critical though he was of the 'many immensities, eternities or suchlike superfluities' and pages of 'mere gilded wind bladders' in his hero's prose, he forgave 'the glorious kind hearted old chap' for writing books fuller of 'real gold & solid weight and close packed wisdom ... than any other writing now published.'[10]

Work's thesis derives in particular from *Sartor Resartus* (1831) and *Past and Present* (1843). In his day Carlyle was the most widely read and influential critic of

modern industrial society. In aphoristic and rhetorical prose he had attacked capitalism as a fraud and ridiculed the utilitarians for their faith in 'the gospel of Mammonism'. The consequences of neglecting social justice seemed all too apparent in the civil unrest, riots and strikes of the 1840s, and Carlyle's warnings impressed an uneasy middle class. His ideal organic society – governed by mutual helpfulness rather than fair competition and the cash nexus – no less than his gospel of work, made sense to many. Carlyle's countervailing dislike of democracy, firm belief in social hierarchies and cult of the strong hero-leader were only later pushed to extremes, alienating the support of Brown's circle.

Carlyle's interest in 'types' of benevolent or erring humanity is also reflected in *Work*. Bobus [Bogus] Higgins, the election candidate, is an obvious borrowing: a type of unscrupulous modern manufacturer with a fortune made in adulterated food, his political pretensions are satirised in *Past and Present*. The posters on the street walls are also humorous variations on Carlyle's theme of 'Mammonism'.

In passages often quoted in the context of *Work*, Carlyle had touched on the nobility and necessity of work, had contrasted industry and idleness, had attacked the 'Unworking Aristocracy' and the dilettanti for exploiting the poor and had warned against flouting the 'Laws of Nature'. Less familiar, perhaps, is the double tribute to manual and intellectual workers in *Sartor Resartus*. At the centre of his stratified society, Brown depicts the hand workers, set apart by the tools of their trade from machine 'slaves': 'Venerable ... is the rugged face all weather-tanned, besoiled, with its rude intelligence; for it is the face of a Man living manlike.' Complementing them, to the right, is the class Carlyle admired 'still more highly: Him who is seen toiling for the spiritually indispensable; not daily bread, but the bread of Life ... Highest of all, when his outward and his inward endeavour are one: when we can name him Artist; not earthly Craftsman only, but inspired Thinker ...'[11]

Carlyle's philosophy is not 'illustrated' but forms the very substance of Brown's painting. For example, the symbolic distribution of light and shade (used in *Harold* to distinguish conqueror from conquered) separates the very rich at the apex of the pyramid from those at its base. The couple on horseback cannot enter the navvies' sunlit space; their way and, by implication, society's progress is barred by potential class conflict. Riding into the shadows, the couple symbolise Carlyle's warnings to his rich contemporaries.

Sartor Resartus examines the way in which people in modern society define themselves through dress. The English dandy 'whose trade, office and existence consists in the wearing of clothes' is contrasted with the many variations of the 'slave costume' of the poor – mostly other people's cast-offs. In *Work*, Brown too distinguishes sartorially 'those that work, the brainworkers, those who have no need

to work and the idlers', with all the force of caricature. The hatmaker – epitome of Mammonism in *Past and Present* – is acknowledged in the cast's distinguishing headgear.

Lastly, the threat overhanging the governing class is underlined by Brown's placing of the poor alienated flowerseller, the hostile dogs and the ragged children at the base of the pyramid: in this democracy, policemen and soldiers with rifles must patrol the streets.

By the time Brown began painting his figures in March 1857, the euphoria of the commission had faded. Unable, like Rossetti, to play *Work* off against other commissions, he now began to rely for bread and butter on the sale of retouched older works and replicas – quicker and cheaper to produce. These distracted him, but *Work* dragged on for six years largely because of its complexity. As Hueffer says:

> To fall in line with Madox Brown's methods everything must be ... where possible, painted from Nature. Workmen in pits must be painted in pits, and pits must be dug out or sought; mortar must be turned again and again to get the requisite soiling of a spade. Of each implement studies must be made in just the right shade or ... requisite glare of sunlight ... it is scarcely to be wondered at that lists of pictures and bank balances fell away before this almost ceaseless work.[12]

True, also, to principle, each character had to be drawn from life – using friends and family wherever possible, but no professional models. His first sortie was in search of suitable Irish for the vagrants and unemployed:

> Tuesday last I went into Gray's Inn Lane to look for Irish people & after some prowling about found a poor woman and baby in Holborn who next day brought me a young man & in six days I painted these three into the picture ... Two days I painted at the head of the man mixing mortar from the Irishman & today ... the man leaning against the tree ...[13]

He persisted, despite a vintage quarrel signalling Lizzie's final break-up with Gabriel: 'To Hampstead with Emma. Heard Miss Siddall abuse Gabriel & afterwards bought a very dirty old wide awake off the head of a man I met & went home and painted it.'[14] By August he was painting the young workman shovelling – the 'hero' of the picture. By November the hero's legs were under way '& the figure of the man with the hod, chiefly in the open air from a navvy I had met in the streets'.[15]

Such street-raiding was commonplace in his circle – Rossetti habitually accosted

handsome women and invited them to pose – but, in bringing his Irish and working-class models to Fortess Terrace, Brown's purpose was as much sociological as artistic. His genuine interest in his sitters made them willing collaborators, and his discussions with the navvies produced valuable insights into their working lives:

> ... if you can break through the upper crust of mauvaise honte which surrounds them in common with most Englishmen you will find them serious, intelligent men, with much to interest in their conversation which ... contains about the same amount of morality and sentiment commonly found among men in active ... walks of life; for that their career is one of hazard and danger none should doubt ...[16]

With the very poor, he was equally genuine and unaffected. In January 1858 he records a visit to '[Burne-]Jones ... with an outfit Emma had purchased at his request for a poor miserable girl of 17 he had met in the street at 2 am, the coldest night this winter, scarce any clothes and starving, in *spite of prostitution* after only 5 weeks of London life ...' The Browns involved themselves with such cases quite naturally and, as Hueffer noted with a hint of disapproval, 'his tendency to give monetary, as well as monitory, assistance to all and sundry askers materially straitened his circumstances and occupied his time'.

Instances of Emma's good nature also abound. When the Gilchrist family went down with scarlet fever (Alexander Gilchrist, a friend of Rossetti, died in the epidemic), Emma volunteered to nurse the children – until Mrs Gilchrist, discovering the ages of Cathy and Nolly, forbade such a sacrifice.

Cathy's abiding memory was of her parents' open-handed charity to local unfortunates – to 'Crazy Jane' who slept under the hedges of Kentish Town and was fed and clothed (was she the source of Brown's herbseller?), to the unmarried mothers who called at the house and to the artist friends down on their luck who regularly appeared for Sunday lunch. Equally characteristic was the opening of a soup kitchen at Fortess Terrace in the harsh January of 1860. With poverty and hardship all around, generosity was their natural response.

They were poor enough themselves. Cathy remembered being kept indoors for weeks for lack of boots, and the tragedy of Arthur's death in 1857, when Plint had to advance money for the funeral, sharply illustrates their situation.[17]

New departures in education held greater hope for the poor. Brown's interest in teaching workmen went back to his association with Seddon and Thomas at the North London or 'Camden' School, a precursor of the Working Men's College founded in 1854. A flagship for Christian Socialism, this latest experiment in

'collegiate' adult education attracted enthusiastic support: Ruskin was actively involved as a drawing teacher, and Rossetti, Lowes Dickinson and Woolner all gave up an evening a week to teach at Great Ormond Street. Meeting the Principal, F. D. Maurice, at one of Lowes Dickinson's conversaziones in spring 1857, Brown elicited a promise to sit for *Work*; he followed it up in January 1858, when he records two sittings and a day spent contriving 'a rail for Maurice to lean against'. The resulting life-size cartoon was unsatisfactory: '. . . drawn exactly from himself it looks ridiculously stumpy and the head enormous', and on 31 January pragmatism took over — 'Out to see about a photographer for Maurice.'

Brown joined the staff of the college in October 1858, taking over Gabriel's life class at his request. He would have done so sooner, but for Ruskin's long incumbency, but changes were in the air. Ruskin was to be away for a time, while Maurice himself, in difficulties with his Council, was on the point of resigning. In the event it was Ruskin who introduced him to his class. Brown, he told them, was not only Rossetti's equal as a painter but would prove superior as a teacher, because of his greater experience. He remained at the college until the spring of 1861, assisted by Burne-Jones. A pupil, J. Phillips Emslie, later recalled that 'Mr. Brown's teaching was as systematic and precise as Mr. Rossetti's had been free'. As a teacher he was something of a disciplinarian (as Rossetti had long ago discovered), always insisting on accuracy of representation, correct proportions and firm outlines to impart a clear idea of the subject. As might be expected, 'He took a great personal interest in his pupils, and this, together with his very genial manner, caused him to be very much liked by them', not least, one suspects, for his stories. He asked each student what he hoped to achieve and made every effort to help him.[18]

A letter from Brown — perhaps to F. J. Furnivall of the Council — adumbrates a curriculum for Great Ormond Street and future working men's colleges. It outlines a broad approach to the arts and a programme of lectures to include music and poetry as priorities, with archaeology, painting, sculpture, architecture and decorative art. Such liberal studies were at a basic level. Conversely, Brown's knowledge of working men prompts the suggestion that practical art classes should have a more vocational bias. His own classes cover, he reveals, 'drawing in French chalk, and pen and ink, painting in oil and watercolour from life, still life and casts from nature'. His dislike of Ruskin's teaching methods in the preliminary drawing course is clear, and he recommends that students come to him as soon as they have produced 'one good drawing of the kind there produced' — meaning fossils, twigs, and suchlike.[19]

Work, meanwhile, progressed at a snail's pace. In the summer of 1858, Rossetti expressed misgivings:

Work will surely be, in many respects, his finest picture; but I am beginning to doubt more and more, I confess, whether that excessive elaboration is rightly bestowed on the materials of a modern subject – things so familiar to the eye that they can really be rendered thoroughly (I fancy) with much less labour, – for instance the flowing waistcoat of a potboy on which Brown has lately been spending some weeks of his life. Hogarth used to paint the things of daily life in a different way, and we do not find them wanting ... I admire all that Brown does; but I almost fear that the plans of work he has adopted lately may result in his producing one work where he might produce three equally good.[20]

Rossetti had recently introduced Brown to Major William Gillum, a friend of the Brownings who had been invalided out of the Crimea minus a leg. Gillum, later a colonel, was the type of the rich colonel on horseback in *Work*, and this art-loving soldier became an important figure in Brown's life, taking painting lessons at Fortess Terrace and buying several of his pictures.[21] Gillum would be an important patron of Morris, Marshall, Faulkner and Co. in the 1860s, but in 1858 his opening and financing of the Boys' Home for Orphans in Euston Road was recorded in *Work*. Brown's design for a badge for Gillum's boys is now in the Tate.

On 26 December 1858 George Boyce visited Fortess Terrace with Rossetti and saw *Work* with 'Martineau as a swell on a horse introduced, Maurice and Carlyle in the corner'.[22]

Friends did not like Brown's Carlyle, with his unflattering grimace and open mouth showing the gap in his front teeth. Brown had drawn Carlyle from memory after visiting Chelsea with Woolner, when the sage had declined to sit for him. Despite several approaches from admiring Pre-Raphaelites over the years, Carlyle had little sympathy with art or artists, and Woolner had been lucky to get in early with a portrait bust. The great man had promised sittings to Holman Hunt, but by the time of Brown's approach would agree only to a short session in a photographer's studio. The image thus produced was at odds with Brown's conception; the expression Brown had observed on first meeting Carlyle – animated but not particularly pleasant – was the one he stuck to for its *dramatic* truth, for it shows him speaking. Hunt pointed out that this might be 'painful when for hours, years and ages they remain the same as in a picture'[23] and Brown must have modified it, for Rossetti writing on 22 June 1859 found 'your new Carlyle a vast improvement. The whole picture seems growing together in a thorough satisfactoriness ...'[24] But in 1866 Thomas Dixon (Carlyle's artisan friend from Sunderland) vindicated the artist's perception: 'Well, I saw Mr. C. lately, and, strange to tell, he had that singular expression that you have given to him ... I *never liked it*; in fact it used to haunt me ...'[25]

More than any of his contemporaries – and certainly more than 'slice of life' merchants like Frith – Brown entered into the psychology of his sitters. When he saw *Work* in 1865 Carlyle did not object; on the contrary his repeated visits to Brown's exhibition acknowledged the great compliment paid him.

There is a delightful irony in the placing of Emma in front of the lady with the temperance tracts, modelled by Mrs Plint. The two women must have been painted in after May 1859, at which date Plint wrote complaining of the 'ugly female faces in the bulk of the Pre-Raphaelite works' at the Academy – and asking Brown to avoid this fashion: 'I am sure you will get two or three pretty models for the young ladies in my picture, and don't have red hair please!!'[26]

It was now that James Leathart, genial lead manufacturer of Newcastle, approached Brown. Leathart had been introduced to the London Pre-Raphaelites by William Bell Scott when his famous collection was in its infancy. In July 1859 he bought the first of many Madox Browns, *The Pretty Baa-Lambs*, and in August a watercolour replica of *Jesus Washing Peter's Feet*. Negotiations for these – conducted by post – show the cordial relations between artist and patron which continued for thirty-five years.[27] In November, he commissioned a smaller replica of *Work* for 300 guineas, thus enabling Brown to continue with both versions of the picture. In December 1860, Plint, who had patiently waited four years already for his picture, reluctantly agreed new terms with Brown: to pay a further 400 guineas in monthly instalments, in return for an exclusive commitment to *Work* and a replica of *Harold*. At the same time, he complained of the dilatoriness of Brown and his artist friends.[28]

Brown's reply was robust. Glad as he had been to accept the original terms and to accommodate Plint over the content of *Work*, he reminded his old patron that *Work* was cheap even at the new price, given the time, effort and care he had expended: 'Seeing that all my pictures are by far the greatest bargains you have ever made (as I believe you will find one day), I am certainly gratified ... But, had you not done so ... I should have had to set to work at other pictures which are as good as sold ...' Nor would *Work* gain from being hurried: 'In fact, I can never shorten or lengthen the duration of any work, however much I may desire it.'[29]

Plint never received *Work*: he died suddenly three months later, at the age of thirty-eight. His affairs were left in a tangled state, his assets being largely uncompleted pictures, many of which had been paid for in advance. The new commission for *Work* was repudiated, but then successfully renegotiated (with Gambart acting for the Plint heirs). The picture was finished, at last, in August 1863. On 10 August, Brown told Leathart that Gambart had offered him £500 over and above what Plint had advanced – Gambart planned to exhibit and engrave the picture. All in all he

had 'made £1,320 from *Work* – not so bad a bargain ... considering I am not Mr Frith.'[30]

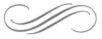

Leathart stepped into Plint's shoes. In building his collection he was advised by Bell Scott and Rossetti, while Brown's letters show him educating this distant Maecenas as the complete patron he had called for in his *Builder* articles of 1848. He warned Leathart against 'commonplace works', emphasising the superiority of his Pre-Raphaelite friends in whose art 'sentiment' was transformed by the key qualities of 'colour, beauty of drawing, and imagination'.[31]

The Leatharts had proved eager collaborators over *Work* – Mrs Leathart, at Brown's invitation, posed for the fashionable lady, her austere pallor matching his conception better than Emma's high colour. He finished it at Brackendene, their Newcastle home, where in October 1863 he painted a portrait of Leathart to match Rossetti's of his wife. 'I shall be most happy to undertake it,' he had written; '... as [yours] is to be one of *the* collections of Great Britain I think the portrait of the collector as well as his lady's ought to form part of it ...'[32] He painted Leathart in his study, including in the background the newly finished *Work*, still unhung and propped against a wall. Across the river appears St Anthony's leadworks, its chimney belching smoke, while against the window a wilting rose provides an aesthetic touch. This fine portrait does equal justice to artist and patron.

Brown had been much impressed by Bell Scott's Scenes from Northumbrian Life painted for Sir Walter Trevelyan at Wallington Hall, hoping to show them at the Hogarth Club. Like *Work*, the Iron and Coal panel celebrates manual labour (but in an industrial setting), rearranging reality to symbolise Newcastle's pre-eminence in modern industry. Now Brown discovered this world for himself and, unprepared for the industrial scenery of Tyneside, was greatly excited:

> I liked its waste of dreary cinder mounts. With the now blue Tyne rushing between them with its numberless craft and steamboats and glimpses of the red tiles of North Shields in the distance ... I wandered on till I found myself in South Shields – the dingiest, grimmest looking place that perhaps ever a searcher for the beautiful found himself in. And yet ... on a sunny afternoon look over its scarlet roofs descending to the busy river ...[33]

He longed to capture the scene in paint.

He never got the chance. Patrons, as well as artists, were abandoning Pre-Raphaelite realism for the fashionable aesthetic mode, and Brown's own work began to reflect this trend. His last *plein air* landscape, *Walton-on-the-Naze*, had been completed in 1860; his realist phase, probably his finest, culminated in *Work*.

11
DOMESTIC HEARTHS
1860–1865

AFTER THE ROW OVER HIS DESIGNS, Brown had dissociated himself from the Hogarth committee for a year. During 1860, determined efforts were made to increase the membership, but still the Hogarth could not pay its way and in 1861, reinstated as Chairman, Brown gave his casting vote to a resolution introducing paying exhibitions. This turned the Hogarth into a professional alternative to the Academy and caused a final rift among the members, who included Establishment figures like Leighton and Watts. At the end of the year, the club collapsed. Writing to the critic F. G. Stephens, Brown was sanguine: 'The HC is indeed defunct. Alas I think it a great pity and had there been the requisite amount of common sense among the members no doubt it would still be flourishing. But with such a set of fellows! Such a set of fellows! All far too artistic to have any foresight . . .'[1]

Sensing imminent collapse, in April 1861 Hunt wrote triumphantly to John Tupper: 'From the beginning I have expressed my feeling that the club would never succeed and only joined because I hoped my evil presentiment might turn out false . . . It has turned out rather worse than I expected . . . I wish still to enjoy immunity from censure and therefore must avoid all interference in the treatment of the poor invalid . . .'[2]

As he wrote, Gambart was vindicating Hunt by paying the huge sum of 5,500 guineas for *The Finding of our Saviour in the Temple* and exhibiting it to large crowds. Meanwhile, Hunt sought allies in his attempts to discredit Rossetti. In a letter to Thomas Combe, he attacked *Bocca Baciata*, a portrait of Fanny Cornforth shown at the Hogarth: 'Most people admire it very much and speak to me of it as the triumph of *our school* . . .' he wrote. 'I will not scruple to say that it impresses me as very remarkable in power of execution – but still more remarkable for gross sensuality of a revolting kind peculiar to foreign prints. I . . . see that Rossetti is advocating as a principle the mere gratification of the eye . . . the animal passions to be the aim of art.'[3]

This is redolent of sexual as well as professional jealousy. Rossetti had renewed his attentions to Annie Miller; in February 1860 he had visited Boyce's studio, where she was posing: 'Rossetti came in towards dusk and touched on my oil portrait of her begun and went away with her,' Boyce noted in his diary[4] – and this despite a concurrent liaison with Fanny Cornforth. Rossetti's pencil study of Annie at this time is particularly fine.

Ford and Emma received with misgivings the news of Gabriel's imminent marriage to Lizzie, who was dying. How rapturously, four years earlier, they would have greeted the marriage, but now they could only share Gabriel's anxiety, relayed in a series of bulletins from Hastings.

After repeated postponements, the wedding took place on 23 May 1860:

> All hail from Lizzie and myself just back from church. I am sorry I cannot give you any good news of her health, but we must hope for the best. We go to Folkestone this afternoon ... with a view to spending a week or so in Paris and if we stay long enough I hope Ned and Georgie will join us. PS If you are still with Top as Ned told me you were, best love to the Topsies. The Towers of Topsy must darken the air by this time [a reference to the Morrises' newly-built Red House].[5]

The sad marriage began at Hampstead, always Lizzie's preferred territory for its cleaner air and proximity to the Browns in Kentish Town. She loathed Chatham Place, associating it with the stink of the river and Gabriel's bachelor life, which had excluded her for so long. But he was spending most of his time there, hard at work on the Llandaff commission and a series of portrait drawings, and she reluctantly agreed to move back. To encourage her, Gabriel promised to paint the woodwork summerhouse green and to hang a sumptuous wallpaper of his own design:

> I shall have it printed [he told Allingham] on common brown packing paper and on blue grocer's paper to try which is best. The trees are to stand the whole height of the room ... of course they will be wholly conventional, the stems and fruit will be Venetian Red, the leaves black. The fruit however will have a line of yellow to indicate roundness and distinguish it from the stem; the lines of the ground black and the stars yellow with a white ring around them...[6]

Marriage and house decoration were much in the air in 1860. The Browns, who had done everything to bring it about, were delighted when Ned Jones and Georgie Macdonald tied the knot in June. That spring they had invited Georgie to Fortess Terrace, giving the lovers a chance to be together, and Georgie recalled their unselfishness in putting up with a courting couple; 'but a small house and slender means were made spacious and sufficient by their generous hearts and my recollection is of one continuous stream of hospitality.'[7]

After their marriage the couple moved into two rooms in Russell Place, Bloomsbury. The furnishing of these included an oak table by the architect Philip Webb and 'high backed black chairs with rush seats and a companion sofa of panelled wood painted black'.[8] Both were probably designed by Brown; the high ladder-backed chairs were, as we shall see, among his contributions to the Firm — Morris, Marshall, Faulkner and Co. — while a settee answering this description appears in Brown's *The Death of Sir Tristram* begun soon afterwards.

Brown's friendship with Morris had ripened since Gabriel first brought 'his ardent admirer' to 13 Fortess Terrace in 1856. The two men had much in common, and Morris's purchase of *The Hayfield*, painted for pure love of landscape, was significant in view of the rural imagery, the cycle of seasons, which colours so much of his poetry. In Morris's *Guenevere* poems, Brown recognised a kindred feeling for the medieval world, whose brutal realism and high colour were evoked, respectively, in his own *Harold* and the Froissartian *Chaucer*. Later, Morris's Prologue to *The Earthly Paradise* would portray Edward III and the Black Prince exactly as Brown had painted them. Both men were members of the Medieval Society, which, like the Hogarth, brought painters into close contact with leading Gothic-revival architects like Street, Bodley, Burges, Webb and Woodward, generating some of that immense enthusiasm for decorative architectural projects which led to the Firm.

Of all the circle, Morris and Brown were most alike temperamentally — vigorous, independent characters both. Rossetti had called Morris 'one of the finest little fellows alive . . . a real man'; both were active in the Artists Rifles Corps of 1859–60, regularly drilling together on Wimbledon Common or at Leatherhead, while Brown practised target shooting for hours in the garden of Fortess Terrace. Ideals of social justice also drew the two together, forming a bond strong enough to survive their later estrangement.

Morris was frequently at Fortess Terrace before his marriage: Cathy remembered boisterous evenings when he, Ned and Rossetti descended on the family, terrifying the sleeping children with loud imitations of animals.[9] By day, Morris came to paint. In 1861 he was working on his unfinished *Tristram Recognised by the Dog* under Brown's guidance. It had been commissioned by Plint, to whom Brown wrote: 'His

picture is now at my house and at my suggestion he has so altered it that it is quite a fresh work. There is still a figure in the foreground to be scraped out and another put in its place ... I take as much interest in Morris's picture ... as though it were my own ... I have repeatedly told you that Morris is a man of genius.'[10]

Morris had married Jane Burden in April 1859. Seeking to build a house which would also serve as the base of an artists' community, he found a plot at Bexley Heath, a mile or two from Uncle Madox's house at Foots Cray — an area he may have explored at Brown's suggestion. Red House, Webb's small masterpiece, was finished in the summer of 1860.

All the friends spent time there. In January 1861, Emma — the only mother among the wives — was helping Jane through the birth of her first daughter, Jenny — an event recorded in Morris's laconic note to Brown: 'Kid having appeared, Mrs Brown kindly says she will stay till Monday,' wrote Morris, 'when you are to come to fetch her please...'[11]

Out of the communal decoration of Red House came the idea of the Firm. Morris, Marshall, Faulkner and Co. was also born in January 1861, when the friends took offices, workrooms and a showroom at 8 Red Lion Square. In April the partners issued their ambitious prospectus.

The Firm both met and created a demand for practical design in home and church decoration. It gave Brown a welcome outlet for his gifts, boosted his output significantly and increased his income. Besides Brown, Morris, Burne-Jones and Rossetti, the co-operative included the architect Philip Webb, the mathematician Charles Faulkner and Brown's pupil Peter Paul Marshall, engineer brother-in-law of Major Gillum and a keen amateur painter.

The partners met at least once a fortnight at Red Lion Square, and in early days Brown chaired the convivial sessions which to Faulkner had

> rather the character of a meeting of the Jolly Masons ... than of a meeting to discuss business. Beginning at 8 for 9 pm, they open with the relation of anecdotes ... this store being exhausted Topsy and Brown will perhaps discuss the relative merits of the art of 13th and 15th century, and then perhaps ... business matters will come up about 10 or 11 o'clock and be furiously discussed till 1 or 2.[12]

But Brown found less and less time for these meetings, and Webb eventually took over the chair.[13]

Webb, prominent both in the Hogarth and in the Medieval Society, is scarcely mentioned in Brown's diary, but this close friend reinforced his enthusiasm for modern

functional design, craftsmanship and unity. He admired Webb's work, while Webb respected his 'keen intellect, honesty ... thoroughness' and confidence in his own ideas. Webb characterised Brown accurately: 'With more grace [he] would have been a great master, but on the other hand, some of the Pre-Raphaelites were injured by looking too much to grace. Grace is not enough to save a picture.'[14] Architect and painter each recognised the other's pragmatic bent in the struggle to realise sound design principles, whether in pictures, furnishings or buildings. Impelled by democratic ideals and responsible in early years for the Firm's furniture, they helped pioneer the move away from archaeological into functional 'Gothic'.

Furniture was prominent in the Firm's first display at the International Exhibition of 1862. One major piece was the cabinet designed by John Seddon in memory of his brother Tom and decorated by Rossetti, Jones and Brown with scenes showing King René of Anjou on his Honeymoon. The four main panels show the king as painter, sculptor, musician and architect. For architecture, Brown produced one of his most graceful and imaginative designs. The young king and his bride embrace at twilight as they discuss plans for their new palace, architectural drawings and instruments at their feet. A bookcase of Brown's design (lost) had seven gilded panels of scenes in the life of an English officer's family from the Peninsular War to the Crimea. Probably first made for Major Gillum, only the designs survive.[15]

Such set pieces were not, however, the kind of furniture Brown instinctively liked. His finest, most characteristic work for the Firm came out of the ordinary household furniture in use at Fortess Terrace. Many years before, in 1849, the Seddon firm had made up a settee to his own design, while his association with Tom Seddon and working craftsmen at the North London School stimulated more practical furniture for working men. This was, of course, precisely the sort of furniture he needed – functionally designed, cheap to make and childproof.

The furnishing of the studio at 17 Red Lion Square must have stimulated Brown, who wrote in March 1857 of 'my new table which ... I have designed among other work' as in use at Fortess Terrace. According to Hueffer, this was a 'substantial bit of furniture, with a top in shape like a vertical section of a barrel, and with pierced lockers underneath'.[16] Four designs for chairs mentioned in January 1858 may have been those he tried to exhibit at the Hogarth, while in that year Hunt asked him for sketches for an oak table and other furniture – including perhaps the 'Egyptian' chairs in Brown's drawing room at his death. Certainly he designed Egyptian chairs for the Firm. The Firm's catalogue describes furniture made to Brown's designs as 'of solid construction, joiner made or cottage furniture'. An early example may be the green stained-oak ladderback chair with rush seat which anticipates more refined versions by Ernest Gimson and others. Another was a round-seated version of the popular

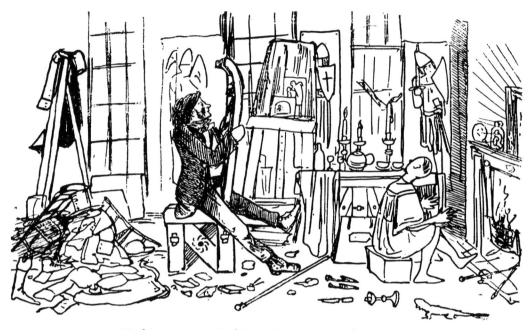

Ned Jones at 17 Red Lion Square, December 1856.

Sussex chair – the others being by Webb and Rossetti – and a cane-seated upright chair of similar type illustrated in the *Furnisher* in 1900. According to *The Artist* in 1898, 'for [the Firm], Madox Brown designed eight different chairs, four tables, a piano, bookshelves, couches, wall papers, embroideries, stamped velvets, tiles, wineglasses and decanters and two sets of worsted bell ropes. The Firm also executed a number of washstands, towel horses and toilet tables which he had designed for his own use.'[17] The latter are of plain deal stained chrome-green, with simple rectilinear lines: 'Let us be honest, genuine in furniture as in aught else' was his motto. 'If we must needs make our chairs and tables of cheap wood do not let them masquerade as mahogany or rosewood. Let the thing appear only that which it is; it will not lack dignity if it be only good of its kind and well made.'[18]

Perhaps these were too brutal and 'inelegant' for the middle-class clientèle, for few items survive, though the Sussex chair and its variants became fashionable, staying in production until the First World War. Webb, on the other hand, increasingly designed what Morris called 'state furniture' – grander items for large households. In such houses, and in the halls of Cambridge colleges, the Firm installed painted-tile panels as overmantel decorations. In Brown's tiles for Queens' College, for example, an energetic *Pig Killing* and a *Sheep Shearing* contrast with stately representations of the two founding queens.

Within a few years, Brown's activity became concentrated on stained glass. It was not until 1884–5 that he again designed furniture for working men, but his ideal had never changed since 1855, when opulent Stafford House had provoked the cry: 'Oh how much more beautiful would 6 model labourer's cottages be built by a man of skill for £100 each.'[19]

All the partners contributed to the Firm's early stained glass. Their individual hands can be seen in the Bodley churches of 1861 at Brighton, Scarborough and Selsley. Yet remarkably harmonious effects were achieved, and 'the Morris style', both decorative and dramatic, soon established itself. It was Morris and Webb who transformed the black-and-white cartoons, adjusted the scale and co-ordinated the colours, leading, patterned backgrounds, borders and lettering to achieve this unity. The style relied more on sympathetic handling of the glass than on elaborate painting, using traditional deep blues and reds with subsidiary yellows and greens to achieve a heraldic boldness. Its medievalism – like Morris's poetry – was evocative, not imitative. Ironically it was 'for glass in the medieval manner' that they won a prize at the 1862 Exhibition and were accused by angry rivals of reassembling fragments of ancient glass.

Brown's stained glass is better discussed in terms of his dramatic cartoons than as finished windows. With Jones, he supplied the bulk of the Firm's glass designs in the fourteen years of the original partnership – contributing some hundred and fifty drawings. Over this period there was little development towards a stained-glass style; unlike Jones, he made few concessions to the medium. His work is readily distinguished by its vigour and realism.

Brown's earliest stained-glass windows are formal, as in the Michael and Uriel archangels at St Michael's, Brighton. His series for St Oswald's Church, Durham, and fine cartoons of *Christ Walking on the Water*, *Christ Watching the Disciples in a Storm* and *The Miraculous Draught of Fishes* for St Mary and All Saints, Sculthorpe, 1864, are conceived in the dramatic spirit of his paintings.

He had first treated the Christ and Peter theme in *Jesus Washing Peter's Feet* of 1852, developing it in his first glass design for Powell's, *The Transfiguration* of 1858. These both show a measure of self-identification, with Peter standing for Everyman as well as Brown himself.

Peter reappears in *Christ Walking on the Water* for Sculthorpe. Christ stands at the centre of the composition, occupying its full height. Immediately behind, the haloed heads of three disciples are seen over the side of a ship and behind them again a row of buildings and a crescent moon. The three watch as Christ grasps the hand of the sinking Peter. This meeting of hands at the very centre of the composition provides the emotional focus, while Christ's vertical figure stabilises the scene,

calming both disciples and storm. Here Brown faithfully illustrates the text of St Matthew's Gospel (14:22–33).

In the vividly conceived *Christ Watching the Disciples in a Storm*, however, Brown departs from both Matthew and Mark, placing Jesus high above the sea, his cloak and hair blown by the storm and looking down as the disciples try to steady their capsizing boat. It is sunset – always a favourite emotive device with Brown.

The St Oswald lights are in the west window, dramatic small scenes involving several figures and full of action. The scene showing *St Oswald killing Caedwallader* is especially virile, recalling *Harold*. This, like Morris's *Guenevere* battles, stems ultimately from the Bayeux tapestry and Froissart. In *The Enshrining of St Oswald* the saint's haloed head is carried in procession, recalling Morris's contemporary St George Cabinet, while *The Baptism* – derived partly from Dyce's early *Baptism of St Ethelbert* – looks forward to the first of Brown's Manchester murals, *The Baptism of St Eadwin*.

Designs made for one medium often found their way into another. An example is *The Death of Sir Tristram*, mentioned above – a stained-glass panel installed at Harden Grange, Yorkshire, in 1863, where Sir Tristram falls from a settee clearly designed for the Firm.[20] This was also the first of Brown's glass designs to be translated into a painting, its fluid, patterned shapes, flatness and linearity heralding his new decorative style.

Book illustrations, such as those for the projected Dalziel Bible (later published as *Dalziel's Bible Gallery*) in 1863, also became paintings. An oil of *Elijah and the Widow's Son* was commissioned by the Brighton brewer John Hamilton Trist in 1864, a *Coat of Many Colours* by George Rae of Liverpool in the same year, while Frederick Leyland (also of Liverpool) bought an *Entombment* in 1868. His patrons' taste confirmed the new shift towards religious subjects in the 1860s, stemming from glass designs for the Firm.

At 5 a.m. on 11 February 1862, Brown was awakened by a hammering on his door. Outside was a distraught Gabriel. Within an hour both men were back at Lizzie's bedside in Chatham Place watching Dr Marshall try – too late – to pump the laudanum out of her stomach. Brown took Lizzie's suicide note and burned it in the grate. This done, he had to take care of Gabriel, notify the authorities and make arrangements for the inquest and funeral.[21]

The tragedy affected Brown deeply. He had loved Lizzie, not least because he believed she had inspired Gabriel's best work. This crisis was to be the first of many

in which he would prove Gabriel's staunchest friend, and it bound the two artists inseparably. It is entirely appropriate that Lizzie lies now in the grave next to Elisabeth Brown's in Highgate Cemetery.

Gabriel fled Chatham Place. First he went to his mother's in Albany Street, then to the Browns at Fortess Terrace, where he resumed painting. In October he settled at Tudor House, 16 Cheyne Walk, Chelsea.

In 1862 Brown exhibited independently in the Fine Art section of the London International Exhibition. He did so with extreme reluctance, remembering his treatment at Manchester in 1857, and, despite Hunt's urgings, at first refused to participate:

> The whole drift of your advice for some years has always been ... to the effect that it is better and necessary to put oneself in the power of Academicians and keep to the beaten track. Now I have never found anything but disaster from contact with Academicians and the beaten track to be barren as well as beaten and altogether provisionless. Suffer me therefore to make my own tracks. Your friends are not my friends ...

Once again it came down to hanging:

> ... it is very important that neither he [Augustus Egg] nor anyone else should have the chance of hanging them ill again, *which is a ruinous thing* ... The long and short of this ... is that I am very pig headed and never take anyone's advice now... but I like ... my old friends best and men of genius best of all, so I trust to be ever friends with you ...![22]

It was George Rae, new owner of *An English Autumn Afternoon*, who persuaded him, along with Gillum, owner of *The Last of England*, and Leathart, who was anxious to lend *Cordelia at the Bedside of Lear*. Brown wrote to Rae in April: '... you three gentlemen being just now more important to me than the rest of the British public, I at once felt which was the right course to adopt ...'[23] and, despite several requests to 'Her Majesty's Commissioners' to expunge his name from the catalogue, Brown's works joined those of Hunt, Millais, Martineau and Davis in the English section. He was agreeably surprised to find his misgivings unfounded: 'I am happy to tell you,' he wrote Rae, 'that the *Autumn Afternoon* has a first-rate place as well as the other

two ... all three are on the line and as well placed as anything there.'[24] To Davis, also exhibiting there, he reported gleefully that they were better hung than Hunt.

The experience confirmed his old belief in the Pre-Raphaelite achievement and, as at Manchester, admiration overcame his differences with Hunt: 'Hunt, Millais, Martineau and ourselves look the only works that are powerful in truth and richness of tone at that end of the English Room ... From Hogarth and Sir Joshua the pictures get weaker and weaker and poorer in style till they come to the revival *in us*.'[25]

But there was friction with Hunt over the Lord Mayor's Fund for the relief of Lancashire cotton workers, victims of the trade blockade in the American Civil War. Brown responded characteristically, proposing an artists' committee and an exhibition, the proceeds of which would go to the fund. Equally characteristically Hunt declined – preferring 'individual charity'. Artists, he reminded Brown, were also victims of the economic situation.

Besides money, Brown contributed his delightful *Mauvais Sujet* and induced his friends to do likewise. The crisis caught his imagination: he would paint two modern histories – *John Brown Assisting the Escape of Runaway Slaves* and another representing *The Arrival of the First Bale of Cotton* after the famine. 'The weavers, assembled in enormous numbers, struggled to have a hand in pushing the railway truck on which it was placed, and the bystanding men and women by one impulse began to sing the "Old Hundredth".'[26] Neither work was painted, for lack of a commission.

Such realist impulses, however, were being modified not only by the Firm but by Rossetti's female portraits of 1859–60, notably *Regina Cordium* and *Bocca Baciata*, with their embellishing 'symbols' such as flowers, jewels or musical instruments. The patterned backgrounds may have derived from such Brown precedents as *Our Lady of Saturday Night* and *William Rossetti by Lamplight* (1856). At the final Hogarth Club exhibition of 1861, Brown had shown two superb child portraits commissioned by Plint – *The Irish Girl* and *The English Boy*. The latter was Brown's tribute to his much loved son Oliver, then five years old, remembered by Georgie Burne-Jones as 'an enchanting child and in his own home so bold and manly as he roved about in a rough pinafore...'[27] This small tyrant, with a passion for animals and drawing, is portrayed as a young king, his straw hat a crown, a whip and top his childish regalia, against the striped green wallpaper of Fortess Terrace. These emblems in so realistic a portrait are an amusing comment on Rossetti's new manner.

The companion *Irish Girl*, with Paisley shawl and a carnation in her fingertips, also bows to Rossetti, but her watchful eyes also imply the active life of a real child. There are further links here with contemporary Rossetti portraits, notably *Girl at a Lattice* (1862), painted while Gabriel was at Fortess Terrace that summer and portraying the Browns' young maidservant. This looks like the same Irish girl; she gazes

absently out of the window as if in reverie, the warm tones of her complexion picked up in the coral beads around her neck and echoed, in true Rossettian style, by flowers in a Chinese vase. But these are wallflowers from the Browns' garden and the vase a Staffordshire jug of common design. One hand listlessly plays with the necklace, the other cushions her cheek from the lattice. A girl called Mary of similar appearance sat for *Mauvais Sujet*, quill-pen in hand, at the school desk on which she has scratched her name. There is a Brunonian spontaneity about this nymphet, whose portrait otherwise shows great affinities with Rossetti's – a black ribbon draws attention to the neck; she stares abstractedly into space: she nibbles a green apple, lips parted in incipient sensuality. Brown probably encountered her while searching for Irish models for *Work*. Equally fine, and more fashionable, is a chalk portrait of his young cousin, Louisa Jones, made at this time.

Rossetti moved to Chelsea in October 1862. In that month, offended by the erection of a church opposite 13 Fortess Terrace which spoiled their view, the Browns moved round the corner to 14 Grove Terrace, near the Seddons. The new house stands on the lower slopes of Highgate Hill, looking across Highgate Road to Parliament Hill Fields and is the tallest and grandest in this fine Georgian terrace. Number 14's elegant first-floor drawing-room boasts three French windows, splendid plasterwork and classical columns. It overlooks a huge garden. It was not a poor man's house, as William Rossetti later implied, but demonstrated Brown's growing prosperity. True it was not in central London, but the artist plainly preferred his open country views to crowded streets; this move also suggests some friendly rivalry with the splendours of Red House and Cheyne Walk.

For many months since its completion, Brown's *Work* had been in Gambart's hands, unsold and unexhibited. As Brown told Rae on 29 April 1864:

> I called on Gambart yesterday, being impatient at hearing nothing about the exhibition of *Work*. I now find that the Executors and he have had a shindy ... the upshot for me is that he had got the exhibition of *Work* all arranged and cut out, even the spaces for placards taken at the railway stations and now it is all stopped again and the picture in a warehouse somewhere in London.[28]

Shortly afterwards he wrote again, proposing that Rae take the picture off the executors' hands 'as you are so near upon having a first rate collection ... Meanwhile,

either to the accident of this quarrel ... or to some more subtle cause ... I owe it that the work of my life ... is shut up in a cupboard.'[29] Brown approached the executors too, offering to have the picture engraved at his own expense and to exhibit it with a selection of his other pictures.

Rae did not bite. In October, Plint's executors agreed to lend *Work* against the security of a Bond guaranteed by Morris and Rossetti, and Brown's plans for a retrospective exhibition built around it took shape.

The idea was novel: although exhibitions of *chefs-d'œuvre* were gaining in popularity (Hunt's *Christ in the Temple* and Whistler's *Woman in White* were recent precedents), no leading artist had documented his career in this way since Blake, whose example Brown certainly had in mind.[30] A more immediate spur was Hunt and Martineau's joint exhibition at the Hanover Gallery, in May 1864, but Brown intended to bypass the dealers altogether and to supervise every detail – venue, choice of works, arrangement, lighting and entrance fee – while he would produce a catalogue amounting to a personal manifesto. A risky course, it must alienate the art Establishment still further.

The Burleigh Gallery at 191 Piccadilly was known for off-beat, even disreputable, exhibitions: recently, crowds had been drawn by 'Juliana Pastrana, the female Hairy Monster, Embalmed, Standing Erect dressed as in Life. Pronounced by the Medical Profession to be the greatest scientific curiosity ever exhibited in London' and the 'Talking Fish'. The central location suited Brown, who booked the gallery for three months from 10 March 1865. As spring approached, he placed costly advertisements in the papers and on station hoardings.

For different reasons, Hunt, Stephens, Rossetti and Cave Thomas discouraged the plan, trying unsuccessfully to dissuade him. They feared that *Work* would be unpopular, and that Brown would lose money and reputation. But in Hunt's case the projected show also threatened competition with his own carefully staged independent exhibitions.[31]

Gabriel, although alarmed at the financial and professional risks his friend was taking, proved staunch, and came to hang the pictures. 'Mr Madox Brown's Exhibition' opened on 10 March. The private view was well attended, despite pouring rain. Ninety-nine works represented every phase of Brown's art, augmented by the carefully prepared catalogue describing the pictures. A tight layout was dictated by the smallness of the room, which was divided by a curtain to get all the works in, for Brown wanted to demonstrate not only his evolution but also his broad vision of art.

After paying a shilling at the door, the visitor came face to face with the great *Chaucer*, twelve feet high and unseen in London since 1851. After this, in chronological

sequence, twenty-six works of the Pre-Raphaelite phase culminated in the luminous *Walton-on-the Naze* and *The Irish Girl*, representing a high peak of naturalism. Recent paintings were more decorative, beginning with Leathart's portrait – a sharp contrast to the 'modern Holbein' of *James Bamford* (1846). In his catalogue, Brown called for the restoration of portraiture to real artists (as in Titian's day), distinguishing it from photography. Some early curiosities followed, notably the darkly melodramatic *Parisina's Sleep* and *Manfred on the Jungfrau* – 'my first though not very recognisable attempt at outdoor effects of light'. Here also were found the Paris illustrations to *King Lear* – sixteen embryonic pictures waiting for commissions – and the recent illustrations for Dalziel's Bible. Finally, a large number of designs, mostly monochrome, for Morris, Marshall, Faulkner and Co. showed the artist's range – these included nineteen cartoons for stained glass, the bookcase shown in 1862, designs for furniture and one for a wallpaper. With the glowing *Work* in its place of honour, the exhibition reached its climax.[32]

Over three thousand visitors attended, over and above the friends and patrons who had season-tickets. Brown was gratified by so much enthusiasm: the Carlyles came several times, and Mr Gladstone shook his hand in congratulating him. His misgivings confounded, Rossetti became enthusiastic, sending invitation cards to innumerable friends and bringing collectors like James Anderson Rose, Frederick Craven of Manchester, and John Mitchell of Bradford to see the show. He urged William Cowper (later Lord Mount Temple) of the Ministry of Works to give Brown a mural commission at the Palace of Westminster. He was delighted by the favourable press reception, writing at the end of March: 'I congratulate you heartily on *The Telegraph* and *The Saturday Review* . . . I believe the *Morning Post* proposes to prolude on you. Also the new Shilling Magazine which is to be the event of 1st May.'[33]

Francis Palgrave's article in the *Saturday Review* was indeed full of high praise: 'his work', the critic wrote, 'startles one into the belief that we have in him an artist of singular truth, soundness and originality; while so strong is the evidence . . . of intellectual insight at once into the spirit of the past and of our own day, and of vividness in the dramatic exhibition of character, that we must henceforth assign him one of the leading places among our very small but honoured company of genuine historical painters.'[34] William Rossetti's long and meticulous review in *Fraser's* also underlined the intellectual and dramatic power of Brown's work, emphasising, as Palgrave did not, the importance of his glass and furniture designs.

Brown knew that the time had come to move back to central London. Rossetti was urging him to capitalise on his success and to woo the art-loving public in earnest. But Gabriel's attempt to put him up for the influential Garrick Club (Millais seconded the proposal) ran into trouble; its Establishment-minded members blackballed an artist who had so consistently flouted the RA.

Nevertheless, for all the circle the prospects were now bright. In November the Browns took a lease on a substantial house at 37 Fitzroy Square, Bloomsbury. In the same month the Morrises left Red House for 26 Queen Square, not far from the Browns, where they lived above the new Morris shop. The following year Holman Hunt bore off his handsome bride Fanny Waugh to Florence, *en route* for Jerusalem.

12
FITZROY SQUARE
1866 – 1872

'HOW YOU WILL LIKE MADOX BROWN!' wrote Mrs Alexander Gilchrist in 1865. 'He seems to me to have a wider range of thought and sympathy and more geniality than any other of dear Alec's delightful friends.'

The Hampstead recluse had become the genial host and proud paterfamilias of 37 Fitzroy Square. To another admirer, Charles Rowley, Brown was 'not only one of the handsomest men but also the best talker in London'.[1] In studio photographs, the beard is now full; the luxuriant hair, parted in the middle and carefully tended by Emma, falls to the collar of a dark frock-coat, and a waistcoat and light tweed trousers complete the ensemble. In some pictures he faces the camera with élan; in others, the famous suspicious scowl bears out Rossetti's limerick about 'a painter called Brown/Who had a most terrible frown'.

He had won his professional laurels at last and could bask, like his Edinburgh grandfather, in the pleasures of success. In 1865 Madox Brown's income reached a peak of £1385 5s. 2d. – about forty to fifty thousand pounds by today's reckoning.[2] Rich new patrons – Frederick Craven of Manchester, the Liverpool banker Frederick Leyland and William Graham MP – were now buying from the Rossetti circle, and, with commissions from Rae and Leathart still in hand, the outlook had never seemed better.

The Madox Browns had become serious party-givers well before taking 37 Fitzroy Square – in fact ever since the move to Grove Terrace, when they began to emulate Rossetti's lavish life-style. Their modest dinner parties increased in scale and frequency, and soon Emma was issuing 'Mrs Madox Brown At Home' cards like any society hostess, filling in the details in a neat hand.

Two memorable parties anticipated the transition from suburb to central London in 1865. Rossetti's, in April, was held in his Cheyne Walk studio and was attended by all the circle. The Brown family turned up two and a half hours late, having travelled to Chelsea via Kew, Clapham Junction and Sloane Square to save the cab

fare, arriving 'smiling and unruffled' to everyone's amusement. It was that night that Georgie Burne-Jones noticed 'a sign that we were mortal in the fact of Madox Brown's beautifully thick thatch of hair having turned very grey'. In June, the Browns gave a party at Grove Terrace, a characteristically Pre-Raphaelite affair:

> Many of the same people were there ... Swinburne in evening dress ... Whistler looking more like a Frenchman than Legros. Gabriel was there in magnificent mood – no other word describes it. When he passed through a room bringing pleasure to great and small by his beautiful urbanity, a prince amongst men. With Morris and his wife came Miss Burden, Janey's sister, Warington Taylor[3] and Christina Rossetti gently caustic of tongue ... The little ten-year-old Nolly sat up all evening ...[4]

The famous Fitzroy Square evenings, held fortnightly from 1866 for about eight years, were larger – more like salons than the intimate parties of old. Georgie for one regretted them: 'In the new house,' she wrote, 'we never felt the same joy as in the old ...'[5]

Number 37 Fitzroy Square was a substantial Georgian town house, adorned with pilasters, rusticated stone facing and a large Roman urn cantilevered over the door, which struck fear into visitors' hearts.[6] Inside, a wide stone staircase led up to the first-floor studio where the Browns 'received'. The studio rooms were large – high enough to accommodate the great *Chaucer*, which presided over this modern artistic court. Brown showed his latest pictures here at private views, but work in progress would be turned to the wall.

'Madox Brown ...' wrote Hueffer, 'was an excellent host, and the company, as a rule, mixed well. For the rest, the entertainments were reasonably informal, enlivened with songs and with dissertations on this and that, from such and such a distinguished poet of the so-called Pre-Raphaelite group, and adorned with so many fair women, more or less aesthetically garbed, who moved amongst articles of furniture mostly after the "Firm" taste.'[7] This furniture included tables and chairs of Brown's own design, and a piano decorated by William Morris.

These fashionable Bloomsbury parties anticipated their famous Edwardian counterparts by some forty years: artists, intellectuals, musicians and poets – successful or unknown – came to 'this house of focus for all that was excellent and profound in literature and the arts'.[8] A young lawyer, Justin McCarthy, remembered Fitzroy Square as 'a kind of open house ... for all who had an interest ... in art or ... the welfare of humanity ... I met many men and women of rising distinction and some who had already achieved fame.'[9] Over the years, the Madox Browns entertained

Browning and Tennyson, Mazzini and Charles Dilke, Mark Twain and Turgenev, Franz Liszt and Cosima Wagner, as well as Swinburne and the younger writers Arthur O'Shaughnessy, Edmund Gosse and Oscar Wilde. Many of their guests were refugees from Europe, reflecting the continuing sympathy in Brown's circle for libertarian and nationalist causes. After the Paris Commune of 1871, an international-socialist element predominated, and among the refugees they welcomed were the revolutionary socialist Karl Blind and his adopted daughter Mathilde, who caught Bell Scott's eye at a party of Swinburne's: 'Such a jolly little red republican, with an immense mop and spread of black hair and an Indian or Turkish (bright yellow stripes you know) scarf tied across her and hanging behind.'[10] Mathilde's literary talents, and the passion for Shelley she shared with William Rossetti, made her a natural member of Madox Brown's circle, and Ford, greatly taken with her, became a keen admirer — as we shall see.

Rising to her new role, Emma became a successful hostess. She was now in her late thirties and becoming matronly, wearing her long fair hair in a snood. Her singing, whether solo or in duets with Brown, became a feature of their evenings — Rossetti once referred to her, unkindly, as 'the scarlet warbler',[11] perhaps alluding to her flushed complexion. It often fell to flaxen-haired Cathy — an excellent pianist — to accompany her parents at these musical evenings — an alarming experience for a teenage girl. As she recalled,

> If mistake marred the concord, the singing would stop with 'My dear you are wrong' or 'Ford, that note is F sharp', to end in a huff, at which Mr Madox Brown would leave the room by one door and Mrs Madox Brown by the other. As both doors led to the hall, meeting and reconciliation of necessity ensued and a return to the room to discover that the mistake was due to the unfortunate accompanist.[12]

Such party-giving was really beyond the Browns' means, and, among older friends, their social pretensions provoked some amusement. Bell Scott, now living in London in a *ménage à trois* with his wife Laetitia and Alice Boyd, was a caustic commentator on the Pre-Raphaelite scene:

> Laetitia no doubt told you about 'The Browns' and their great dinner party, with Mrs Street's strictures private and confidential. It was an extraordinary effort ... a formidable affair, 23 I think with half a dozen courses and dishes handed round between. What Brown meant by the affair no one can understand. Because he has got a biggish house, he seems to think they should have numbers of people.[13]

Scott's own affection for Brown – 'one of the leaders of the new school and much beloved by all within the charmed circle' – never extended to his womenfolk, whose use of make-up particularly shocked him: '... all the ladies at least Mrs B and Lucy – quite fluffy in the faces with white powder, I can't think Brown ought to let them.'[14]

Emma was no longer her husband's preferred model. Her looks did not suit the 'aesthetic' taste, and pretty Cathy began to take her place. At thirteen she was the subject of an 'aesthetic' portrait, *Myosotis*, and in 1865 Brown painted her again in a garden of lilies, pinks and roses for Craven's *The Nosegay*. This picture, with its brick wall and purring cat, harks back to the childish Cathy of *Stages of Cruelty* (1856) hitting the dog in the garden of Fortess Terrace. Talented, like all the younger Madox Browns, Cathy was fast developing as an artist in her own right. Along with Brown's powers of observation, she inherited his realist bias, producing, among several accomplished family portraits of the 1860s, an unusual glimpse of Brown at work, palette and brush in hand, in the walled summer garden of Fitzroy Square. He looks quizzically at his canvas, whose subject was, no doubt, Cathy herself.

Both Cathy and Lucy learned painting in their father's studio, and by 1865 they were already useful studio assistants – able to lend a hand with the duplicates which now featured increasingly in the busy artist's output. At sixteen, Cathy worked on a watercolour of *The Last of England*, for example. At first Lucy, the better educated, acted as chief amanuensis; she was twenty-five before she discovered her own powers, on taking over a picture from Brown's assistant Albert Goodwin. Then, like Cathy, she took up art professionally, but she was a more 'intellectual' artist, painting a series of poetic dramas notable for their construction and rich colour. Both girls attracted favourable reviews when, from 1869 onwards, they began to exhibit at the Academy and at the Dudley Gallery.[15]

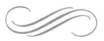

In the summer of 1864 a weekly pupil had joined the studio at Grove Terrace. Tall, doe-eyed Marie Spartali, of the wealthy Anglo-Greek community in London, was the elder daughter of Michael Spartali, later Greek Consul in London. He had gained an introduction to Rossetti through the Ionides family, major patrons of the arts as of the Morris Firm, and was in turn recommended to Brown. Soon Gabriel was writing, 'I hear that Miss S. is to be your pupil ... [and] that she is one and the same with a marvellous beauty of whom I have heard much talk so just box her up and don't let fellows see her as I mean to have first shy at her in the way of sitting.'[16]

Marie, a famous Pre-Raphaelite beauty, was later immortalised by Rossetti. W. Graham Robertson dubbed her 'Mrs Morris for beginners' on account of her graceful carriage, long neck, dark hair and soft, regular features.[17] But Marie also impressed Brown by her artistic promise and professional approach to painting. At a time when few women of her class contemplated a career in art, she refused, with his encouragement, to settle for a drawing-room accomplishment as her parents wished, demonstrating her independence and toughness of character. The painter argued her cause with the Spartalis, and Marie remained his devoted student for the next seven years — always describing herself as 'Pupil of Ford Madox Brown'. Her painting, however, shows no obvious debt to him: her original choice of Rossetti is reflected in the other-worldly, languid character of her work, which shows more gift for colour than for drawing and moved along late-Pre-Raphaelite lines. The themes Marie chose — from Malory, Dante, Boccaccio and classical legend — show wide reading but little invention and no dramatic impetus.

Cosmopolitan, softly spoken Marie had an acerbic wit. She was the same age as Lucy, and the two became close friends. Not least among their shared interests was the burgeoning feminist movement of the 1870s. Marie's example probably prompted Lucy's decision to become a professional painter; Lucy was often invited to the Spartali homes in Clapham and the Isle of Wight and exhibited alongside Marie and Cathy at the Dudley Gallery. Later, when compelled to abandon painting owing to family commitments and illness, she and Marie kept up a correspondence for many years.

In September 1865, when Marie had been his pupil for sixteen months, Madox Brown took up his diary again, after a seven-year lapse. Once again he recorded works in progress and hours at the easel, but the new entries were noticeably terse and uninformative. Only 'Miss Spartali's' weekly lessons were regularly noted. On 15 September we read, 'Miss Spartali. Painted at Cathy in The Nosegay. Had to leave off to go after Emma. (5 hours).' The lines scarcely conceal a developing crisis. Aware of Marie's attractions, yet excluded from the family's studio life unless called upon to pose, Emma felt threatened. She reacted by repeating the tantrums which had plagued their early married life, and Brown's terse entries recording the sulks, rows and bouts of drinking which each of Marie's visits provoked make pathetic if comic reading:

1st Oct 65 Worked at apron & dress in Nosegay and walked to Tottenham with Marshall and Rossetti. Beautiful day. Home in fly with G[abriel], E finished B. sherry.

2nd same. Evening letters. E tried to get cherry Brandy at pastrycooks. I just in time. E very unhappy because failed.

3rd ... a row, then a walk about the fields with E. then work.

4th Miss Spartali ... walked to Holloway with E. Sulky returning, ungrateful.

When the family moved to Fitzroy Square, Emma resumed her old place in the studio, posing in November 1865 for Cordelia in Craven's *Cordelia's Portion*, the role in which she had first entered Ford's life. The diary entries in early 1866 record little more than hours of work on the drawing and Spartali's visits, but the occasional use of initials, 'E[mma] D[runk] evening' or 'R[ow]', reveal a continuing rift. From July 1866 until the final diary entry on 24 January 1868, the single word 'Spartali' appears on Marie's lesson days, all other days being left blank. By now Emma must have known of the existence of the diary.

These entries bear witness to a silent obsession. Week after week, as he corrected Marie's work in the crowded studio, the teacher worshipped his dark goddess. Many were the projects and exhibition plans they discussed, but of his growing passion he could not speak or write. At night he dreamed of her, but by day he was forced to repress every natural response – each casual touch of hands, each soft glance, each routine contact between pupil and teacher was a torment. He strove to sublimate and idealise his love.

If Marie knew of this – as she must have done – she was much too sensible and self-possessed to encourage the man whom she regarded as no more than a kind and sympathetic teacher; romance was confined to her pictures. Besides, Marie, like most of her family, saw Rossetti as the 'Apostle of the Purest Poetic Love and adoration', and seems to have cherished hopes of marrying him.[18]

For five years family life continued on outwardly normal lines, but the cause of Emma's frequent distressing illnesses, or 'Mrs Street's strictures', may be surmised. Each summer, when Marie departed, Brown took Emma and the children away for seaside holidays, visiting Southend, Yarmouth, Gorleston and Lynmouth in successive years. In 1867 he took Emma to Calais for the first time, to show off the scenes of his childhood and trace old family friends. Emma was convalescing, and Brown's letters to Lucy are full of anxious care of her, describing good meals, visits by omnibus to local beauty spots, long walks and paddling on the beach at low tide. Emma was a keen swimmer.

Back home, Emma posed for Juliet in Craven's newly commissioned *Romeo and Juliet*, a picture made incongruous by its buxom and none-too-youthful heroine, who would have been better cast as the nurse. But its significance for their relationship is

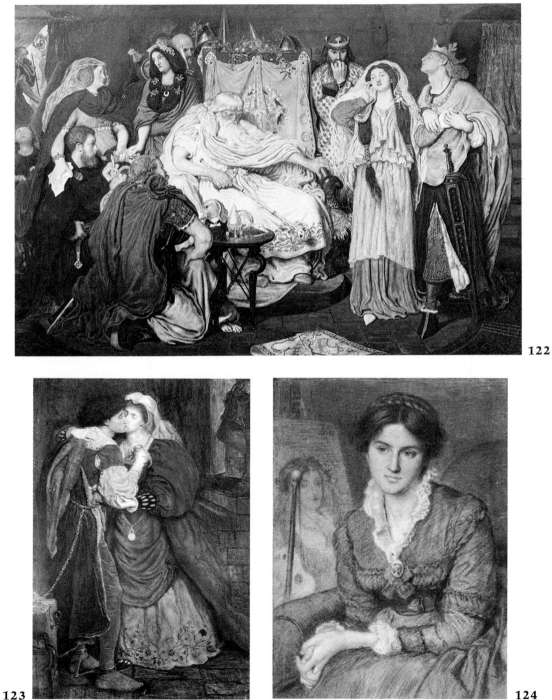

122 *Cordelia's Portion.* One of several versions developed from the Paris drawing of 1844.

123 *Jacopo Foscari in Prison.* Developed from FMB's illustration for the Moxon Byron.

124 *Marie Spartali at her Easel,* chalks, 1869.

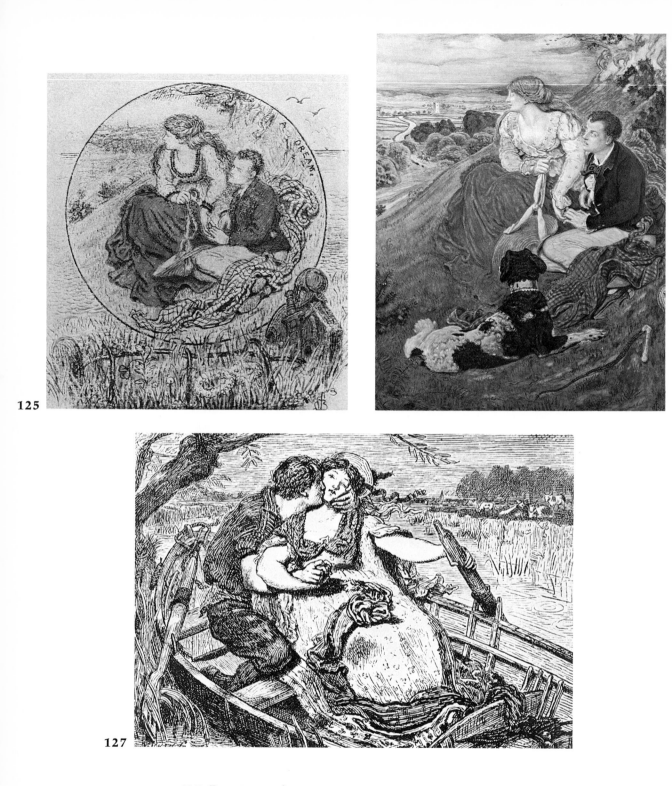

125 Frontispiece for Moxon Byron, original design.

126 *Byron's Dream,* developed from **100**.

127 Illustration for D G Rossetti's poem *Downstream* published in *The Dark Blue Magazine,* 1871.

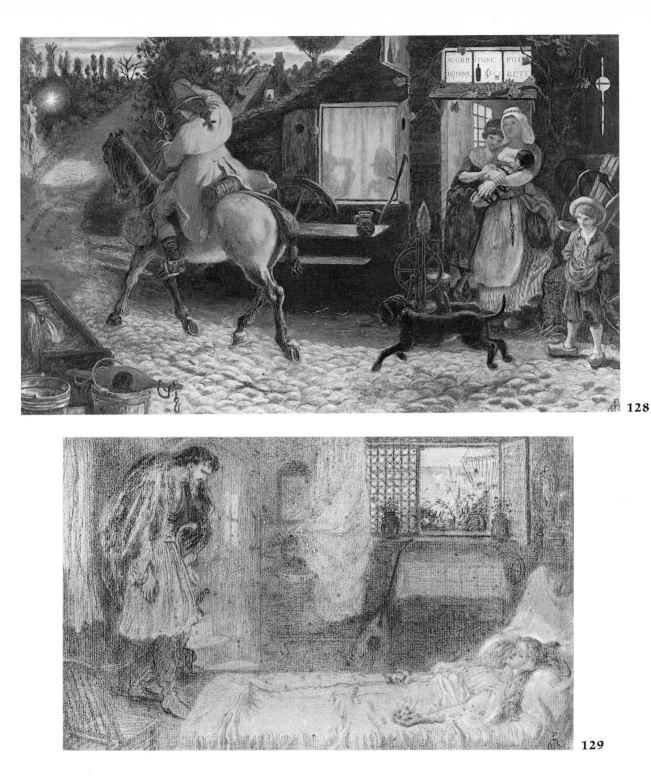

128 *The Traveller*, painted for Henry Boddington, 1884.
Originally an illustration for a poem by Victor Hugo,
Once a Week, 1867.

128

129 *The Corsair's Return*, first drawing for this illustration
to the Moxon Byron.

129

130

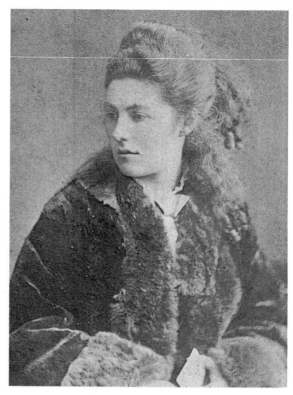

13

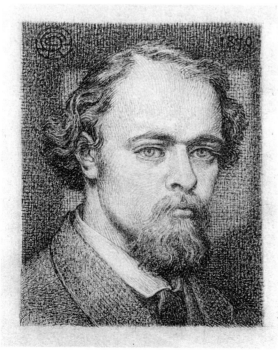

132

133

130 37 Fitzroy Square, FMB's home from 1865 to 1881.

131 Mathilde Blind, carte de visite.

132 *Self-Portrait* by D G Rossetti, 1870s.

133 *Mrs Morris in a Blue Dress* (detail), oils, by Rossetti, 1866–8.

134 *Exercise*, watercolour by Oliver Madox Brown, 1870.

135 *Oliver Madox Brown*, aged about ten, pencil.

136 *Ford Madox Brown*, photograph, early 1860s.

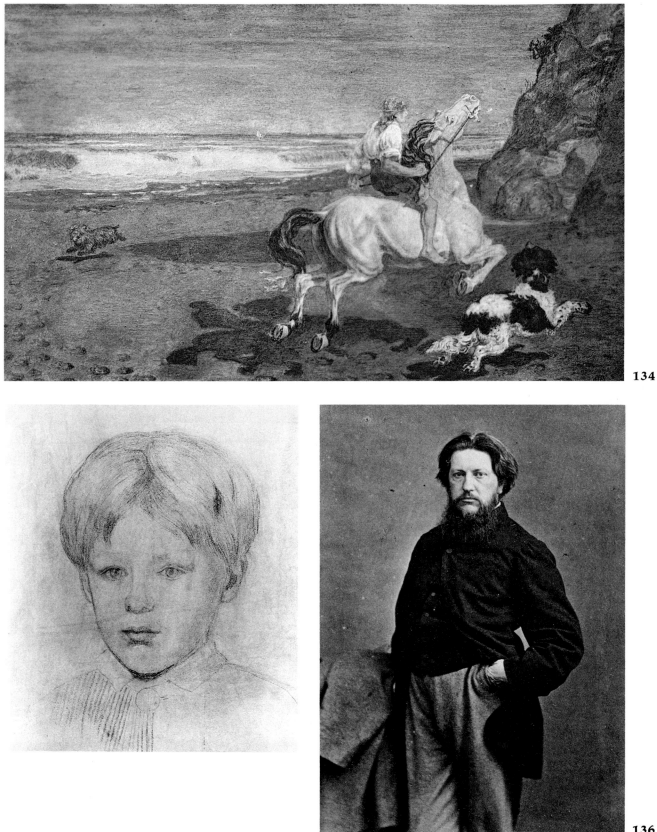

134

136

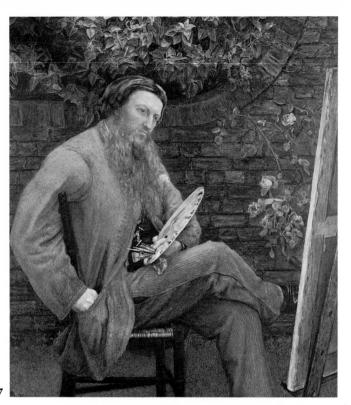

137

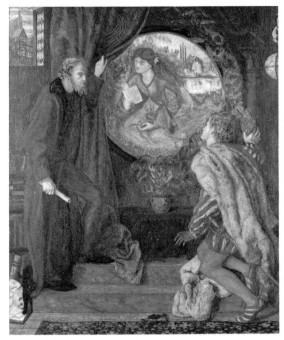

139

137 *Ford Madox Brown at his Easel* by Cathy Madox Brown.

138 *The Magician* (*The Tempest*) by Lucy Madox Brown.

139 *The Nosegay,* painted by FMB in 1865 at Grove Terrace, when Cathy was fifteen.

140 *Lucy Madox Brown,* chalk drawing by Rossetti, 1874, on the occasion of her marriage to William Rossetti.

141 *Emma Convalescent,* chalk drawing by FMB, October 1872.

142 *Oliver Madox Brown, aged eighteen,* photograph.

143 *Francis Hueffer,* oils, by Cathy Madox Brown.

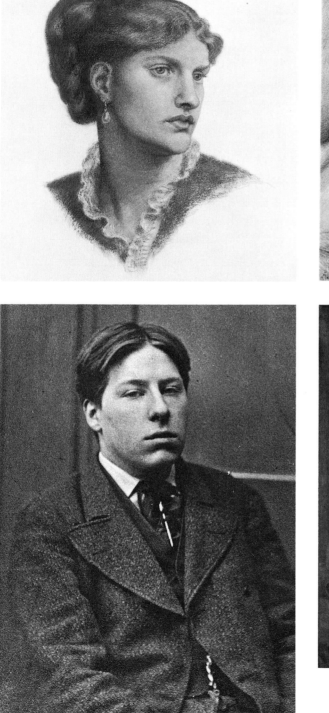

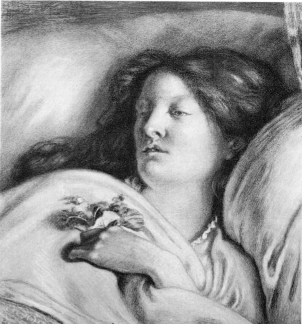

141

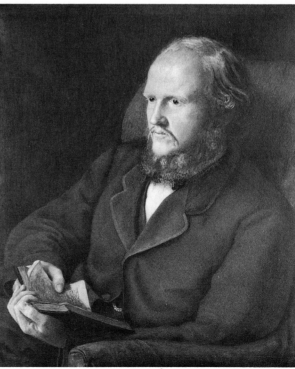

143

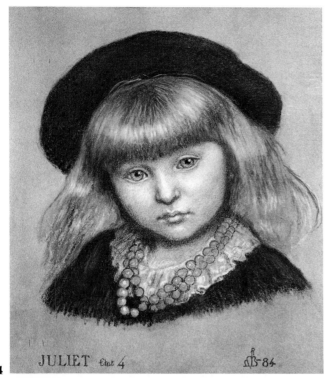

144

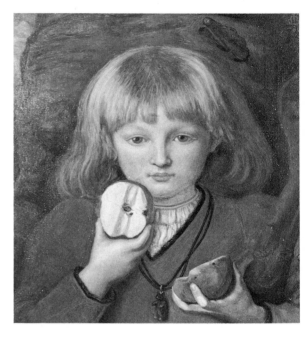

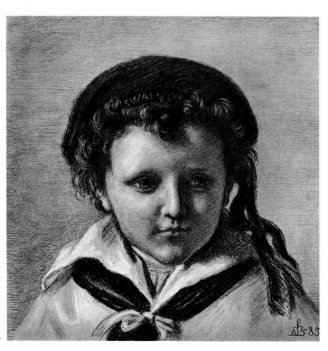

146

144 *Juliet Hueffer, aged four*, chalk, 1884.

145 *William Tell's Son* by FMB. Ford Madox Hueffer aged about five.

146 *Ford Madox Hueffer*, chalk drawing by FMB, 1885.

clear enough. Later that year Brown also made a pencil portrait, approximately life-size – a disturbing likeness in which Emma's dishevelled hair, escaping from its snood, stands out around her head.

Ford's sublimated desire for Marie reached a climax in 1869. That year he made two chalk portraits of her. The first is full-face, sitting beside her easel on which appears a half-finished picture of a red-haired woman. Marie's dark hair is swept up in a braid, her expression tender and thoughtful, the slightly asymmetrical mouth half-smiling, long hands clasped on her lap. The sitter's warmth and humour are wonderfully captured. The second shows her at work, holding a sketchbook in one hand and a porte-crayon in the other. She wears the same red dress as in the first portrait, though a coral necklace replaces the ruffled lace collar. This second portrait is neither flattering nor romantic, and William Rossetti thought it 'not beautiful nor a characteristic likeness and rather dowdy looking, yet interesting'. By contrast, Gabriel's portrait of Marie of that year is idealised and artificial – he admitted finding her head 'one of the most difficult I ever drew'.[19]

In May 1869 Craven had commissioned a *Haidee Discovering the Body of Don Juan*, based on Byron. The subject was peculiarly appropriate. Marie posed for the heroine, the daughter of a Turkish pasha, who discovers Don Juan washed up naked on a beach and falls in love with him. Madox Brown finished this masochistic watercolour in December. More mysterious are the origins of a chalk drawing of a woman's shawled head, inscribed *Mercy*.[20] Undated, it appears to be a reworking of the head of Mercy in the early *The Abstract Spirit of Justice*, with Marie's features – perhaps a wordless appeal to his Belle Dame sans Merci?

This is the more likely since Brown was writing a sonnet sequence, entitled 'Hopeless Love'. At least seventeen survive – in one or more drafts – the last dating from 1871. These passionate poems, modelled on Rossetti's contemporary 'The House of Life' sonnets and more accomplished than Brown's other verse, were certainly reworked under Rossetti's guidance.[21] Two poems were inspired by Marie's pictures, whose subjects he had planned with her. Three drafts of 'For a drawing by Marie Spartali' date from November that year. With his help, Marie had conjured up the image of the unattainable goddess. In 'Love's Problem' he wrote:

> *This is that sov'reign lady of all bliss,*
> *The baffling aim of every man's desire*
> *With snow-like purity to feed his fire*
> *With tantalizing lips that none may kiss:*
> *And should one rashly think to make her his*
> *Enslaved he shall remain who did aspire*

To own those matchless eyes yet shall not tire
While from their depths some song is heard like this:

I am Love's Problem! Ye who thread his maze
Be warned! My crown foreshows your martyrdom!
While others court the throng, afield I come
While others covet dower, I covet praise
And childlike I can view your passionate gaze
But where my glances fall — 'tis ill for some.

This is Rossettian imagery. So are such titles as 'Cruelly Kind', 'Mute Worship', 'Amor Incendiaris', 'Angela Damnifera'. Other poems chart the course of Hopeless Love:

We met! No word disclosed what either thought
I touched her hand — we proffered greetings staid
An interchange of friendship soft — Such aid
To bridle passion's eloquence I sought.
Only my faltering voice's tones in aught
Belied the calm of sentences well weighed
As quivering lips the mentor's part essayed
With moistened eyes . . .

That summer Lucy was with the Spartalis at Rhylstone on the Isle of Wight. From Fitzroy Square, as Cathy contemplated a portrait of Emma musing 'in the black flame powdered grenadine',[22] Brown described the decorators at work: 'Outside your window, you will now have a cheerful view of white walls, a Venetian Red door, windows etc. It really looks well.' The letter was also for Marie:

Rossetti writing from Penkhill wishes to know if there is any date on the copy of 'My sister's sleep' . . . which I gave Marie. Will you ask her if she remembers? And ask her from me not to forget to work entirely but *to meditate her subjects* while at Rhylstone, for I think a great deal more of what you four are going to produce in the next few years than of my own work . . .[23]

In September 1869, as the beloved left for Paris and autumn gales swept Clapham Common, Brown agonised about the Channel crossing in 'Watching Fancies':

My mistress this dark hour is on the sea
Oh may the gales deal gently with such freight,
While on my sleeplessness strange visions wait
By turns each saddening and each one she:
Till one not her in mien approaching me
Told how bewept by kindred desolate,
She lay at point of death . . .

Marie returned unscathed, but Brown's attentions were weighing on her. At the end of 1869 she met and fell in love with Rossetti's friend William J. Stillman. Unaware of this, but guilt-ridden, Brown made a new portrait of Emma — *May Memories* — in which her wedding-ring is conspicuous. He also penned the sonnet 'To Emma' quoted in chapter 5, declaring fidelity despite his enslavement:

Be soothed! you still shall be my heart's best care . . .
But not that Venus-like you still allure
With horrid glances — but that yours in part
Is that nobility which neither smart
Nor lassitude can weary out . . .

Stillman was strongly identified with Greek nationalism. As American Consul in Crete, he had helped to organise an abortive insurrection against the Turks in 1867–8, vigorously promoting the Greek cause in England. Fleeing afterwards to Athens, his wife Laura committed suicide — leaving him a widower with three small children. Such Byronic credentials in an artist and writer ensured Stillman's welcome by the London Greek community and made him peculiarly attractive to Marie.

At midnight on 15 January 1870, Rossetti brought word of Marie's engagement. 'An End' acknowledges Brown's debt to this staunch friend, with whom he sat up talking all night, and in the morning Ford faced Marie, who confirmed the news:

No word — no tear — no wild embrace
Gave hint of love as we did part,
No sigh where lookers on might trace
An anguish struck from heart to heart
But hurriedly and not again
One handshake — and one look of pain . . .

Madox Brown continued to write poems until well after Marie's wedding in 1871. His interest took the form of continuing concern: to help her was to be able

to see her, and, when Marie's visits to the studio ceased the following year, the teacher still urged her to send pictures for correction. Abruptly, in 1873, the Stillmans put an end to the relationship by pleading Marie's ill-health.[24]

Brown had never liked the bohemianism of Cheyne Walk. He felt uncomfortable with Sandys, Whistler and the more dubious elements of Rossetti's entourage. Nor did he approve, after Lizzie, of Gabriel's irregular relationship with Fanny Cornforth – the disorderly household offended so domestic a man. With Rossetti's increasing infatuation with Mrs Morris from 1866 he could sympathise, but he saw his friend's peace of mind and the cohesion of the Firm threatened. The princely postures, the reckless pursuit of another friend's wife, were so many hostages to fortune.

Symptoms of decline in Rossetti appeared soon after the Morrises left Red House for London. By 1866 his quarrelsome and aggressive traits were pronounced, although concealed by his habitual urbanity. One quarrel with Brown himself – perhaps over an indiscretion of Emma's about Jane – was mended, as was Rossetti's way, by an instant and graceful apology: 'I feel myself to have been without doubt in the wrong, and can only most sincerely ask your pardon. Nothing on reflection could pain me more than to inflict the slightest pain on you, whom I regard as so much the most intimate and dearest of my friends that I might call you by comparison the only one I have . . .'[25]

Next May another devoted friend, Boyce, saw Rossetti drunk and quarrelsome on an outing, and Bell Scott observed the usually sober poet drunk at a party. Expenses were mounting at Cheyne Walk. Despite an income which rose from £2050 in 1865 to a peak of £3000 in 1867,[26] purchases of antique furniture, old masters (including a 'Botticelli'), exotic animals and blue-and-white china ran up huge bills, while Fanny – none too scrupulous herself – kept no check on cheating servants. To stave off his creditors, Rossetti needed paid assistants to turn out replicas.

Gabriel's growing love for Jane Morris seemed at first to parallel Brown's for Marie, and these secret passions strengthened the intimacy of twenty years. Like Brown, Gabriel was obsessed with the image of the beloved:

> *Let this my lady's picture glow,*
> *Under my hand to praise her name, and show*
> *Even of her inner self the perfect whole.*

Her face is made her shrine. Let all men note
That in all years (Oh Love, thy gift is this!)
They that would look on her must come to me.

'The Portrait' was written to accompany *Mrs Morris in a Blue Dress* (1866); other portraits with sonnets followed, notably *La Pia* (1868) and *Pandora*. Rossetti's overt expression of passion acted, it would seem, as a catalyst for the expression in verse of Brown's suppressed emotions.

The strain of his unconsummated relationship told on Gabriel. In 1868 his eyesight deteriorated and, fearing blindness, he consulted several specialists. In September, staying with William Allingham in Hampshire, his host was shocked by Rossetti's misanthropy, 'irritability, lassitude, restlessness and irresolution'. In November, Bell Scott concluded that '. . . the greatest disturbance in his health and temper is caused by an uncontrollable desire for the possession of the said L[ucrezia] B[orgia]'[27] – a perception shared by Brown. Gabriel had become a recluse, hostile to his friends. He should go out more into society, Brown told William. All concerned saw Jane Morris as a destructive influence.

Anxiety about Gabriel was not all that united William and Brown in the later 1860s. William too seems to have cherished romantic feelings for Marie, praising her art in two articles – 'English Painters of the Present Day: Miss Spartali, the Junior Madox Browns' and 'The Younger Madox Browns' – in *Portfolio* (1871). In June 1867 the Rossetti family had moved to a large house in Euston Square, just north of Fitzroy Square. With Brown as a close neighbour, William now regularly dropped in on his way home from Somerset House for a pipe and a chat. They would discuss politics – the Irish question, the execution of the Manchester Fenians, the Cretan insurgency, Mazzini and Italy. Or they would talk of Stendhal or (as two atheists) of religion. Brown had appreciated William's 'glorious puff' of his 1865 exhibition in *Fraser's* and regarded the critic as utterly dependable. Now, early in 1869, when the artist was short of work, William helped him again. As editor of the new Moxon series of British poets, he commissioned the artist to illustrate Byron, and five of the resulting designs were later commissioned as paintings.

Charles Augustus Howell – Ruskin's private secretary – was no less useful to Madox Brown. By the late 1860s this Portuguese Iago was deep in the private affairs of the circle. He had every virtue except honesty. Enterprising, amusing and a brilliant raconteur, he was a popular figure at their dining-tables, while his business sense, flair and unfailing helpfulness made him everyone's friend. Howell bought and sold their pictures, introduced clients and would volunteer more personal favours when occasion demanded. For Rossetti he scoured the sale-rooms for blue-and-white china,

jewellery and exotic studio properties; he acted as courier between him and Jane and, a year later, he masterminded the gruesome exhumation of Lizzie's corpse to rescue from the worms the poetry that Gabriel had buried with her.

Madox Brown's daughters had been bridesmaids at Howell's wedding in August 1867, when the Morrises, Joneses and two Rossettis signed the register. Brown's affection comes across in the letter sent on that occasion: 'Accompanying this Nolly and Charlotte our 'ousemaid will bring you two poor offerings of love and encouragement towards the change … tomorrow. The 'umble scrawl styled *The Entombment* is from self and spouse, the blue thing [a blue-and-white teapot] with Lucy and Cathy's kind wishes.'[28] Since June that year the handsome Howell had been posing in Brown's studio for Romeo for his watercolour *Romeo and Juliet*, commissioned by Craven.

Howell – already selling Rossetti's paintings and Whistler's prints – soon offered to become Brown's agent. On his behalf he sold the duplicate *Chaucer* to Leyland, and disposed of *The Traveller* (an illustration to a poem by Victor Hugo). He offered to take any work by Madox Brown or his children that he cared to entrust to him. This arrangement suited both, and at the end of 1868, when Howell was setting up as a print-dealer, Brown kindly supplied a financial reference: 'I have been on terms of friendship with Mr C. A. Howell for 3 or 4 years, and owing to the property of various kinds which to my knowledge he has acquired and paid for of late, I should have no hesitation in accepting him as security for … Seven hundred pounds.'[29]

He trusted Howell: '… I would much rather sell to him [Leyland] through you than personally,' he wrote on 3 February 1868; and, three days later, 'As far as Hamilton and Graham are concerned you can at any time assert … that you have the entire selling of my pictures.' As for the art company, 'I will do what I can of course, with pleasure, to make known your venture and get subscribers …'[30]

When Howell was dismissed by Ruskin in 1870 and dropped by most of the circle, Rossetti and Brown continued to rely on Howell's business flair. But he was no longer invited to their parties. How keenly Howell felt Brown's rejection in not inviting him to Cathy's wedding in September 1872 he revealed to Gabriel:

> Brown is affectionate and I am sure true to me … but I feel it as a marked slight, when I see that *everybody* is asked except myself. It matters little … if Lord this or Lord that forgets me … but caring for Brown I cannot help feeling the damned thing. Cathy was married, she was Kitty's bridesmaid and not a word from Brown on the subject to me! … B asked friends and foes, and no doubt knew that he had to ask Ned Jones, but he might have sent me an affectionate line …[31]

A third extra-marital affair within the circle proved as disastrous for Brown as for everyone concerned. This involved another beautiful Greek. The passion of Maria Zambaco and Ned Jones — concealed for some years — erupted publicly in January 1869 when a suicide pact failed noisily in Holland Park.

Howell's fall from grace was due in part to the implacable hostility of Jones. Georgie later described Howell as 'a stranger to all our life meant'. Ned put it more vehemently in a private letter to Rossetti — the man was 'base, treacherous, unscrupulous and malignant'.

At Ruskin's behest, Howell had moved to Fulham in May 1868 to keep a friendly eye on Ned who now lived at The Grange, North End Road. But, taken into his confidence about Maria and unable to resist intrigue, he had contrived to reveal the true state of affairs to Georgie. According to Whistler, he brought Maria unannounced to The Grange one day at the end of 1868: Ned fainted, splitting his head on the mantelpiece, and the dramatic suicide attempt followed.[32]

Shortly afterwards, on 3 February 1869, Ford and Emma called at The Grange to commiserate over Ned's illness. Afterwards, Brown wrote to Howell: 'I wished to have called on you some days ago, when we called on Mrs Burne Jones. But on reflection I feared that should she know about it she might fancy our visit was prompted more by curiosity than sympathy, so refrained.'[33]

Neither Ned nor Georgie ever forgave Howell — nor Rossetti and Brown for their continuing friendship with him. Ned's bitterness grew like a cancer within the formerly close circle of friends, undermining then destroying his former intimacy with Madox Brown.

13
DISSOLUTION
1872–1875

O N THE EVENING OF MONDAY 3 JUNE 1872, Brown was in his front studio painting the blind MP Henry Fawcett and his wife from lay figures – a commission from Swinburne's friend Sir Charles Dilke. Nearby, on a second easel, Leyland's large *Don Juan* awaited attention. A cab drew up outside number 37, from which William Rossetti and a wildly gesticulating Gabriel descended. The latter was talking loudly of Lizzie, whose spirit had assured him at a Cheyne Walk séance that she loved him still.

Gabriel's breakdown, amply documented in the literature, was the first of a series of grievous blows that Madox Brown suffered over the next three years. No one, not even the devoted William, loved Gabriel as he did, and the shock of his collapse was proportionate.[1]

The crisis came with terrible suddenness; yet, looking back, Gabriel's friends saw it as inevitable. For two years the artist's disturbed state of mind had been exacerbated by anxiety over the reception of his *Poems*, published in April 1870, and his passion for Jane Morris. Lizzie's ghost hung over both. A deception permeated these sensual and erotic poems, ostensibly written by husband to wife – a deception compounded by Gabriel's guilt at robbing Lizzie's grave of its worm-eaten manuscript and then reworking Lizzie's poems for Jane. Yet he was under compulsion to rival Morris, whose *Earthly Paradise*, published in 1868–70, had put him in the first rank of English poets. Rossetti's painstaking revisions of his poems and careful orchestration of favourable reviews in the press (which Morris was persuaded to lead in the *Athenaeum*) betrayed deep anxiety about their reception. It was not their technique, but their explicit content that laid him open to attack.

Long delayed, but thoroughly prepared, this attack came in October 1871 in a pseudonymous article by one Thomas Maitland – 'The Fleshly School of Poetry' in the *Contemporary Review*. The article accused Rossetti of 'wheeling the nuptial couch out into the public streets'. By now his relationship with Jane, and Morris's

acquiescence, were known in literary and artistic circles. Kelmscott Manor, Oxford-shire, had been taken as a retreat for them, and Morris, spending the summer in Iceland, had left the pair to their idyll.

Rossetti's counter-attack, 'The Stealthy School of Criticism' in the *Athenaeum* that December, provoked more adverse publicity. In May 1872 the poet Robert Buchanan republished his article in pamphlet form and under his own name, accusing Rossetti and Swinburne of 'sensualism' under the guise of art. Brown had observed the catastrophic effect of this on his friend, and when, soon afterwards, Browning sent an advance copy of his poem 'Fifine at the Fair', Rossetti's fragile equilibrium snapped. Here was a disguised personal attack, confirming a world conspiracy to destroy him.

Four months later, writing from Kelmscott, where he was convalescing from his illness, Rossetti paid tribute to Brown's heroic support at this time: 'The better I am,' he wrote, 'the more intensely I feel your friendship in word and deed.'[2] Brown's determination to keep Gabriel out of an asylum, whither doctors and family proposed to send him, crowned his many acts of friendship.

Madox Brown organised a rota of friends to distract and calm the agitated man: they took him for long walks – fresh air and exercise being prescribed for an overwrought mind. But his condition deteriorated, doctors were called, and on Friday 7 June 1872 a friend and fellow poet, Dr Thomas Hake, offered to care for Gabriel at his Roehampton home. It was there next day that Rossetti, following Lizzie, took an overdose of laudanum and was found unconscious in bed the following morning. Despairing of his life, William summoned their mother and sister Maria to the bedside. Bell Scott was also present.

Four days later, with William on the verge of collapse, Brown took charge. According to Scott, William's account of his brother

> was that of a maniac with so many and such dreadful delusions that there seemed nothing for it but to send him to an asylum ... as William had no influence, Brown proposed to bring him back to Cheyne Walk, and alone to take charge of him ... It is very noble of Brown, this independence of view and the determination to keep him out of an asylum and if the move is successful we must honour him for it.[3]

Quick to perceive the dangers to Rossetti's professional reputation at a time when creditors were pressing, Madox Brown removed Rossetti's most important pictures from Cheyne Walk to prevent their seizure. At the same time, taking charge of all financial outgoings, he opened a joint account with William at the Westminster Bank in St James's Square.

On 17 June, Scott reported again to Alice Boyd: '. . . as Brown, who has sacrificed so much time that should have been spent on the portraits he is painting, could not remain longer from home (he has been day and night with DG), Jones and then Morris offered to take his place . . . but Brown proposed . . . that Gabriel should go with him to Fitzroy Square.'[4] Money was urgently needed to meet expenses at Cheyne Walk, and Gabriel agreed to sell his valuable collection of blue-and-white china. But before the move to Fitzroy Square could take place, Rossetti's patron, Glasgow MP William Graham, stepped in to offer the artist refuge in his Perthshire houses, Urrard and Stobhall. In Victorian Britain, the isolated country house was the accepted alternative to an asylum.

Graham's invitation was promptly taken up. But who would go with Gabriel to Scotland? Writing to Scott on 18 June, William sounded him out: 'Marshall distinctly objects to my being of the party. We are . . . beating up for possible friends. Could you be one? Brown would find much difficulty in going at all and *could not* remain more than a day or two.'[5] William himself was also trying to cope with an illness of Christina's.

On 20 June, nevertheless, Madox Brown and Rossetti, with Dr Hake's under-graduate son George, on vacation from Oxford, and a manservant, boarded the night train to Scotland, arriving at Urrard House at midday on 21 June. Brown stayed eight days. A strict regime of long walks, drives and regular meals was instituted, while a concerted effort was made to reduce Rossetti's dependence on whisky and chloral. All letters from London – and particularly those from Jane, which might excite the patient – were intercepted. The delusions and paranoia continued: 'You have no idea,' wrote young Hake, 'how he invests with an undue importance the most trivial circumstances: If we start a rabbit . . . or a passing countryman civilly bids us "Goodnight" or even a watchdog barking as we pass, all are studied insults.' The demands of this querulous invalid – who slept fitfully, complained endlessly and threatened suicide when thwarted – placed his patient keepers under intense strain and after supervising the second move, to Stobhall on 28 June, Brown thankfully handed over to Scott. From now until the end of September, the care of Rossetti devolved on Scott, good-natured George and his sympathetic father Dr Hake. Their letters to William and Brown in London – detailed bulletins charting Rossetti's painful recovery – were all sent to Fitzroy Square.[6]

Brown returned to his easel and tried to make up for four lost weeks, but self-imposed duties prevented him. Visiting the Rossetti household at Euston Square, he found William depressed and morose. 'Billy Waggles', as Scott called him, must be protected from unpleasant news.

They deliberated, meanwhile, on how to get rid of Gabriel's pilfering servants.

LEFT Rossetti and Bell Scott at Penkill.
RIGHT *Kelmscott Manor from the Garden Door*. Drawing by F L Griggs.

William wrote to Scott, 'Brown thinks they ought both to be paid off with any liberal treatment that may be fitting, and I also think this the most sensible course: but no doubt they ought not to be exasperated or they may spread many rumours abroad *on more subjects than one* of a very unpleasant kind.'[7]

Brown's mind was constantly on Stobhall. In July, seventeen-year-old Nolly volunteered to keep Gabriel company. 'Dunn[8] and my son Oliver,' Brown wrote to Scott, 'will arrive to take your place. Don't be surprised ... it would only be for a few days and he is 5ft $10\frac{1}{2}$ and has his wits about him.' To his surprise, this plan alarmed the invalid: 'Yesterday,' Hake told William, 'we told him of the plan that young Mr Brown was coming here on Mr Scott's departure and he was much excited and said that he was too young to be with him in his present state and ... insisted that we send off a telegram ...' 'Why in the world send him?' Gabriel was demanding angrily of Scott.

Rossetti may not have wished to be exposed to Nolly's youthful egotism, but so strong a reaction could be connected with the novel that Nolly had secretly written. Within days of reading the manuscript of *The Black Swan*, Madox Brown had proudly invited William, Gabriel and Morris to hear 'this prose tale of passion and extraordinary power'.[9] The reading took place at the end of May, two days

before Gabriel's breakdown, and neither he nor Morris came. But so full was Brown of this new evidence of Nolly's genius that readings from Oliver's 'imperishable prose' must have filled Gabriel's lucid intervals in Perthshire.

Nolly's high destiny was foreshadowed in *The English Boy* of 1860, where Brown shows him with kingly regalia. His early *Queen Margaret and the Robbers* had been presented to Gabriel. At thirteen, Nolly had painted an allegorical *Jason and the Centaur*, illustrating a scene from Morris's *Jason* where the infant's father hands him to the all-wise centaur to be educated. The destined-child theme was on Brown's mind at this time; in 1863 he had painted the first of several versions of *Jacob and Joseph's Coat*, using the same model, dagger and embroidered cloak as appear in *Jason*.

Nolly's unusual empathy with animals and small children is shown in *Jason*, which also demonstrates his Pre-Raphaelite training – the forest background was painted in Richmond Park. It appeared at the Dudley Gallery in 1869, alongside the works by Lucy, Cathy and Marie which launched Brown's small academy on the London art world.

Until he stopped painting in 1872, Nolly showed annually at the Dudley, the Royal Academy or the British Institution. In 1869 he produced a lively view of *Yarmouth Pier* on a breezy day and *Exercise*, a splendid study of a groom reining in his horse on the beach. What distinguishes Nolly is his mastery of movement – in the elements, animals or people. We see it in *Mazeppa* (exhibited in 1870), first designed for the Moxon *Byron*, and in *Prospero and Miranda* (1871), while his last finished work, *Silas Marner* of 1872, shows real feeling for human drama.

This illustration of George Eliot marked a burgeoning interest in literary ideas. He had begun to read and explore prose fiction – a field hitherto untapped by the poetic Pre-Raphaelites, which he determined to make his own. Abandoning the studio, he spent the winter of 1871–2 up in his attic.

The Black Swan has genuine power. Its roots are in the popular novels of the period, with overtones of Wilkie Collins, Dickens, and the Brontës. The dialogue is wooden, the plot melodramatic and not particularly original, but the young author's descriptive powers and interest in human psychology, his theme of doomed humanity at the mercy of elemental forces, bear comparison with the young Hardy's.

The novel tells the story of unscrupulous Gabriel Denver, of Anglo-Portuguese parentage, who travels to England with his rich but hated wife Dorothy to claim a legacy. On board he falls in love with the beautiful and innocent Laura and finds his passion reciprocated. The desire for Laura overrides even his lust for money, but his behaviour will destroy all three. Dorothy's jealousy arouses in Denver thoughts of murder. A sudden fire envelops the ship, killing all but these three, who escape in a boat. In the melodramatic climax, Dorothy confesses to arson, and Laura dies as they

are being rescued. In the moonlight, the black silhouette of Denver – her body in his arms – leaps over the side of the rescuing ship.

It is easy to see how Rossetti's paranoia would see in this innocent fiction a thousand personal references. The hero's Christian name, exotic looks, Anglo-Portuguese ancestry and obsessive passion for the corrupted heroine would have struck an uncomfortable chord in one living in dread of exposure. Here was a further attack, and from a most unlikely quarter.

Brown urgently sought a publisher and begged Gabriel to approach George Meredith at Chapman and Hall, but Rossetti – who stood accused not only of immorality but also of operating a literary coterie – demurred. Hake had no doubt that Rossetti might be induced to write a letter to Meredith, 'but it is better not to urge this until ... absolutely wanted – as he has some scruple about doing it ...'[10] Gabriel's recommendation of Nolly's novel was likely to rebound, and indeed its subsequent fate at the hands of the publishers Smith Elder may be seen in this context.

The enchanting child painted by his father and lovingly described by Georgie Burne-Jones had as a schoolboy been distinguished for his idleness; his menagerie of rats, frogs, toads, chameleons and Japanese salamanders; his extra-mural collection of stray cats and the grubbiness celebrated by Rossetti:

> *There was a young rascal called Nolly*
> *Whose habits, tho' dirty, were jolly*
> *And when this book comes*
> *To be marked with his thumbs*
> *You may know that its owner is Nolly.*

From infancy, Nolly was conscious of a special position in his father's charmed circle; now, on the verge of manhood, he was a minor celebrity. A friend of his own age, the blind poet Philip Bourke Marston, recalled how 'he enjoyed the friendship of some of the most distinguished men of his time'. On friendly terms with Rossetti, his younger friends included the Paris-oriented poets Arthur O'Shaughnessy, James Thomson (author of 'The City of Dreadful Night') and James Payn, later editor of the *Cornhill Magazine*.

Photographs do less than justice to the young writer, suggesting a taller, heavier, sulkier version of Brown. Nolly wore his light-brown hair like his father, parted in the middle. His grey eyes were usually masked by spectacles, but, 'when animated, his features assumed a sort of intensified keenness mingled at times with a sweet playfulness of expression'. Letters to family and close friends reveal an affectionate though somewhat reserved nature. Unreliable, he was constantly in hot water for

losing and forgetting things. In company he adopted a supercilious manner 'as shield against commonplace chatter' and could appear somewhat 'flip'. His conversation, Marston recalled, was 'quick with repartee, which sometimes hurt just a little, but his bright smile and cordial shake of the hand always healed instantly the slight wound ... his nature was essentially masculine and robust, having that almost maternal tenderness which in noble natures is generally coupled with strength.'[11]

Brown had cause to celebrate in September 1872. With his sanity at last restored, Rossetti was able to leave Scotland and settle with Jane Morris at Kelmscott. In the same month, Smith Elder agreed to take *The Black Swan* for fifty guineas, provided certain drastic revisions were made. Their reader, William Smith Williams, advised the young author to modify his plot and the morally neutral attitude to his characters, which would alienate respectable readers. As it was, Mudie's select Circulating Library, at the height of its influence on publishers, would refuse to take it. Though reluctant to do violence to his story, Nolly was anxious to see it in print and agreed to rewrite it. The winter of 1872–3 saw him reconstructing and diluting his work, aware that he must sacrifice its integrity. The final, tamed version would be published as *Gabriel Denver* in November 1873, with cover design by Brown, to mainly unflattering reviews: undiscouraged, Nolly had embarked on a second novel – *The Dwale Bluth*.

That September the Madox Browns gave a big party at Fitzroy Square to celebrate twenty-two-year-old Cathy's wedding to the German musicologist and critic Franz Hueffer. With his florid Prussian looks and general erudition, Hueffer had quickly established himself in the circle, reviewing Swinburne's *Songs before Sunrise* in glowing terms and arranging the Tauchnitz edition of Rossetti's *Poems*. He had become a firm favourite with the musical Browns because of his passionate championship of modern German music, especially Wagner.

Bell Scott, a devotee of German art, liked this 'amiable and very charming man who had all the talents of the élite of his native country ...'[12] and tried to get him journalistic work. But Hueffer's fecklessness thwarted his efforts, as it did Brown's. Even after his appointment as music critic of *The Times*, Hueffer's income remained precarious, and he and Cathy were always hard up. He bequeathed both his talent and his prodigality to his son Ford.

The couple settled into Fair Lawn, a villa in Lower Merton in Surrey. From Dover, *en route* for their honeymoon in France and Germany where they would visit Franz's relatives, Cathy wrote to her 'dearest Mama' on 5 September: 'I am so happy Mama dear and I am sure that I shall continue to be so as Franz is a dear good man and does anything to give me pleasure.'[13] But Emma, overccme by all the excitement and the loss of her beloved daughter, succumbed to a serious infection and lay

dangerously ill for much of the autumn. As she lay in bed, convalescing, Brown made a chalk drawing of her holding a posy of violets.

On 30 November 1872 William Rossetti had recorded in his diary, 'Brown writes that he intends to try for the Slade Professorship at Cambridge.' Two days later, calling at Fitzroy Square, he found Brown 'busy writing to people likely to influence the Cambridge election. This it seems lies in the choice of seven persons, one of whom is the President of the RA.'

On his death in 1869, the wealthy collector Felix Slade had endowed three Professorships – at Oxford, Cambridge and University College, London – 'to promote the study of the fine arts'. Ruskin, who had been swaying Oxford audiences with his customary brilliance, was the natural choice at that university; in London, Edward Poynter RA had set up the Slade School as part of University College; while, at Cambridge, Digby Wyatt, eminent architect, former Secretary to the Great Exhibition, and Slade Professor since 1869, had resigned his post.

Madox Brown's incongruous bid for a top job in Academe alarmed his friends. At fifty-one he had no academic qualifications, experience as a lecturer or standing as a critic, and was notoriously hostile to the Royal Academy. He was bound to be rejected, as he had been by the Garrick Club and by the Old Watercolour Society in 1869.

Brown's decision came out of the blue. He had consulted nobody. Yet this bid was the logical outcome of a life's work. He had produced important paintings, but disabling gout increasingly undermined his health, affecting his output. Looking back at the 1865 retrospective, with its statement of a lifetime's beliefs, he saw it as a vindication never to be repeated. He had launched three children into the professional art world with every expectation of success. Was this not the time to assume a new public role as educator? An old rivalry spurred him too: Cambridge offered a unique opportunity to challenge 'The Graduate' on equal terms!

Long ago, with Cave Thomas in the *Builder*, he had argued the case for *educated* and enlightened patronage of the arts – not to encourage connoisseurship (which he despised) but to encourage native artists and give them a higher status. Holding art pundits and art 'twaddle' in contempt, he would match Ruskin's flights of rhetoric with the wisdom of the practical man. Art, whether in theory or practice, belonged to the artist.

All this came out in his 'Address to the Vice-Chancellor', dispatched to the Cambridge electors in December 1872.[14] The new Professor, he argued, should be a practising painter and no mere theoretician. But knowledgeable he should certainly be: Madox Brown's impossibly ambitious scheme of lectures would include 'the history, critical analyses and technical examination of all the fine arts of every nation and epoch'.

Typically Brunonian was the proposal to start with Hogarth, father of modern art. Equally clear was the continuing commitment to the Pre-Raphaelite belief that art must play an intellectual role in the life of the nation, fostering realism and democratic values as against the aristocratic legacy of the Renaissance. From modern art, the course would reach back to the ancient and medieval arts of Europe, to oriental art and thence to the ornamental or decorative arts. Such sentiments would be taken up in 1877 by William Morris in his first lecture, 'The Decorative Arts', and become common currency in the Arts and Crafts movement.

Brown told the Cambridge electors that he had opposed the setting up of the Slade School in London on the grounds that art schools did not belong in a university context. Such a school would distract serious students, while short courses would do little for intending artists: 'I am convinced it would be a mistake to attempt the like in Cambridge where the number of real art students could be but very limited ...' Finally he referred the electors — who included his *bête noire* Sir Francis Grant, President of the Royal Academy — to his own pictures, critical notices of which were appended with his 1865 catalogue.

How his long and sometimes obscure Address — distinguished by his own original syntax, spelling and punctuation — was received by the Cambridge electors can only be imagined.

Madox Brown feared the worst when, late in the contest, Ruskin intervened. By 17 December he was nervously hinting to Stephens that 'I might withdraw, possibly in favour of Colvin who has a good chance though I believe his dons think him too young. The peculiarity of the affair now is that J.R. [Ruskin] has just been civil to me promising all kinds of aid and encouragement.'[15] In fact, to Brown's chagrin, one of his friends had solicited from Ruskin an embarrassing testimonial, 'scarcely of a nature to make public', and sent it to Cambridge.[16] Ruskin had also sent a testimonial in favour of young Sidney Colvin, a fellow of Trinity College and a friend of Burne-Jones.

Colvin was elected in January. He proved an ideal Professor, founded the Cambridge School of Art and later became Director of the Fitzwilliam Museum.

According to Hueffer, Madox Brown quietly accepted his defeat and returned to his painting. But, beneath the surface, the old resentment and bitterness of

rejection simmered – to be assuaged only by the prospect of Nolly's forthcoming triumph.

The summer months of 1873 were perhaps the last truly happy ones of Madox Brown's life. Rossetti had settled, apparently permanently, at Kelmscott and had begun painting again – 'some of his best and grandest heads' – and writing poetry. Much of his old sparkle had returned; he was looking 'extraordinarily well and stout and younger than a year or two ago'.[17]

It was like the old companionable days. Early in June Ford and Emma arrived at Kelmscott with *Cromwell*, newly commissioned by Mr Brockbank of Manchester. Brown set up his easel in the peaceful meadowland adjoining the manor, beside the willow-fringed Thames. Here, over the next five weeks, he painted the 'Huntingdon' background and, encouraged by Gabriel, rediscovered his old delight in landscape. 'I am now painting a lamb into the Cromwell picture,' he wrote to Lucy, who was on holiday in Italy with William Rossetti and the Scotts, on 21 June. 'The country round this is decidely beautiful and we have little expeditions in the boat or chaise, on the Thames or to neighbouring small towns ...' On 7 July: 'I have painted the horse and the lamb and the willow stump and the oak branch and am on the lookout now for pigs.' He spent a day looking with George Hake, Rossetti's genial young companion. Other guests came and went: old Mrs Rossetti and Christina; beautiful Alexa Wilding, modelling for *La Ghirlandata*, in which little May Morris appears as an angel; Rossetti's new friend the poet-solicitor Theodore Watts (later Watts-Dunton); and Franz Hueffer. Cathy – now pregnant – was in London. Alone too, at Fitzroy Square, Nolly was correcting proofs of *Gabriel Denver*.

Now Lucy announced her engagement to 45-year-old William. Her father can hardly have been surprised – he had done much to encourage this match since her illness that spring and William's depression. After Marie and Cathy's marriages, Lucy had worked alone in the studio and Brown had proposed her as William's travelling companion in Italy. 'He, W.R. is one of the men I most esteem of those I have known for a long time,' he wrote to Lucy, 'and as we all know quite incapable of allowing anyone who is near him to be unhappy – he is moreover of congenial tone of mind and occupations to you – how then could I do otherwise than cordially approve if you love each other and wish to be united?'[18] To William he wrote, 'Lucy is fortunate in securing the affection of a man so trusty and tried in ways as yourself, and I must say that I consider the difference in age ... perfectly immaterial ...'[19] He assumed

that Lucy would join the Rossetti household at Euston Square, a stone's throw from his studio. Anxious to retain the last of his talented assistants, who was also his amanuensis, he wished only that 'Cathy could be a little nearer to us for the same reason'.

The year ended happily, with the publication of Nolly's book on 5 November. Just before Christmas, on 17 December 1873, Cathy gave birth to the Browns' first grandson, Ford Madox Hueffer.

By contrast, 1874 was to be a terrible year. It opened wretchedly with Emma and Ford both confined to bed till March. Struck down with disabling gout, unable to walk or work, Brown obeyed Dr Marshall's instructions to sweat the disease out and, lying in bed, brooded on the reviews of Nolly's book. So far they had been mixed, and he was wounded by the failure of old friends, especially Morris and Burne-Jones, to applaud his son's achievement. Lucy's wedding-party, fixed for 30 March, now hung over them. In depressed and angry mood, Brown wrote to Gabriel in a left-handed childish scrawl. What sort of gathering, he wondered, would it be?

> As to the wedding, we must of course have you at it. So we have now arranged it on a plan common abroad, an evening party the night before for friends and the breakfast in the morning for relations only, ... as to my *old* friends, alas! I don't know where they are; it would be *you* and Hughes – Morris I certainly regard with great affection but what sort of an *old friend* is it who can't bring himself to say a few civil words when one's son brings out such a book as mine has.

Nor was Scott, who had failed to attend Cathy's wedding, any more in favour:

> Callous and insufferable conceit seem to be the distinguishing characteristic of old friends as I find them. Newer friends ... come whenever they are asked and are proud whenever I and my wife go to see them ...[20]

Morris was complaining at the same time to Louisa Baldwin, Georgie Burne-Jones's sister: 'Sad grumbling, but do you know I have got to go to a wedding next Tuesday; to wit Lucy Brown and William Rossetti and it enrages me that I lack courage to say "I don't care for either of you and you neither of you care for me and I won't waste a day out of my precious life in grinning a company grin at you two old boobies." '[21]

These letters herald the personal rifts which would lead to the dissolution of the Firm at the end of the year. A silent but growing hostility between Brown and

Burne-Jones – exacerbated by the Zambaco affair – lay at the heart of it. Coolness had grown into resentment as Brown's former protégé rose to fame with Ruskin's powerful support. With it, the friendly mockery of 'old Bruno' had turned to ridicule of 'old Brown', while the valuable cartoon work for the Firm had fallen more and more into Burne-Jones's hands. There was also rivalry over the talents of their respective sons. In early days, little Nolly had been a firm favourite with Ned and Georgie, but now Ned's indifference to his pictures and to his novel were keenly felt, compounding Brown's sense of rejection.[22]

For his part, Burne-Jones complained to Rossetti of Brown's unfriendliness: 'I hear through third and fourth people from time to time of his wrongs at my hands. As I hear them, they are all fabulous and untrue ... He has never once had the regard for old friendship to state them to me ...'[23]

Both men, despite differences in temperament, had caustic tongues and unforgiving natures, and the split between them was never healed. On the day of Brown's funeral Jones obscured the reasons: 'At first he was very kind to me then he wasn't. I know no more why than you do. Perhaps chatterers came between. He knew no middle way between loving and hating and I ought to understand that – a turbulent head, impetuous, unjust – always interesting, but it was more fun for those he liked than those he hated ...'[24]

Beyond the personal differences of its members, the dissolution of the artists' co-operative Morris, Marshall, Faulkner and Co. and its reorganisation under Morris's sole control had, since 1870, become inevitable. Pressing economic reasons, based on the altered character of the business, dictated it. The large one-off commissions, especially for ecclesiastical stained glass, which had sustained the firm in the 1860s had almost disappeared, along with such prestigious schemes as the decoration of St James's Palace. Faced with increasing competition in a shrinking market, Morris had turned his attention to domestic interior decoration and to the production of wallpapers and chintzes which could be sold to trade and public. Between 1870 and 1874, Morris had created a new recognisable style, which his middle-class clients were quick to adopt.

Morris now wanted control of a reconstructed firm. Only he could provide the new capital and the full commitment it needed; the old freelance system was incompatible with expansion. In the period preceding the dissolution, the volume of domestic decorative work grew dramatically, and Morris worked intensively to supply the demand. In the spring of 1874, he moved to buy his partners out.

The Madox Browns were on holiday in Margate in the summer of 1874 – all but Nolly, who had remained at Fitzroy Square suffering from a liver complaint and gout in the foot. 'I am still laid up and grievously afflicted by the Lord,' he wrote to Philip Bourke Marston on 19 September.[25] Too ill to join his family, and lonely in the great house, he asked Philip to spend a few hours with him.

He recovered sufficiently to get to Margate, but returned, feverish, within a week. His parents, used to his headaches, finished their holiday, discovering the seriousness of his condition only when they got home. Brown expressed his disquiet to Howell: 'Nolly I am sorry to say is very ill – has been for three weeks ... with a sort of low intermittent fever ... bad enough to make us anxious.' He had called in Marshall, who 'takes the most admirable care of him'.

Madox Brown's faith in Marshall was unshakeable. Nevertheless, his and Emma's anxiety grew. Day and night they took turns to sit by the invalid's bed, watching for any sign of improvement. From time to time Brown would steal away to his studio to touch half-heartedly at his waiting canvases, or write progress reports to close friends.

These letters also touch on the frenetic activity of dissolving the Firm. During October, each partner received from the solicitor Theodore Watts Morris's proposals for compensation, with a supporting balance sheet. Brown reacted with anger and suspicion, writing immediately to Gabriel: 'We want to have the accounts of the firm properly audited by a public accountant and I want Mr Fraser [Rae's brother-in-law] to be chosen. Please add your voice to mine in this matter by dropping a line to Watts ... Nolly's illness seems as though it were becoming less severe – fresh lumps keep developing, but not turning out abscesses again.'[26]

Gabriel's response was measured. Anxious to avoid a row with Morris and to settle the matter amicably – and prompted also by urgent letters from Jones – he wanted a quiet discussion at Cheyne Walk. He thought Morris's proposal reasonable on simple financial grounds, but considered 'his proceeding sudden and arbitrary'. On 22 October, Brown pressed his original point, anxious that Rossetti should make a more positive stand: 'There *must* be some accountant employed and I only wanted to have your voice added to mine for the one Watts and I had agreed on.' By now, his hostility to Morris was total: 'I could never meet him again with the least pleasure, but even if I could, it would disturb all our negotiations which are going on satisfactorily in Watt's hands.' He wanted 'to be quit of it as soon as I can ... but I am not inclined to go at M's dictation.' Neither he nor Gabriel attended meetings at Queen Square on 23 October or 4 November.[27]

At long last Marshall had diagnosed blood-poisoning (pyaemia), but his treatments were ineffective. Still Brown clung desperately to his belief in this old friend.

On 29 October he wrote to Rossetti, 'Nolly is not yet convalescent though John Marshall is satisfied with the way he is going on.' Although Nolly grew daily weaker, '... we have excellent hopes and promises given by Marshall. Of course he is a shadow of what he was seven weeks ago and will be more wasted yet before he mends.'[28] Now a trained nurse was installed. 'I steal a few moments from my night watch,' he told another friend, Frederic Shields:

> He had a relapse, which is a common feature of these fevers, ... then his illness assumed the form of blood-poisoning – recently it is more like enteric or gastric fever. He is no longer in pain ... No end of people keep calling and inquiring ... But I can scarce see any of them. I pass the night in his room, sleeping, but not undressing, until 6, when I wake the nurse and go to bed for two or three hours.[29]

In his stronger moments, the invalid dictated part of a story about London slum-dwellers to his mother and William Rossetti. He also listened with enjoyment to *Lorna Doone* and the first chapters of *Far from the Madding Crowd*, then being serialised in the *Cornhill*. This magazine had rejected his own *The Dwale Bluth* and, coming to Hardy's chapter describing the shepherd's 'care for the young lambs through the winter night', he generously exclaimed, 'No wonder they did not want my writing!'[30]

Nolly turned delirious as the desperate struggle for his life went on. Sir William Jenner, called to assist Marshall, offered some illusory hope to the distraught parents. On 5 November, Brown dashed off a letter to Gabriel: 'We are waiting for the event [the crisis] but with fear and trembling.' But that evening, to the accompaniment of fireworks in the square outside, Nolly at last gave up the struggle. Brown wrote again to Gabriel: 'It is over and the poor boy is at rest again – I shall have much to tell you some day ... His agony was like a poem throughout ... he seemed to weave up his sufferings and the anguish of his relatives into a beautiful romance. One of the last things he uttered was "Courage, father, you'll need it tomorrow."'[31]

> *O broken promises that showed so fair!*
> *O morning sun of wit set in despair*
> > *O brows made smooth as with the Muse's chrism!*
> > *O Oliver! us too Death's cataclysm*
> *Must soon o'ertake – but not in vain – not where*
> > *Some vestige of your thought outspans the abysm!*
> > > *F.M.B., 1874*[32]

14
MANCHESTER
1875 – 1887

IN THE TRIAL OF NOLLY'S DEATH, none of Madox Brown's friends proved stauncher than the Manchester artist Frederic Shields, who had shared his high estimate of his son. Writing to Shields three days after his death, Brown was in a mood of calm stoicism: 'The loss from every point of view is heavy ... but, being no ordinary loss, we have decided to bear it if we can in no ordinary way ... The irony of fate does not display itself in this way for the first time.'[1] 'You are heavily in my heart,' Shields replied, '... for I know that this is no common loss: his age, his sincerity of character and largeness of heart, and the gifted mind which promised such rich fruition ...' were irreplaceable, and he could only offer the consolations of a Christian faith Brown had long since abandoned: 'If my poor affection can thus weep with you I cannot doubt God will not leave you comfortless.'[2]

There would be no comfort, only the stoical will to carry on, to 'patch up what remains of hope in other directions and get to work again'. As Cathy's daughter Juliet records, 'When they were going to bury his boy ... he called my mother and grandmother to him and forbade them to shed a single tear. He said "This is the funeral of my son and not a puppet show".'[3] A Unitarian friend, Moncure Conway, conducted the non-sectarian ceremony at St Pancras cemetery; above the grave, Brown erected a Celtic cross of his own design. Afterwards, 'Oliver's room' – filled with his pictures and boyhood possessions – was preserved as a shrine. But, as each anniversary of 5 November came round, Brown and Emma fled their haunted house.

Shields had admired Brown from the moment he saw *Jesus Washing Peter's Feet* skied among the Pre-Raphaelite pictures at the 1857 Manchester Art Treasures Exhibition: '... it held me riveted – large and simple in the composition of its masses as Giotto, brilliant and forcible ... and wonderful for its grasp of human character and passion', it was a masterpiece of modern religious art.[4] Like Holman Hunt, the devout Shields was an artist with a mission. Eager, unworldly, a nervous-depressive, he proved unstintingly generous to Rossetti and Brown, whom he had first met in

London in May 1864. Brown soon became his mentor, while Shields was in his turn a valuable ally, introducing patrons like Craven, Brockbank and Mitchell to them. By 1869 Shields was already an intimate of Fitzroy Square: 'Your welcome letter has come just as Craven called in this morning to complete in the shape of a cheque 2 fresh ... commissions which this truly satisfactory man has given me ... Mrs Brown and all the family are quite determined that you shall come for Christmas. Put a few things in a bag and come at once ...'[5] Brown enclosed the railway fare.

Through Shields, Madox Brown had won a reputation in Manchester. Writing from Nolly's sick-room in October 1874, he looked forward to two lectures he must shortly deliver there and to the dinner the merchant Brockbank would give in honour of *Cromwell on his Farm*, hanging in the Manchester Academy exhibition. Shields himself was preparing to leave Manchester for London: Brown contributed to his farewell exhibition and at a Corporation banquet held in Shields's honour in February 1875 replied to the toast 'English art'. There, as guest of honour, Shields 'urged the worthy decoration of their public buildings upon the Manchester men'. A carefully staged bid was thus made.

Alfred Waterhouse's new Gothic Town Hall on Albert Square triumphantly asserted Manchester's pre-eminence in world commerce. A cultural symbol in the height of architectural fashion, richly carved and ornamented, it was a source of pride to the recently incorporated city. Now the idea of painted mural decorations in some of the principal rooms was being mooted in the Decoration Committee. Not that the departing Shields wanted the work. For years he had regarded the brooding *Chaucer* at Fitzroy Square as a reproach to the art Establishment; no one better understood Brown's frustrated ambition to paint public murals, and now he saw an opportunity worthy of his friend. Confident in his own local standing, Shields determined to engineer a joint commission in which he would later relinquish his own interest.

By 1876, the mural decorations were agreed in principle. But the rooms to be painted, the subjects to be depicted, the artists to be employed and the fees to be paid involved a further two years of negotiation. At first, urged by Waterhouse, the Committee approached two Belgian muralists, Guffens and Swerts, trained like Brown at Antwerp. Later, three Royal Academicians (Poynter, Leighton and Watts – all experienced muralists) were proposed, but they too declined. Next Waterhouse wanted Albert Moore, W. B. Richmond and Thomas Yeames – popular younger painters – to work alongside Brown and Shields, who, tired of waiting in the wings, had submitted a scheme of their own in January 1877.[6]

Inside the Council, Brown and Shields found a strong ally in the small, ebullient Charles Rowley, Brown's admirer and patron, who worked tirelessly to influence

fellow councillors in favour of this 'fine scheme worthy of any building', as he told Shields, while admitting the Committee's continuing reservations: 'I believe it would have been acceptable if Brown had not been so great a man, but they were afraid of his work being outré ... It would be a great thing ... to have such work as he would do amongst us ... grand stuff to live with and making the popular art look very feeble even at its best.'[7]

Rowley won the day. Despite a last-minute attempt by Manchester Academicians to eliminate Madox Brown, he and Shields were commissioned in February 1878 to paint twelve panels below the windows of the Great Hall. In his relief, Brown readily accepted the Corporation's terms of £250 per panel.[8] He had reckoned on '18 months' toiling like a nigger and not much richer', but, as he told Shields, 'the moment we get the commission we shall, you will see, get all sorts of better things thrust upon us and no time to do them.'[9] Dreams of Westminster now revived, and he made repeated approaches to the Ministry of Works.

If Maclise's heroic House of Lords mural, *The Death of Nelson at Trafalgar* (1864), was his ideal, he found no comparable subjects in the 'history' of Manchester, dating effectively from the seventeenth century. His own researches in the British Museum, coupled with those of Alderman Thompson and Manchester antiquarian W. E. Axon, yielded a list of subjects, the first six of which had the most tenuous links with Manchester:[10]

> The Romans Building a Fort at Mancenion
> The Baptism of Eadwin (Establishment of Christianity)
> The Expulsion of the Danes from Manchester [invented]
> The Establishment of Flemish Weavers in Manchester 1363
> The Trial of Wycliffe (in Old St Paul's, London)
> The Proclamation regarding Weights and Measures 1556 [national]

while the remainder invest local events with national significance:

> Crabtree watching the transit of Venus 1639
> Chetham's Life Dream, 1640
> Bradshaw's Defence of Manchester 1642
> John Kay, Inventor of the Flying Shuttle 1753
> The Opening of the Bridgewater Canal 1761
> John Dalton collecting Marsh Fire Gas (early 19th C)

These are hardly the dramatic events Madox Brown had hoped to paint 'for the instruction of the people', but rather a history of ideas and processes. His original

147 *The Death of Sir Tristram*, 1862, stained glass. Installed by Morris Marshall Faulkner & Co at Harden Grange, 1862.

148 *The Miraculous Draft of Fishes*, designed for MMF & Co, installed with (**149**) Llandaff Cathedral, 1874.

149 *Christ walking on the Water*, adapted from design of 1865 for Sculthorpe St Mary's.

150 *The Nativity*, 1862. Installed in Bodley's Church

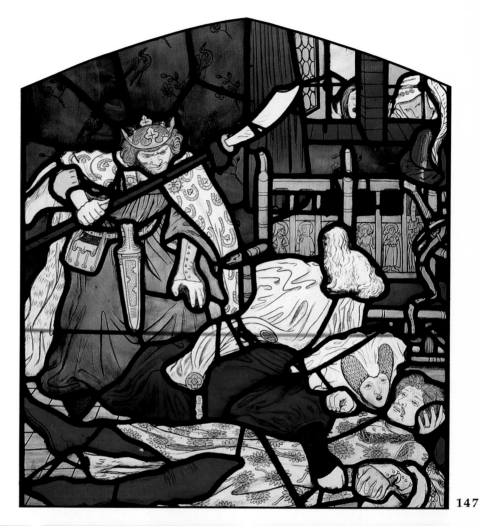

147

148

149

150

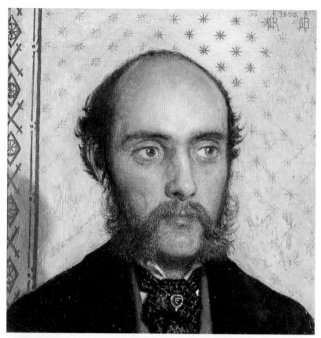

151

151 *William Rossetti by Lamplight*, 1856.

152 *The English Boy*, 1860. Oliver Madox Brown aged five. Painted for Plint.

153 *Miss Louie Jones*, 1862, watercolour, chalks. Portrait of one of Brown's cousins.

154 *Girl at a Lattice*, by Rossetti, painted at Brown's house, 1862. Portrait of Brown's maid.

155 *Mauvais Sujet*, 1863. Influenced by Rossetti's *Girl at a Lattice*.

156 *Myosotis*, 1864, watercolour. Portrait of Cathy Madox Brown.

157 *James Leathart*, 1863–4. Succeeded Plint as Brown's most sympathetic patron.

152

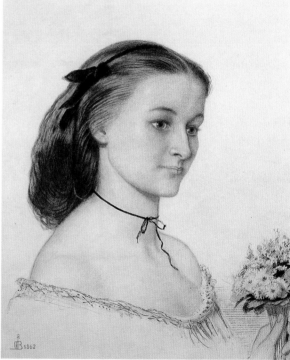

15

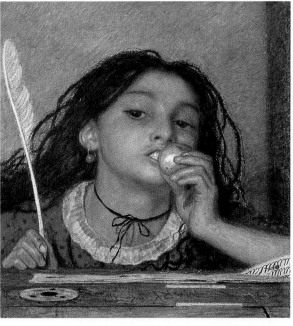

155

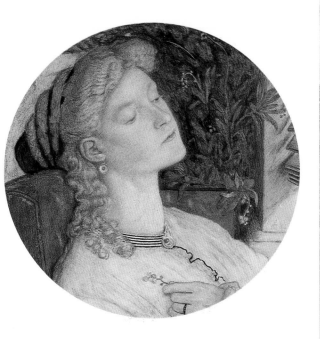

156

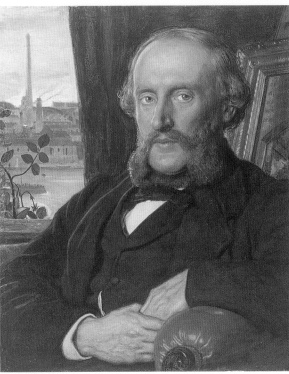

157

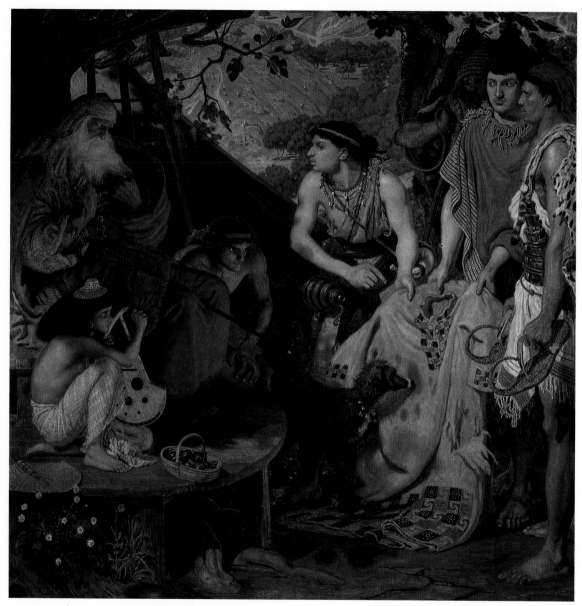

158

158 *The Coat of Many Colours*, 1864–6. Painted from Brown's illustration for the Dalziell Bible.

159 *Don Juan found on the Beach by Haidée*, 1878. Painted from Brown's illustration to the Moxon Byron edited by W M Rossetti.

160 Marie Spartali. Head of Haidée (see plate **159**).

161 *Romeo and Juliet*, 1867. Emma and Charles Augustus Howell were the models.

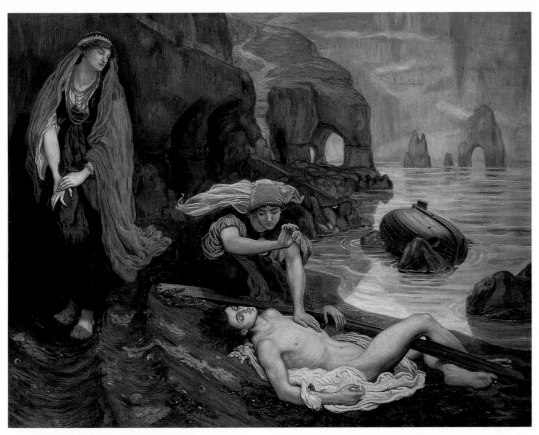

159

160

161

162 *The Romans building their Fort at Manchester, 1879.*

163 *The Expulsion of the Danes, 1880–1.*

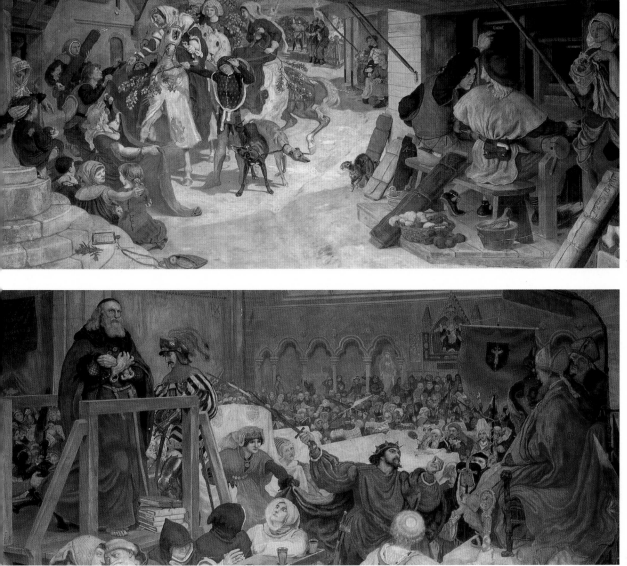

164 *The Establishment of the Flemish Weavers at Manchester, 1879.*

165 *The Trial of Wycliffe at Westminster, 1885–6.*

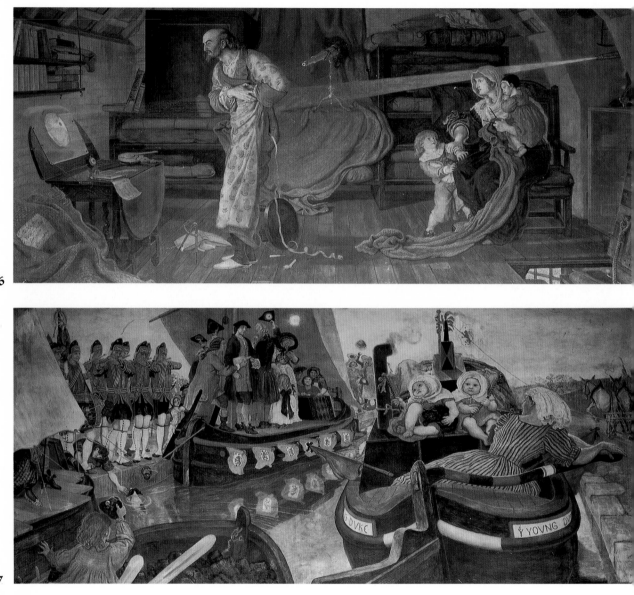

166 *Crabtree observing the Transit of Venus,* 1882–3.

167 *Opening of Bridgewater Canal,* 1890–1.

suggestions to the Committee had included a *First Shot in the Civil War, 1642*; *The Peterloo Massacre, 1819*; and *The Cotton Famine*, showing the first bale of cotton arriving in Lancashire after the American Civil War. The first became *Bradshaw's Defence of Manchester, 1642*; the Committee rejected the others as too politically sensitive.

As executed, the panels are too small for their setting and inadequately lit. There are inconsistencies of conception, technique and style, with some of the 'historic-dramatic' subjects sitting uneasily with 'decorative-anecdotal' ones. A few designs are over-complicated. Yet overall the strength and ingenuity of the scheme amply justified the city fathers' hopes.

The Westminster murals had shown the unsuitability of true water-based fresco for damp English buildings. To prepare himself technically, therefore, Brown visited Antwerp in 1875 and 1877 to examine Baron Leys's recently executed wall paintings in the Hôtel de Ville; he also looked at Leighton and Poynter's work in the South Kensington Museum and, on G. E. Street's advice, visited Gloucester to discuss the new 'spirit fresco' process with its inventor, Thomas Gambier-Parry.[11] The first seven pictures are carried out directly on the wall by this wax process. The remainder are in oils on canvas, cemented to the walls.

The decision to go to Manchester had been forced upon Madox Brown. For months each year now, gout immobilised him, undermining his work and isolating him from developments in the London art world. He would have welcomed an invitation from Sir Coutts Lindsay to exhibit at the new Grosvenor Gallery, but was too proud to approach him.[12] A new challenge to the Royal Academy, the 'aesthetic' Grosvenor Gallery successfully promoted Whistler and Burne-Jones and would surely have benefited Brown. But, suspecting a hostile cabal, the latter stuck to his northern commissions — *Cromwell, Protector of the Vaudois* for Rowley, and a *Supper at Emmaus* for Councillor Pooley. He had recently completed, though not exhibited, a series of fine portraits — *Rose de l'Infante*, of Marie Stillman's young daughter Effie; a pastel of Lucy with her two-year-old daughter Olivia; and, for Cathy, *William Tell's Son*, a portrait of Ford Hueffer aged three. Most striking, perhaps, was the *Self-portrait* (*Frontispiece*) painted for Theodore Watts in gratitude for his support for Nolly's work and his practical help over the break up of the Firm.

When, in the summer of 1877, Gabriel suffered a third breakdown, Brown declined to shoulder the Rossettis' burden again. A suggestion from William drew an exasperated response: '*I have no time* to take care of Gabriel ... if I were to spend six weeks over him and half ruin my affairs I question very much if it would be of any use.' As he pointed out, Rossetti's addiction was worse than ever and what with Fanny's presence and 'servants fetching brandy and no-one to look after them nothing but contradiction and absurdity reigns at Cheyne Walk'.[13]

Yet he made one last heroic effort. In August, closeted alone with the invalid in a cottage at Herne Bay, he battled to break the chloral habit. It was weary work. To Franz Hueffer he complained of having 'very little to talk about, so I bully Gabriel and that does him more good than medicine'. But, despite reducing the nightly dosage by half, he knew that there was no winning this battle: 'While the nurse and I remain, the improvement will go on,' he predicted, begging Shields to come down and relieve him – 'after that ... the deluge ... I get horribly bored and fidgetty down here reflecting on all my own affairs going to wreck ...'[14] When Rossetti's indulgent mother and sister arrived to undo his good work, there was an unpleasant scene and Brown left. Even their presence would not 'restrain [Rossetti's] lamentable ways and speeches'.

For two years, silence fell between them.

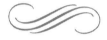

The Great Hall in Manchester, where Madox Brown installed himself in April 1879, is approached by a grand staircase. One hundred feet long, its open hammer-beam roof ornamented with the arms of Manchester's trading partners, it is modelled on the medieval cloth halls. At the far end, a great organ in a Gothic apse proclaims for Manchester the cultural status of a Bruges or a Florence.

He set about preparing the wall surface for *The Baptism of Eadwin*: ensconced in his 'opera box' – a mobile room with one open side – and stirred by the playing of the great organ in the centrally heated hall, he wrote in buoyant mood to Shields:

> I date to you from this to us memorable place ... my *box* ... is far too comfortable. At night when I am all alone with an excellent gas stand it is perfectly delightful, and by daylight I feel charmingly free from household worries ... The cartoon seems highly successful with all who have seen it and all the masters and servants at the Hall are as pleasant and attentive as they can be except for Mr Mayor who is a Philister and a curmudgeon and will not let me have a room in the building.[15]

He stayed instead with Rowley at Harpurhey, hoping through him to meet new Manchester patrons.

By May the euphoria had subsided. To Lucy he wrote, 'The painting is going on all right ... but things are very slow here. I have been introduced to all the chief picture buyers likely to do anything, but not one of them has the heart to buy a

picture ...' Meanwhile he lectured to the Manchester Academy of Fine Arts and Literary Club and toiled at *Eadwin*.

Keen to arouse national interest in his murals, he fed the first of many progress reports to *Athenaeum* critic F. G. Stephens in June:

> I have now got more than half done, and twenty-four heads painted in out of thirty. My hours are from 10 am to 10 pm seven days a week – consequently no dinners or little trips to friends out of Manchester ... Waterhouse ... is thoroughly satisfied with the process which for luminousness and rendering of the texture and colour of flesh is all anyone could desire – and I have invented a plan of my own for *deadening* any bit of the surface that may have become shiny. I used heat (as Delaroche did with his Hemicycle), to ensure the greater absorbency of the wall.[16]

Eadwin – finished in July – was well received; but, as nobody bought the cartoon, Brown reconsidered his procedures. 'I intend for the next subject, *The Romans*, to execute a quarter-sized picture, oil or water, instead of the cartoon ...' he told Shields. 'I think it will offer greater opportunities for sale ... and be less cumbersome and more fit for copying ...' He had discovered that the Gambier-Parry process 'keeps on *drying* and getting *paler and weaker* for three or four weeks which makes it difficult to know what one's work will look like'. He wondered why Shields did not begin work on *The Trial of Wycliffe*: 'Permit me to say that it would be very desirable that you should make some show in that direction.'[17] But Shields – hard at work on a stained-glass commission for Waterhouse at Eaton Hall – never came.

In September, Madox Brown returned to Fitzroy Square. Care of Emma had devolved first on Cathy, then on Lucy and William. Her nervous fits, bronchial troubles and accident-proneness were an anxiety; the alcoholism made it dangerous to leave her alone. Earlier he had engaged Cecily Marston (sister of Nolly's friend Philip) as her 'companion', but Emma, adept at stealing his keys, proved too clever for her. There was no substitute for his own constant vigilance, and Emma must accompany him back to Manchester.

The big house, empty of family and friends, was now a costly incubus. In January 1880, Brown meditated a permanent move north: 'Things look so gloomy,' he wrote to Rowley, that

> I have come to the determination to get rid of this expensive house and take a small one at Marple or Hayfield and there if possible live within my means. Could you let me know the price of season tickets and if you hear of some

pretty seven or eight roomed house, not over £30 or £40 a year ... I think this the time, now or never, to make a new start in life. With a painting room in the Town Hall I might, perhaps, get in with a fresh lot of clients.[18]

The Romans Building a Fort and *The Expulsion of the Danes* occupied him from April to September. *The Romans* is one of his most successful and dramatic conceptions. Whereas *Eadwin*, an interior scene based on Dyce's *Baptism of St Ethelbert* in the House of Lords, was static and old-fashioned, *The Romans* carries a strong whiff of the northern outdoors. Draperies swirl in the wind as the Roman general gestures towards 'Mancenion': behind the centurion with his plan, a standard-bearer holds up the legion's dragon, while the building of the fort goes on around them. Enslaved Britons do the humping; the skilled work is done by Roman soldiers. In the distance, under an overcast sky, the Pennine foothills run down to the Cheshire plain — a reminiscence, perhaps, of Bell Scott's *Building of the Roman Wall* at Wallington Hall.

The Expulsion of the Danes, begun in September, is a piece of dramatic realism charged with Brunonian grotesque. Driven from Manchester, the Danes bear their chief on an improvised stretcher as they run a gauntlet of missiles, spears and boiling water. A frightened pig crosses their path, flinging the leaders to the ground. Madox Brown had arrived at the Hall one morning to discover a visiting organist at the console and a four-month-old pig waiting for him in an official's arms. As he told Rossetti, 'the pig set up a series of hideous screams that pretty soon overpowered the loudest tones of the organ. What the maestro thought of the rivalry I don't know or whether he expected it to last all through his public performance ... but short as the time was it was agony to me and probably to the pig.'[19]

The Browns and their local servant lodged first in Grafton Street and later at Marshall Place, Cheetham Hill. To begin the new life they had promised themselves, Emma embraced 'total abstinence' while Brown gave up whisky. Daily, she accompanied him to and from the Hall, helped him in a variety of ways and was, he told Lucy, 'very good tempered'. But the respite was short. By September she was 'so ill and miserable that I have been forced to advise her leaving the abstinence practice ... the funniest part is that she persists in wishing to persevere and only breaks the rule whenever she thinks it will not be found out.'[20]

He had struck up a warm friendship with the Town Hall organist, Kendrick Pyne, who introduced him to the music of Berlioz. But Mrs Pyne's friendship had drawbacks: when Emma was found unconscious and black in the face 'Charlotte had to tell me Mrs Pyne came too often and she was sure brought bottles with her ... how to act?' Taking Emma by surprise next morning, he confronted her: 'I told her I had found out all about Mrs P ... and Emma handed over a *bottle of rum*.' Brown

next tackled Mrs Pyne: 'while her poor husband was playing the organ ... I told her that since seeing her Emma had had to see the doctor who pronounced it to be spirits which if we could not intercept death and a coroner's inquest would follow.' She herself would be called as a witness, to the ruin of Mr Pyne. To Lucy he observed, 'Emma does talk people over in an astonishing way.'[21]

Daily letters reveal how much the artist relied on this devoted daughter, as Emma's condition deteriorated. Now thirty-six, Lucy had three children: Olivia, Arthur and Helen, while infant twins, Michael and Mary, were to be born the following April. After marriage she had continued to exhibit, but her energies went increasingly into radical and feminist causes – in 1879, for example, she was narrowly defeated by Elizabeth Garrett Anderson for the presidency of University College Ladies' Debating Society[22] – and she applied progressive ideas to her children, whose education she undertook herself. Her first happiness with William was past: his emotional reserve frustrated her passionate nature, and his days at Somerset House were too often followed by long evenings alone in his study or with Gabriel at Cheyne Walk. Lucy's continuing dependence on her father was as marked as his on her: his departure to live in Manchester coincided with the onset of the long tubercular illness which would kill her at fifty.

In June 1880 the Rossettis brought the children to Chapel-en-le-Frith, in the Peak District, where the Browns had taken holiday cottages. Here they were joined by Mathilde Blind, whose appearance had so struck Bell Scott on meeting her at a party of Swinburne's. Ten years on, Mathilde had established an extraordinary ascendancy over Madox Brown, replacing Marie Stillman in his galaxy of female 'genius' and filling the intellectual and emotional void left by Nolly's death. She was a prolific and talented writer, if not the genius Brown proclaimed her to be, publishing with his encouragement lives of *George Eliot* and *Madame Roland*, literary criticism, several novels and volumes of poetry. Brown designed the frontispiece for her *Dramas in Miniature* in 1891.

In her mid-thirties and still an attractive woman, Mathilde was both assertive and temperamental. She was often ill with bronchitis and, when not reading her works aloud to friends, might be found in the Browns' spare bedroom 'consuming hot meals and hot potions'.[23] Arousing Brown's fierce compassion, she also provoked jealousy in his daughters – now especially, when his infatuation with her was at its height. Soon after the holiday at Chapel, Brown installed Mathilde at York Place, Cheetham Hill – near his own lodgings – and from this address came many of his letters of 1881 and 1882.

Relations with Gabriel were resumed at last, chiefly through the agency of the young Hall Caine, who in 1881 was negotiating the sale of *Dante's Dream* to

Liverpool.[24] Yet a full reconciliation hung on the litmus test of Mathilde, whom the reclusive poet had never invited to Cheyne Walk. By now Brown was promoting her work almost as aggressively as he had Nolly's and, unable to accept Gabriel's aversion, tactlessly enlisted Lucy's help: 'It is too absurd seeing the terms on which we all are,' he wrote, 'and the pleasure she might be to him going to talk to him, that he should keep up this prejudice against her.' Again, '. . . have you ever spoken to Gabriel about her work or about his seeing her? You have I believe much influence with him . . .'[25] But Rossetti was obdurate.

Brown pressed the attack on 20 March 1881 when, with Emma resplendent in a new bonnet on one arm and a batch of Mathilde's poems beneath the other, he dined at Cheyne Walk. A sonnet was produced for Gabriel's inspection, but the poet's lukewarm response sent Brown storming out of the wrong door, into a dark room where he smashed a valuable peacock-feather screen. Afterwards pleading overwork, Brown nevertheless refused to withdraw 'one inch from the position I took up . . .' Rossetti's charming reply is among the last of his letters to Brown: 'I am very glad you have written and never loved you better than I do now. If I did not say as much as it is quite just to say of the Sonnet, it was because you had been making such a very loud noise the whole time I was reading it . . .'[26]

In London that spring, Madox Brown designed *The Flemish Weavers, Crabtree Watching the Transit of Venus* and *Weights and Measures* for the Town Hall. In August came the final move to Manchester. With the lease of Fitzroy Square finally sold, the Browns took a house in Crumpsall, a brand-new suburb just north of the city. 'A last line from the old home,' he wrote on 12 August to Lucy as they were packing. With them would go Mathilde and their old London servants Maggie and Charlotte Kirby. On 17 August came 'A line to say we are here safe . . . it is so pretty and fresh and sun for a wonder shining brightly that it was worth waiting for', though Mathilde had been left at Buxton 'in a dolorous condition . . .'[27]

The choice of Calais Cottage in a brand-new terrace was utterly characteristic, evoking memories of Church End and Fortess Terrace. The house stood beside open country, with views of the Derbyshire hills. The roads were still unpaved, and there were no shops, but the landscape enchanted Brown: 'I have an expanse of country to look out upon,' he told Shields, 'and a field of cabbages which, under all sorts of atmospheric changes with a cart and white poney and bronzed labourers to gather them, is something of a consolation — nothing can vie long with the simple workaday beauties of the country.'[28] But he was too busy to paint this tempting landscape.

The Flemish Weavers harks back to *Chaucer*, of which it is, we might say, a plebeian version. It is Maytime, 'at which season Chaucer tells us the English people delight to go on Pilgrimages'. Queen Philippa, with Emma's face, rides gaily into

town in the spring sunshine, greeted by weavers – some from Bruges, the Manchester of the Middle Ages – with bales of newly woven cloth. Brown peopled this informal scene with Manchester friends and their children, horses, dogs and cats.

In April 1882, he was about to start work on *Crabtree Watching the Transit of Venus* when word came from Birchington, in Kent, of Gabriel's death at the age of 53. It 'shot a pang to my heart such as I have not felt since the acuter phase of the grief for poor Nolly,' he wrote to Lucy. 'He was the warmest and truest friend anyone could have – and that over such a long period.' The century's great original was dead and 'how things will go on in art and aesthetics now that he is gone I cannot ... foresee. I feel almost inconsolable ...'[29] Lucy took pride in their unique relationship: 'Papa's and his meeting had undoubtedly great influence on both their lives. Gabriel knew what Papa was and I feel loved him with some of his best love ... I shall always rejoice in the fact that Papa from first to last was his best friend and proved himself such where others could not or would not help.'[30]

Rossetti's death affected Brown deeply: '... I used to paint always with a vague idea of his approbation in the distance,' he told James Leathart a few days later, and in the ensuing months and years he honoured the younger artist's memory by 'finishing' his paintings for sale, by designing his tombstone at Birchington and by erecting (with J. P. Seddon) the public monument on Cheyne Walk.

To help liquidate Gabriel's heavy debts, Madox Brown worked much of the summer with Rossetti's assistant Treffry Dunn at the Cheyne Walk studio. He gave particular loving care to a late *Beata Beatrix*, but seems also to have rescued a *Rosa Triplex* in poor condition and a *Salutation of Beatrice*. With difficulty, William persuaded him to accept two guineas a day for his pains.[31]

A 'runic' cross erected at Birchington in the autumn of 1884 was Brown's apology for Gabriel's religious unbelief. Pagan and Christian elements mingle ingeniously in the design, which includes a tree of life with a serpent representing woman, symbolic figures of 'Divine Love uniting Dante and Beatrice in Heaven', St Luke (patron of painters) at his easel and, at the foot, a fourfold maze with Gabriel's monogram.[32] Similar thought and labour were devoted to the public memorial on Chelsea Embankment, by the Thames. Brown modelled the bust of his old friend, cloaked and holding quill-pen and palette, from memory; the apse and drinking-fountain were by J. P. Seddon. Holman Hunt delivered a long address at the unveiling ceremony, past bitterness and recrimination apparently buried with the poet.

The winter of 1882–3 found Brown nursing a particularly severe attack of gout, lying bedridden at Mathilde Blind's new Hampstead lodgings. A proposal that Mathilde should take him to the seaside to convalesce now fanned Lucy's and Cathy's resentment into a blazing row which threatened to split the family. Brown took Mathilde's side and, furious with his daughters, immediately left London for Manchester to start work on *Crabtree*.[33]

This successful design depicts an authentic event of 1639 when, from his attic room-turned-camera obscura, the Manchester clothier and amateur astronomer first observed the passage of Venus across the sun. The tense figure of Crabtree and swirling draperies, contrasted with the severe perspective of the dim attic, convey the excitement of the moment. A similarly Hogarthian imagination marks the tenth panel in the Town Hall – *John Kay Escaping the Mob*.

Shields had relinquished his share in the joint commission early in 1883, confident that the work would be given to Madox Brown. But once again the Committee prevaricated. During that year Brown kept busy with local commissions, of which a portrait of Madeleine Scott, daughter of the Editor of the *Manchester Guardian*, on her tricycle is perhaps the most appealing. That summer he advised C. P. Scott on the decoration of the City Art Gallery, which was to open with a major exhibition in the former Manchester Institution building. Which London Academicians, Madox Brown was asked, should be invited to take part?

The irony was not lost on him: 'I have been able to do a good turn to Sir Noel Paton, Leighton, Gilbert and even such humble folk as Holman Hunt, Albert Moore and Poynter,' he told Lucy. 'Unfortunately Jones, Millais and Watts had already been agreed on so I could not patronise them.' The admired Cope and Herbert were not invited, and to his rage Val Prinsep, the chief hanger, rejected his own *Waiting*. Madox Brown took his revenge at the opening banquet, when Prinsep was called upon to speak, telling Lucy: 'His speech I regret to say was foredoomed. I could listen no more but made Emma and Mrs Pyne come out and as we were in front, seeing us move, everyone else got up and so broke up the speechifying.'[34]

At Christmas the Committee awarded him the remaining six murals, at a new rate of £400 each.[35] He was also elected (to his secret gratification) Associate of the Manchester Academy of Arts. Anticipating a long stay, the Madox Browns had already left damp Crumpsall for a larger and warmer house in Addison Gardens in fashionable Victoria Park where they could put up the grandchildren when they came to stay from London. Their visits, a source of delight, were often protracted; if measles struck, or Lucy's chest kept her in bed, they gladly exchanged the rigours of her London schoolroom for Emma's easy-going régime and the chance of posing for Grandpapa's pictures.

In Victoria Park, as leading light in Manchester's art world, Brown began again to entertain in style. In February 1884 the guests at the Browns' large house-warming party were treated to the singer Miss Griswold; frequent visitors to Addison Gardens included the cream of Manchester's intelligentsia: Charles Rowley and Alderman Heywood, the Kendrick Pynes, C. P. Scott and his wife (she was young, beautiful, and an early graduate of Girton College), Alexander Ireland (proprietor of the *Examiner*) and Professor Roscoe of Owen's College. Keen music-lovers, the Browns were regularly present at Hallé's concerts in the Free Trade Hall, hearing performances of Bach, Gounod and Saint-Saëns, and attending recitals in private houses. Brown also took part in the exhibitions and conversaziones of the Manchester Academy.

Plump and charming, Emma shone at such gatherings, and Brown — still inordinately proud of her — lavished money on her wardrobe: on 6 January, 'We were out at the Behrens last night with music. Mama had on a new plush and brocade dress ... the finest dress she ever wore, dark olive plush faced with brocade.' Lucy, in London, was commissioned to buy rings — 'Your package arrived safe this morning, and Emma seems to be very pleased ... the cheaper ring is the most beautiful ... but all look exceedingly well on the fingers'[36] — and Emma sports several in *May Memories*, the portrait begun in 1869 which Brown showed at the 1884 Manchester Academy.

Contacts of a different kind came through the 'improving' Sunday lectures that Rowley organised for working men at Ancoats. In August 1882 Madox Brown had addressed this audience on 'Possible Aesthetics in Manchester', summarising his theme as 'simple directions to simple folk on how to look beautiful forever. Teaching them the artistic beauty of whitewash, thatch and good colours instead of bad colours, of flowers, cabbage gardens, roses etc. to include tidiness as one of the holiest of aesthetics, the same to be a duty to the community more than a selfish vanity.'[37]

Such wholesome ideas were already the stuff of William Morris's lectures on decorative art. In 1884 Morris gave the first of his 'Communistic' lectures to the Ancoats audience. The old rift unhealed, Madox Brown stayed away: but Morris, who had recently opened a branch shop in Manchester, visited the Town Hall and admired the murals. A year later came the long-desired *rapprochement*, when Brown issued an invitation to stay at Addison Gardens. Morris asked Rowley to 'share' him with Brown: 'As you are aware there has been a cloud between him and me and ... I am more than rejoiced that it should be cleared off in such a pleasant way by my old friend himself for whom I have always had the greatest respect and affection.'[38]

The poetic upholsterer-turned-socialist agitator arrived fresh from Thames police court, where he had been charged with assault.[39] The friends talked chiefly of politics. Brown found him 'much changed in looks', as he told Lucy, but otherwise unchanged:

'... of course he was very jolly – we sat up very late and he expressed himself much delighted with his visit. Though he talks much, he seems more considerate and less excitable than of yore ...' Now he urged her to write to Georgie Jones, to effect a reconciliation with Ned.[40]

Morris's visit (repeated in 1886) took place against a rising tide of unemployment, particularly severe in the industrial north, where the Manchester poor suffered great hardships. Distrustful, like Morris, of parliamentary politics, Brown felt pangs of guilt at his own comfortable life-style and a revival of old ideals: 'I have been thinking seriously of turning communist,' he told Lucy in March 1885. 'Moreover so many people seem in want whom one cannot relieve at the present rate of living, that it seems a duty to avoid expensive entertainments ...' Soon, although afraid that Morris 'lacked balance' politically, he was subscribing to the new *Commonweal* and meeting 'certain rather socialistic parties' at Kelmscott House, Morris's London home.[41]

He played a conspicuous part in relieving local distress. In April 1886, he sent Lucy a cutting from the *Manchester Guardian* reporting a mass meeting at Pomona Gardens in the city: 'The object of the gathering was to form a permanent committee to look after the unemployed in future in some systematic manner. Mr Ford Madox Brown described the efforts initiated to form a Labour Bureau which as yet had been able to find work for only 5% of the applicants.' Brown wanted Government Labour Bureaux set up all over the country 'to make it compulsory to all districts to employ their own labour. As all the men there present had to be fed *somehow*, so it was to the interest of the whole country that they should work'. A second demonstration by the unemployed took place on 27 May, when C. P. Scott paid the arrested men's legal fees.[42]

Brown gave what employment he could – first to an out-of-work joiner, the ragged and tubercular 'people's tribune' Joe Waddington, whose tiny home he visited with Rowley in May 1886.[43] The bareness moved him, but seems also to have rekindled his enthusiasm for 'cottage' furniture, and soon Waddington was making up designs for him at sixpence an hour, remaining Brown's handyman for the rest of his time in Manchester. Waddington made up the Workman's Chest of Drawers exhibited on Arthur Mackmurdo's stand at the Manchester Jubilee Exhibition.

The progress of Madox Brown's decorations for the specially erected Jubilee building, the last of his civic undertakings, was chronicled in regular bulletins to H. Marion Spielmann, art critic of the *Pall Mall Gazette*. On 13 November 1886, Brown told Spielmann that '... people are all animation here over their Jubilee Exhibition for May next and seem indeed to be doing the thing handsomely.' A few days later 'the chief of the Decoration Committee (Mr Clegg) has been here ... about my doing

8 large cartoon figures for the spandrels of the Dome ...' These Brown undertook for £500 plus £100 expenses.

The Exhibition was to open the following May, and time was short. By 23 December he was

> almost beside myself with the huge figures I have undertaken ... my present town hall decoration John Dalton is just now in abeyance ... For the ... Dome I am executing 8 colossal figures on gold grounds representing Coal, Corn, Wool, Spinning, Weaving, Shipping, Iron and Commerce. Each figure will be accompanied by an angelic figure of Energy ... some idea of the size will be gained from the fact that the wings measure fourteen feet across.[44]

With as many as seven assistants, Brown worked on the symbolic figures 'here in my house ... Eight spandrels, each 36 by 18 feet ... in oil on gold ... would contain the figures about 12 feet high.'

Significantly, though busier than for 30 years, Brown felt 'never a twinge of gout' in five months of hectic labour. So vast and dazzling a work — on a scale far outstripping his Town Hall paintings — was the realisation of a lifetime's dream. In January 'a Titanic Shepherd with his Sheep' was under way with a vast angel on the wall opposite. On the eve of the May opening, he described 'putting the last touches to my work at a height of 50 feet, hauled up by ten men with ropes' to Lucy. Yet paranoia erupted even at this moment of triumph: perceiving that his canvases were not hung straight, the artist ungraciously refused Mr Clegg's congratulatory hand and swept out of the building. Back at home, however, he recovered sufficiently to entertain his assistants and small granddaughter Maisie (Mary) to a 'Shampagne supper'.[45]

Eight pictures by Madox Brown were included in the Fine Art section of the Exhibition — a measure of his standing in Manchester. *Work*, recently acquired by the City Art Gallery, occupied a place of honour. But he saw the hand of Agnew (Chairman of the Fine Art section) in the 'skying' of three paintings, and took revenge in a lecture later published in the *Magazine of Art*. 'The Progress of English Art as Not Shown at the Manchester Exhibition' was Brown's judgement on British art of the preceding half-century and his lament that the great history painters of his youth — Dyce, Maclise and Haydon — had been excluded.[46]

Even as he proudly conducted distinguished London visitors around 'his' exhibition, the artist was planning a return to the capital. The long exile was drawing to an end. With only three murals remaining, nothing now tied him to Manchester. The damp climate had never suited Emma, who suffered so badly from rheumatism,

bronchitis and deafness that he feared that another winter would kill her. Even more serious was Lucy's illness, which forced her to spend the winter months abroad, while Cathy's marriage to Franz Hueffer was unhappy. Mathilde, still ailing, had settled permanently in Hampstead. And there were the grandchildren.

Ford and Emma had taken a tenancy of 1 St Edmund's Terrace — 'high and dry' on the edge of Primrose Hill — where they would be neighbours of their friends Richard and Olivia Garnett. They would also be close to the devoted Shields in St John's Wood, with Lucy and William a short cab ride away at Euston Square.[47]

The Madox Browns left Manchester in December 1887 in good spirits. At the close of the Jubilee, a new and bountiful patron had appeared — Henry Boddington of the Cheshire brewing family — with a big new house, an appetite for Brown's pictures and almost unlimited funds. Brown would eventually sell Boddington thirty-two pictures — almost the entire contents of his studio. Thus, reunited at last with his family, with money in the bank and £1000 invested in the brewery, he looked forward confidently to a new life.

15
ST EDMUND'S TERRACE
1888 – 1893

THE CITY THAT MADOX BROWN returned to had long forgotten him. For thirty years he had ignored the London market, excluding himself not only from the Royal Academy but also from important groups outside it, while his hostility to dealers like Agnew was fuelled by neurotic suspicion of 'plots' against himself. Approaching seventy, Brown felt himself a stranger in the London art world.

The shape of that world had greatly altered. At the Royal Academy a sentimental naturalism reigned in the work of Herkomer, Orchardson, Dicksee, Briton Rivière and their followers. The Grosvenor Gallery had waxed and waned, giving way to the New Gallery in Regent Street, while the New English Art Club, formed in 1886 by artists who looked to France for inspiration, represented the new avant-garde. From this, one faction had joined with the Art Workers Guild to organise the Arts and Crafts Exhibition Society. As for the unfinished Westminster murals, the authorities had long since lost interest in them, while Leighton and Poynter's corresponding works at South Kensington were completed. Brown, approached by Walter Crane to join the A & C in 1886, had at first refused, but his contacts with William Morris and Arthur Mackmurdo and involvement in the Jubilee reawakened old hopes.

While in Manchester, Brown had cultivated friendly critics like H. Marion Spielmann of the *Pall Mall Gazette* and Harry Quilter of the *Universal Review*. With their encouragement, he published several articles, promoting his idiosyncratic and now old-fashioned views about art, defining his credentials for posterity. These writings reinforce the image of a grand old painter from the beginning of Victoria's reign. In 'Historic Art' (September 1888), he vigorously championed large-scale public art, assigning a leading place to his own Jubilee decorations.[1] 'The Progress of English Art as Not Shown at the Manchester Exhibition' that year was a piece of pure polemic, while in 'Our National Gallery' he returned to his old preoccupation with art as education, calling on fellow artists to exploit this valuable teaching resource

for the benefit of students.[2] The elevating function of 'Mural Painting' was again stressed in an article for *Arts and Crafts Essays* (1893), which reiterated in the last year of his life beliefs first spelled out in the *Builder*. Most interesting, perhaps, was 'Self-painted Pictures', published in the *Magazine of Art* in 1889. Here he indulged in some highly imaginative word-painting, conjuring up a series of scenes which he had planned but failed to bring to life on canvas.

The literature generated by Rossetti's death and memorial exhibitions of 1882–3 had distorted the public view of Pre-Raphaelitism: while Rossetti was posthumously glorified, Madox Brown found his own contribution marginalised. To avoid further misrepresentation, he got Spielmann to publish an illustrated biographical article by Lucy Rossetti in the *Magazine of Art* of February 1890. As a grand old man, he showed at the International Exhibitions in Berlin (1891) and Chicago (1892),[3] and was invited by the Belgian symbolists, *Les Vingt*, to exhibit with them.

Brown had settled into 1 St Edmund's Terrace at the end of 1887 in optimistic mood. Once again he was strategically placed on the edge of the city, and the end-of-terrace house had spacious views over Primrose Hill. With the old Fitzroy Square days in mind, and assisted by Arthur Mackmurdo, he set about creating an original setting for the modest possessions of a lifetime. He painted the dados bronze-green and covered the drawing-room walls with Japanese gold-embossed paper. He hung the dining-room with portraits. On the first floor, the walls of the big double studio were fashionably clad in gilded leather, with dark-green paintwork, yet this remained a homely sanctum for work and gossip, with Indian rugs and two old armchairs (one of them Rossetti's) in front of the fire. On the mantelpiece, casts of Hercules and fighting horses gathered the dust, while Brown's ancient lay figure with the yellow hair, minus most of its stuffing, lolled behind the door. Beyond the easels and canvases-in-progress stood an oak table designed long ago for Fortess Terrace, with its litter of useful odds and ends. In spite of its splendours, 1 St Edmund's Terrace was a home – a far cry from the palatial studios of the rich Academicians.[4]

Here, in July 1888, the old Sunday 'afternoons' were reinstated. Over two hundred guests were invited, but, to Brown and Emma's chagrin, only thirty turned up. First to come and last to leave was William Morris, but Arthur Hughes, the Alma-Tademas, Theodore Watts, the Garnetts, the Holman Hunts and the Alfred Hunts also came to celebrate their return. Afterwards, exhausted by the effort, the couple collapsed – Brown with gout and kidney trouble, Emma with rheumatism. The servants carried letters between the two bedrooms.

Work for the Boddingtons took up much of 1888–9. Madox Brown visited Pownall Hall, Cheshire – expensively decorated by Mackmurdo – to work on the family portrait and assist with the hanging of 'his' gallery. But such work was

backward-looking, mostly retouching the many early pictures Boddington had acquired (including the big *Execution of Mary Queen of Scots*) and painting replicas: for Boddington he also completed oil versions of several of his Manchester murals.

In 1888 he took part in the first showing of the Arts and Crafts Exhibition Society, which Crane had promised would be

> a really open exhibition ... in which the art of the designer and workman shall be represented as well as the painter. This is what those of us who have associated our names with 'the Revolt against the Academy' ... really mean ... no reform – no enlargement of the present Academy could really be comprehensive enough to do anything like this and would still leave it a more or less privileged body.[5]

Such aspirations echoed Brown's own in founding the Hogarth Club. Crane's real admiration for Madox Brown was shared by Mackmurdo, who published an article on his *Architecture* panel from the Seddon cabinet of 1862 in his *Century Guild Hobbyhorse* (Volume 3, 1888). The article concludes, 'We cannot but regard Mr Madox Brown as a great teacher and pioneer in English Art, distinct, not comparable; a unique figure among our few noble painters and in many of the grandest qualities second to no living man.' A second article described his early archangel windows at St Michael's, Brighton, as being, 'with the exception of Mr Burne-Jones's altarpiece in St Paul's West Street, by far the most important and interesting piece of art in any public building there'.[6]

Franz Hueffer's sudden death in January 1889, aged only forty-two, laid new burdens on the ageing painter, involving him for months in disentangling Hueffer's financial affairs and laying on his shoulders responsibility for Cathy, her teenage sons Ford and Oliver and eight-year-old Juliet. These anxieties were sharpened by new concern about Emma, whose health was rapidly deteriorating – by April 1890, she was bedridden with severe bronchial and choking fits. A gentle, uncomplaining invalid, her grandchildren would find her sitting on sunny days by her window watching the birds in the garden and delighted to receive their small gifts of flowers and drawings.[7]

Cathy nursed her mother as life slowly ebbed away. In October 1890 Brown begged Shields to come before it was too late: '... my wife is dying ... she has expressed a wish to see you and perhaps you might be of comfort to her in some way. Will you come?' But Shields was away from London, and by 11 October it was all over: '... Cathy and I watched her breathing grow gradually slower', Brown wrote, 'and her pulse get weaker till both disappeared at once. There was neither pain nor

effort, she never opened her eyes again nor made a sound but passed from temporary sleep into that of eternity ...'[8]

The widower was not left to grieve alone: by the end of the year his whole family had taken up residence in St Edmund's Terrace, Cathy and her children moving into number 1, while William and Lucy took over Richard Garnett's lease at number 3 when he moved to the British Museum.

Now the activities of seven lively grandchildren broke into Brown's peaceful working days. The Hueffers and Rossettis, different as chalk from cheese, engaged in fierce rivalry. The delicate Rossetti children were, in Ford Hueffer's highly subjective memory, 'horrible monsters of precocity ... perpetually held up to us ... as marvels of genius ...' He complained that during the school holidays he, Oliver and Juliet had for years been subjected to 'the full educational fury of our aunt Lucy' and now the Hueffers took revenge, 'leading our unsuspecting cousins into dangerous situations from which they emerged with broken limbs ... if we were immolated in butter muslin fetters and in [Olive's] Greek plays, we kept our end up a little ... whilst my cousins ... were never out of the bonesetters hands.'[9]

Dedicated anarchists, the young Rossettis printed a magazine in the basement of number 3, with the encouragement of their elders. Carrying their banners, they sold *The Torch — A Journal of Anarchist Communism* — each Sunday at Speakers' Corner in Hyde Park, and on station platforms. A typical issue of the early 1890s featured articles on 'Methods of Propaganda', 'The Influence of Beauty on Health', 'Three American Thinkers' (Emerson, Thoreau and Whitman), a letter by Volkhovsky on the causes of the Russian famine, 'Note on the Chicago Anarchists' and so on. Louise Michel, a distinguished veteran of the Paris Commune was a contributor, and Prince Kropotkin was widely quoted. Grandpapa was a regular subscriber.[10]

Fair and blue-eyed like all the Hueffers, the youngest child, Juliet — 'Poppy' to the family — now became a favourite model. She sat for several later works, including *Stages of Cruelty*, abandoned so long before that she replaced her mother Cathy as the little girl. Madox Brown had portrayed Juliet, aged four, in Manchester as a sly little angel with golden hair set off by a black beret, capturing the watchfulness that enabled her, thirty years later, to evoke her beloved grandfather with such artistry in her memoirs.

His loneliness was acute after Emma's death:

He used to sit alone in the studio for hours together, doing no work at all ... he would wander about the house looking everywhere for her. One evening ... he stopped half way up the stairs ... and leant his head down on the bannisters and his shoulders moved up and down and he was sobbing. The big clock in

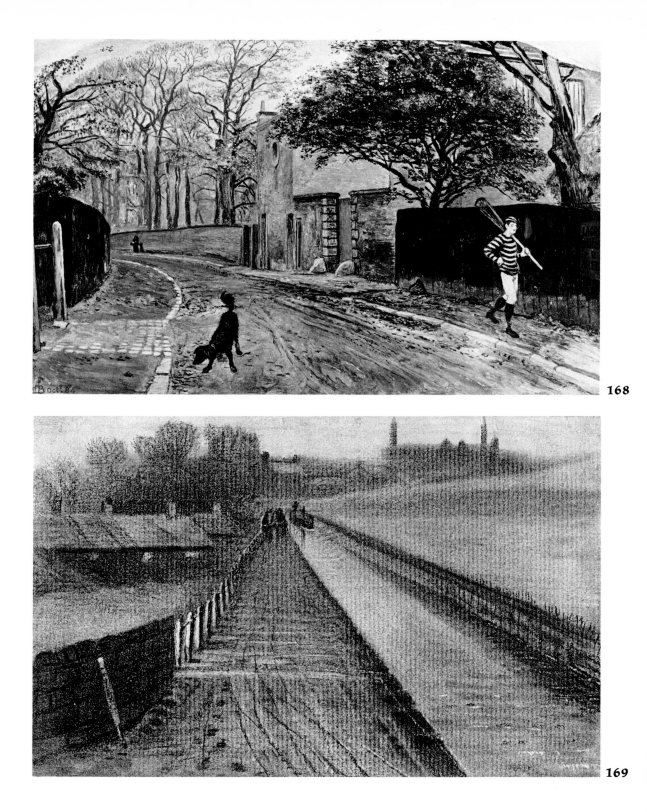

168 *Platts Lane, Manchester, oils, by FMB, 1884.*

168

169 *View along the Bridgewater Canal near Manchester,* charcoal, by FMB, 1890.

169

170

171

172

173

CHARLES ROWLEY JUNR.

175

176

170 *Madeleine Scott on her Tricycle*, oils, by FMB, Manchester, 1883.

171 Frontispiece by FMB for *The Brown Owl*, a volume of fantasies by Ford Madox Hueffer, published in 1892.

172 Cover of the Ancoats Brotherhood Programme, designed by Walter Crane, 1889–90.

173 *Manchester's New Town Hall* by Waterhouse. From *Manchester Illustrated*, 1883.

174 *Charles Rowley Jnr*, chalk drawing by FMB, 1885.

175 *Frederic Shields*, photograph, 1903.

176 *William Morris*, photograph, 1876.

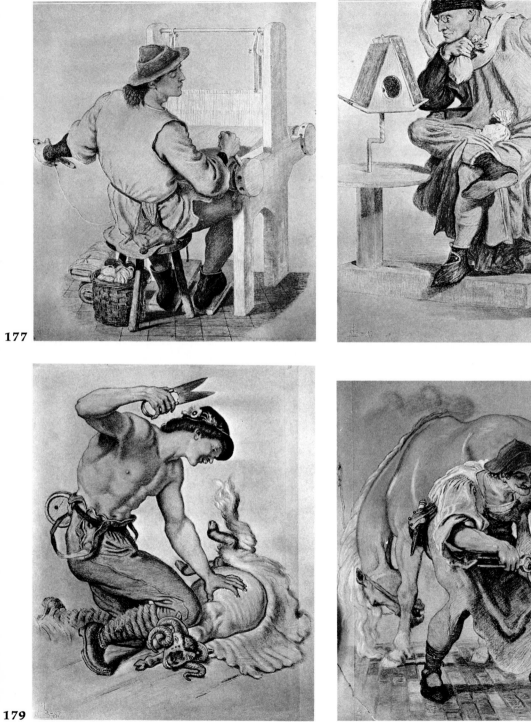

177

178

179

180

181

182

183

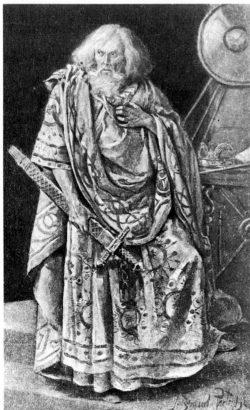

184

183 *King Lear; Act 1, Scene 3,* Irving's Lyceum production of November 1892, from the Souvenir Programme. Sets and costumes after FMB's designs.

184 *Irving as King Lear,* painting by Bernard Partridge for Souvenir Programme.

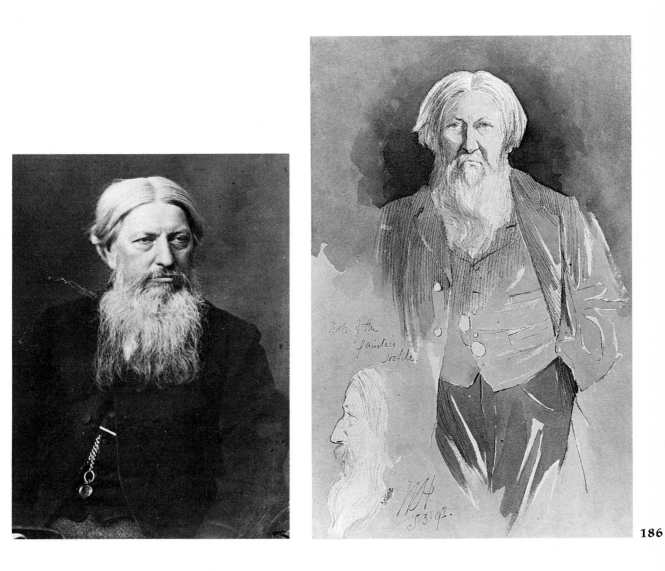

186

185 *Ford Madox Brown*, photograph, 1885.

186 *Studies of FMB*, pencil and wash,
by Walker Hodgson, 1892.

187

187 *Ford Madox Brown*, deathbed portrait, pencil, by Frederic Shields.

the hall was going Tick Tick ... and the gas was turned low, and the beautiful gold paper on the wall looked dim ... A long way down the stairs I could hear the servants laughing and having supper in the kitchen, but there was no other sound.[11]

Sitting on a low stool, Juliet watched the painting of *The Opening of the Bridgewater Canal*, last but one of the Manchester murals on which he was working between April 1891 and May 1892. It depicts the first coal barge starting down the canal from Worsley to Manchester. The bargee's wife with her twin babies steers the boat, watched by the Duke and his engineer Brindley. Fifers of the Lancashire Yeomanry provide a musical send-off.

Juliet watched her grandfather, perched on his adjustable chair and wearing his old painting-beret and pince-nez as he worked. The canvas stretched across the longest studio wall, reaching nearly to the ceiling. After a search (Brown was very particular about babies), they had found an infant to model the twins in a Camden Town baby show: 'At last we found a very fat and red one sitting in the corner ... it came next day in a mail cart ... We ... dressed it in a soft little petticoat with short sleeves and a little round cap that my mother used to wear ...'[12] Juliet got him to put her in the picture too: 'I was the little girl ... with long golden hair stretching up on tiptoe with her arms up begging her mother for a sip out of her glass of wine. The wife of a local cabman (the most pious cabman in the mews) was the beautiful woman who sat in the barge.'[13]

The subject had been imposed in place of his own suggestion, *The Peterloo Massacre*, and this, as much as failing powers, accounts for its inconsistencies. While the treatment of the barge and its occupants on the right is masterly, showing Brown at his designing best, the group of onlookers and soldiers to the left is feeble, perfunctory and so out of scale as to render the occasion comic. No wonder the Corporation were displeased when they received the panel in the summer of 1892.[14]

An article on Brown by the critic Harry Quilter had appeared in the autumn of 1891, one of a series on the leading Pre-Raphaelites. It portrayed Brown as poor, neglected and forgotten:

In a small house on the side of Primrose Hill, without a studio save his sitting room, without recognition from the public, the press, or the Academy authorities, in but indifferent health and with narrow if not failing income, this great man lives ... Poor, brave and patient still ... Is it desirable? Is it decent? Is it tolerable that such a noble servant to art and England should be so neglected and forgotten ... might we not pension our artists when they have worked for us fifty years?[15]

This caricature had just enough truth in it to alarm Burne-Jones, now an Associate of the Royal Academy. In November he invited Shields and Stephens to The Grange to launch a fund for their old friend, with the intention of raising £1000 to buy one of his paintings for the National Gallery. Hastily and secretly, most of the leading artists and collectors of the day were approached and almost all responded generously. But in January 1892, when £900 had been collected, a crude paragraph in the *Pall Mall Gazette* revealed the rescue plan.

Knowing Brown's notorious pride, Burne-Jones at once attempted to set the record straight: 'Our object is the single one of showing our admiration and sympathy with Madox Brown as an artist ... it is a tribute to an artist whom some of us venerate.'[16] He would never be an object of charity. But Brown had seen the paragraph and angrily confronted Shields. Stephens wrote to Shields:

> the PMG has done the devil's own work ... I do not know what new mischief it has achieved anent our affectionate scheme for honouring FMB. Burne Jones writes that B had been to you in a fury and all the fat is in the fire. I will go to him even at the risk of being kicked out of the house if needful ... but we ought to consult ... and perhaps a day or two will cool B ...[17]

'Who could foresee such an ungracious ending?' Burne-Jones exploded, as he drafted a letter of explanation to Brown: 'All the contributors supported the plan under the supposition that the result would be grateful to you. If we have made so terrible a mistake, upsetting your peace of mind and humiliating you, I can only ... say we are extremely sorry and it is easy to receive our money back again.'[18] Persuaded at length that no one had meant to patronise him, Madox Brown duly accepted the honour in 1892 and a commission to paint a replica of his *Wycliffe* mural. He never completed it. After his death, the money raised bought for the nation the picture he most wanted vindicated: *Jesus Washing Peter's Feet*, long ago skied at the Royal Academy, now hangs in the Tate Gallery. What remained was earmarked to buy his cartoons and drawings for provincial galleries.[19]

On 30 April 1892 the Lord Mayor of London held a banquet at Mansion House in honour of Art and Literature. The Academicians would be there in force and, 'for a wonder I shall be there, if well enough', Brown told Watts. Holman Hunt, who was present, described the scene:

> Millais [deputising for Leighton, the President] ... was seated at the High Table next to the host and Madox Brown was exactly on the opposite side facing Millais and a bevy of other Academicians. There were many vacant places

between him and me and I asked him to come and take the chair next to me
... 'thank you' he said, 'I would rather sit here.' I left him alone severely frowning
at his diplomaed brothers of the brush where he remained all the evening
silent.[20]

Brown had wanted 'particularly to draw the attention of the Academicians to
the fact that although he was not a member ... he had been conspicuously honoured
with a central place at the high table ... It is possible that many of them went home
without benefiting by this reproof,' Hunt commented wryly.

Later that year Madox Brown undertook his last big commission. It was a new
departure: to design the sets and costumes for Sir Henry Irving's production of *King
Lear* at the Lyceum. An engraving of Brown's *Cordelia's Portion* hung in Irving's
dressing-room, while in 1889 the great actor-manager had purchased several of the
early *Lear* sketches, so full of passion and pathos. Irving's production, closely modelled
on Brown's vision, set the drama in an indeterminate dark age, allowing for rich
symbolic invention of scenery and props. The set-designer Hawes Craven made the
sets from Brown's sketches, but the production took its cue above all from his images
of the leading characters – their costumes, made by Mrs John Nettleship, follow the
artist precisely.

Irving, like Brown, had drawn inspiration from accounts of Kean's great per-
formances earlier that century, in which the mad king's ravings were tempered with
tenderness and subtlety. According to Laurence Irving, 'when Irving first appeared
looking like one of Michelangelo's prophets and magnificently robed, there was a
strange stir among the audience as though his perfect embodiment of their mental
conception of the character promised to fulfil their highest hopes'.[21] But any hopes
Brown may have had of sharing Irving's fame were dashed by the actor's performance
on the first night. Overwrought, Irving was inaudible, and poor notices ensured a
short run. But Graham Robertson, present five nights later, described the sets based
on Brown's chalk sketches – a grandiose Romano-British palace and, harking back to
Cordelia at the Bedside of Lear, 'flowery downlands where white chalk cliffs towered
out of a sea of dazzling blue under skies of pitiless sunshine'.[22] He found Irving's
rendering 'magnificent, its pathos terrible', while photographs of Irving in the role
confirm how completely he adopted the persona of Brown's king.

It might have been Brown himself who sat on the old king's throne or carried
his dead daughter to the centre of the stage. Behind his patriarchal appearance – blue
eyes twinkling in his ruddy face and white beard flowing – a genial and courteous
manner concealed a growing remoteness. A banished king, tragically disappointed,
was how he seemed to his grandchildren; to young friends like Graham Robertson,

who called at St Edmund's Terrace, 'a shadow of I know not what sorrow or disappointment' clung about his 'grand personality'.[23]

A more frequent visitor, a friend for forty years, was Arthur Hughes. In April 1891 he 'saw Madox Brown – but in bed with a little attack of gout in the foot – otherwise looking extremely well and sending off pictures to the Berlin Exhibition ... Cathy and her sons all looking bright and healthy. It was very pleasant to see them all together. William Rossetti is living next door but one ...'[24]

Brown had drawn exceptionally close to his grandson Ford, on whose literary genius he pinned the highest hopes. As a child, dressed like Little Lord Fauntleroy in green velveteen knickerbockers or in a sailor suit, yellow hair cut in a page-boy bob, Ford had posed for the oil portrait *William Tell's Son*. Now a tall youth of seventeen, 'a fair clever young man, rather scornful, with smooth pink cheeks and a medium sized hooked nose like my grandfather's, a high intellectual forehead and quiet, absent looking blue eyes', Ford inherited Nolly's spiritual mantle, just as he would inherit Rossetti's real cloak and stride about Bloomsbury and Montmartre in it, playing the last Pre-Raphaelite. His younger brother Oliver, however, caused Brown endless anxiety by his extravagance and dishonesty.[25]

In his study at the back of St Edmund's Terrace, Ford wrote a fairy story for Juliet. Delighted, his grandfather set about making two luminous illustrations, among his most attractive printed works, and persuaded Edward Garnett of Fisher Unwin to publish it. The success of *The Brown Owl* led to further children's stories and an early novel. But Ford's first major achievement, at the age of twenty-three, would be *Ford Madox Brown: A Record of His Life and Work*, every page of which acknowledges his intellectual debt to, and affection for, 'this most loveable, the sweetest of men'.

Living as he did for two years at St Edmund's Terrace, Ford spent many hours in Brown's company and knew him perhaps as well as a young man could. 'I would give very much of what I possess,' he wrote much later, 'to be able to live once more some of those old evenings in the studio. The lights would be lit, the fire would glow between the red tiles; my grandfather would sit with his glass of weak whisky and water in his hands and would talk for hours. He had anecdotes more lavish and picturesque than any man I ever knew ...'[26] If Brown was Lear and dead Emma his Cordelia, young Ford was Edgar to William Rossetti's Kent:

He would come in ... and begin to talk of Shelley and Browning and Mazzini and Napoleon III and Mr Rossetti, sitting in front of the fire would sink his head nearer and nearer the flames, his right ... foot would approach nearer and nearer to the fire-irons which stood at the end of the fender ... presently the foot would touch the fire-irons and down they would go into the fender with

a tremendous clatter. Madox Brown half dozing in the firelight would start and spill some of his whisky ... presently bang would go the fire-irons again. I would replace the fire-irons again and the talk would continue. When for the third time they went down, Madox Brown would hastily drink what little whisky remained to him and jumping to his feet shout 'God damn and blast you William, can't you be more careful!' to which his son in law, the most utterly calm of men, would reply 'Really Brown, your emotion appears to be excessive. If Fordy would leave the fire-irons lying in the fender there would be no occasion for them to fall.'[27]

Lucy's health caused increasing anxiety. An invaled well before 1885, when she first showed symptoms of her mother's tuberculosis, she had been forced to winter abroad in 1886 and again in 1888. Arthur Hughes met her at St Edmund's Terrace in the warm April of 1891, when she was busy planning a series of 'at homes'. But two years later, at a private view in Brown's studio in July 1893, he was shocked by the change in her appearance − 'so dreadfully thin and hollow-eyed' − and could not believe she would survive another English winter.

Despite this, Madox Brown kept working. The picture Hughes had come to view was Brown's twelfth and last panel for Manchester Town Hall, *Bradshaw's Defence of Manchester AD 1642*. 'I am sorry to hear it was refused by the Manchester Corporation,' Hughes wrote: it was '... certainly not very successful ... I am afraid his illnesses and great age have fought against him. It was a pain to see it, but he himself looks wonderfully well just now.'[28]

It is hard to quarrel with Hughes's judgement, or with the Corporation's initial refusal of *Bradshaw*, which, though well-designed, was crudely executed and left unfinished. Brown had had to paint much of it with his left hand following a stroke − an incapacity which affected his writing, as can be seen in his letter advising Alderman Thompson of the picture's arrival in Manchester. The Committee sent the picture back, refusing payment until satisfied, and further correspondence ensued in July when Brown dispatched it again, this time demanding payment in default of which 'within six months I shall sell it, or otherwise dispose of it'.[29] Confused and agitated, anxious as ever about money and again afflicted with gout, the artist begged Shields to advance £200 from the *Wycliffe* fund to enable him to pay off his Manchester assistant. 'I am dreadfully in want of money,' he wrote. On 22 August, when the Corporation had still not paid up, he consulted the solicitor Robert Garnett 'about the Manchester Corporation who seem to be behaving very badly to me, but I don't want it spoken about'.[30]

Thus distracted, Brown was unable to return to the *Wycliffe* commission until

the autumn of 1893. He was working at it slowly but steadily until the Saturday preceding his death. It was half-finished, Ford Hueffer recalled:

> he worked until darkness intervened, and then, whilst cleaning his palette, pointed to his name inscribed on the upper bevelling of the frame, and laying down his brushes upon his painting cabinet, said, referring to the fact that the picture was just half-finished, 'There, I've got it all finished as far as the "X". I'm very glad because it seems as if I was going home.' On the following day he felt too ill to get up, though able to sit up in bed and talk with very much of his accustomed vivacity, and, on the evening of the following day ... to dictate to the present writer the sketch of parts of his life, of which use has been made in the opening chapters of this record. His last quite coherent words must, I think, have been uttered whilst advising some alterations to a work of Miss Blind's, or perhaps in taking leave of Mrs Rossetti, who was on the point of departure for the Riviera.[31]

Lucy left England on 4 October, two days before her father's death.

As Brown lay dying, dozing, Juliet slipped upstairs to his bedroom:

> He was lying on his back with the clothes up to his chin and his beard ... spread out over the sheet. His face looked intensely proud and lonely; it seemed to have changed somehow and to be made of some cold and hard material. His white hair was spread out on the pillow and as I looked at him I remembered the picture of a great stern snow mountain lying all alone that he had once shown me.

He did not recognise her.

> It was terribly lonely. The wind was howling outside but it was quite quiet inside the room. Then my grandfather said, without turning his head, 'The Guy Fawkes boys were making just such a noise outside the windows as they're doing now on the night your brother Oliver died.'

He took her for Cathy, who had been nursing him, and then he began to say,

> 'Please to remember the 5th of November ...' And laughed, a little, very low, peculiar dreadful laugh and I said 'Grandpapa, my Oliver isn't dead at all, it was your own boy who died on Guy Fawkes night.' He turned to me and his face

seemed to melt a little ... 'My own boy?' And he kept on looking at me and smiling kindly ... and I felt very happy. I was just going to say 'Grandpapa, do you feel well now?' when all of a sudden his face seemed to die away and grow hard and he turned his head and forgot ...[32]

Ford Madox Brown died peacefully on 6 October, as journalists gathered outside the house. Once again, on 10 October, a funeral procession moved slowly along the winding paths of St Pancras cemetery to the family grave where, without Christian ceremony, he was laid beside Emma and his two sons. As at Oliver's funeral, Moncure Conway delivered a farewell address beside the grave. Many old friends were there, testifying to the great affection in which he was held; among them was Holman Hunt, who left 'feeling profoundly how his death would be to me a never ending loss'. Georgie Burne-Jones stood by the grave, and Arthur Hughes, writing later to William Bell Scott, lamented the passing of a second great Pre-Raphaelite: 'Yes indeed that Table Round was beautiful and strong.'

For William, as Lucy lay dying in far-away Italy, Brown's death was especially poignant, representing above all else the loss of Gabriel's closest friend, and in the spirit of family piety which characterised all his actions he conceived an Italian epitaph, associating the artists in death as in life. Neither this nor any of William's later voluminous memoirs did justice to Brown. Today the headstone, covered in brambles and badly askew, with its touching inscription scarcely legible, seems doubly incongruous – symbolising the neglect of a great independent spirit and the overshadowing of his reputation by the younger man.

Va dov' ogni altra cosa
Dove naturalmente
Va la foglia di rosa
E la foglia d'alloro.

(Go where all things
Go naturally, where goes
The leaf of the rose,
And the laurel leaf.)

Abbreviations

Austin	Harry Ransom Humanities Research Center, the University of Texas at Austin.
Bodleian	Bodleian Library, Oxford.
Cornell	Olin Library, Cornell University, Ithaca.
DGR *Letters*	*Letters of Dante Gabriel Rossetti*, ed O Doughty and J R Wahl, Oxford University Press, 1967.
FJS	Frederic Shields.
FMB 65	Catalogue of Mr Madox Brown's Exhibition, 191 Piccadilly, 1865.
FMBD	*The Diary of Ford Madox Brown*, ed Virginia Surtees, Yale University Press, 1967.
GBJ	G Burne–Jones
Hueffer	Ford M Hueffer, *Ford Madox Brown: A Record of his Life and Work*, Longmans, 1896.
Huntington	The Huntington Library, San Marino, California.
ILN	The Illustrated London News.
Merseyside	National Galleries of Merseyside, Liverpool.
Paden	W D Paden, 'The Ancestry and Families of Ford Madox Brown', *Bulletin of the John Rylands Library*, No 50, 1967.
Princeton	Princeton University Library, Princeton, New Jersey.
UBC	Library of the University of British Columbia, Vancouver.
WBS	William Bell Scott.
WHH	William Holman Hunt.
WMR	William Michael Rossetti.

Notes

CHAPTER 1

1 W D Paden, 'The Ancestry and Families of Ford Madox Brown', *Bulletin of the John Rylands Library*, No 50, 1967, gives a detailed account of Brown's family background.

2 FMB to F J Shields, 27.11.82. UBC.

3 Paden, op cit.

4 FMB to Henry Boddington, 25.3.89. UBC.

5 For accounts of Dr John Brown, see entry in DNB and in *Edinburgh Portraits by the late John Kay*, Edinburgh, 1837.

6 Ford Madox Hueffer, *Ford Madox Brown, A Record of his Life and Work*, 1896, pp 11–12. Brummell lived in Calais 1816–30.

7 FMB to Boddington, op cit.

8 William Michael Rossetti, entry in unpublished diary 25.1.79. UBC.

9 Hueffer, op cit, pp 12–13.

10 Ibid.

11 Information on the Bruges Academy and Brown's attendance there from the Stadsarchief, Bruges.

12 Dante Gabriel Rossetti to the Pre-Raphaelite Brotherhood, 25.10.49. *Letters*, Vol 1, No 50.

13 Hueffer, op cit, p 23.

14 The *Diary of Ford Madox Brown*, ed Surtees, 1981. Entry 6.1.56. Brown's original spelling has been retained throughout.

15 Hueffer, op cit.

16 FMBD, 6.1.56.

17 Student records, Antwerp Academy of Art, 1838–9.

18 *Art Union Monthly*, 1846. Interview with Gustave Wappers.

19 Hueffer, op cit, p 406.

20 Information on Daniel Casey from City Archives, Bordeaux.

21 Hueffer, op cit, pp 16–18.

22 Ford Brown to FMB, 24.1.39. Cornell.

23 Caroline Brown to FMB, 24.1.39. Cornell. Trissy was Tristram Madox, only child of James Fuller Madox (Uncle James).

24 Calais Register of Births and Deaths. She died on 2.9.39.

25 FMB to Theodore Watts–Dunton, 29.1.81. Brotherton Library, Leeds.

26 Eliza Coffin Brown to FMB, 16.12.89, Cornell.

27 Hueffer, op cit, quoting W M Rossetti, p 20.

28 Catalogue. Sale of Contents of Wappers' studio. Antwerp, 18.5.75. Antwerp Academy.

29 Drawing of swooning attendant from Elisabeth Brown. Whitworth Art Gallery.

30 Lucy Madox Rossetti, 'Ford Madox Brown', *Magazine of Art*, 1890.

31 Paden, op cit, for location of marriage, and Hueffer, op cit, p 27.

CHAPTER 2

1 FMB 65.

2 Lucy Madox Rossetti, op cit.

3 FMB 65.

4 Ford Brown's Will, 10.6.42, in Public Record Office.

5 Lucy Madox Rossetti, op cit.

6 Records of Montmartre cemetery show Ford Brown buried on 22.11.42.

7 *Official Conditions of Competition*, dated 25.4.42, but repeated annually.

8 Hueffer, op cit, pp 33–4.

9 *Art Union Journal*, February 1845. See also the *Builder* for that month.

10 William Etty to FMB from 14 Buckingham St, Strand, 8.9.43. UBC.

11 Foerster's *Kunstblatt* review, 1844, was translated and published in *Art Union Monthly*, April–May 1845. The 'unorthodoxies' in *Harold* included the lighting (with the Conqueror in shadow and dead Harold illuminated), the savagery of the foreground group and the general lack of 'grace'.

12 The Bromley family in Meopham: Paden, op cit. Milliker Farm appears in Meopham Church ratebooks, Kent County Archives, Maidstone.

13 *Pre-Raphaelite Diaries and Letters*, ed W M Rossetti, 1900, prints parts of five letters from FMB to Elisabeth.

14 Letter III, 6.5.45. Mrs Wharton was a favourite model of Etty's.

15 Letter IV, nd May 45.

16 Letter V, nd May 45.

17 *Art Union Monthly*, August 1845.

18 Tom Taylor, *The Life of Benjamin Robert Haydon*, 1853.

19 B R Haydon to FMB 3.7.45. UBC.

20 FMBD 4.9.47.

21 Brown's passports to and from Rome are at Cornell. The routes can be traced from the many visa and police stamps.

22 Hueffer, op cit, p 409.

23 FMB to George Rae, 2.1.65. Merseyside.

24 FMBD records sending him a picture on 29.11.47.

25 Sir Charles Eastlake, later President of the Royal Academy, and William Dyce, muralist and intimate of the Nazarenes.

26 FMB's lecture, 'Styles in Art', published in the *Universal Review*, May 1888, describes how Overbeck and Cornelius were consulted, and recounts his own visits to them.

27 FMBD 4.9.47.

28 Ibid.

29 Lucy Madox Rossetti, op cit.

CHAPTER 3

1 FMB to William Davis, nd 7 May 1857. Princeton.

2 FMB 65.

3 FMBD 4.9.47.

4 FMB 65.

5 The diary consists of six small exercise books, covering (with long breaks) the years 1847–68. The first five books (Ashmolean) were owned by W M Rossetti who used them for his *Pre-Raphaelite Diaries and Letters*. The sixth (Pierrepont Morgan Library, New York), belonged to Hueffer who drew on it for his *Life*. The whole was published by Yale University Press in 1981.

6 'young Elliott' was Robert Elliott, a fellow competitor for *The Ascension* commission.

7 The MS of 'To Ireland' is at Princeton. Richard Bromley (1813–65), Elisabeth's brother, was a civil servant at the Admiralty and was sent to organise famine relief in Ireland in 1847. His house in Tavistock Street W1 was round the corner from Brown's studio.

CHAPTER 4

1 In 1847, C Lucy won a £200 prize in the Westminster Competition with his *Embarkation of the Pilgrim Fathers in the Mayflower A.D. 1620*. In 1848 he showed its companion, op cit, at the Royal Academy.

2 The Maddox Street academy was adver-

tised as 'for the study of Painting and Sculpture, and Preparatory for the Royal Academy. Open every evening from 7 to 10. The Living Model four evenings a week. Instruction: Drawing and Painting, Charles Lucy Esq, Lowes Dickinson Esq.' (ILN 15.1.48).

3 The Free Exhibition echoed the Free Society of Artists of the 1760s, formed in opposition to an English Royal Academy with its powerful system of patronage. The Free's democratic character and broad scope (exhibitions included industrial design) in turn anticipated Brown's Hogarth Club of 1858–61.

4 See J P Seddon's *Memoir and Life of Thomas Seddon*, 1858.

5 FMBD 1.2.48. The books borrowed were Henry Shaw, *Specimens of Ancient Furniture*, 1836, and either J H Parker, *Glossary of Terms used in Gothic Architecture*, 1846, or John Britton, *Dictionary of the Architecture and Archaeology of the Middle Ages*, 1838.

6 W M Rossetti, *Fine Art, Chiefly Contemporary*, 1867.

7 D G Rossetti, *Letters*, Vol 1, No 30.

8 DGR to W Bell Scott, 25.11.47. ibid, No 27.

9 W M Rossetti, *D. G. Rossetti, Family Letters with a Memoir*, 1895, Vol 1, p 119, attributes this story to W Bell Scott and F G Stephens.

10 These descriptions appear in ibid and in W M Rossetti. *Some Reminiscences*, 1906, and in his short unpublished memoir of Brown, nd. (MS at Princeton.)

11 Ibid.

12 Robert Vernon had made a fortune supplying horses to the army. His collection, mainly of British artists, is now in the V & A Museum.

13 By the 1840s, there was a considerable historical and critical literature of painting. Brown could have read Passavant, Lanzi, or d'Agincourt in German, Italian or French, Kugler's *Handbook of the History of Painting*, Lindsay's *History of Christian Art* or Anna Jameson, *Sacred and Legendary Art*. The *Art Union Monthly* published historical articles.

14 Ruskin's *Modern Painters*, Vol 2, appeared in 1846: Section 2, Chapter 3, 'Of Imaginative Penetrative' is largely given over to Tintoretto.

15 Hueffer, p 59, transmits family legend. Paden, op cit, and our research in Gloucester County Archives and elsewhere refutes most of this.

16 W M Rossetti, *Some Reminiscences*, 1906, op cit.

17 Juliet M Soskice, *Chapters from Childhood*, 1921.

CHAPTER 5

1 W Holman Hunt, *Pre-Raphaelitism and the Pre-Raphaelite Brotherhood*, 1905.

2 Ibid, Vol 1, p 123.

3 Ibid, p 126.

4 Ibid, pp 101–2.

5 Hueffer, op cit, p 63.

6 FMBD 29.3.49.

7 FMB Papers.

8 DGR, *Letters*, Vol 1, 25.10.49.

9 *The Germ* was reprinted in 1979 (Ashmolean and Birmingham Museums) with W M Rossetti's 1899 Introduction.

10 WMR, *The P.R.B. Journal*, 19.12.49.

11 Ibid, 14.3.50.

12 Ibid, 12.1.50. Thirteen other tenants

lived in No 17, mostly small tradesmen, craftsmen and governesses.

13 Lowes Dickinson to FMB, quoted Hueffer, p 69.

14 WMR, op cit, 12.1.50.

15 On 10 February 1850, the MP Hotham wrote to Brown from the House of Commons, acknowledging a further application to Admiral Runcombe. The tone suggests that the artist was importuning for work. UBC.

16 FMBD 16.8.54.

17 Maitland and Wild posed for several PRB pictures. Walter Deverell, best known for his Pre-Raphaelite *Twelfth Night* 1850, was a close friend of Rossetti, who later shared a studio with him.

18 PRBJ, op cit, 26.10.50. Dickinson went to Rome to study painting.

19 FMB to Hunt, quoted Hunt, op cit, Vol 1, pp 246–7.

20 Ibid.

21 FMB to Lowes Dickinson, 14.5.51. Princeton.

22 Lowes Dickinson to FMB, May 1851, quoted Hueffer, pp 62–3.

23 FMBD 16.8.54.

24 *Chaucer* was noticed in *The Illustrated London News* (17.5.51), *Art Union Monthly* 1.6.51, *Athenaeum* 24.5.51, *Spectator* 10.5.51 and *The Times* 7.6.51.

25 FMBD 16.8.54 and FMB to Robert Dickinson 22.11.53 (Library, Victoria & Albert Museum) about this arrangement.

26 FMBD 16.8.54.

27 WHH, op cit, Vol 2, p 96.

28 FMB 65.

29 FMBD 16.8.54.

30 R Ironside and J Gere, *Pre-Raphaelite Painters*, 1948.

31 FMBD 16.8.54.

32 WHH, op cit, Vol 1, pp 276–8.

33 See Surtees, *Dante Gabriel Rossetti, The Paintings and Drawings 1828–82*, 1971. Elizabeth Siddal took over as Delia in a later version (62B).

34 FMBD 16.8.54.

35 FMB 65.

36 FMBD 16.8.54.

37 Just who posed for which figure remains doubtful: see M Bennett, *The Pre-Raphaelites*, Tate Gallery, 1984, p 101.

38 FMBD 16.8.54.

39 This account of Brown's brush with the Royal Academy is in WHH, op cit, Vol 1, pp 318–19.

CHAPTER 6

1 W Dyce to FMB, 25.5.52. UBC.

2 FMBD 16.8.54.

3 Paden, op cit, and Borough of Camden Rate Books/Registers.

4 FMBD. See Introduction.

5 Paden, op cit, and Camden Rate Books/Registers.

6 FMBD 16.8.54.

7 On the location of *Work*, see M. Bennett, op cit, p 163.

8 See FMB 65 for his extensive account of *Work*.

9 FMBD pp 163–4. Appendix 2 reproduces 2 mutilated pages, from which this information is gleaned.

10 Brown's debt to Hogarth is discussed by E D H Johnson in 'The Making of Ford Madox Brown's *Work*' in *Victorian Artists and the City*, ed Ira Bruce Nadel, 1980.

11 FMB to Lowes Dickinson, 17.10.52. Princeton.

12 WHH, op cit, Vol 2, p 96.

13 Ibid.

14 The view from his landlady's bedroom is identified by Bennett, loc cit, 1984, p 110.

15 FMBD 65.

16 Ibid.

17 FMB to Lowes Dickinson, 17.10.52. Princeton.

18 FMBD 16.8.54.

19 For the North London School of Drawing and Modelling, see J P Seddon, *Memoir and Letters of Thomas Seddon*, op cit, and ILN, 3.1.52, and 17.4.52.

20 DGR, *Letters*, Vol 1, Nos 81, 83, 85 & 94.

21 FMBD, Introduction.

22 Brown uses both titles.

23 FMBD 16.8.54.

24 Paden, op cit, FMBD, Introduction.

25 FMB to WHH, nd. Huntington.

26 For Annie Miller, see Diana Holman Hunt, *My Grandfather, his Wives and Loves*, 1969.

27 DGR to FMB, *Letters*, Vol 1, No 85.

28 WHH to FMB, 19.11.52, quoted Hueffer, p 87.

29 Troxell Coll. Princeton.

30 Reports and letters about the state of Hogarth's tomb appeared in the ILN of 8.2.53 and *Art Journal*, May 1853.

CHAPTER 7

1 FMBD 26.9.54. Quotations from Brown in this chapter, unless otherwise identified, are from his Diary of 1854–55.

2 FMB to Emma, 19.11.53. FMH, op cit, pp 94–5.

3 FMB to Emma, nd. Cornell. Variants on Catherine's name in early childhood include Kate, Kattie, Cattie(y), later standardised as Cathy.

4 FMBD 16.8.54.

5 Brown's numerous letters to Davis are at Princeton.

6 *The Life of Benjamin Robert Haydon*, op cit, 1853.

7 Exhibition of Sketches, Dec 1852–Jan 53, 121 Pall Mall.

8 FMBD 10.10.54.

9 DGR *Letters*, Vol 1, No 190.

10 Ibid, No 157, 14.4.54.

11 Ibid.

12 V. Surtees (ed) *Sublime and Instructive*, 1972, prints a letter from Ruskin to Ellen Heaton of Leeds (12.3.62) strongly discouraging any purchase from Brown.

13 The advertisement was placed on 28.1.55.

14 The Old Lady was probably one of James Madox's aunts. A family arrangement was easier than a mortgage, given Brown's part-ownership of the wharf.

15 FMB 65.

16 Ibid.

17 Ibid.

18 FMBD 6.4.55. John Seddon was then restoring Llandaff Cathedral, Cardiff. Brown's perception that Seddon did not wish to offend the powerful Ruskin was almost certainly correct.

19 FMBD 27.6.55. White bought *The Brent* for £10 and *Carrying Corn* for £12.

CHAPTER 8

1 FMB to WHH, 30.9.55. UBC.

2 Bonheur's *The Horse Fair*, exhibited Cambart's French Gallery, July 1855.

3 *Peace Concluded*, 1856.

4 As in the previous chapter, unless other-wise identified our account is based on Brown's diary for the period.

5 FMB to WMR, 22.12.55. UBC.

6 FMB to Maria Rossetti, February 1856. UBC.

7 Hueffer, op cit, p 106.

8 Holman Hunt failed in his bid and never became an ARA.

9 J E Millais to Euphemia Millais, 6.4.56. Huntington.

10 The Crimean subject was never painted, but the idea furnished one of the seven scenes from *An English Family's Life* deco-rating Brown's bookcase for Morris, Mar-shall, Faulkner & Co. in 1862. *Stolen Pleasures* became *Stages of Cruelty*, not completed for 25 years.

11 DGR to Ellen Heaton, September 1856. Heaton Coll.

12 DGR *Letters*, Vol 1, 18.12.56, No 254.

CHAPTER 9

1 WHH to FMB, 3.8.57. Huntington.

2 FMB to WHH, nd. David Dallas Coll.

3 FMB to WMR, 28.5.57, in *Ruskin, Rossetti, Pre-Raphaelitism*, 1899, p 166.

4 FMBD 16.3.57.

5 Ruskin's address was reported in the *Journal of the Royal Society of Arts*, 1857.

6 FMBD 20.3.57.

7 DGR to Lowes Dickinson, *Letters*, Summer 1858, Vol 1, No 287.

8 FMB to W Davis, nd. Princeton.

9 Ibid.

10 Ibid, nd. William Lindsay Windus was a leading figure in the Liverpool Academy.

11 John Miller to FMB, nd, quoted Hueffer where it is wrongly ascribed to Peter Miller.

12 *The Diaries of George Price Boyce*, ed Surtees, 1980, entry for 27.6.57. Brown had carefully mounted and framed the pictures. Boyce's *Sunset* was amongst the works at 1 St Edmunds Terrace at Brown's death in 1893.

13 In *Ruskin, Rossetti, Pre-Raphaelitism*, op cit, WMR lists all the exhibitors.

14 FMB to John Miller, 20.6.57. Princeton.

15 *The Athenaeum*, 11.7.57, thought by WMR to be by Walter Thornbury, a notori-ously inaccurate critic.

16 For an account of Ruxton's part in getting up the Exhibition, see WMR, *Ruskin, Rossetti, Pre-Raphaelitism*, op cit.

17 Hueffer, op cit, p 145.

18 See Jeremy Maas, *Gambart: Prince of the Victorian Art World*, 1975, for a general account of the American exhibition.

19 E Gambart to WMR, 21.7.57. UBC.

20 FMBD 17.1.58.

21 FMB to Davis, nd August 57. Princeton. Pickersgill was a successful member of the Academy old guard.

22 FMBD 17.1.58.

23 Amy Woolner, *Thomas Woolner RA. His Life in Letters*, 1917.

24 WHH to FMB, 22.9.57. Huntington.

25 FMBD 27.1.58.

26 Frederic Shields, Lecture to Manchester Literary Club, 1875, quoted Hueffer, pp 146–7.

27 FMBD 6.7.56.

28 See WMR, *Family Letters with a Memoir*, 1895, Vol 1, pp 200–1.

29 DGR to Allingham, *Letters*, Vol 1, No 254.

30 G Burne-Jones, *Memorials of Edward*

Burne-Jones, 1904. Vol 1, p 164, quoting Val Prinsep.

31 Mackail, *Life of William Morris*, 1899, Vol 1, p 127, quoting the diary of Cormell Price, a close friend of Morris. Morris was called Topsy or Top from his mop of black hair.

32 Captain Augustus Ruxton to WMR, 20.10.57, in *Ruskin, Rossetti, Pre-Raphaelitism*, op cit.

33 W J Stillman to WMR, 15.11.57. Ibid.

34 FMB to WMR, 12.8.58. UBC.

35 WHH, op cit, Vol 2, pp 142–3.

36 Alfred Hunt to the Rev Arthur Greenwell, 9.3.58. Cornell.

37 WHH, op cit, Vol 2, for his account of the Hogarth Club.

38 GBJ, *Memorials*, op cit, Vol 1, pp 176 and 179.

39 Ibid, Vol 2, pp 202–3.

40 For the original membership, see WMR, RRP-R, pp 216–17. For the story of the Hogarth Club, see Deborah Cherry, 'the Hogarth Club 1858–61', *Burlington Magazine*.

41 FMB to Davis, nd September 1858. Princeton.

42 DGR to FMB. *Letters*, 25.12.58, Vol 1, No 295. 'Shop Puseyism' implies high Anglican, pietistic work produced for church furnishing.

43 FMB to Davis, 4 January 1859. Princeton.

44 See D Cherry, op cit, for a list of Burne-Jones's drawings and four stained-glass cartoons in the Victoria & Albert Museum.

CHAPTER 10

1 Brown's sonnet introduces the detailed account of *Work* in FMB 65. Hueffer prints this in full.

2 The biblical quotations are taken from the frame of *Work*.

3 FMBD 4.9.47.

4 FMB 65.

5 Hueffer, op cit.

6 FMBD 2–3.1.55.

7 Plint to Brown, 24.11.56. FMB Papers, Merseyside.

8 Hueffer, op cit, p 195: 'I happen to possess the artist's copy of that work [*Past and Present*]. It is of the American edition of 1840 and passages ... enunciating the gospel of *Work* are pencil-marked.'

9 FMBD 7.8.55.

10 FMBD 15.12.55.

11 T. Carlyle, *Sartor Resartus*, 'Helotage', 1831.

12 Hueffer, op cit, p 156.

13 FMBD 16.3.57.

14 FMBD 17.3.57.

15 FMBD 17.1.58.

16 FMB 1865.

17 Catherine Madox Hueffer, *Jottings* (1922) and *A Retrospect*. FMB Papers, House of Lords.

18 J. Phillips Emslie, quoted by Hueffer, op cit, Appendix A.

19 Brown's letter was published in *The Journal of the Working Men's College*, 1934.

20 DGR to Lowes Dickinson, *Letters*, Vol 1, No 287.

21 Gillum bought *Walton-on-the-Naze*, a small duplicate *Last of England*, a chalk version of *Cordelia at the Bedside of Lear*, and (after Morris had parted with it) *The Hayfield*.

22 *The Diaries of G. P. Boyce*, 26.12.58.
23 WHH, op cit.
24 DGR, *Letters*, Vol 1, No 310.
25 Hueffer, op cit, p 165.
26 Plint to FMB. FMB Papers, Merseyside.
27 Leathart Papers. UBC.
28 Plint to FMB, 3.12.60. FMB Papers, Merseyside.
29 FMB to Plint, 23.4.61. FMB Papers, Merseyside, quoted Hueffer, pp 174–5.
30 FMB to Leathart, 10.8.63. UBC.
31 FMB to Leathart, 27.1.63. UBC.
32 FMB to Leathart, 8.2.63. UBC.
33 'Self-Painted Pictures' appeared in *The Magazine of Art* 1890. MS in John Rylands Library, University of Manchester.

CHAPTER 11

1 FMB to FG Stephens, 12.1.62. Bodleian.
2 WHH to John Tupper, 3.4.61. Huntington.
3 WHH to Thomas Combe, 12.2.60. Bodleian.
4 *The Diaries of George Price Boyce*, 11.2.60.
5 DGR to FMB, *Letters*, 23.5.60, Vol 1, No 328.
6 DGR to W. Allingham, *Letters*, Vol 2 (after 18.1.61), No 363.
7 G Burne-Jones, *Memorials*, op cit, Vol 1.
8 Ibid.
9 Catherine Hueffer, *Jottings*. FMBP.
10 FMB to Plint, 23.4.61, quoted Hueffer, op cit, pp 174–5.
11 WM to FMB, 18.1.61, J.W. Mackail, *The Life of William Morris* Vol 1, p 160.
12 C J Faulkner to C Price, April 1862, quoted Mackail, Vol 1, pp 157–8.
13 Minutes of Morris, Marshall, Faulkner & Co. Copy in Hammersmith Local History Archive.
14 Philip Webb on FMB, in W Lethaby, *Philip Webb and His Work*, ed G Rubens, 1979.
15 Fitzwilliam Museum, Cambridge.
16 Hueffer, op cit, p 161.
17 *The Artist*, No xxii, 1898.
18 Ibid.
19 FMBD, 7.8.55.
20 *The Death of Sir Tristram* was also executed in watercolour for G P Boyce.
21 See Violet Hunt, *Wife to Rossetti*, 1932 – unlike much in that book, this incident is probably true.
22 FMB to WHH. 21.7.61. UBC.
23 FMB to George Rae, nd April 1862. FMB Papers, Merseyside.
24 Ibid, 9.5.62.
25 FMB to W Davis, nd. Princeton.
26 Hueffer, op cit, p 184.
27 G. Burne-Jones, *Memorials*, op. cit.
28 FMB to Rae, 29.4.64. FMB Papers, Merseyside.
29 Ibid, nd.
30 DGR and WMR had collaborated with Alexander Gilchrist on his *Life of William Blake* throughout 1861 and had helped his widow get it published in 1863. Blake's example is likely therefore to have been in FMB's mind.
31 See Jeremy Maas, *Gambart, Prince of the Victorian Art World*, 1975, and a correspondence (copies in Maas files) between Hunt and Stephens concerning Brown's show in December 1864.
32 FMB's 1865 Catalogue can be consulted in the Library of the Victoria & Albert Museum.
33 DGR to FMB, 28.3.65, *Letters*, Vol 2, No 599.

34 Francis Palgrave (1824–97), critic and poet, had recently published his *Golden Treasury of Songs and Lyrics* (1864).

CHAPTER 12

1 Charles Rowley, Manchester philanthropist and art-dealer, greatly admired Brown. In the 1870s he commissioned several pictures from him and, as a leading Manchester Councillor, was influential in securing him the Town Hall mural commission (see Chapter 14). His *Fifty Years of Work Without Wages*, 1910, paints an affectionate picture of Brown and his family.

2 FMB's Account Book for the 1860s. FMB Papers, Merseyside.

3 George Warington Taylor was business manager of Morris, Marshall, Faulkner & Co from 1865 until his death in 1870.

4 G Burne-Jones, *Memorials*, Vol 1, pp 292–3.

5 Ibid, p 303.

6 For an earlier description of 37 Fitzroy Square, see W M Thackeray's *The Newcomes*, 1855.

7 Hueffer, op cit, p 240.

8 Charles Rowley, op cit.

9 Justin McCarthy, 'A Fitzroy Square Bohemia', in *Reminiscences*, Vol 1, 1899.

10 W Bell Scott to Alice Boyd, nd 1869. UBC.

11 W R Lethaby, *Philip Webb and his Work*, p 248.

12 Hueffer, op cit.

13 WBS to A Boyce 2.11.67. UBC.

14 Ibid, 17.11.68. UBC.

15 This gallery, for independents, had opened at the Egyptian Hall, Piccadilly, in February 1865.

16 DGR to FMB, 29.4.64, *Letters*, No 528.

17 'Mrs Morris' was William Morris's wife, Jane, doyenne of all Pre-Raphaelite beauties.

18 W J Spartali to DGR, nd February 1871. UBC.

19 Rossetti's portrait of Marie Stillman, 1869. Private Coll.

20 Formerly in possession of Fanny Schott, *Mercy* is now at Wilmington Art Gallery, Delaware.

21 DGR to FMB, ?31.8.69, *Letters*, Vol 2. 'The new sonnet is one of the most in need of further finish I think. This we can talk over when I see you.' From midsummer 1869 until April 1870, Rossetti was busy revising his own poems for publication. FMB's manuscript book of poems, FMB Papers.

22 C Madox Brown, *Thinking*, oil, 1869. Maas Coll.

23 FMB to Lucy Rossetti, 29.8.69. UBC.

24 Stillman papers, Schenectady.

25 DGR to FMB, 9.2.66, *Letters*, Vol 2, No 667.

26 WMR, *Dante Gabriel Rossetti, His Family Letters, with a Memoir*, 1895, op cit, Vol 1, p 249.

27 WBS to Alice Boyd, nd 1868.

28 FMB to Howell, 20.8.67. Austin.

29 FMB draft letter. UBC.

30 FMB to Howell, 11.4.69. Austin.

31 Howell to DGR, September 1872. Austin.

32 Joseph Pennell, *The Whistler Journal*, 1921.

33 FMB to Howell, 3.2.69. Austin.

CHAPTER 13

1 Rossetti's illness is fully documented in W H Fredeman, 'Prelude to the Last Decade: Dante Gabriel Rossetti in the summer of 1872, *Bulletin of the John Rylands Library*, Autumn 1970 and Spring 1971. His account is based on the correspondence between Brown, W M Rossetti, William Bell Scott and the Hakes, father and son.

2 DGR to FMB, 25.9.72, *Letters*, Vol 3, No 1238.

3 WBS to Alice Boyd, 13.6.72. Penkill Papers. UBC.

4 WBS to Alice Boyd, 18.6.72. Penkill Papers. UBC.

5 WMR to WBS 18.6.72. UBC.

6 Fredeman, op cit.

7 Ibid.

8 H. Treffry Dunn was Rossetti's studio assistant from 1866 until the latter's death in 1882. His *Recollections of Dante Gabriel Rossetti and his Circle* were published in 1904.

9 *The Diary of William Michael Rossetti 1870–1873*, 1977, entry of 18.3.72.

10 Thomas Hake to WMR, 31.7.72. UBC.

11 The quotations from Philip Bourke Marston's letters appear in J H Ingram's *Oliver Madox Brown*, 1883.

12 Bell Scott paints an amusing portrait of Hueffer in his *Autobiographical Notes*, II, pp 183–9.

13 Catherine Hueffer to Emma Brown, 5.9.73. Cornell.

14 Brown's 'Address to the Vice Chancellor', dated 20.12.72. Fitzwilliam.

15 FMB to F G Stephens, 17.12.72. Bodleian. And see W M Rossetti's *Diary*, op cit, for 18.12.72.

16 FMB to F G Stephens, 12.1.73. UBC.

17 FMB to WMR, 8.7.73. UBC.

18 FMB to Lucy Rossetti, 7.7.73. UBC.

19 FMB to WMR, 8.7.73. UBC.

20 FMB to DGR. March 1874. UBC.

21 W Morris to Louisa Baldwin, 26.3.74. *Collected Letters*, ed Kelvin, I.

22 See DGR to Jane Morris, 17?.11.80, *Dante Gabriel Rossetti and Jane Morris: their correspondence*, John Bryson and Janet C Troxell, 1976. Nos 120 and 121.

23 EBJ to DGR. Sept? 1874. UBC.

24 G Burne-Jones, *Memorials*, op cit, Vol 2, pp 239–40.

25 Oliver Madox Brown to Philip Bourke Marston 19.9.74 in Ingram, op cit.

26 FMB to DGR, 20.10.74. UBC.

27 DGR to FMB, 21.10.74, and 27.10.74, *Letters*, II and *Collected Letters of William Morris*, I, pp 233–7 and footnotes.

28 FMB to DGR, 29.10.74. UBC.

29 FMB to FJS, 30.10.74, quoted Hueffer p 294.

30 Ingram, op cit.

31 FMB to DGR, 5.11.74. UBC.

32 Hueffer reproduces FMB's sonnet to 'OMB' in full, p 297.

CHAPTER 14

1 FMB to Shields, 8.11.74, quoted Hueffer p 295 where incorrectly ascribed to Rae (see E Mills, *Frederic Shields*, 1912, pp 171–2).

2 Shields to FMB, nd 11.74, Mills, op cit.

3 Juliet M Soskice, *Chapters from Childhood*, 1921.

4 Lecture to Manchester Literary Club, February 1875, quoted Hueffer, pp 146–7.

5 FMB to FJS, 23.12.69, quoted Mills, op cit, pp 136–7.

6 The first scheme, covering the proposed five rooms, was outlined by FMB to Shields 22.7.76 (Mills, op cit, pp 198–9): 'I have just written off a scheme ... to Rowley. 1. Committee Room – Religious. 2. Politics. 3. Entrance Hall – Manufactures and Commerce. 4. Legendary. 5. The Banqueting Hall, to be devoted to great men of different municipalities (your idea, and as I told them, most important).'

7 Charles Rowley to FJS.

8 Hueffer, p 350. The first £100 was to be paid on approval of each cartoon, the rest on completion of the mural. Brown retained the right to sell his cartoons and make easel paintings from them.

9 FMB to FJS, April 1876.

10 For the continuous research into subjects, see Mills, pp 234–5, FMB to FJS, and Hueffer, pp 331–53, including FMB to FJS, Nov 1878.

11 Gambier-Parry invented the process, used by Leighton at the South Kensington Museum (now V & A). The medium was a mixture of resin, wax, oil and copal, diluted and used to prepare the wall surface before the application of the colour. The colours were then absorbed, as in true, water-based, fresco.

12 Sir Coutts Lindsay, banker, soldier and amateur painter, opened his Grosvenor Gallery in New Bond Street in May 1877 – to coincide with the opening of the summer exhibition at the Royal Academy. The Prince of Wales attended the opening banquet and Burne-Jones, Poynter, Leighton, Millais and Whistler were the stars.

13 FMB to Lucy Rossetti, August 1877. UBC.

14 FMB to FJS, 23.8.77, quoted Mills, op cit, p 213.

15 FMB to FJS, early April? 79, quoted Mills, op cit, p 237.

16 FMB to F G Stephens, 1.6.79. Bodleian.

17 FMB to FJS, 18.7.79, quoted Mills, op cit, p 244.

18 FMB to Rowley, 29.1.80, quoted Hueffer p 341 with slightly different wording.

19 FMB to DGR, 9.1.81. UBC, replying to DGR's of 12.12.80, quoted Hueffer, p 345. Rossetti had heard the pig saga from Hall Caine (see (24) below).

20 FMB to Lucy Rossetti, 25.9.80. UBC.

21 FMB to Lucy Rossetti, 14.1.86. UBC.

22 WMR, unpublished diary entry 29.1.79. UBC.

23 Helen Rossetti Angeli, 'Ford Madox Brown' in *Dante Gabriel Rossetti, His Friends and Enemies*, 1949.

24 Sir Hall Caine (1853–1931) of Liverpool, poet, novelist and Rossetti's companion from 1881–2, published his *Recollections of Rossetti* in 1882.

25 FMB to Lucy Rossetti, 21.2.81. UBC.

26 DGR to FMB, 21.3.81, *Letters*, Vol 4, No 2437. See also Brown's to DGR of the same day and No 2438 to Watts-Dunton, who had been present at the dinner.

27 FMB to Lucy Rossetti, 17.8.81. UBC.

28 FMB to FJS, 27.11.82.

29 FMB to Lucy Rossetti, 10.4.82. UBC.

30 Lucy to William Rossetti, 1.7.82. UBC.

31 'Altogether', wrote Brown to Lucy in October 1883, my work on the Beata will have cost you £32 for 22 days work.'

32 FMB's MS 'Explanation of the Design for D. G. Rossetti's Grave' is at UBC.

33 FMB to Lucy Rossetti, 4.9.82, and 15.4.1883. UBC.

34 FMB to Lucy Rossetti, 6.9.83. UBC.

35 See Hueffer, pp 361–3 & FMB to FJS,

25.12.83 (see Mills pp 284–5), recording the decision to give Brown the commission 'at such a price as would pay all round £375 for each picture of the twelve. It is only five years more exile.'

36 FMB to Lucy, 2.2.84. UBC.

37 See FMB to C Rowley, 14.8.82. Getty Library, Malibu.

38 Morris to Rowley, 13.9.85. Morris to FMB, 16.9.85. *The Collected Letters of William Morris*, 11, pp 576–7 and FMB to Morris, 18.9.85 (footnote).

39 The episode was reported in *The Daily News* of 22.9.85. See E P Thompson, William Morris: *Romantic to Revolutionary*, 1955.

40 FMB to Lucy Rossetti, nd October 1885. UBC.

41 FMB to Lucy Rossetti, nd March 1886. UBC.

42 FMB to FJS, 16.4.86, quoted Hueffer, p 376.

43 See Rowley, op cit and FMB to H Marion Spielmann, 8.5.86, John Rylands Library.

44 FMB to Spielmann, and Hueffer, pp 377–8, quoting FMB 29.12.86 to FJS.

45 FMB to Lucy, 30.4.87, and FMB to M Blind, quoted Hueffer, p 378.

46 *The Magazine of Art*, 1888, pp 120–22 prints 'The Progress of English Art as *not* shown at the Manchester Exhibition'. Brown's lecture given in the Mayor's Parlour, Manchester, was a pointed reply to Claude Phillips' article in the previous issue (pp 42–6), viz 'The Progress Of English Art as shown at the Manchester Exhibition.'

47 See FMB to FJS, quoted Hueffer, p 388.

CHAPTER 15

1 'Historic Art', *University Review*, September 1888.

2 'Our National Gallery', *Magazine of Art*, 1890.

3 Brown sent *Work, The Last of England, Romeo and Juliet* and a replica of *Wycliffe on his Trial* to Chicago.

4 1 St Edmund's Terrace was destroyed by enemy action in the war. The house and its furnishings are described by Hueffer in *Ancient Lights*, 1911, and by Juliet Soskice in *Chapters from Childhood*, op cit.

5 Walter Crane to FMB, 31.8.86. Huntington.

6 *The Hobby Horse*, V, 1890.

7 Soskice, op cit.

8 FMB to FJS, October 1890. UBC.

9 Hueffer, *Ancient Lights*, op cit.

10 *The Torch* ran from September 1891 to January 1897. There are (incomplete) sets at the British Library (Colindale) and Princeton.

11 Soskice, op cit.

12 See Hueffer, op cit, p 387.

13 Soskice, op cit.

14 Hueffer, op cit, p 394.

15 Quilter's article (*The Universal Review*, Autumn 1891) reprinted in his *Preferences in Art, Life and Literature*, 1892.

16 EBJ to FJS, nd.1.92. UBC.

17 F G Stephens to FJS, 18.1.92. UBC.

18 EBJ, draft letter nd. ? Jan 92. UBC.

19 These included the South London Art Gallery (Camberwell School of Art), Westminster School of Art and Owen's College, Manchester.

20 The episode is recounted by Hunt, op cit, 2, pp 382–4.

21 Laurence Irving tells the story in *Henry Irving*, mcmli, pp 550–2.

22 W Graham Robertson, *Time Was*, 1931.

23 Ibid.

24 Arthur Hughes to Alice Boyd, 6.4.91. UBC.

25 Soskice, op cit.

26 Hueffer, *Ancient Lights*, op cit.

27 Ibid. William Rossetti, having read and approved the manuscript of Hueffer's *Life* (Cornell), demurred only at what he considered the author's over-cautious portrayal of Brown. In 1911, however, he took issue with Hueffer's more colourful *Ancient Lights*, objecting particularly to mention of FMB's swearing. ('The Inaccuracies of F Madox Hueffer', *The Outlook*, 27.4.11.) On this, most sources support Hueffer.

28 Arthur Hughes to Alice Boyd, July 1893. UBC.

29 FMB to Alderman Thompson, 29.7.93. Manchester City Archives.

30 FMB to Robert Garnett, 22.8.93. Wilmington.

31 Hueffer, op cit, p 397.

32 Soskice, op cit.

Picture Acknowledgements

A note on Brown's pictures: Many of Brown's earliest works have disappeared, notably those of his Belgian youth. In addition, after he threw in his lot with the Pre-Raphaelite *avant-garde* in 1850 the artist retouched or re-painted some early paintings, modifying his designs and heightening his colours. The result was partially to obscure the record, and we have therefore tried to include as many unretouched early works as possible. Conversely, Brown's later work poses problems of selection. Once his paintings began to sell in the 1860s he made several versions, typically two or more oils and a watercolour or chalk drawing, quite apart from designs for stained glass or book illustration which later became paintings. Given significant variations between all these, we have chosen the version which seems to express Brown's idea most completely.

Acknowledgements and thanks for permission to reproduce paintings, drawings, designs, photographs in their possession to:

COLOUR
The Ashmolean Museum, Oxford: Nos. 7, 26. The City Art Gallery, Birmingham: Nos. 2, 17, 22, 25. The City Art Gallery, Bradford: Nos. 9, 28.
The City Art Gallery, Manchester: Nos. 3, 23, 24, 35. The Town Hall, City of Manchester: Nos. 45, 46, 47, 48, 49, 50. The Castle Museum, Nottingham: No. 11. National Museums

& Galleries on Merseyside: Nos. 16, 27, 41. The Whitworth Art Gallery, University of Manchester: Nos. 10, 33, 43. The Fitzwilliam Museum Cambridge: No. 37.
The Tate Gallery: Nos. 8, 14, 19, 20, 21, 32, 38. The National Trust (Wightwick Manor): Nos. 13, 34. The Musee d'Orsay, Paris: No. 42. The Fogg Art Museum, Harvard: No. 1. The Delaware Art Museum: No. 18. The Forbes Collection: No. 4. Andrew Lloyd Webber: No. 17 (photo, David Crewe Read). Peter Rose & Albert Gallichan for No. 41. Don Green for No. 31. Malcolm Pollards for Nos. 29 & 30. Peter Nahum for No. 36. To Mrs. Imogen Dennis, Mrs. R. O'Conor, Dr. R. O'Conor, Mr. J. H. Leathart, for help and kindness and permission to reproduce works in their possession, special thanks are due.

BLACK AND WHITE
The Ashmolean Museum, Oxford: Nos. 14, 57, 87, 88, 90. The City Art Gallery, Birmingham: Nos. 1, 21, 22, 23, 24, 25, 39, 40, 41, 43, 45, 46, 48, 50, 62, 65, 67, 70 and 112. The City Art Gallery, Bradford: No. 40. The Cecil Higgins Art Gallery, Bedford: Nos. 42, 89. The City Art Gallery, Carlisle: No. 69. The City Art Gallery, Manchester: Nos. 13, 16, 34, 58, 59, 64, 66, 70, 71, 101, 103, 104, 110, 120, 125, 126, 141. Central Library (Local History): No. 136. National Museums & Galleries, Merseyside: Nos. 49, 63, 73. The City Art Gallery, Southampton: No. 97. The National Portrait Gallery, London: Nos. 47, 51, 72, 106, 140. Whitworth Art Gallery, University of Manchester: Nos. 26, 27, 28, 29, 101, 131, 132, 133, 134, 135. The Fitzwilliam Museum, Cambridge: No. 93. The William Morris Gallery, Walthamstow: No. 98. The Victoria & Albert Museum: Nos. 84, 85, 86, 138. The Tate Gallery London: Nos. 11, 12, 15, 44, 55, 74, 76, 77, 122, 123, 142. The House of Lords Sub-committee on Works of Art: Nos. 30, 31, 33. The Society of Antiquaries of London: No. 111. The Royal Photographic Society: No. 113. The Greater London Photo-Library: Nos. 80, 107. The Shakespeare Birthday Trust: No. 137. National Gallery of Belgium, Brussels: No. 18. The National Gallery of Canada, Ottawa: No. 38. Sothebys: Nos. 32, 79, 100. Christies: No. 119. Jeremy Maas: Nos. 109, 139. Local History Archive, Barnet.

Index of Pictures

by Ford Madox Brown

Index